THE CULTURED CANVAS

THE CULTURED

New Perspectives on
American Landscape
Painting

EDITED BY NANCY SIEGEL

CANVAS

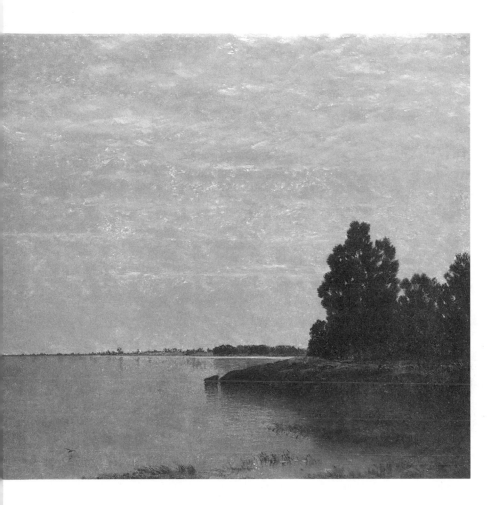

UNIVERSITY OF NEW HAMPSHIRE PRESS | DURHAM, NEW HAMPSHIRE

University of New Hampshire Press
An imprint of University Press of New England
www.upne.com
© 2011 University of New Hampshire
Manufactured in the United States of America
Designed by April Leidig-Higgins
Typeset in Adobe Caslon Pro by Copperline Book
Services, Inc.
5 4 3 2 1

For permission to reproduce any of the material
in this book, contact Permissions, University Press
of New England, One Court Street, Suite 250,
Lebanon NH 03766; or visit www.upne.com

Library of Congress Cataloging-in-Publication Data
The cultured canvas : new perspectives on American landscape
painting / edited by Nancy Siegel. — 1st ed.
p. cm. — (Becoming modern : new nineteenth-century studies)
Includes bibliographical references and index.
ISBN 978-1-61168-197-0 (cloth : alk. paper)
ISBN 978-1-61168-198-7 (pbk. : alk. paper)
1. Landscape painting, American — 19th century.
2. Landscapes in art. I. Siegel, Nancy. II. Title: New
perspectives on American landscape painting.
ND1351.5C85 2011
758'.10973 — dc23 2011034656

This book was published with the generous support of
Furthermore: a program of the J. M. Kaplan Fund.

CONTENTS

Acknowledgments ix

Introduction | Redefining the Canvas xi

ONE TIM BARRINGER
The Englishness of Thomas Cole 1

TWO KENNETH JOHN MYERS
Above the Clouds at Sunrise:
Frederic Church's Memorial to Thomas Cole 53

THREE REBECCA BEDELL
Andrew Jackson Downing and the
Sentimental Domestic Landscape 85

FOUR ALAN WALLACH
Rethinking "Luminism":
Taste, Class, and Aestheticizing Tendencies in
Mid-Nineteenth-Century American Landscape Painting 115

FIVE NANCY SIEGEL
"We the Petticoated Ones":
Women of the Hudson River School 148

SIX DAVID SCHUYLER
Jervis McEntee:
The Trials of a Landscape Painter 185

SEVEN KATHIE MANTHORNE
Eliza Pratt Greatorex:
Becoming a Landscape Painter 217

EIGHT ADRIENNE BAXTER BELL
Body-Nature-Paint:
Embodying Experience in Gilded Age
American Landscape Painting 241

Contributors 287
Index 291

Color plates follow page 170

ACKNOWLEDGMENTS

This collection of essays is the result of many meaningful conversations with colleagues from various fields of study. Over countless cups of coffee, lunches and dinners at conferences, and serendipitous meetings, we exchanged ideas and shared a desire to create a publication in which new perspectives and modes of inquiry would be brought to the field of American landscape studies. It became immediately obvious that this goal would best be accomplished through the efforts of multiple voices. I am indebted to my colleagues who contributed to *The Cultured Canvas:* Tim Barringer, Rebecca Bedell, Adrienne Bell, Kathie Manthorne, Kenneth Myers, David Schuyler, and Alan Wallach. Their generosity in taking part in this project is matched only by their wisdom and superb scholarship.

I would like to thank the University Press of New England for their immediate support of this book, in particular editor Richard Pult, who has been an incredible source of support and encouragement in his stalwart marshalling of this manuscript from abstract into print. Others at UPNE also have been wonderful to work with, including Amanda Dupuis, Peter Fong, and Katy Grabill.

Financial support for this publication was generously provided by numerous individuals and institutions. This project began while I was teaching at Juniata College; the college's provost, Dr. James Lakso, provided necessary subventions and much appreciated encouragement. My colleagues Karl Fugelso, Emily Halligan, Susan Isaacs, and Amy Sowder in the art history program at Towson University have been equally as supportive and I am grateful for a monetary award from that program. Likewise at Towson, Christopher Spicer, dean of the College of Fine Arts

and Communication, and Stuart Stein, chair of the Department of Art + Design, have provided both time and funding to move this anthology forward toward publication—my sincere thanks to them both.

Of course, friends and family are always a critical part of the success of any such endeavor. Although contributing authors make their acknowledgments known at the beginning of their chapter notes, I would like to single out a few individuals who had an impact on the overall structure of this book. Kathleen Parvin has provided exceptional editorial assistance in so many ways—formatting, proofreading, indexing—she has been consistently at the ready even with the strictest of deadlines. Matthew Baigell, Georgia Barnhill, and Eleanor Harvey have provided continuous support while, in the broadest sense, Jenny Seller, Sharon Harrow, and Kate McGivney have been instrumental to the shaping of this book. A special thank you is due to the anonymous outside readers who provided wonderful insights and suggestions for the contributing authors.

I am ever grateful for the company and kindness of my sister, Laura Parizeau, with whom I have climbed many mountains both real and imagined, enjoying the views and vistas along the way.

REDEFINING THE CANVAS

Footnotes at the bottom of a page, conversations at symposia and conferences, questions posed via listserv and email—these exchanges become the sources for new modes of inquiry and, in fact, established the genesis for this publication. The field of American art history, landscape studies in particular, endeavors increasingly to push beyond the comfortable reaches of visual analysis. Despite a lack of catalogues raisonné for its iconic figures, many scholars, while still incorporating connoisseurship and visual analysis, have been spirited away by the lure of cultural and historical muses, curious to explore the interrelationship and interconnectedness between the object and society (American and the trans-Atlantic). Through a collection of essays situated neither in the purely aesthetic nor the distinctly historical, *The Cultured Canvas: New Perspectives on American Landscape Painting* explores myriad ways in which American visual culture—as it pertains to nineteenth-century landscape studies—can be reevaluated. Indeed, the title of this book is meant to suggest a broadly conceived definition of the canvas that moves beyond our traditional notion of "oil on canvas" to consider both a literal and figurative surface upon which artists construct or construe the landscape as an intellectual, cultural, or physical canvas.

The chapters in this book address four major critical responses to the field of nineteenth-century American landscape studies: a reevaluation of the founding figures of the Hudson River School; a challenge to the language and the vocabulary of landscape studies; the reinsertion of artists previously subject to historical oversight back into the discourse; and the physiological components required as part of the corporeal process of

painting. In each of these four areas of inquiry, the authors situate their arguments within the nineteenth-century cultural milieu in which their subjects painted or in which stylistic tendencies occurred. Each of the contributors employs distinctly different methodological and theoretical perspectives, yet these essays serendipitously overlap and intertwine between chapters. From here, the canvas extends.

Specific topics covered in this book include: the Englishness of Thomas Cole, the literary and visual languages of landscape studies, elegies and memorial paintings, the popularization of the Hudson Valley as a tourist site, the dissemination of American landscape imagery in the early to mid-nineteenth century through a variety of media, the education of women artists and the possibility of a gendered landscape experience, luminism and tonalism as social as well as aesthetic constructs, sentimentalism as part of the American landscape architecture experience, and the physical and metaphysical processes required for painting landscapes in the Gilded Age. The accompanying illustrations include the work of well-known artists and of those perhaps previously overlooked in scholarship or seemingly disparate to a conversation about nineteenth-century American landscape painting. This includes work by: J.M.W. Turner, George Cruickshank, Thomas Cole, John Constable, Frederic Church, the engraving firm of Fenner Sears and Co., Andreas Achenbach, Andrew Jackson Downing, Harriet Cany Peale, Louisa Minot, Jane Stuart, Sarah Cole, Susie Barstow, Mary Josephine Walters, Asher Durand, Laura Woodward, Sanford Robinson Gifford, John Kensett, Tompkins H. Matteson, Jervis McEntee, William Cullen Bryant, Calvert Vaux, Ferdinand Boyle, Thomas Nast, Winslow Homer, William Hart, Eliza Greatorex, Albert Pinkham Ryder, Abbott Thayer, George Inness, and Daniel Huntington.

Chapters 1 and 2 address Thomas Cole and Frederic Church, certainly two of the most renowned artists of the American landscape movement in the early to mid-nineteenth century and included in comprehensive studies of the field. How better to begin a discussion of the reevaluation of the founding figures of the Hudson River School than to address the artistic, cultural, and industrial influences upon Thomas Cole from his English, not American, sources? In "The Englishness of Thomas Cole," Tim Barringer reinterprets Cole's artistic and professional career in response to English socioeconomic conditions and the European visual culture which

informed Cole in his youth and throughout his career. Barringer removes Cole from the ideological confines of American nationalism and places the artist within a trans-Atlantic historical context. Since Cole spent his formative years in the educational and industrial systems of England, this approach to the evaluation of contributing influences allows for a significant reinterpretation of key works, including *The Oxbow* and *Course of Empire* series. Barringer's research prepares us to read such seminal works in Cole's oeuvre as commentaries upon the development and significance of the industrial revolution in Britain. As context for his analysis of Cole's paintings, Barringer also includes a fascinating discussion of the marginalized yet influential anti-industrial Luddites and the development of the British Empire in the nineteenth century. This point of view, however, does not require us to dismiss the historiography on Cole as it relates to his incorporation of American ideals. On the contrary, this chapter provides greater insight to the analysis of a complicated artist. Cole, in the hands of Tim Barringer, emerges as a sophisticated critic of European sources and influences, adopting and adapting to American culture as his artistic style developed and matured.

Kenneth Myers continues the examination of those key figures in American landscape studies with his essay, *"Above the Clouds at Sunrise*: Frederic Church's Memorial to Thomas Cole." There is little doubt that Church considered himself to be the true heir to Thomas Cole's artistic throne. However, Myers demonstrates that, as Cole's successor, Church could not have become a major artist without separating himself artistically from his teacher. As we learn in this chapter, separations and divergences may also be betrayals. We see Church from a post-Oedipal perspective—the desire of the son to overtake the father, of the student to master the master. Here we are reminded of the relationship that emerges between Cole and Church, the elder artist welcoming Church into his family, with Church then forming lasting friendships with the Thomsons, the Bartows, and Cole's young son, Theddy. Myers provides us with an overview of Cole's extensive production of Catskill landscapes—those in which the artist took advantage of the most awe-inspiring and beautiful vistas imaginable. Yet, Cole never painted the location depicted by Church in *Above the Clouds at Sunrise* (1849), making this, according to Myers, the visual means by which Church could distinguish himself as a master painter of the Hudson River

School—a mere pupil no longer. While recognizing the contributions of prominent Church scholars, including Franklin Kelly, Gerald Carr, J. Gray Sweeney, and John Howat, Myers suggests that Church's *Above the Clouds at Sunrise* is both "a memorial to Cole and an artistic declaration of independence." Although the view from the escarpment at the Catskill Mountain House was a famous Catskill vista, Myers asserts that Cole would not, or could not, paint the dramatic cloud formations that fill the valley in the morning, and that by combining the naturalistic with the moralizing, Church indeed established a means to represent what his teacher was never able to achieve. In *Above the Clouds at Sunrise,* Church both honors Cole's memory while claiming his own authority and identity within the Hudson River School.

From the founding figures to the lexicon with which we discuss their work, *The Cultured Canvas* moves to consider the language of landscape. Chapters 3 and 4 present reevaluations of our general parlance as they pertain to the discourse of the American landscape at mid-century. Terms such as *landscape architecture, domestic,* and *sentimental,* in addition to the stylistic designation *luminism,* are featured in these next two spirited essays. Rebecca Bedell explores the relationship between sentimentality, domesticity, and the physical canvas of landscape architecture in her essay "Andrew Jackson Downing and the Sentimental Domestic Landscape." Bedell addresses the phraseology associated with the words *sentimental* and *sentimentality* within the developing ideology of the home, as it was constructed for and by men in the nineteenth century. Figures such as Andrew Jackson Downing, a truly influential writer on American architectural and horticultural topics at mid-century, believed that the ideology of sentimentality was a powerful motivator for men. The emotional properties associated with the home (as distinguished from a house) could, as asserted by Downing, save a man from the perils of worldly dangers and in fact strengthen the nation. Increasing one's attachments to the concept of home and, by extension, to country provided a corrective measure to the increasing and encroaching hardships associated with industrialism and the mechanisms of market capitalism. The vocabulary of home as Bedell evaluates it was a gendered space—masculine, however, not feminine as previous scholarship has posited. In this chapter, we come to understand the ways in which peace and happiness could be ascertained within the

walls of a home carefully arranged and built with the help of architectural plans designed to facilitate domestic bliss. Although women certainly played an important role in the promotion of domestic expectations, Bedell demonstrates that men such as Downing not only participated in but dominated the formulation and dissemination of a sentimental domestic architecture and horticulture. Through his designs for houses, and in particular the selection and placement of trees and plantings, Downing establishes a call to put down roots, literally and figuratively. With the planting of groves and gardens, the landscape is created for personal enjoyment—a living Hudson River School composition. In the antebellum era, as Bedell contends, "no single place was considered more important to the cultivation of sentimental feelings than the family home."

And then there is luminism, a term for which consensus no longer exists as to its definition and appropriate use. In the Hudson River School idiom, the word is often employed to characterize the artist's evocation of the presence of light and air, but the very existence of a luminist aesthetic has been called into question. For Alan Wallach, this becomes the point of departure for an in-depth examination of the historiography of luminism as well as the means to move scholarship forward and establish the term as reflective of a larger socioeconomic discourse. In "Rethinking 'Luminism': Taste, Class, and Aestheticizing Tendencies in Mid-Nineteenth-Century American Landscape Painting," Wallach asserts that Americanists have distanced themselves from the term altogether. Moving away from the strict confines of luminism as primarily a formal or stylistic term, Wallach analyzes the historical phenomenon of luminism beyond mainstream Hudson River School aesthetics. He presents a compelling and innovative analysis in which luminism coincides with a growing appreciation and market for landscape sketches and smaller paintings of popularized landscape scenes within the larger context of the New York art market at mid-century. Accordingly, as the city's elite evolved into a new generation of patrons, they asserted their aesthetic authority through institutional means. Indeed, this new bourgeois class, as Wallach explains, would come not only to dominate the political and economic structure of the nation in the years following the Civil War, but would assert itself as arbiter of taste as it contributed to and controlled the establishment of iconic cultural institutions, such as the Metropolitan Museum of Art. In this chapter, Alan

Wallach asks us to consider luminism beyond its conventional descriptive confines and to reconsider a high-art aesthetic as it develops in the second half of the nineteenth century with far greater socioeconomic and class implications than have hitherto been presented.

As the canvas of nineteenth-century landscape studies widens to accommodate reevaluations of founding figures and existing terminologies, there is also the increased need to correct historical oversight. Chapters 5, 6, and 7 address specific artists of the Hudson River School such as Sarah Cole, Susie Barstow, Jervis McEntee, and Eliza Greatorex. If these names do not immediately come to mind when considering the landscape movement of the nineteenth century, they should. This interest in understudied artists led me to explore such a theme in "'We the Petticoated Ones': Women of the Hudson River School." As a challenge to the mid-century barometer for the perceived abilities of women in intellectual and artistic realms, there exists a new canon of artists who were decidedly part of the nineteenth-century tradition of American landscape painting. This essay provides insight into an area of scholarship often overlooked—that is, the presence of women landscape artists in the nineteenth century. By the early decades of the century, women traveled in increasing numbers to experience American scenery, and many wrote poetically of their adventures. From reading personal diaries and published travel accounts, we know that women artists explored the mountains and woods of America alongside their male companions. A growing tourist industry in America by the late 1820s resulted in the increased production of travel guides which highlighted specific sites that women might enjoy viewing as well as offered advice on appropriate clothing to bring on such excursions. So too were schools and private instruction established to provide artistic education for young ladies, especially in the art of landscape studies. This chapter reinserts into the history of American art such figures as Susie Barstow, Jane Stuart (daughter of Gilbert Stuart), Sarah Cole (sister to Thomas Cole), Harriet Cany Peale (wife of Rembrandt Peale), Evelina Mount (niece to William Sidney Mount), and Louisa Davis Minot. Beyond their supporting roles as wives, sisters, nieces, and daughters, these talented and accomplished landscape artists have, until recently, received little scholarly attention. This chapter provides a platform, or canvas, on

which to portray these artists within the American landscape experience of the nineteenth century.

Likewise, in "Jervis McEntee: The Trials of a Landscape Painter," David Schuyler examines the art and personage of Jervis McEntee, long regarded as a lesser-known member of the Hudson River School but here presented as both an artist and biographer of sound importance. McEntee was a prolific painter of the smaller landscape scenes; he maintained deep friendships with Frederic Church, John Kensett, and Sanford Gifford, and he wrote prodigiously on cultural and artistic topics in a series of lengthy diaries composed over a period of decades. Those tomes not only provide us with insight into the working process of the artist, but also divulge copious details about the artistic and social milieu of New York City during the second half of the nineteenth century. Schuyler has begun to mine the depth and breadth of these diaries, finding intimate details and gossipy notes of interest. The voyeurism associated with reading McEntee's private thoughts, desires and, as Schuyler maintains, anxieties reveals how concerned the artist was to prove himself to his esteemed colleagues and friends. McEntee writes eloquently of his psychological struggles; his own friends describe him as melancholy. The canvas here is clearly cultural, yet the works that illustrate this essay demonstrate that there is much scholarship to be conducted regarding McEntee's art and life. His landscapes of the 1860s reflect the influence of European styles—despite McEntee's stated distaste for Corot—while presenting many additional questions regarding the role or function of American landscape painting during the years surrounding the Civil War.

Kathie Manthorne calls attention to a painter whose importance as an artist of the nineteenth-century urban and rural landscape is long overdue in the scholarship of landscape studies. In "Eliza Pratt Greatorex: Becoming a Landscape Painter," Manthorne does not accommodate anti-Irish prejudice or "the neglect suffered by women artists" as part of her argument. Rather, this chapter immediately delves into the life and visual production of the artist. Manthorne reinserts Greatorex into the environs of the New York art world prior to and after the Civil War. Whereas Schuyler finds in Jervis McEntee an artist who struggled emotionally for his place within the academy, Manthorne provides us with a biographical

sketch of an artist who overcame great odds and achieved prominence as an elected associate of the National Academy in 1869. Although Greatorex endured the difficulties associated with widowhood and supporting her family, this is not a study of hardship and woe. Perseverance, personal fortitude and, of course, the American landscape take center stage in this chapter. In addition to her commitment to drawing and painting American scenery—both the pastoral and the urban landscape of New York—Greatorex is also important, so we learn, as a preservationist, documenting now-historic landmarks as part of a hundred-image folio entitled *Old New York: From the Battery to Bloomingdale*. Manthorne constructs a framework in which to best comprehend Greatorex as an historical figure and artist through a series of questions that consider artistic production, patronage, training, and access to the landscape itself. This frame establishes the means by which Greatorex and other women artists of the nineteenth century negotiated the art world in concert with, or distinct from, their male counterparts. Manthorne suggests that if we accept Asher Durand as Dean of the Hudson River School, Greatorex was surely Dean of Women Artists, situated between figures such as Lilly Martin Spencer and Mary Cassatt.

Turning to the physiological complexities necessary for the corporeal act of painting on canvas, Adrienne Baxter Bell carries our discussion of American landscape painting through to the end of the nineteenth century and beyond. In her chapter "Body-Nature-Paint: Embodying Experience in Gilded Age American Landscape Painting," Bell takes us from the ideologically based framework of landscape painting into the physicality of the painterly process. Analyses of the artist Jackson Pollock have at times anchored the discussion concerning the emotive and energized application of paint on canvas, yet Bell calls this assumption into question. She revisits the European sources of inspiration for the Hudson River School as integrated in chapter 1 by Tim Barringer and propels us through the theoretical rigors of John Ruskin and the artists of the New Path, and the poetic musings of Emerson, to the postulation that artists of the Gilded Age were part of an era's examination of the body as a political, social, economic, and philosophical entity. Within this evaluation of the body as an artistic instrument, Bell speaks of the "slurries of paint, stippled marks, scored and scratched lines, finger prints, and use of wax

and bitumen" to describe how American artists such as Abbott Thayer, Albert Pinkham Ryder, and George Inness were occupied not solely with their intellect and creativity as mental forces but also with their bodies as they engaged in the physical dance-like properties of painting. The canvas here is literal, as the materials of the painterly process become the conduit for and the vehicle upon which these artists expressed or even created emotions—giving physical form to the nebulous, ponderous world of feeling—inspired by the American landscape.

Through this combination of aesthetic, sociopolitical, historical, cultural, literary, and psychological approaches to the study of the American landscape in the nineteenth century, these essays—with their fresh interpretations and interdisciplinary perspectives—are intended to complement methodological approaches utilized in recent publications, including but clearly not limited to *A Keener Perception: Ecocritical Studies in American Art History*, edited by Alan C. Braddock and Christoph Irmscher (Tuscaloosa: University of Alabama Press, 2009); *Seeing High and Low: Representing Social Conflict in American Visual Culture*, edited by Patricia Johnston (Berkeley: University of California Press, 2006); *Within the Landscape: Essays on Nineteenth-Century American Art and Culture*, edited by Phillip Earenfight and Nancy Siegel (University Park: Penn State University Press, 2005); and *American Iconology*, edited by David C. Miller (New Haven: Yale University Press, 1993). As interdisciplinarity is employed with increasing frequency in the scholarship of the arts and humanities, so too have innovative exhibitions and their corresponding catalogues become prevalent, in which one finds greater inclusivity and comprehensive discussions regarding landscape studies. This methodological shift began in many respects with *Views and Visions: American Landscape before 1830* (Washington, D.C.: Corcoran Gallery of Art, 1986); *American Paradise: the World of the Hudson River School* (New York: Metropolitan Museum of Art, 1987); and *The Catskills: Painters, Writers, and Tourists in the Mountains, 1820–1895* (Yonkers, N.Y.: The Hudson River Museum, 1988). More recently, the influential exhibition *Thomas Cole: Landscape into History* (Washington, D.C.: National Museum of American Art, 1994), as curated by William Truettner and Alan Wallach, placed the artistry of Thomas Cole within the larger framework of nineteenth-century American politics and society. The tradition of acknowledging and contextualizing the importance of

the American landscape movement continues to shape exhibitions as varied and picturesque as their titles. In brief, this list includes *Frederic Edwin Church: In Search of the Promised Land* (New York: Berry-Hill Galleries, 2000); *American Sublime: Epic Landscapes of Our Nation, 1820–1880* (London: Tate Britain, 2002); *George Inness and the Visionary Landscape* (New York: National Academy of Design, 2003); *Luminist Horizons: The Art and Collection of James A. Suydam* (New York: National Academy of Design, 2006); *Kindred Spirits: Asher B. Durand and the American Landscape* (New York: Brooklyn Museum, 2007); *Fern Hunting Among These Picturesque Mountains: Frederic Edwin Church in Jamaica* (Hudson, N.Y.: Olana, 2010); and *Remember the Ladies: Women of the Hudson River School* (Catskill, N.Y.: Thomas Cole National Historic Site, 2010).

As mentioned in the acknowledgments, I am indebted to my colleagues who contributed to *The Cultured Canvas: New Perspectives on American Landscape Painting:* Tim Barringer, Rebecca Bedell, Adrienne Bell, Kathie Manthorne, Kenneth Myers, David Schuyler, and Alan Wallach. Their participation has resulted in a series of dynamic essays. Clearly, the work of these scholars speaks for itself, far better than I can summarize their efforts. And so, I invite you to explore the cultured canvas of the nineteenth-century American landscape.

THE CULTURED CANVAS

The Englishness of Thomas Cole

Kindred Spirits, the celebrated double portrait and composite landscape by Asher Brown Durand, has long been enshrined in the historiography of American art as a retrospective manifesto of the so-called "Hudson River School."[1] The painting pays homage to the memory of Durand's friend Thomas Cole, whose sudden death on 11 February 1848 represented, according to one newspaper, a "public and national calamity."[2] Durand's visual eulogy identifies Cole as the leader of the national—rather than merely a local—school, and testifies to the success of the recently deceased painter's quest to promote landscape painting in America, in parallel to the efflorescence of American landscape poetry and travel writing at the hands of the other individual pictured, William Cullen Bryant. The painting, moreover, asserts a natural connection between Cole's poetic and painterly sensibility and the landscape of the Hudson River Valley—indicated by the jaunty angle of his maulstick across his portfolio, gesturing with a sense of enraptured reverie towards the hybrid landscape of Kaaterskill Clove beyond. Cole's name, along with that of Bryant, is inscribed on a tree-trunk in the lower left corner, in an imagined act of harmless rural vandalism, which also signifies Cole's organic connection to the Hudson Valley, his place beneath the bark—as it were—of America itself.

Although a rich and sophisticated historiography has developed in rela-

tion to Cole since the centenary of his death in 1948, many of the underlying assumptions of Durand's painting have remained unchallenged. Cole's special status was widely recognized in his own time and, on his death, Bryant delivered a funeral oration before the National Academy of Design that remains a resonant text in the historiography of American art. Its central rhetorical strategy is to parallel Cole's uniqueness with that of the American landscape. Cole's early work captured what Bryant described as "mountain summits, unmistakably American, with their infinity of treetops, a beautiful management of light, striking the forms of trees and rocks in the foreground, and a certain lucid darkness in the waters below."[3]

Surveying the artistic landscape without Cole, Bryant attempted a somewhat hubristic metaphor: "It is as if the voyager on the Hudson were to look toward the great range of the Catskills, at the foot of which Cole, with a reverent fondness, had fixed his abode, and were to see that the grandest of its summits had disappeared, had sunk into the plain from our sight."[4] Cole had become a fixture of the landscape, as American as the Catskills themselves.

Later accounts emphasized Cole's protean role as the progenitor of American landscape painting. Thus Henry T. Tuckerman in *American Artist Life*, of 1867:

> To [Cole] might be directly traced the primal success of landscape painting as a national art in the New World; his truth and feeling excited enthusiasm: all who had ever enjoyed the aspects of nature peculiar to this continent were, to use the language of Bryant in his discourse on Cole's career and character "delighted at the opportunity of contemplating pictures which carried the eye to a scene of wild grandeur peculiar to our country."[5]

Cole was, according to this account, himself "peculiar to our country," a "primal" exponent of a national art.

Yet these accounts either elide or underestimate a significant fact. Cole was born in Bolton-le-Moors, the town now known simply as Bolton, in the English county of Lancashire, in 1801, the son of an unsuccessful textile manufacturer in the early years of the industrial revolution. Thomas Cole lived in England until the age of seventeen, acquiring there a rudimentary training in image-making and a visual, as well as a verbal, literacy

based on the conventions of art-making in Britain at the high point of Romanticism. By all accounts an intelligent and sensitive youth, he absorbed much from his experience of the industrial northwest of England at a moment of violent historical transformation and one of creative ferment across the visual and verbal arts. This chapter will argue for a reconsideration of the Englishness of Thomas Cole, by proposing—in contradiction to the artist's own fervent assertions and much of the edifice of subsequent scholarship—that the experience of those early years shaped, even determined, Cole's later cultural and aesthetic positions. While Cole distanced himself—through a careful campaign of self-fashioning—from the modern, the industrial and, after 1818, the English circumstances of his formation, I suggest that his creative project was defined—albeit negatively —by the geographical, economic, and cultural milieu of his early life. Cole's paintings, I will claim, can be seen to make frequent, if tacit, references to British art and culture. While they resist the explicit interrogation and celebration of English national identity that was a defining theme in the work of John Constable and J.M.W. Turner, works from the entirety of his career bear the imprint of the processes of history as Cole observed them in northern England as the Napoleonic Wars came to an end.[6] We must begin, however, by placing the figure of Thomas Cole in relief against a very different set of landscapes from the Hudson Valley wilderness so artfully delineated by Durand in *Kindred Spirits*.

Bolton-le-Moors in the Age of Ned Ludd

Bolton-le-Moors, the archaic version of the town's name, always cited in the Cole literature, immediately suggests the stark contrasts between the industrial city and the rugged landscapes that surround it. Bolton's factories and workshops are set deep in a valley beneath the moors, open areas of windswept high ground, sparsely clad with vegetation, used mainly for sheep farming and as hunting grounds for aristocratic sportsmen. The contrast between densely populated centers of industrial modernity and the sublime uninhabited landscape became a key trope of late-Romantic fiction, most notably in the work of Emily and Charlotte Brontë, whose home in Howarth, in the neighboring West Riding of Yorkshire, shared with Bolton its outcrops of dark millstone grit, a cold, wet climate, and burgeoning manufacturing industries.[7] J.M.W. Turner, the single most

important influence on Cole throughout his career, showed himself to be a sophisticated observer of the new industrial cities in his prospect of *Leeds* (1816; fig. 1.1 and plate 1), where industrial smoke and northern England's natural cloud cover blend inextricably together.[8] Leeds lies about forty-five miles from Cole's place of birth, and was connected to it by a network of canals and turnpike roads such as that seen in the right foreground of Turner's watercolor. Turner's *Leeds* betrays a less awestruck response to the spectacle of industry than can be seen in his later oil painting *Rain, Steam and Speed* (1844; National Gallery, London). His formulation of the industrial sublime in representing the northern city is ideologically neutral, refusing to guide the viewer as to the merits of the transformation underway before him in Yorkshire. Turner remains enigmatic: are we witnessing a providential turn of events among a chosen people—a vision of progress itself—or a blackening of England's pristine countryside, and a debasement of its rural populace, as the aging William Wordsworth, among many others, came to believe? Do the robust, rough figures in the foreground personify the barbaric vulgarity of the industrial mob, or the "sinews of England," upon whose hard labor the nation's prosperity relied? Unlike the more conservatively minded Cole, Turner was open to a positive, even laudatory, response to industry and to the industrial working class. He was even prepared to acknowledge analogies between his own work and that of skilled manual laborers—both of them endeavors of national importance. The English artist pointedly includes a tinter's frame, set up for the bleaching of textiles, in the left foreground of *Leeds;* the echoes resonating between this unfamiliar contraption and the artist's canvas have been noted by Stephen Daniels.[9] It was precisely such vivid connections between his own work and that of the people at large that Cole—whose early years were spent engraving designs for cheap calico prints—would aim to deny throughout his life as an artist.

Key to the prosperity of Cole's home town was the Manchester, Bolton, and Bury canal, begun by authority of an Act of Parliament of 1791, but still unfinished when Cole was born a decade later. The cutting of the canal created a vast geometric gash across the rural landscape, dug by itinerant crews of navvies (the term deriving from an early term for the canals, *navigation*), whose drunken wildness became a thing of legend.[10] An artery of commerce, the canal provided a route for raw materials, such as

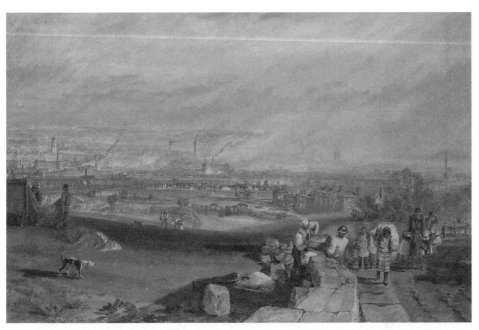

FIG. 1.1. (Plate 1.) Joseph Mallord William Turner, *Leeds*, 1816, watercolor, scraping out and pen and black ink, 11½ × 17 in. Yale Center for British Art, Paul Mellon Collection, B1981.25.2704.

coal and iron ore, from their origins to the factories, and carried finished goods, especially textiles, from Lancashire to markets across the country and, via the Liverpool docks, to markets in the British Empire and across the world. Bolton thus became an important node in the complex network of largely unregulated flows of capital, labor, and goods that constituted the world's first industrial nation. The young Cole was witness as a boy to processes of environmental, social, and economic change and development as dramatic as any in history.

The town's position on the west of the Pennines provides a damp, cool climate ideal for textile spinning and weaving, and the area was at the forefront of industrial development in the last decades of the eighteenth century. Bolton's population in the year of Cole's birth was only 12,549 but it grew rapidly to exceed 40,000 by 1851. Large, steam-powered textile mills came to dominate the town's skyline, providing the major employment and defining the rhythm of the working week. The atmospheric

pollution caused by the industry was such that an annual shutdown for maintenance in late June became Bolton's holidays, or Wake's Week, the only time of year when the air was clear enough to see the nearby hillsides with Pre-Raphaelite clarity.

Bolton enjoyed a special place in the history of British industrialization as the birthplace and home of Samuel Crompton, the celebrated, though impecunious, inventor of the mule, a technological innovation responsible for the transformation of cotton spinning from domestic to factory production, a process already underway during Thomas Cole's boyhood. According to figures collected by Crompton himself, by 1810–11 the industry employed over 70,000 people nationally, with almost four million cotton spindles in operation.[11] Resistance to this transformation took violent forms, including machine-breaking by groups of dispossessed workers. Although the mule initially created vast amounts of work for self-employed handloom weavers, large-scale factory production suddenly rendered them virtually obsolete in the 1790s, a definitive act of dislocation that became an emblem of the malign social effects of the industrial revolution.[12]

Cole's early years in Bolton coincided with a period of working-class unrest under the vague but powerful banner of Luddism, an anti-industrial movement responsible for sporadic campaigns of arson and machine-breaking, aimed at the protection of the traditional rights and privileges of manual laborers.[13] The mythical leader of the movement, Captain Ned Ludd, appeared in a caricature, *The Leader of the Luddites* (fig. 1.2). It depicts Captain Ludd wearing a cotton dress; a calico, in fact, of the type made in the factory where the juvenile Cole was employed. While the intention was to ridicule and effeminize Ludd and his army by linking rebellious textile workmen to the female consumers of the fabrics they produced, the actual effect of the print is quite other—the menacing visage and powerful physique rendered the cross-dressed figure close to that of the feared Scottish Highland soldier in his kilt. The flames of a burning textile mill, seen in the background, were familiar sights to the members of Thomas Cole's generation in Lancashire.

The long-established traditions of millenarian thought among Dissenting sects in the north of England ensured that, in the flames of Luddite rebellion, many saw signs of the end of the world or, at very least, the

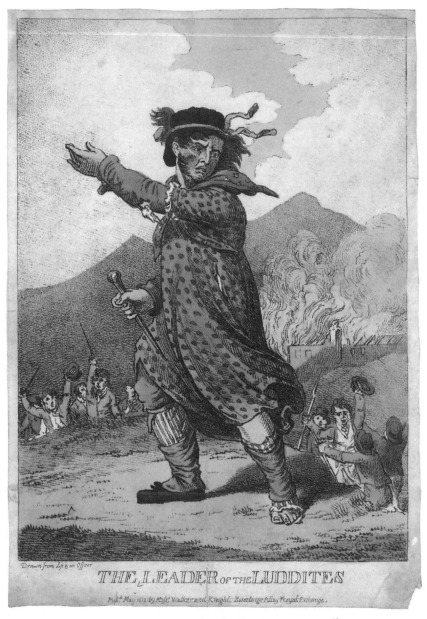

FIG. 1.2. *The Leader of the Luddites*, 1812, hand-colored engraving, 12¹³/₁₆ × 8 in. © Trustees of the British Museum, London.

destruction of empire—a theme to which Cole would return a quarter century later, at the height of his powers as an artist. Much though the local gentry may have attempted to play down the incident, the burning of the West Houghton Factory in Bolton in 1811 was typical of a much larger pattern of unrest and violence.[14] Haunted by fresh memories of the French and, to a lesser extent, the American revolutions, the authorities viewed civil disobedience and industrial violence with great seriousness, and extremely repressive measures were taken both by local magistrates and by forces under the ultimate control of the central government of Lord Liverpool. Some of these—such as the mounted dragoons who killed fifteen people and injured several hundred at the so-called "Peterloo Massacre" at St. Peter's Fields, in Manchester (the nearest major city to Bolton) on 16 August 1819, shortly after the Cole family emigrated—utilized the traditional, military means of oppression. George Cruikshank's etching of the scene managed to harness the conventional rhetorics of history painting with the vivid immediacy of the satirical print, creating a powerful emblem of state power turned against the people (fig. 1.3). This febrile period in British history also saw the government's extensive use of covert forces to attempt to infiltrate supposedly subversive elements. These undercover *agents provocateurs*, spies, and informers were marked (as one of their opponents in Bolton put it in 1813) by a "disposition to *smell sedition in every wind.*"[15] Class war may seem an old-fashioned term, but the period around 1815 saw intense and violent social fragmentation along class lines, with a sense of impending crisis felt by much of the citizenry, likely including the teenage Thomas Cole.

If the physical and social geography of Bolton provided the young Cole with the starkest possible contrasts between country and city, rich and poor, employer and operative, old and new, what of the ideological and cultural matrix within which his very distinctive sensibility took shape? Alan Wallach has provided an excellent analysis of the religious climate in late-eighteenth-century Lancashire, emphasizing the importance of Dissenting religious groups—those rejecting the teachings and institution of the Church of England—among the middle classes of the northwest of England. Through assiduous research, Wallach successfully identified various members of the Cole family as occupying "a variety of middling-class occupations," and traced a web of relations between the Coles and

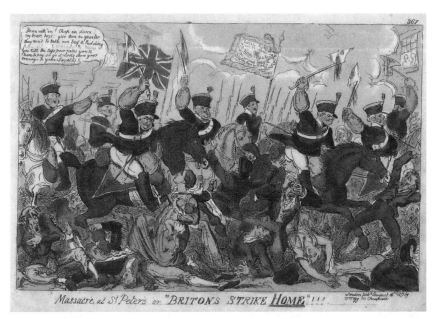

the Pendlebury family, long-established and wealthy yeomen and, by the end of the eighteenth century, members of the professions.[16] He also identified direct connections between Cole's family and the Dissenting tradition. One of them, Jonathan Pendlebury, was a bleacher who prospered in the early decades of the nineteenth century (he would have been the owner, rather than the operator, of bleaching frames such as those depicted in Turner's *Leeds*). While class status was by no means always a determinant of religious affiliation, Wallach demonstrates that there was a strong Dissenting tradition in the middle-class Cole and Pendlebury families. Thomas's aunt, Sarah Cole, specifically bequeathed to a relation "Matthew Henry's Commentaries of the Old and New Testament, together with all Mr Henry's other works belonging to me," these being the writings of the founder, in 1699, of the first Dissenting chapel in the nearby city of Chester, where Thomas Cole gained a rudimentary education. Henry's *Exposition of the Old and New Testament* was distinguished, one nineteenth-century commentator noted, "not for the depth

of its learning, or the originality of its views; but for the sound practical piety, and large measure of good sense, which it discovers."[17] It was, then, part of the ideological matrix linking Protestantism with capitalism, as described in classic texts by Max Weber and R. H. Tawney.[18] Even as opulence was frowned upon in the Dissenting tradition, high value was placed on worldly success, and Cole himself was often praised for his energetic pursuit of his worldly calling in later life.

This same Puritan tradition remained resonant in antebellum American writing on the arts, as on other subjects, and commentators such as William Dunlap and Louis Legrand Noble gently contrasted the worldly failure of the artist's father with the ambitiousness and conspicuous achievements of the son. Following the failure of a "manufactory" in Bolton, almost certainly making cotton cloth, Cole's father, James, seems to have moved to Chorley, a smaller town fifteen miles to the north, in about 1810. Chorley, with a nascent textile industry and several small coal mines, retained something of the character of a rural market town. Here, according to Noble, "young Thomas was more intimately made acquainted with those trials and privations which attended him for several years."[19] As a result of the family's parlous finances, Cole himself "entered a print-works as an engraver for simple designs in calico."[20] He was, in fact, hardly more than a factory laborer, in a lowly position albeit in Britain's most prosperous industry. Britain had been at war with France since 1793 and the naval blockade meant that imports entirely ceased. The need for uniforms for the army and navy had fueled massive production, but the purchasing power of newly empowered working-class female consumers, mainly factory workers, also accounted for the demand for cheap muslin dresses. Crompton's mule, and related technologies, had reduced the unit costs of cotton to bring this fabric within the reach of the working-class consumer.[21] As an apprentice textile engraver in 1815, Cole was at the very center of the industrial revolution, but his social status had fallen far below that of his respectable middle-class forebears.

Murky Buildings and Flowery Slopes

His biographers (basing their comments, perhaps, on Cole's own accounts) were at pains to distinguish him from the class of men among whom he found himself, despite their shared livelihood and place of work: "From

the rude character of many of his fellow-operatives his moral sense, which, from earliest childhood, was most delicate and lively, forbade him to form any intimate acquaintances with those of his own age." To Cole, then, is ascribed an instinctive aversion to the industrial working class, based, perhaps on the fear of becoming a member of it. As Alan Wallach rightly noted in 1981, "It is perhaps hard to overestimate the effect the English class system had on him."[22] He had, as Wallach attests, learned to think of himself as a gentleman, despite his family's impoverished condition. It formed, Wallach rightly asserts, "the core of his identity, the alpha and omega."[23] His only associates in his days as an industrial artisan were those who stood outside the modern hierarchies of class. Thus Noble allows the young Cole only one friend, "an old Scotchman, who could repeat ballads and talk of the wild hills and blue lakes of his native land." This gnarled Scot—perhaps real, perhaps a figure of Cole's imagination— recalls the bardic types popular from legends of Ossian and also resonates with the works of Walter Scott, which were eagerly consumed by a wide readership in the first decades of the nineteenth century. Scott's *Minstrelsy of the Scottish Border* had appeared in 1802; *The Lady of the Lake* met with phenomenal success in 1810 and his first novel, *Waverly*, appeared in 1814.[24]

Noble's account of Cole's Chorley years repeatedly emphasizes the contrasts of industrial and rural, and of the exertions of manual labor versus the play of artistic genius. Thus, "if he was subjected to much loneliness and vexation during the hours of work, he has his happiness in the intervals of leisure. The park-scenery, the ivy-mantled walls, and even the sounding-rooms of some of the old halls in the vicinity, afforded a range for his eye and fancy."[25] In this account, Cole was instinctively attracted to the haunts of the gentry, and pathologically horrified by the sites of artisanal labor. Already a budding—if only moderately talented—pastoral poet, he also took up the flute, an instrument associated with the courtier- shepherds of the *fête champêtre*, of which "he was a tolerable player. . . . [I]t was his delight to wander off into the shady solitudes, and mingle music and lonely feelings with dreams of beauty."[26] Noble is, of course, engaging in the mythmaking which was the stock-in-trade of the mid- nineteenth-century artistic biographer. There is a long tradition of the melancholic or saturnine artist seeking out the solitude of the woodlands and creating pastoral music. To take one example, Thomas Gainsborough

memorably wrote of his wish to escape fashionable London and Bath, and "to take my Viol da Gam and walk off to some sweet Village where I can paint Landskips and enjoy the fag End of Life in quietness & ease."[27] In this vein lie Noble's depictions of the teenager wandering with his sister "through the surrounding countryside, in search of the picturesque, for which he had already a remarkable love." Romantic self-fashioning thrived on such rambles: a fine example is John Keats's "Sonnet VII," which first appeared in a collection published in 1817, and the work of a teenager born only six years before Cole. It was from this poem that Durand would, years later, take the phrase "kindred spirits."

O Solitude! if I must with thee dwell
　　Let it not be among the jumbled heap
　　Of murky buildings; climb with me to the steep,—
Nature's observatory—whence the dell,
Its flowery slopes, its river's crystal swell,
　　May seem a span; let me thy vigils keep
　　'Mongst boughs pavillion'd, where the deer's swift leap
Startles the wild bee from the fox-glove bell.
But though I'll gladly trace these scenes with thee,
　　Yet the sweet converse of an innocent mind,
　　Whose words are images of thoughts refined,
Is my soul's pleasure; and it sure must be
　　Almost the highest bliss of human kind,
When to thy haunts two kindred spirits flee.[28]

Noble's account of Cole's life, like Cole's own creative output, was structured by this fundamental trope—a desire to withdraw from "murky buildings" to the countryside, "'Mongst boughs pavillion'd." It is repeated in Noble's depiction of the moment in Cole's career when the young artist leaves his father's "poorly lighted closet," where he was "pinched and blinded . . . elbowed and pushed by mean partitions," and escapes to the Hudson River Valley. The *locus classicus* of this trope is found in John Ruskin's discussion of the childhood of J.M.W. Turner. It was published in 1860, just seven years after Noble's biography of Cole, and describes events during a period just before Cole's birth. The passage opens with an

evocation of the drab, urban surroundings of Turner's youth, among the "murky buildings":

> Near the south-west corner of Covent Garden, a square brick pit or well is formed by a close-set block of houses, to the back windows of which it admits a few rays of light. Access to the bottom of it is obtained out of Maiden Lane, through a low archway and an iron gate: and if you stand long enough under the archway to accustom your eyes to the darkness you may see on the left hand a narrow door, which formerly gave quiet access to a respectable barber's shop, of which the front window, looking into Maiden Lane, is still extant, filled this year (1860), with a row of bottles, connected, in some defunct manner, with a brewer's business.

From his childhood here, "to the very close of his life," Ruskin explains,

> Turner could endure ugliness which no one else, of the same sensibility, would have borne with for an instant. Dead brick walls, blank square windows, old clothes, market-womanly types of humanity— anything fishy and muddy, like Billingsgate, or Hungerford Market, had great attraction for him; black barges, patched sails, and every possible condition of fog.[29]

We seem to have encountered an artist entirely at odds with Cole's cherished conceptions: urban, modern, vulgar, proletarian. Yet Ruskin's text carries Turner northwards out of the city on a stagecoach, and bears him to the peak of a hill in rural Yorkshire, beyond the reach of industry.

> For the first time, the silence of Nature round him, her freedom sealed to him, her glory opened to him. Peace at last: no roll of cart-wheel, nor mutter of sullen voices in the back shop; but curlew-cry in space of heaven, and welling of bell-toned streamlet by its shadowy rock. Freedom at last. Dead-wall, dark railing, fenced field, gated garden, all passed away like the dream of a prisoner; and behold, far as foot or eye can race or range, the moor, and cloud. Loveliness at last. It is here, then, among these deserted vales! Not among men. Those pale, poverty-struck, or cruel faces;—that multitudinous,

marred humanity—are not the only things that God has made. Here is something He has made which no-one has marred. Pride of purple rocks, and river pools of blue, and tender wilderness of glittering trees, and misty lights of evening on immeasurable hills.[30]

On the basis of this epiphany, Ruskin claimed, Turner "must be a painter of the strength of nature, and there was no beauty elsewhere than that."[31] These are sentiments that Cole—who died just before Ruskin's *Modern Painters*, volume 1, made a major impact on American art—would surely have endorsed. The pattern is a familiar one; the urban context of a life is radically rejected in a moment of quasi-religious revelation. God has made nature; man has made the city.

The moment at which Cole's sensitivity to the natural world was transformed into the avocation of a landscape painter is difficult to identify. If his early sensitivity to nature was heightened by exposure to literature, his formation of a visual aesthetic seems to have developed later. It seems unlikely that in Bolton or Chorley he would have had much exposure to works of art. However, his father's business failure resulted in the family moving once again, to Liverpool, where Thomas Cole became an engraver's apprentice in 1817. Liverpool, whose wealth came from shipping and from the slave trade, had been a significant regional center for art and art collecting since Joseph Wright had left his native Derby to set up his studio there in 1768, painting his pioneering, though ambiguous, series of industrial subjects, such as the two versions of *A Blacksmith's Shop*, of 1771.[32] Although the young Cole's access to paintings must have been limited, many art exhibitions occurred in Liverpool, and he would certainly have had access to the rich print culture of the period. Through the engravings, aquatints, and mezzotints inevitably present in a printmaker's shop, he must have absorbed the main compositional tropes and expressive effects of British landscape art of the period. The type of print which circulated widely in late eighteenth- and early nineteenth-century England may be exemplified by Paul Sandby's print in etching and aquatint, *Llangollin in the County of Denbigh, from the Turnpike Road above the River Dee*, published in 1776 (fig. 1.4).[33] Dramatically composed to maximize the contrasts made available by the tonal medium of aquatint, this composition incorporates many of the tropes to be found in Cole's Hudson River

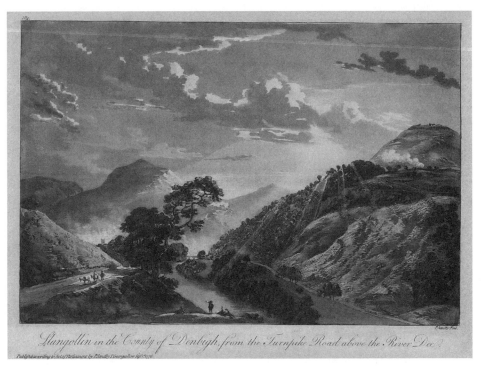

FIG. I.4. Paul Sandby, *Llangollin in the County of Denbigh, from the Turnpike Road above the River Dee*, from part II of *XII Views in Aquatinta*, London, 1776, aquatint. Yale Center for British Art, Paul Mellon Collection.

landscapes. The sunlight bursting through clouds; distant mountains with rising mists; shimmering river water in the foreground; the dramatic bulk of a mountain to the right—all of these would be taken up by Cole in his pioneering American landscapes.

There can be no doubt that the knowledge of such images was already a part of Cole's intellectual formation, and retained their currency in his mind long after he crossed the Atlantic with the family, hoping, like many whose lives had been disrupted by the wild swings of the industrializing economy of Britain, to seek their fortune in the young United States.

Glorious Features Unknown to Europe

Cole's biographers have all implicitly served a nationalist and exceptionalist agenda in their fabrication of the artist as an all-American product.

Cole himself also seemed to have felt the need to establish his American identity and dissociate from his British origins. Thus Bryant stated in his eulogy:

> He regarded himself . . . as an American, and claimed the United States as the country of his relatives. His father passed his youth here, and his grandfather, I have heard him say, lived the greater part of his life in the United States.[34]

Historian William Dunlap claimed in 1834, during Cole's lifetime, that Cole's grandfather was a "farmer, that is, what all American farmers are, a yeoman cultivating his own soil, near Baltimore,"[35] and as recently as 1948, Wolfgang Born, in the first modern account of American landscape painting, still identified the family as being of American origin.[36] There is no documentary evidence to support these statements, which may reflect an embroidery of the truth originating with Cole himself. Dunlap goes on to report that "so strong is his desire to have a right to call . . . [America] his, which he feels *to be his*, that I have heard it said he has exclaimed, 'I would give my left hand to identify myself with this country, by being able to say I was born here.'"[37]

Cole's progress from obscurity to national fame is likewise the stuff of myth.[38] Here Dunlap is the key figure.[39] His *History of the Rise and Progress of the Arts of Design in the United States* oscillates between an aspiration to become the American Vasari and the more typically Protestant project of presenting miniature biographies as homiletic moral exemplars, placing it in a trajectory from the keystone of English Protestant biography, Foxe's *Book of Martyrs*, to its Victorian successor, Samuel Smiles's *Self-Help, with Illustrations of Character and Conduct*, of 1859. Surprisingly, perhaps, Dunlap concentrates on the social and economic travails of the "amiable, virtuous, well-educated and tenderly nurtured" Cole family, who, "expatriated by reverse of fortune, and struggling among strangers for subsistence," arrived in the "western wilds of America." Much emphasis is placed on the family's fall in social status; they "try avocations, of which their only knowledge is derived from the reading of days when books were the elegant employment of leisure hours, and the study of science the favourite pursuit of life."[40] Cole's genteel father, pictured here—as in Noble's account—as idealistic but feckless, "applies the knowledge he had gained

from books" (the middle-class, white-collar way) "to the establishment of a manufactory on a puny scale, of some articles which begin to be wanted in the newly risen towns of the west." The failure of this business, and the wallpaper works in Steubenville, Ohio, which followed it, are duly chronicled. Thomas, who joined the family in Steubenville some months after their arrival, is pictured "drawing patterns and combining pigments for colours. This was his first step on the ladder, whose summit he has attained."[41] A letter from Cole's own hand reaches the heart of the issue: "My employment in my father's business was too little art and too much manual labour for one of an imaginative mind."[42] This fundamental distinction of mental and manual, the liberal versus the practical arts, lay at the heart of artistic self-fashioning in late eighteenth-century Britain; it could indeed be identified as the overriding theme of Joshua Reynolds's *Discourses,* delivered to the students and members of the Royal Academy in the two decades after its foundation in 1768. Dunlap's narrative follows Cole's autodidactic training, by which he climbed from manual labor to mental, from mechanic to artist. An early step in this direction was his close study of a book, "an English work on painting" lent to him by a Mr. Stein, an itinerant portrait painter. Cole avers, however, that he has forgotten the name of this text, another example of the erasures by which the artist disavowed his debts to British visual and cultural traditions. In a presumptuous move, Dunlap even commandeers the vocabulary of the sublime to describe Cole's campaign against destitution and failure:

> To me the struggles of a virtuous man endeavouring to buffet fortune, steeped to the very lips in poverty, yet never despairing or a moment ceasing in his exertions, and finally overcoming every obstacle, is one of the most sublime objects of contemplation as well as the most instructive and encouraging, that can be presented to the mind. Such a man is truly a hero, whether he sink or swim.[43]

This is homiletic writing entirely in sympathy with the Dissenting tradition of Cole's forebears.

According to all the major texts—including almost every account of Cole's work to the present day—his abrupt transformation into an American genius came in 1825, during a visit to the Hudson Highlands and the Catskill Mountains. This direct confrontation with the wilderness,

which (it is claimed) utterly displaced all previous experience, produced a wholly original art form standing outside of the tropology of existing landscape painting. After this American epiphany, Cole exhibited *ex nihilo* three paintings of Catskill scenery in the window of the New York bookseller William A. Colman. In a scene of symbolic endorsement typical of art-historical mythmaking, Cole's *Lake with Dead Trees (Catskill)* was purchased by Dunlap himself and *Kaaterskill Falls* was purchased by Colonel John Trumbull, president of the American Academy,[44] who (in a much-quoted paraphrase) declared "I am delighted and at the same time mortified. This youth has done at once, and without instruction, what I cannot do after fifty years' practice."[45]

Central to the reception of these works was the notion of Cole as a distinctively, paradigmatically American artist. Cole's writings, among which the "Essay on American Scenery" of 1836 is the most significant, lauded these scenes of the American wilderness, in comparison with the cultivated landscapes of Europe:

> I would have it remembered that nature has shed over *this* land beauty and magnificence, and although the character of its scenery may differ from the old world's, yet inferiority must not therefore be inferred; for though American scenery is destitute of many of those circumstances that give value to the European, still it has features, and glorious ones unknown to Europe. . . . The most distinctive, and perhaps the most impressive, characteristic of American scenery is its wildness.
>
> It is the most distinctive, because in civilized Europe the primitive features of scenery have long since been destroyed or modified—the extensive forests that once overshadowed a great part of it have been felled—rugged mountains have been smoothed, and impetuous rivers turned from their courses to accommodate the tastes and necessities of a dense population—the once tangled wood is now a grassy lawn; the turbulent brook a navigable stream—crags that could not be removed have been crowned with towers, and the rudest valleys tamed by the plough.[46]

For all his ardent advocacy of New World scenery, Cole was somewhat disingenuous here. He sought, in fact, precisely the same kinds of features

as the landscape painters of Britain. He alighted on rivers, waterfalls, and mountains, just as seekers of the picturesque had long done in England, Scotland, and Wales, and particularly in regions such as the Lake District, the Trosachs, and Snowdonia. In those remote parts of the British Isles, the impression, at least, of an untouched wilderness could be obtained, despite occasional traces of the management of the landscape over centuries by its aristocratic owners. Cole's eye had been trained by looking at picturesque prints in Liverpool, and his responses to what he saw in the Hudson Valley were shaped by pre-existing mental formulations—such as the picturesque itself—which had developed principally in Britain. Moreover, Cole was by no means the first to produce picturesque images of American scenery; in addition to many pioneering eighteenth-century efforts, consider *Picturesque Views of American Scenery* (1819–21) engraved by John Hill after Joshua Shaw—both of them English artists—and *The Hudson River Portfolio* (1821–25), again engraved by Hill, this time after William Guy Wall.[47] Both of these highly accomplished sets of aquatints performed the ideological work of processing the American landscape, by mobilizing an essentially British visual repertoire of image types, from "nature" into "art." Shaw, the apostle of the picturesque, insisted that, "Striking however and original as the features of nature undoubtedly are in the United States, they have rarely been made the subjects of pictorial delineation. America only, of all the countries of civilized man, is unsung and undescribed."[48] Both have largely been forgotten, however, while Cole's early landscape paintings in oil are habitually celebrated as standing at the birth of a tradition.

Controversy over Cole's landscapes of 1825 through 1828 in the recent historiography has focused on the validity of Bryan Jay Wolf's interpretation, in which these works represent the artist's attempt to disavow the historical and to create a parable of his own birth as a self-conscious creative individual. Wolf's overall claims are compelling: "through the Romantic sublime, Cole invents his own story, filling the silence of nonnarrative vistas with the clamor of self-discovery." He sees a "primal battle between the father and the son, antecedent art and modern revision" which is "recast from the position of the victor to appear as an inevitable and foregone conclusion."[49] In contrast, many more-recent commentaries have insisted on the presence of historical forces within Cole's early works to a degree

that determines—even overdetermines—their meaning. Thus scholars have—I believe rightly—read these works in relation to the opening of the Erie Canal, and the resultant opening up of midwestern and western trade routes, the development of a market economy centered in New York, the burgeoning tourist trade along the Hudson, and the conflict between Jeffersonian and Jacksonian political ideologies. I would like to suggest, however, that—as Wolf himself intimates—a psychoanalytic reading of these works is compatible with a historical and contextual analysis.

Whereas Wolf sees the family drama as being played out largely among the members of Cole's intimate circle, I would contend that the paternal force with which Cole engages in his early paintings is precisely that of the English landscape tradition and the social structures informing and bolstering it. I see Cole's landscapes of the late 1820s as heroic acts of disavowal and rebirth. The picturesque, the sublime, the country-house park—all of them were imbricated within the class hierarchies and strictures under which Cole was born, brought up, and oppressed. In his insistence on a landscape not yet inscribed with meaning, whose associations are of the future, Cole attempts to negate the long history of landscape in which his own figure must inevitably be one of subservience. By painting a landscape whose associations are in the future, Cole may seem to be offering up himself—and the wilderness—reborn, as personifying a vanquishing of that exhausted tradition. Yet, paradoxically, the more American he insists on being, the freer from the agonies of a "gentleman" reduced to "manual labour," the more closely Cole replicates the visual tropes produced by a patrician British culture. Moreover, he seems to have found through his affiliation with the Federalists of the Hudson River Valley, a reinforcement of the fantastical, genteel self-image that, despite his impoverished, lower-middle-class background, he had formulated as a teenager in Lancashire. The dreamy Chorley artisan was able, almost, to become a Federalist gentleman. His heroic act of re-envisioning was, in my reading, however, no more than a repeated projection of the repressive social and aesthetic values he imagined himself to have escaped, a return of the repressed Englishness that Cole was so keen to disavow and replace with fictitious American ancestors and a virgin countryside altogether freed (in his schema) from cultural history.

These processes are especially vivid in Cole's estate portrait of Monte

Video, the country villa of his patron Daniel Wadsworth, painted in 1828 on the basis of a visit in June 1827 (fig. 1.5 and plate 2). The painting is an homage to Cole's easy social interaction with superior families, in contrast to the landed gentry of Britain, where the social class structure would most likely have precluded any such contact.[50] Turner was the exception in this regard, as in so many others, and was on intimate terms with members of the gentry such as Walter Fawkes of Farnley Hall, and even aristocrats such as the Earl of Egremont at Petworth House.[51] Wadsworth's Monte Video was a modestly proportioned villa in the modish Gothic Revival style, positioned on the west slope of Talcott Mountain at Avon, Connecticut. Wadsworth had built a tower—a fashionable folly—from which to view the splendid panorama of the estate. Cole adopts the downward gaze of the monarch-of-all-he-surveys, in contrast to the more respectful distant prospects adopted even by the brash and confident Turner when painting Harewood House for its owner, Edward Lascelles, first Earl of Harewood (fig. 1.6). Harewood, here, is monumental, dominating the local landscape, to which it turns a blank, impassive face. Turner, however, positions himself among the peasantry. Where Cole is keen to emphasize his social interaction with the elegant, rather forward, young lady in the foreground of *Monte Video*, Turner gives us a couple of female reed-cutters, one sleeping, perhaps with a child alongside her, another carrying her bundle.

A later correspondence between Cole, when in Italy, and the ageing Daniel Wadsworth performs an elegant dance around the concepts of nature and culture, the American and the European, with Monte Video as its crux. Looking back on the Connecticut scene in memory in 1832, Cole—faced in Italy with visible evidence of the course of empires, and memories of Claude Lorrain and Turner at every turn—wrote to Wadsworth: "since I have been in Europe I have sometimes feared I was losing that keen relish for the beauties [of] Nature . . . [yet] I anticipate the pleasure of seeing with you another sunset from the *Tower*—one of the view of Monte Video I had engraved in England."[52] In reply, Wadsworth notes that "*to us* . . . Monte Video remains as beautiful as ever . . . but after the splendid Mountains [and] Palaces you have lived amongst—it will appear but a miniature—& a rude one."[53] Yet despite this play of false modesty, Cole's painting is a masterly idyll, on which the sublime and the beautiful

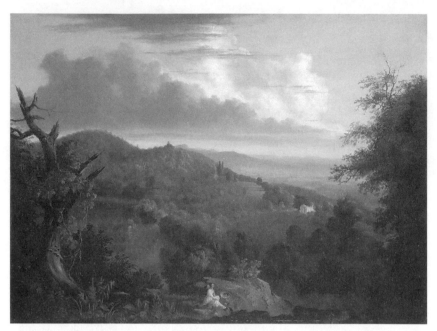

FIG. 1.5. (Plate 2.) Thomas Cole, *View of Monte Video, the Seat of Daniel Wadsworth, Esq.*, 1828, oil on wood, 19¾ × 26¹⁄₁₆ in. Wadsworth Atheneum Museum of Art, Hartford, Connecticut, bequest of Daniel Wadsworth, 1848.14. Image copyright © Wadsworth Atheneum Museum of Art / Art Resource, NY.

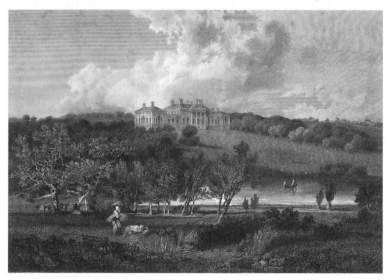

FIG. 1.6. J. Scott after Joseph Mallord William Turner, *Harewood House,* 1816, engraving. Tate Britain, London, T05957.

are held in perfect equipoise, a blasted oak on the left balancing its living twin on the right, in New World emulation of the Claudean *repoussoir.* The lake, calm and perfectly proportioned, with a hint of a tiny Palladian boathouse, occupies the middle ground. The modest villa sits proudly among cultivated, picturesque "park-lands" like those Noble imagined the young Cole feeling akin to in his native Lancashire. The forces of social and economic change are successfully held at bay. In the foreground sits the confident, elegantly attired (if awkwardly drawn) young woman, per- haps a member of Wadsworth's household, her straw hat strewn with wildflowers picked on the estate. In the background, cultivation and wil- derness can both be seen, but the boundary between them is blurred, implying a happy conjunction, a merging rather than a violent incursion by man on nature's domain. In contrast to the violent meeting of wild moor- land and dark city streets in Cole's childhood—terrain of the aristocratic huntsman and Ned Ludd, respectively—the relations between parkland and virgin forest here seem almost flirtatious. In the distance, blessings are offered to the scene by a church tower in a small town cradled by the distant purple hills. Despite the lately-come historical status of Monte Video, especially as perceived by Cole from Florence, the painting insists on a moment of historical stasis, an American idyll beyond the reach of those processes of historical development which had so scarred Cole as a boy. This painting celebrates the transformation of the Lancashire artisan into a Federalist gentleman, and of the Connecticut wilderness into a gen- teel playground. The painter of the true America replicates, and competes with, the artistic conventions of a specifically British landscape tradition he had yet to master.

Yet the victory Cole celebrates in *Monte Video* was modest, if not Pyr- rhic; only intermittently successful, he himself remained at the mercy of the markets and of patrons. Moreover, far from reinventing landscape as a purely American art—an emanation of his own re-invented self—he had in fact forced the materials of the American landscape into a pre- existing format by quite violent means—the sole, surviving oak tree, in this reading, stands a mute testament to the trimming and cropping, Pal- ladianizing and Claudeanizing, which Cole has undertaken. From his panoptical viewpoint at Monte Video's tower, Cole enforced discipline on the scene, transforming a modest summer residence in parkland hewn

from the wilderness into the equivalent of a Wilton House or a Stourhead. Like Capability Brown's teams of surveyors and planters, lake diggers and mound-builders, Cole smoothed and shaped the landscape before him until it matched a pre-existing aesthetic pattern. Yet even here there are hints of resistance. Perhaps there is menace, after all, in the purple clouds piling up to the left and the harsh, dark-hued outline of a distant peak visible beyond Wadsworth's lush acres. Evening is approaching, a moment when—as Cole's pupil Frederic Edwin Church demonstrated in his superbly Gothic study *Twilight, "Short Arbiter 'Twixt Day and Night"* (1850; The Newark Museum, New Jersey)—the benign character of New England can undergo dramatic changes.[54]

And if the local climate and flora resisted Anglicization, so too did the social structures of the new republic. Even such grand families as the van Rensselaers, let alone a financier's son like Wadsworth, were not truly aristocrats (and here I diverge from Alan Wallach's justly celebrated analysis of Cole's patrons). Unlike the Earl of Egremont at Petworth or the Lascelles family at Harewood, Wadsworth could claim no special status in relation to the local community on the basis of bloodlines, nor a different role in the constitution from commoners. They did not sit, by birthright, as Lords Temporal alongside bishops—the Lords Spiritual—in the highest court of the land; and they did not enjoy primogeniture as a legal structure designed to retain the integrity of their estates over generations. Wadsworth's tenure at Monte Video was the same as that of any owner of property in Connecticut. Cole's attempt to conjure a Claudean, aristocratic idyll—a "landscape of reaction" such as Richard Wilson imagined for the English aristocracy of the mid-eighteenth century—was thus doomed to fail.[55] Those forces of historical change that Cole had witnessed uncomfortably close at hand in Bolton and Chorley, so violently opposed there by Lord Liverpool's aristocratic Tory governments, could not be held in check by a balancing act of neoclassical estate portraiture. The artist's self-fashioning as a gentlemanly Federalist would prove equally fragile. Moreover, as a frequent resident of New York City, until he finally fled up the Hudson to live permanently at Cedar Grove in 1836, Cole was once again well placed to see the forces of capitalist modernity in their most rampant form. His famous bestowing of "maledictions on all dollar-godded utilitarians" who cut down trees to build a railroad along

Catskill Creek was only one example of his widely noted opposition to the Jacksonian market economy.[56]

Cole's defense of his practice as a painter of the American landscape was at its most perceptive when he addressed the theoretical underpinnings of the picturesque in the philosophy of associationism, which so richly endowed English sites such as Tintern Abbey (replete with medieval history and the subject of Turner's watercolor from 1795 as well as Wordsworth's poem of 1798) or Senlac Edge (where the Battle of Hastings took place in 1066) with meaning and sentiment. While the sites of the battles of the War of Independence offered some associations with the historical narrative of the United States, Cole noted: "American associations are not so much of the past as of the present and the future."[57] This admission effectively undermined the claims of his portrait of Monte Video, but made possible, in his later works, the expression on a grand scale of the more dramatic—and more political and historical—implications of the sublime, as glimpsed up the Hudson in 1825.

On one rare occasion, Cole did turn a celebratory eye to the recent achievements of American capital, as opposed to the nation's untouched wilderness. Before returning to Europe in 1829, he saw the city of Rochester, New York, which was experiencing the same process of transformation he had witnessed in Bolton and Chorley. The town seemed handsome and impressive, however, in implicit contrast to its English counterparts. "But for the appearance of newness, the traveller would imagine that it would have been the work of ages. Bridges, Aqueducts, Warehouses and huge mills which are the Castles of the United States are standing over the rushing waters and in future ages they shall tell the story of the enterprise and industry of the present generation—These edifices will not be hallowed by the deeds of noble knights. . . . No! But they will stand as monuments of the triumphs of peace and liberty—and the romantic interest of chivalrous days shall be dimmed by the brighter and happier exploits of peace."[58] Yet Cole's paintings are notably deficient in monuments of peace and liberty, and his portrayals of the course of American history are shot through with warnings, implicit and explicit. Despite his claims to the contrary, Cole's imagination, steeped in Romantic historicism, remained focused on the deeds of noble knights of the Old World, as in the twinned canvases *The Past* and *The Present* (1838; Mead Art Museum, Amherst

College). Even here, however, a glittering vision of the Gothic in *The Past* gives way to dereliction and decay in the melancholy and picturesque contemplation of *The Present*.

The Return

Cole's most astute patron, Robert Gilmor of Baltimore, understood both the strengths and weaknesses of Cole's startling Hudson Valley canvases of the late 1820s, which remain among Cole's most notable achievements. His advice was deeply ambiguous:

> By studying the work of English artists, and particularly Turner, you will be able to improve your style, though I should be sorry if you depart from expressing nature in the manner you do, which is *without manner at present*. And consequently pleases more generally than a regular habitual way of rendering objects. Let me know some time before you go as it may be in my power to render you some services.[59]

As Gilmor cannily pointed out, Cole could only improve his art by extending his knowledge of the consummate achievements in the genre by contemporary British painters. Yet by subjecting himself to European influences, Cole risked losing precisely the natural, untutored quality which marked out his productions, leading to a bland conventionalism, or "regular habitual way of rendering objects." The artist felt understandably uncertain about the effects this might have on his own work and feared, too, the reception his paintings would receive in the wider world.

Cole did, however, leave for Europe in the summer of 1829, arriving at Portsmouth and taking a post chaise to London, which arrived there on 27 June 1829, just over a decade after he had left for America. He wanted in particular, he wrote to a friend, "to be in London in time to see the Exhibition at Somerset House,"[60] and the next day, he hurried to the Royal Academy's summer exhibition, nearing its end, in which he admired works by "Turner, Calcott and others," though finding most of the landscapes to be "very far from perfection in art."[61] He did, however, jot down excited sketches of Turner's *Ulysses Deriding Polyphemus*, then on the walls of the academy. Cole followed up this experience by presenting himself at Turner's gallery on 12 December 1829. This visit was a complex ex-

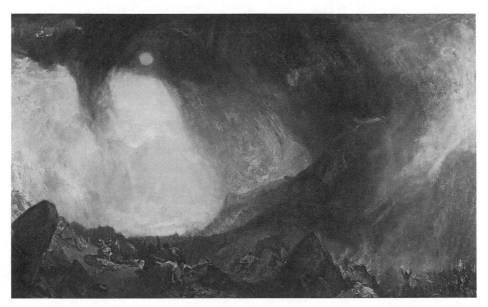

FIG. 1.7. (Plate 3.) Joseph Mallord William Turner, *Snow Storm: Hannibal and His Army Crossing the Alps*, 1810–12, oil on canvas, 57½ × 93½ in. Tate Britain, Clore Gallery for the Turner Collection, London.

perience; both private and public space, studio and gallery, the ramshackle museum represented the massive self-confidence of the English master. Cole was clearly impressed by one work in particular, which he continued to reference, in attempted emulation, throughout his career. A dominant presence in Turner's gallery was the massive *Snow Storm: Hannibal and his Army Crossing the Alps* (1812; fig. 1.7 and plate 3), which Cole described as "a sublime picture with a powerful effect of chiaroscuro."[62] Perhaps here, rather than in any other place, was found embodied the "higher style of landscape" to which Cole aspired. Here, too, was the ultimate instantiation of the sublime, the aesthetic category that Turner took from eighteenth-century theory and applied, in the most unsparing and magnificent way, to landscape painting.

Although he entered the master's lair in December 1829 in a manner suitably reverential for a provincial painter still in his twenties, this soon gave way to the social snobbery that Cole affected for the benefit of his gentrified Knickerbocker patrons in upstate New York. This assumed

social position would have been beyond his reach as the son of a small-scale textile manufacturer, let alone an engraver in a calico works from the provinces in Georgian England. Cole wrote of Turner as follows:

> I had expected to see an older looking man with a countenance pale with thought, but I was entirely mistaken. He has a common form and a common countenance, and there is nothing in his appearance or conversation indicative of genius. He looks like a seafaring man, a mate of a coasting vessel, and his manners were in accordance with his appearance. . . . I can scarcely reconcile my mind to the idea that he painted those grand pictures. The exterior so belies its inhabitant the soul.[63]

There is a complex range of responses here. Cole, on the one hand, clearly wanted Turner to conform to the stereotype of the Romantic painter to which he himself aspired. On the other, he wished the senior wrangler in his own profession, a Royal Academician, to be a refined gentleman, and found the raffish and iconoclastic Cockney too earthy for his Knickerbocker tastes. Finally, holding to the moralistic conventions of his Dissenting roots, Cole was doubtless surprised by Turner's lack of religious scruples or Nazarene preachiness.

Ambitious, but clearly shaken by his confrontation with the center of the aesthetic development of which he represented the outer periphery, Cole asserted rather hotly the merits of his own achievements:

> I cannot but think I have done more than any of the English painters. Many of them go beyond me in parts, but, as a whole I have reason to be gratified with the advances I have made. What I have just said I should not wish repeated to any of my friends; they might take it for vanity: and, after all, I may form a wrong estimate of my own merits. I think I shall improve very fast here, having the advantage of seeing so many fine pictures both ancient and modern.[64]

With high hopes, Cole himself sent a painting of *The Falls of Niagara* —an unmistakable emblem of American difference—to the British Institution, where, he wrote, "Imagine the mortification of finding it, as well as another picture of mine, hung so that it cannot be seen."[65] The press entirely ignored the canvas. Hoping for better, he sent to the so-called

"landscape Academy," the Society of British Artists at Suffolk Street, what he described as "the grandest picture, perhaps, I have painted," *A Tornado in the Wilderness* (1830). Cole wrote to Dunlap that "it was praised exceedingly in several of the most fashionable papers," though no trace of such responses can be found.[66]

Cole's ambition was to create an American historical landscape painting, a high art of the new world. It derived from an ambition to emulate Turner and, via Turner, Claude himself. Perhaps it was the anxiety of influence, the fear of not matching up to the older artist's unassailably formidable achievements, which led Cole to attempt to attack Turner so insistently in later writings. Cole, too, had been scorched by the criticism the previous year, 1828, in the *New York Morning Courier*, that he had plagiarized John Martin's *Adam and Eve* in his *Expulsion from the Garden of Eden*. If the author, the pseudonymous "Middle tint" was unfair in suggesting that Cole's painting was "a literal copy" of Martin's mezzotint, the resemblance is plain for all to see. Martin's sublime was heightened by a passionate religious intensity that, unlike Turner's skeptical complexity, particularly appealed to Cole's rather pious temperament. The association with Martin was all the more psychologically and professionally risky for Cole since Martin, like Cole himself, had origins in the north of England, and had become a fine artist only through his apprenticeship as a painter of designs on pottery in an industrial setting.[67] Moreover, both Martin and Cole were deeply imbricated in the traditions of Evangelical Dissent. Martin's mezzotints from *Paradise Lost*, which had thrown so profound a shadow over Cole's 1828 *Expulsion*, also included magnificent renderings of *Pandemonium* and *Satan Presiding at the Infernal Council* which referenced the massiveness of contemporary industrial architecture, conflating hell with fiery visions of precisely that northern industrial world from which Cole had escaped. With Martin's irresistible lure came the potential, and unwelcome, revelation of Cole's true origins, social and geographical, cultural and artistic. Martin's work, so easily and vividly translated into the showman's medium of the moving panorama, also bore the taint of popular culture and urban commercialism, in contrast to Cole's own gentlemanly and rural predilections.[68] Yet Cole's work, too, bordered on the popular, especially when he addressed religious themes.

If the dangers of imitating Martin were clear, Cole must have been

aware of the stakes in reaching even higher, in emulation of the widely acknowledged genius, Turner. This might explain the vehemence of Cole's diminution of Turner's later work. Possibly, however, Turner's paintings of the mid- and late 1820s, although far less obscure and difficult than that he would produce in the succeeding decades, was simply too challenging for Cole's relatively conservative instincts. Of Turner's newest work, Cole wrote in 1829:

> They are splendid combinations of colour when it is considered separately from the subject, but they are destitute of all appearance of solidity. Every object appears translucent or soft. They look as though they were made of confectionary's Sugar Candy Jellies. This appearance is produced by an undue dislike of dullness or black. The pictures are made up of the richest, brightest colours in every part, both in light and shade. The most beautiful nature I have ever beheld has dullness and darkness in its combination and above all solidity.[69]

Later, as he struggled to realize *The Course of Empire*, Cole wrote a similar letter to William Dunlap, who, without the artist's permission, printed it in *History of the Rise and Progress of the Arts of Design in the United States*:

> Turner is the prince of the evil spirits. With imagination and a deep knowledge of the machinery of his art, he has produced some surprising specimens of effect. His earlier pictures are really beautiful and true, though rather misty: but in his late works you see the most splendid combinations of colour and chiaroscuro—gorgeous but altogether false—there is a visionary, unsubstantial look about them that, for some subjects, is admirably appropriate; but in pictures representing scenes in this world, rocks should not look like sugar candy nor ground like jelly.[70]

There is a defensiveness in these critiques of the man and his art which suggest that Turner's work impressed itself upon Cole more profoundly than he wished to admit. Unspoken here is the agonizing question: could Cole's American landscapes display the "imagination and a deep knowledge of the machinery of his art," or exhibit "splendid combinations of colour and chiaroscuro" while remaining "beautiful and true"?

The Question of Empire

Cole's famous *View from Mount Holyoke, Northampton, Massachusetts, after a Thunderstorm (The Oxbow)* in 1836 has become an icon of national identity through its presence in the Metropolitan Museum since 1908. It is, undoubtedly, a meditation on national history and development. Yet the painting surely also offers Cole's formal riposte to Turner's *Hannibal*, whose swirling vortex of cloud it so clearly echoes. Cole's panoramic landscape, like so many of Turner's works, is a history painting of the present day, replete with ambiguity. While the civilizing mission of American culture, moving from right to left of the composition, is apparent, converting the wilderness to smallholdings and peaceful agrarian communities, heavy industry is nowhere to be seen. The small figure of Cole himself appears in the foreground. He is suspended between the wilderness and the farmland, between past and present, standing as a witness to historical change, chronicling the destruction of that very element—wilderness—which he identified as America's claim to aesthetic uniqueness. A man born and brought up in an industrial city, where he worked as an artisan, here presents himself, in gentlemanly attire, as the very spirit of the wilderness. But despite his implicit entreaty, the tide of history is, it seems, moving inexorably across the canvas. The forest is destined to be swept away and the land brought under mankind's rational control, agriculture to industry, just as it had been in Bolton-le-Moors before Cole's birth. The straight lines of canals and railroad tracks will replace the river's meanderings. In *The Oxbow,* Cole seems to offer up a vision of historical process in which the sublime will yield to the beautiful, chaos to order. The artist, however, held ambivalent views about the onward march of progress, thinking perhaps of the degradation of the landscape and the people of Bolton. "There are those," Cole wrote with sympathy,

> who regret that with the improvements of cultivation the sublimity of the wilderness should pass away; for those scenes of solitude which from the hand of nature has never been lifted, affect the mind with a more deep toned emotion than aught which the hand of man has touched.[71]

The "improvements of cultivation" brought with them pollution and poverty, social chaos and environmental catastrophe—effects which John

Ruskin would later describe under the sign of "The Storm-Cloud of the Nineteenth Century," and which Thomas Cole knew from his experience of Bolton, Chorley, and Liverpool.

This role as the prophet of doom, warning of a potentially catastrophic national destiny, inhabited par excellence by Ruskin later in the century, marks Cole's most ambitious series of paintings, *The Course of Empire*, also completed in 1836. Following an imaginary country through the stages of historical development, Cole's pessimistic imperial narrative has recently been the subject of several significant readings.[72] There is a broad consensus that, although not strictly an American subject, the sequence offered a parable of American history. Alan Wallach and Angela Miller have convincingly identified his program as being one of opposition to the expansionist, utilitarian, and democratic platform of Andrew Jackson against the gentrified Federalism of Cole and his patrons. There is, moreoever, no question but that a Gibbonian view of Rome was a key model for his imperial schema. But here I want to offer an alternative reading. I suggest that both explicitly and implicitly, Cole's key exemplar in this series was the empire at whose heart he grew up, whose overweening ambitions and repressive tactics he observed, and whose crisis and ultimate military victory in the Napoleonic Wars he experienced during his adolescence. Moreover, within living memory of the War of 1812 the word *empire* had one overwhelming resonance in the United States: that of Britain. It is fitting that Cole's meditation upon, and damning critique of, the British Empire, should take the form of a series of paintings deeply engaged with the traditions of British art. In this series, one might suggest, Cole attempts, as in his condemnation of Turner, to slay the artistic father, while revealing all the more clearly the sources of his artistic project and the objects of his emulation. In the same way, the historical development of the British Empire, within which the American colonies had played a significant part until 1776, still overshadowed, in 1836, the expansionist historical cycle upon which the United States had embarked.

The idea of a cycle of large paintings representing the rise and fall of a civilization came to Cole not in Rome, but in London, in 1830, during the period when it could without question be called a—or perhaps *the*—"world city."[73] The British capital was undergoing an architectural transformation at the hands of John Nash, under the patronage of the

vainglorious monarch George IV, and the expansion of the middle-class residential districts of the West End.[74] The passing of the emancipatory Catholic Relief Act in 1829 ushered in a decade of political ferment and major reforms, including those of the voting franchise in 1832, the poor laws in 1834, and, most importantly, the repeal of slavery throughout the British Empire in 1834. The onset of this legislative program deeply troubled the rural conservative, John Constable, whom Cole visited in his studio in 1829, instilling in the older man a sense of ruination and a deep conviction that nation and empire were doomed.[75]

Cole's title is taken from "Verses on the Prospect of Planting Arts and Learning in America" (1726), by George Berkeley, Bishop of Cloyne, and an enthusiastic promulgator of British imperialism:

Westward the Course of Empire takes its Way;
 The first four Acts already past
A fifth shall close the Drama with the Day:
 Time's noblest Offspring is the last.

In Berkeley's poem, written before his journey across the Atlantic, the ruin of a decadent Europe is offset by the limitless potential of the American colonies. However, the most immediate literary source was Byron's *Childe Harold's Pilgrimage* (1812–18), from which Cole quoted lines in his newspaper advertisements for *The Course of Empire:*

There is the moral of all human tales;
'Tis but the same rehearsal of the past.
First freedom and then Glory—when that fails,
Wealth, vice, corruption,—barbarism at last.
And History, with all her volumes vast,
Hath but *one* page.[76]

The reason for the popularity of such speculative historical schemes, passing through glory and inevitably ending in doom, surely relates to the epic events of recent history—the American Revolution, the French Revolution and Napoleonic period, and, of course, the social dislocation caused by the industrial revolution. These traumatic developments gave Cole and his contemporaries a vivid sense of history in the making, a turbulent process, which they aspired to comprehend by identifying its

repeating and recognizable pattern. But few artists had experienced the changes brought about by industrialization, whose engine lay in the industrial north of England, in such close proximity as he.

This is not the place to embark upon a full discussion of the rich iconography of the five canvases that form this series.[77] I wish to make two points. Firstly, that specific details link the cycle specifically to the history of the British Empire; and secondly that the historical processes presented in Cole's narrative epic were decisively affected by his youthful experiences in Britain. Drawing together a range of elements from Cole's paintings of the American wilderness, the first canvas, *The Savage State* (fig. 1.8), ranks among Cole's finest essays in the sublime: the rough, uncultivated landscape and dark rolling clouds pay homage to Salvator Rosa, and the work conjures an atmosphere of dangerous exhilaration, with nature red in tooth and claw. Also known as *Commencement of Empire*, *The Savage State* introduces the viewer to the landscape against which Cole's historical pageant is to be acted out.[78] This is no Eden, but an untamed wilderness, inhabited by the hunter-gatherers, the savage peoples who, in Cole's scheme, first inhabited the earth. Although the presentation closely resembles that of imperialist ethnographers observing non-European peoples, the single figure of a bowman in the foreground, whose arrow has killed a deer, strikes a noble pose perhaps borrowed from the famous classical sculpture the *Borghese Gladiator*, which Cole must have seen in Rome in 1832.[79] Scholars have identified a possible source for the distant structures, resembling tipis, in William Chambers's *A Treatise on Civil Architecture* (London, 1759), in which is illustrated a similar structure, referring to "the origin of buildings," an origin discovered in what was then a part of the British Empire.[80] Europe's past is America's present, and Cole's allusion to the native population of America, already driven westwards by the course of American empire, is underlined by the canoes plying the river. Cole's imaginary scene of "savages" dancing round the fire closely resembles both ethnological illustrations and contemporary paintings by explorers and settlers, such as the British artist John Glover's images of Australian aboriginal peoples.[81] Yet Cole's huntsman in the foreground, comically elongated, seems nonetheless to represent a Caucasian type—as the allusion to the *Borghese Gladiator* might suggest. He is, in fact, "our" own

FIG. 1.8. Thomas Cole, *The Course of Empire: The Savage State,* 1836, oil on canvas, 39¼ × 63¼ in. New-York Historical Society, 1858.1.

ancestor, not a figure of racial otherness. The *Course of Empire* emerges as an extended cultural self-portrait, not an exercise in ethnology.

For *The Arcadian, or Pastoral State* (fig. 1.9), the sublime mode derived from Salvator Rosa is replaced by that of the beautiful, in homage to Claude. Among the many narrative and anecdotal strands in the composition, it is important to note here only one element: the round stone temple in the middle distance, which is clearly based on Stonehenge. This is the only identifiable topographical feature in the entire cycle. The mysterious English monument exerted a considerable influence over the imagination of Romantic writers and painters, from James Barry in *King Lear* to William Blake in *Jerusalem,* for whom it provided a tantalizing glimpse of Britain's own distant, pagan antiquity.[82] Constable, in a visionary late watercolor (fig. 1.10), almost exactly contemporaneous with *The Course of Empire* and unknown to Cole, saw the present decay of Stonehenge as a metaphor for Britain's moral and social decline even at the moment of its greatest imperial reach. Cole, however, deploys it as an emblem of things to come.

FIG. 1.9. Thomas Cole, *The Course of Empire: Arcadian or Pastoral State*, 1836, oil on canvas, 39¼ × 63¼ in. New-York Historical Society, 1858.2.

FIG. 1.10. John Constable, *Stonehenge*, 1835, watercolor, 6⅝ × 9¹³⁄₁₆ in. Victoria and Albert Museum, bequeathed by Isabel Constable, daughter of the artist, 1629.1888.

The Consummation of Empire (fig. 1.11), painted on a larger canvas than the other four works, is the centerpiece of the series. It presents a vivid panorama of the vainglorious maturity of a powerful empire. The imperial city stands astride a great river, with the familiar outline of the mountain, seen in all the compositions, distantly visible to the right. Although the natural world has almost disappeared under marble and gold, we can discern that it is the end of summer, as the noonday sun beats down on a spectacular celebration. Most recent interpreters have taken this river for

the Hudson, but a closer analogy in many ways is the Thames. An immediate point of comparison is Constable's *The Opening of Waterloo Bridge ("Whitehall Stairs, June 18th, 1817")*, begun in 1819 but finally exhibited only in 1832 (fig. 1.12). This work was in Constable's studio when Cole visited him in 1829. A commercial city astride a river with a preening monarch celebrating a victory: these words could describe both *The Opening of Waterloo Bridge*, a moment at which George IV savored Wellington's victory over Napoleon at Waterloo, and *Consummation of Empire*, where, to a fanfare of trumpets from above, a returning conqueror, robed in red,[83] crosses the bridge on a chariot pulled by an elephant. The returning victor's subjugation of neighboring states indicates an empire acquired through territorial aggression, typical of British action in India and the Caribbean (but in contrast, perhaps, to the expansion of the United States, at least in part, by treaties and by financial transactions such as the Louisiana Purchase of 1803). The pomp and circumstance would have seemed especially horrifying to an American audience, for whom, in addition to the obvious links to Imperial Rome, it might have had more recent echoes of George III, the last British king to reign over the American colonies, and his flamboyant son, George IV, who had died only in 1830. As Angela Miller has noted, opponents of Andrew Jackson, such as Cole and his Federalist circle, criticized what they perceived as his regal pretentions and aspiration toward absolutist personal rule.[84] The scene is overwhelmingly one of hubris, inexorably leading to the nemesis of the final canvases in the series.

Inevitably, the seeds of destruction are present even at the moment of the empire's triumph. The excessive population, crowding every balcony and parapet, also implied a future catastrophe: such a vast sea of people would have put contemporaries in mind of the millenarian population theories of Robert Malthus who, in a famous essay of 1798, had predicted mass starvation for Britain, and by implication all industrializing countries, if population growth continued at its current rates.[85]

Cole's most eclectic production, *The Consummation of Empire* inevitably draws on a wide range of sources, only a few of which can be noted here.[86] The basic compositional idea—the representation of a busy seaport— derives from two works Cole had seen in London, Claude's *Seaport with the Embarkation of St Ursula* (1641; National Gallery, London) and Turner's *Dido Building Carthage, or the Rise of the Carthaginian Empire* (1815;

FIG. 1.11. Thomas Cole, *The Course of Empire: The Consummation of Empire*, 1836, oil on canvas, 51¼ × 76 in. New-York Historical Society, 1858.3.

FIG. 1.12. John Constable, *The Opening of Waterloo Bridge ("Whitehall Stairs, June 18th, 1817")*, 1832, oil on canvas, 51½ × 85⅞ in. Tate Britain, London.

National Gallery, London). Turner's composition was particularly relevant to *The Course of Empire* because it had, in *The Decline of the Carthaginian Empire* (1817; Tate Gallery, London), a companion piece: Turner explicitly paired imperial rise and fall, sunrise and sunset, appending to the title a stanza of his own poetry drawing out the moral.[87]

Architectural elements are drawn from a range of published sources: the caryatid figures (which hold up the musicians' balcony in the center foreground), like those on the facade of the distant, gold-domed palace, derive ultimately from the Erectheum in Athens, which could have been known to Cole from published sources. During his time in London, from 1829 to 1831, Cole also must have seen W. & H. W. Inwood's celebrated new St. Pancras Church (1819–22; fig. 1.13), where a portico was adorned with full-scale copies of the caryatids of the Erectheum.[88] The creamy fantasy architecture of Cole's opulent city has as much in common with the theatrical neoclassical stucco of John Nash's Cumberland Terrace (1826; fig. 1.14) in Regent's Park, as with Trajan's Rome.

When the series was exhibited in 1836, *The Consummation of Empire* won the warmest acclaim. Most gratifying for Cole, perhaps, was the response of the *New-York Mirror,* which surely encapsulates Cole's intended meaning for the work:

> This splendid picture represents man's attainment of a high state of comparative perfection: but we see the causes of *decline* and *fall* upon the face of it. Mingled with the triumph of art is the triumph of the conqueror, and with the emblems of peace and religion we see the signs of war and display of pride and vanity. The ostentatious display of riches has succeeded to the efforts of virtuous industry, and the study of nature and truth. We see that man has attained power without the knowledge of its true *use:* and has already abused it.[89]

These images clearly held implications for the America of Cole's own time, as well as reflections of recent British history. Cole had seen in Bolton and Chorley the dislocating effects of rapid, speculative, and unplanned industrialization. He had seen the ostentatious wealth of the profiteering textile entrepreneurs, and though he had displayed "virtuous industry," he had seen few rewards. He had observed, moreover, the social cost of the war against Napoleon, and he had also seen the wartime boom

FIG. 1.13. W & H. W. Inwood, portico of St. Pancras Church, London, 1819–22. Archive of the author.

FIG. 1.14. John Nash, Cumberland Terrace, Regent's Park, London, 1826. Archive of the author.

turn to economic crisis in the aftermath of the conflict. The city of New York was growing rapidly, establishing itself as the center of a new market economy and beginning to challenge London's global trading hegemony; indeed, New York was showing many of the same signs of imperialist hubris and, especially, a pattern of market-driven speculative boom and bust which the Federalist interest opposed. Competition with British banks, shipping companies, machine manufactories and, ultimately, textile pro-

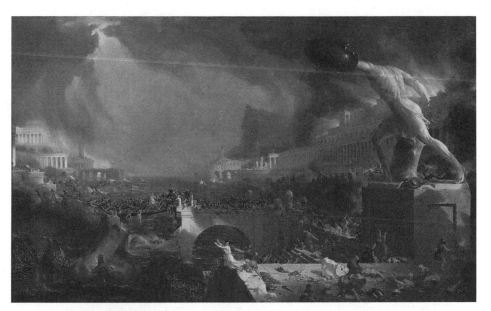

FIG. 1.15. Thomas Cole, *The Course of Empire: Destruction*, 1836, oil on canvas, 39¼ × 63½ in. New-York Historical Society, 1858.4

ducers was an essential aspect of American economic culture in the 1830s. At the Great Exhibition of the Industry of All Nations, in London in 1851, the United States—outgrowing its previous role as a useful source of raw materials such as cotton—would suddenly emerge, to the surprise of its competitors, as a major manufacturing nation.

It is possible that memories of Luddite arson and machine-breaking were in Cole's mind when he wrote, on 30 August 1836, to Asher Durand, "I have been engaged in Sacking & Burning a city ever since I saw you & am well nigh tired of such horrid work."[90] Although we return in *Destruction* (fig. 1.15) to the location depicted in *Consummation*, order has given way to chaos. Cole's own description emphasized that "the combatants fight amid the smoke and flame of prostrate edifices,"[91]—a recollection, perhaps, of the news of the factory burnings of Bolton in 1811, or the violent riots mounted by the followers of Ned Ludd?

Once again, examples from the history of British art throw a long shadow. *Destruction* was Cole's definitive statement of the apocalyptic sublime, emulating earlier works by John Martin and Turner. The overall

The Englishness of Thomas Cole 41

composition owes much to Martin's *Seventh Plague of Egypt* of 1823 (fig. 1.16 and plate 4); but the vortex of swirling dark cloud is, of course, appropriated from Turner's *Hannibal*. Once again, Martin's work provides a link between Cole's fantastical classical architecture and the massive piles of the industrial city. *Destruction* undoubtedly relates, like Martin's work, to more popular manifestations of apocalyptic imagery, though we have only limited evidence concerning the panoramas, dioramas, and stage performances of this period in London and New York. Robert Burford's panorama of *Pandemonium, from Milton's Paradise Lost,* shown in London during Cole's visit in 1829, included broadly similar effects. It was based on Martin's illustrations to *Paradise Lost,* which had earlier influenced Cole's *Expulsion from the Garden of Eden.* As Cole was working on the series, the new diorama building in New York was showing a huge *Departure of the Israelites out of Egypt* and Hannington's "Perestrephic Diorama" included a *Conflagration of Moscow* with lighting effects and moving mannequins.[92] Whether he relied directly on these works or not, Cole could be sure that his public had an appetite for scenes of chaos and destruction. The incorporation into his high-minded history paintings of phantasmagoria from the popular entertainments of the urban crowd adds yet another layer of paradox to Cole's project.

Although it was clear that, if *The Course of Empire* offered parallels with American history, then *Destruction* lay in the future. Nonetheless, aspects of Cole's calamitous scene were prefigured by events taking place as Cole worked on the canvas. On 16 and 17 December 1835, a huge fire swept through lower Manhattan, causing massive destruction in the Wall Street area. Cole must have read of families losing their homes, of businesses destroyed and livelihoods ruined. The flames were contained, and the city soon recovered, but the conflagration, known as the "Great Fire of New York," lingered in the popular memory. Even here, however, there is an uncanny English parallel. After Cole had returned to New York, on 16 October 1834, the Palace of Westminster, the heart of the British Empire, burned to the ground in an inferno which many felt was a moral judgment or an act of God, in condemnation of the reforming administration of the period. Turner saw the blaze, and recorded it in two great canvases, his own renderings of "Destruction of Empire," which were exhibited at the British Institution and the Royal Academy in 1835.[93] Cole

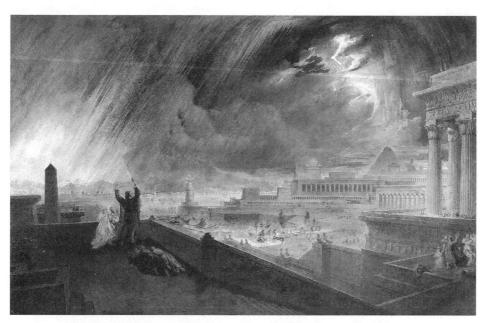

FIG. 1.16. (Plate 4.) John Martin, *Seventh Plague of Egypt*, 1823, watercolor, 9½ × 14½ in. Laing Art Gallery, Newcastle.

could not have seen these complex, multivalent canvases, which as usual perplexed the critics; but it is likely that some inkling of the press coverage might have come his way.

The final canvas of *The Course of Empire, Desolation* (fig. 1.17), presents a view of the ruins of the imperial city, recalling the ruins of Rome—a favorite Turnerian and Claudean subject—from which Cole derived "some minutes of silent, mournful pleasure" in 1832. Cole's work takes on the aspect of an ecological parable.[94] Nemesis has followed hubris; human life has vanished, and nature is reclaiming the landscape. Even here deep, determining references to Britain can be found. The composition is no more than a paraphrase of John Constable's great meditation on the decline of Britain, *Hadleigh Castle: The Mouth of the Thames—morning after a stormy night* (1829; fig. 1.18). The shattered outline of the castle, which stands by the Thames Estuary in Essex, takes on a tragic dimension. Great traditions and the purity and honesty of old England have been lost in the pursuit of empire and the worship of trade. The onset of democracy—for Constable, as for Cole, the rule of the vulgar—will undermine all that is

valuable in the nation. The castle, symbol of aristocratic dominion, stands neglected, and the countryside—so immaculately cultivated and managed in Constable's earlier work—is run to ruin, as livestock wander untended amid the vegetation. Faced only two years later with the prospect of the long-expected Reform Bill, he fulminated:

> What makes me dread this tremendous attack on the constitution of the country is, that the wisest and best of the Lords are seriously and firmly objecting to it—and it goes to give the government into the hands of the rabble and dregs of the people and the devil's agents on earth—the agitators. Do you think the Duke of Wellington & the Archbishop of Canterbury . . . and the best & wisest men we have—would have opposed it, it was to have [done] any good to the country? I do not.[95]

Despite the global reach of British power and wealth, hinted at by the shipping seen in glittering sunlight on the distant Thames, all that remained—for the reactionary Constable in 1829—was ruination. It was a vision that appealed greatly to Cole—in this regard a kindred spirit of the Suffolk artist—whose Romantic pessimism was yet one more trait shared with his British contemporaries. Yet Constable's Englishness was of a completely different stripe than that of Cole. Constable was committed throughout his oeuvre to seek out and to represent the essence of England, a project which veered over time from celebration to equally heartfelt lamentation. Constable's early years in East Bergholt in the 1780s and 90s provided him with an idyll of the prosperous, secure life of the long-established, rural middle-class. He experienced as tragedy the collapse of this social world amid the flux of the early nineteenth century. Constable's childhood remained a constant, and beatific, reference throughout his life and in his paintings. "Still I should paint my own places best," he wrote in 1810; "painting is with me but another word for feeling, and I associate my 'careless boyhood' with all that lies on the banks of the Stour."[96]

A generation later, Cole experienced a very different England, one marked by visible transformations in the landscape and society, constant economic and social dislocation, violent dissent and equally violent government repression. If he developed a profound attachment to his own places, they were places of his choosing in adult life: the Catskills, the

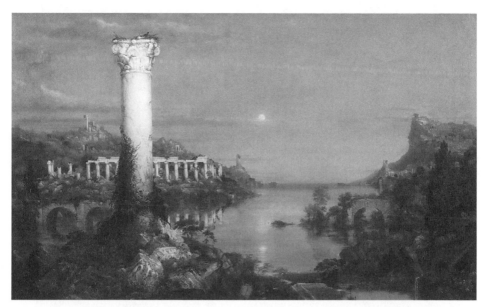

FIG. 1.17. Thomas Cole, *The Course of Empire: Desolation*, 1836, oil on canvas, 39¼ × 63¼ in. New-York Historical Society, 1858.5.

FIG. 1.18. John Constable, *Hadleigh Castle: The Mouth of the Thames—Morning after a stormy night*, 1829, oil on canvas, 48 × 64¾ in. Yale Center for British Art, Paul Mellon Collection, B1977.14.42.

Hudson River, and Cedar Grove. The scenes of Cole's boyhood were anything but careless. The England he experienced was a paradigm of modernity—a modernity he adamantly rejected. Having seen the course of British industrialization, and the toll it took on his own family, the teenaged Cole imagined America—initially through the prism of travel literature—as a utopia. His lifelong lamentation for the transformation and destruction of the countryside played out the experiences garnered in the Lancashire of his youth. Yet America turned out not to be the genteel, static, rural paradise that Cole sought, and its transformations followed the same pattern as those so vividly underway in Lancashire during the Napoleonic Wars. This chapter has argued that, despite his comprehensive disavowal of his own English background, Cole's imagination was haunted by the memories of those boyhood years in industrial England. His artistic project was framed by, and judged against, the work of English landscape painters; and his Federalist social vision, based in hierarchies of class, accorded more closely to that of his English contemporaries than with most in New York. In his most ambitious work, *The Course of Empire*, Cole confronted head-on, and with skepticism, the grand narrative of modernization, whose violent convulsions he had experienced firsthand in the Bolton-le-Moors of Ned Ludd.

Notes

The interpretation here builds on and extends one that I offered in *American Sublime: Landscape Painting in the United States, 1820–1880,* co-authored with Andrew Wilton (London: Tate, 2002). See also my essay, "National Myths and the Historiography of Nineteenth-Century American Landscape Painting: A European Perspective," in Peter J. Schneemann and Thomas Schmutz, eds., *Masterplan: Konstruktion und Dokumentation amerikanischer Kunstgeschichten,* Akten des internationalen Kolloquiums 1 und 2, April 2000, Villa Mettlen in Muri bei Bern, Neue Berner Schriften zur Kunst, Bern, Berlin, Frankfurt a.M., New York, Paris, (Wien: Peter Lang, 2002), 127–54. A revised version of this essay appears as "Unmistakably American? National Myths and the Historiography of Landscape Painting in the USA," in Christiana Payne and William Vaughan, eds., *English Accents: Interactions with British Art c. 1776–1855* (Aldershot: Ashgate, 2004), 225–50. Finally, Cole is discussed in "From Source to Sea: America's River and 'Our English Thames,'" in Mark Dorrian and Gillian Rose, eds., *Deterritorialisations: Rethinking Landscape and Politics* (London, Black Dog Publishing, 2003), 24–39. I am grateful to the edi-

tors and publishers of those essays for the re-use of some material here. This essay was first delivered as the Raymond Beecher lecture at Cedar Grove, Thomas Cole National Historical Site, in 2008; I'd like to record my gratitude to David Barnes, Lisa Fox Martin and Elizabeth Jacks for their hospitality on that occasion.

1. Asher Brown Durand, *Kindred Spirits*, 1848, Walton Family Foundation, Crystal Bridges Museum of American Art, Bentonville, Arkansas.

2. *New-York Evening Post*, 19 February 1848, quoted in J. Gray Sweeney, "The Advantages of Genius and Virtue," in William H. Truettner and Alan Wallach, eds., *Thomas Cole: Landscape into History* (New Haven: Yale University Press, 1994), 113–35; quotation from 113.

3. William Cullen Bryant, *A Funeral Oration occasioned by the Death of Thomas Cole, delivered before the National Academy of Design*, 4 May 1848 (New York: D. Appleton 1848), 13.

4. Bryant, *A Funeral Oration*, 3–4.

5. Henry H. Tuckerman, *American Artist Life comprising Biographical and Critical Sketches of American Artists, preceded by an Historical Account of the Rise and Progress of Art in America*, second edition (New York: G. P. Putnam & Son, 1867), 28.

6. For a useful contribution to the large literature on visual representation and Englishness, see Elizabeth K. Helsinger, *Rural Scenes and National Representation: Britain, 1815–1850* (Princeton: Princeton University Press, 1997).

7. See in particular Charlotte Brontë's *Shirley* (1849), which is set in the period of Cole's youth during the Luddite rebellions of 1811–12 and includes extensive descriptions of the industrial scenery and the surrounding moorlands. The moors themselves are a major feature of Emily Brontë's *Wuthering Heights* (1847). The Brontë novels are set in the West Riding of Yorkshire, which experienced the industrial revolution similarly to Lancashire towns like Bolton, though with woolen manufacturing predominant (cotton was the staple industry in Lancashire).

8. Stephen Daniels, "The Implications of Industry: Turner and Leeds," *Turner Studies* 6.1 (1986): 10–17.

9. Ibid.

10. Terry Coleman, *The Railway Navvies* (Harmondsworth: Penguin, 1968).

11. D. A. Farnie, "Crompton, Samuel (1753–1827)," in *Oxford Dictionary of National Biography*, ed. H.C.G. Matthew and Brian Harrison (Oxford: Oxford University Press, 2004); online edition, ed. Lawrence Goldman, October 2007, http://www.oxforddnb.com/view/article/6760 (accessed July 21, 2010).

12. See Geoffrey Timmins, *The Last Shift: The Decline of Handloom Weaving in Nineteenth-century Lancashire* (Manchester: Manchester University Press, 1993).

13. On Luddism see the classic E. P. Thompson, *The Making of the English Working Class* (London: Victor Gollancz, 1963).

14. See Robert Taylor, *Letters on the Subject of the Lancashire Riots, in the Year 1812* (Bolton: privately printed, 1813), 9.

15. See Taylor, *Letters*, 11.

16. Alan Wallach, *The Ideal American Artist and the Dissenting Tradition: A Study of Thomas Cole's Popular Reputation*, PhD dissertation, Columbia University, 1973 (Ann Arbor, MI: UMI, 1991), 116.

17. W. Orme, *Bibliotheca Biblica*, 1824, 240–41, quoted in David L. Wykes, "Henry, Matthew (1662–1714)," in *Oxford Dictionary of National Biography*, http://www.oxforddnb.com/view/article/12975 (accessed July 21, 2010).

18. Max Weber, *The Protestant Ethic and the Spirit of Capitalism*, 1904–5, translated by Talcott Parsons, 1930 (London: HarperCollins, 1991); R. H. Tawney, *Religion and the Rise of Capitalism: A Historical Study*, with a prefatory note by Dr. Charles Gore (London: John Murray, 1926). For a more recent commentary, see Boyd Hilton, *The Age of Atonement: the Influence of Evangelicalism on Social and Economic Thought, 1795—1865* (Oxford: Clarendon Press, 1988).

19. Louis Legrand Noble, *The Course of Empire, Voyage of Life and other Pictures of Thomas Cole, NA, with selections from his letters and miscellaneous writings, illustrative of his life, character and genius* (New York: Cornish, Lamport & Co., 1853), 15.

20. Noble, *The Course of Empire*, 16.

21. See John Styles, *Dress of the People: Everyday Fashions in the Eighteenth Century* (New Haven: Yale University Press, 2008).

22. Alan Wallach, "Thomas Cole and the Aristocracy," reprinted in Marianne Doezema and Elizabeth Milroy, *Reading American Art* (New Haven: Yale University Press, 1998), 79–108; see 83.

23. Wallach, "Thomas Cole and the Aristocracy," 83.

24. Noble, *The Course of Empire*, 16. See also Wallach, "Thomas Cole and the Aristocracy," 83.

25. Noble, *The Course of Empire*, 16.

26. Ibid.

27. Thomas Gainsborough to William Jackson, in John Hayes, ed., *Letters of Thomas Gainsborough* (New Haven: Yale University Press, 2001), 68.

28. John Keats, "Sonnet VII," in *Odes, Sonnets, and Lyrics of John Keats* (Oxford: Daniel, 1895), 43–44.

29. John Ruskin, *Modern Painters*, part V, in E. T. Cook and Alexander Wedderburn, eds., *Works of John Ruskin* (London: George Allen, 1903–12), vol. 7: 376–77.

30. Ibid., 384.

31. Ibid., 386.

32. Elizabeth E. Barker and Alex Kidson, *Joseph Wright of Derby in Liverpool* (Liverpool: Walker Art Gallery; New Haven: Yale Center for British Art, 2007), 167–71.

33. See John Bonehill and Stephen Daniels, eds., *Paul Sandby: Picturing Britain* (London: Royal Academy of Arts, 2010), 218.

34. Bryant, *A Funeral Oration*, 6.

35. William Dunlap, *History of the Rise and Progress of the Arts of Design in the United States* (New York: George P. Scott & Co., 1834), vol. 2: 351.

36. Wolfgang Born, *American Landscape Painting: An Interpretation* (New Haven: Yale University Press, 1948), 46.

37. Ibid.

38. See Alan Wallach's exemplary analysis of the "Discovery Story" in William H. Truettner and Alan Wallach, eds., *Thomas Cole: Landscape into History* (New Haven: Yale University Press, 1994), 23–24.

39. On Dunlap, see Maura Lyons, *William Dunlap and the Construction of an American Art History* (Amherst: University of Massachusetts Press, 2005).

40. Dunlap, *History of the Rise and Progress of the Arts of Design*, vol. 2: 351.

41. Ibid., 352.

42. Ibid.

43. Ibid., 357–58.

44. As Alan Wallach notes, Linda Nochlin identified this trope in her classic article of 1971, "Why Have There Been No Great Women Artists?" Reprinted in Thomas B. Hess and Elizabeth Baker, eds., *Art and Sexual Politics* (New York: Macmillan, 1973), 7.

45. Dunlap's account, under the pseudonym "American," appeared first in the *New-York Evening Post*, 22 November 1825, reproduced in Ellwood C. Parry, III, *The Art of Thomas Cole: Ambition and Imagination* (Newark: University of Delaware Press, 1988), 25–26.

46. Thomas Cole, "Essay on American Scenery," *American Monthly Magazine* 1 (January 1836): 1–12; reprinted in John W. McCoubrey, ed., *American Art 1700–1960: Sources and Documents* (Upper Saddle River, NJ: Prentice Hall, 1965), 102.

47. See Gloria Gilda Deák, *Picturing America: Prints, Maps, and Drawings bearing on the New World Discoveries and on the Development of the Territory that is now the United States* (Princeton: Princeton University Press, 1988), 213–14 and 217–18.

48. Quoted in Tim Barringer, "The Course of Empires: Landscape and Identity in America and Britain, 1820–1880," in Wilton and Barringer, *American Sublime*, 43.

49. Bryan Jay Wolf, *Romantic Re-Vision: Culture and Consciousness in Nineteenth-Century American Painting and Literature* (Chicago: University of Chicago Press, 1982), 178–79.

50. On Wadsworth, see Richard H. Saunders and Helen Raye, *Daniel Wadsworth: Patron of the Arts* (Hartford, CT: Wadsworth Atheneum, 1981).

51. Turner was on familiar terms with George Wyndham, third Earl of Egremont, 1751–1837, whose collection of art at Petworth House was one of the finest

in the country; he was also a personal friend of Walter Ramsden Hawkesworth Fawkes (1769–1825) of Farnley Hall, Otley, Yorkshire, a politician and art collector who wrote in a public address to Turner in 1819 of the "delight I have experienced, during the greater part of my life, from the exercise of your talent and the pleasure of your society" (W.R.H. Fawkes, "Introduction," *A Collection of Water Colour Drawings in the Possession of W. F.* (London: Benjamin Bensley, 1819).

52. Thomas Cole to Daniel Wadsworth, Florence, 13 July 1832, in J. Bard McNulty, ed., *The Correspondence of Thomas Cole and Daniel Wadsworth: Letters in the Watkinson Library, Trinity College, Hartford, and the State Library, Albany, New York* (Hartford: The Connecticut Historical Society, 1983), 57.

53. Daniel Wadsworth to Thomas Cole, Hartford, 12 December 1832, in McNulty, ed., *The Correspondence of Thomas Cole and Daniel Wadsworth*, 61.

54. For a fuller account of this work, see my catalogue entry in Wilton and Barringer, *American Sublime*, 122.

55. For a controversial but robust discussion, see David Solkin, *Richard Wilson: The Landscape of Reaction* (London: Tate Gallery, 1982).

56. See in particular Alan Wallach, "Thomas Cole's River in the Catskills as Antipastoral," *Art Bulletin* 84.2 (2002): 334–50, quotation on 340.

57. Thomas Cole, "Essay on American Scenery," 108.

58. Thomas Cole, diary entry, 5 May 1829, quoted in Sarah Burns, *Painting the Dark Side: Art and the Gothic Imagination in Nineteenth-century America* (Berkeley: University of California Press, 2004), 18. See also Howard S. Merritt, "'A Wild Scene': Genesis of a Painting" in *Baltimore Museum of Art Annual II: Studies on Thomas Cole, American Romanticist* (1967), 26.

59. Robert Gilmor to Thomas Cole, 5 December 1827, quoted in Parry, *The Art of Thomas Cole*, 96.

60. Parry, *The Art of Thomas Cole*, 94.

61. Louis Legrand Noble, *The Life and Works of Thomas Cole*, edited by Eliot S. Vessell, (Cambridge: Belknap Press of Harvard University Press, 1964), 78. The artist to whom Cole referred to as "Calcott" was Sir Augustus Wall Callcott (1799–1844).

62. Noble, *The Life and Works of Thomas Cole*, 81.

63. Thomas Cole, 1829 notebook entry, p. 14, quoted in Parry, *The Art of Thomas Cole*, 98.

64. Noble, *The Life and Works of Thomas Cole*, 78.

65. Parry, *The Art of Thomas Cole*, 101.

66. Ibid., 113.

67. See William Feaver, *The Art of John Martin* (Oxford: Clarendon Press, 1975).

68. Martin's *Belshazzar's Feast* was plagiarized in a diorama exhibited at Niblo's Garden on Broadway in 1835; see Kevin J. Avery, "Movies for Manifest Destiny,"

in *The Grand Moving Panorama of Pilgrim's Progress* (Montclair, NJ: Montclair Museum of Art, 1999), 1–12. For the history of Martin's painting and the diorama made from it in London, see Ralph Hyde, *Panoramania!* (London: Barbican Art Gallery, 1988), 123.

69. Parry, *The Art of Thomas Cole*, 98.

70. Dunlap, *History of the Rise and Progress of the Arts*, 2, 363.

71. Cole, "Essay on American Scenery," 102.

72. Ella Foshay, *Mr. Luman Reed's Picture Gallery: A Pioneer Collection of American Art* (New York: Harry N. Abrams, 1990), 58–62 and 130–40; Truettner and Wallach, *Thomas Cole*, 90–95; Stephen Daniels, *Fields of Vision: Landscape Imagery and National Identity in England and the United States* (Princeton: Princeton University Press, 1993), 158–61.

73. See Celina Fox, *London: World City, 1800–1840* (New Haven: Yale University Press, 1992).

74. See Dana Arnold, *Re-presenting the Metropolis: Architecture, Urban Experience, and Social Life in London, 1800–1840* (Aldershot: Ashgate, 2000).

75. See Michael Rosenthal, *Constable: The Painter and His Landscape* (New Haven: Yale University Press, 1983).

76. Alan Wallach, "Cole, Byron and *The Course of Empire*," *Art Bulletin* 50 (December 1968): 377–78.

77. For my attempt to summarize the complex narrative, see Wilton and Barringer, *American Sublime*, 98–109.

78. Thomas Cole, "*The Course of Empire*, published for the public exhibition at the National Academy of Design, New York, 1836," quoted in Ellwood C. Parry III, *Thomas Cole's 'The Course of Empire': A Study of Serial Imagery*, PhD dissertation, Yale University, 1970 (Ann Arbor, MI: UMI, 1991), 193.

79. See Francis Haskell and Nicholas Penny, *Taste and the Antique: The Lure of Classical Sculpture, 1500–1900* (New Haven: Yale University Press, 1981), 221–24. The likeness is not exact, notably with regard to the position of the head, and Parry (in *The Art of Thomas Cole*, 157) has suggested as a source the *Apollo Belvedere*, mediated by Rubens's painting (1622–25; the Louvre, Paris). The position of both arms and legs exactly match the *Gladiator*, however, a far more vigorous and animated body type.

80. See Parry, *Art of Thomas Cole*, 154, 156.

81. See, for example, John Glover, *Western View of Mountains*, 1833, Tasmanian Museum and Art Gallery; see also David Hansen, *John Glover and the Colonial Picturesque* (Hobart: Tasmanian Museum and Art Gallery; Art Exhibitions Australia Ltd., 2003).

82. James Barry, *King Lear Weeping over the Dead Body of Cordelia* (1786–88), Tate Gallery, London; William Blake, *Jerusalem*, Yale Center for British Art. See Sam

Smiles, *The Image of Antiquity: Ancient Britain and the Romantic Imagination* (New Haven: Yale University Press, 1994), 165–93; and William Blake, *Jerusalem: The Emanation of the Giant Albion*, ed. Morton D. Paley (Princeton: Princeton University Press, 1991), facsimile image, 70, and text, 246.

83. Cole's description (followed by all subsequent commentators) describes the conqueror's robe as "purple," which would be symbolically appropriate for an imperial victor, but its present appearance is closer to crimson. See Cole quoted in Parry, *The Art of Thomas Cole*, 168.

84. See Angela Miller, "Thomas Cole and Jacksonian America: *The Course of Empire* as Political Allegory," *Prospects* 14 (1989): 65–92.

85. Thomas Robert Malthus, *An Essay on the Principle of Population, or, A View of Its Past and Present Effects on Human Happiness*, second edition (London: T. Bensley, 1803).

86. An exhaustive study of possible sources can be found in Parry, *Thomas Cole's Course of Empire*, 167–71.

87. See Martin Butlin and Evelyn Joll, *The Paintings of J.M.W. Turner*, revised edition, 2 vols. (New Haven: Yale University Press, 1984), 94–96 and 100–101.

88. Nikolaus Pevsner, *The Buildings of England*, vol. 6, *London Except the Cities of London and Westminster* (Harmondsworth: Penguin, 1952), 204. Henry Inwood published an illustrated description, *The Erectheion at Athens*, in 1827, which provides another possible source for Cole's image.

89. *New-York Mirror*, 4 November 1836, vol. 14, p. 150, quoted in catalogue entry by Timothy Anglin Burgard in Foshay, *Mr. Luman Reed's Picture Gallery*, 135.

90. Cole to Durand, 30 August 1836, quoted in Parry, *Thomas Cole's Course of Empire*, 117.

91. Cole's prose description of the series, quoted in Parry, *The Art of Thomas Cole*, 181.

92. Born, *American Landscape Painting*, 81–83; Parry, *Thomas Cole's Course of Empire*, 119.

93. Butlin and Joll, *Paintings of J.M.W. Turner*, 189–91, 194–5.

94. See Jonathan Bate, *Romantic Ecology: Wordsworth and the Environmental Tradition* (London: Routledge, 1991); and Bate, *The Song of the Earth* (London: Picador, 2000).

95. Quoted in Rosenthal, *Constable*, 230.

96. John Constable to Rev. John Fisher, 23 October 1810. The most reliable version is R. B. Beckett, ed., *John Constable's Correspondence* (Ipswich: Suffolk Records Society, 1962–70), 6, 77.

Above the Clouds at Sunrise
Frederic Church's Memorial to Thomas Cole

Thomas Cole was the most influential landscape painter active in the United States from the mid-1820s until the mid-1840s. By the time of his premature death in 1848, at the age of forty-seven, he was widely recognized as the founder of the most important tradition of American landscape art. Frederic Edwin Church was Cole's most important pupil, and the most talked about and financially successful of the landscape painters who dominated the American art market in the 1850s and 1860s. Given the fact that Church studied with Cole and the central importance of both painters to the history of landscape painting in the United States, it is not surprising that the relationship between the two has received a great deal of attention from leading Church scholars including Franklin Kelly, Gerald Carr, J. Gray Sweeney, and John Howat. Although they may disagree with Kelly on secondary issues, Carr, Sweeney, and Howat would almost certainly agree with Kelly's central thesis that the "scientific realism" characteristic of Church's mature style was the result of his desire to meld "the strains of the ideal and the real that had, in Cole's art, seemed irreconcilable." All four of these scholars acknowledge what Carr describes as important "artistic divergences" in the work of the two painters, but agree that Church was Cole's "true successor."[1]

In a recent essay on the painter Lucien Freud, the artist Julian Bell observed that "having stated that Freud was something of a father figure in my own life as a painter, it follows—as you may have realized—that I have a certain urge to kill him."[2] Church no doubt understood himself as Cole's true successor, but one does not need to be steeped in Harold Bloom's seminal essay, *The Anxiety of Influence* (1973), to suspect that the relationship between pupil and master was more psychologically fraught than Kelly, Carr, Sweeney, or Howat have suggested. Church could not have become a major artist without diverging from his master, but artistic divergences, however necessary, are also betrayals. Cole's earliest influential paintings were of the Catskill Mountains, a scenic area in the Hudson River Valley about 120 miles north of New York City. Cole's paintings of the Catskills played a crucial role in establishing them as the most important mountain tourist resort in the United States in the 1830s and 1840s. Cole lived near the Catskills, in the village of Catskill, from 1836 until his death in 1848. Church studied with Cole in Catskill from June 1844 until June 1846. In this chapter, I suggest that Church's early masterwork, *Above the Clouds at Sunrise* (1849; fig. 2.1 and plate 5), is both a memorial to Cole and an artistic declaration of independence. Although the morning view of the sea of clouds as seen from the mountaintop was one of the most famous Catskill vistas, Cole never painted it. In *Above the Clouds at Sunrise,* Church painted a famous Catskill view his teacher would not, or could not, paint. In doing so, Church simultaneously honored the memory of Cole and asserted his power to create his own distinctive means for representing his experience of his world.

Thomas Cole made his first important sales, and achieved his first public recognition, for paintings of the Catskills that he completed between October 1825 and June 1829, when he left the United States for an extended period of study in Europe. Cole returned to the United States in November 1832, settling in New York City, but he soon made his way back to the Catskills. From 1833 until 1835, he spent most of the summer and fall working in the village of Catskill, a small port town located on the Hudson River about fifteen miles east of the mountains. During the summer of 1834, Cole rented studio space at Cedar Grove (fig. 2.2), a modest farm owned by a Catskill businessman named John Alexander Thomson. A bachelor, Thomson shared his home with his niece Maria

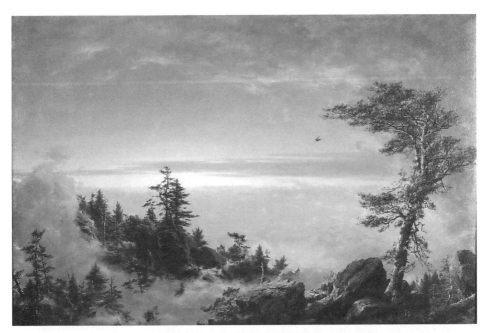

FIG. 2.1. (Plate 5.) Frederic Edwin Church, *Above the Clouds at Sunrise*, 1849, oil on canvas, 27 × 40 in. Property of the Westervelt Collection and displayed in The Westervelt-Warner Museum of American Art in Tuscaloosa, Alabama.

Bartow and her three older sisters. Cole remained in Catskill during the winter of 1835–36, completing *The Course of Empire* (New-York Historical Society), his first major series of historical landscapes. In October 1836, he exhibited *The Course of Empire* in New York City. The following month he married Maria Bartow and moved into Cedar Grove with her. Thomson let the newlyweds have the second-best bedroom. Located on the west side of the second floor, it offered majestic views of the Catskills. All of the Coles' children were born at Cedar Grove: Theodore in 1838, Maria in 1839, Emily in 1843, Elizabeth in 1847, and Thomas, Jr. in 1848. Thomas Cole lived at Cedar Grove until his death in 1848.[3]

Cole was a belated child of the eighteenth-century Enlightenment. He assumed that painting was both a manual craft and a mental activity, and that all genres of art should be valued on the basis of how much thought they required. A great artist had to have good technical skills, but the best still-life was less important than the best history painting because it

FIG. 2.2. Frederic Edwin Church, *Cedar Grove, Catskill*, October 1848, graphite on buff paper, 6½ × 10¼ in. Olana State Historic Site, Hudson, New York, New York State Office of Parks, Recreation and Historic Preservation, OL.1980.1413.

took less research and thought to arrange objects on a tabletop than it did to dress and organize figures into a convincing likeness of a historical or imaginary event. Cole dabbled in architecture and supplemented his income by producing images to be engraved and occasional estate portraits, but most of his income came from naturalistic, "pure," landscapes like *Kaaterskill Falls* (Wadsworth Atheneum Museum of Art) or from historical or moral landscapes like those in *The Course of Empire*. Cole's patrons generally preferred his naturalistic landscapes, as did the generation of landscape painters who rose to prominence in the late 1840s and 1850s, but Cole assumed that his reputation would ultimately rest on his historical and moral landscapes.

Cole was the most influential and successful painter of both naturalistic and historico-moral landscapes in the United States from the late 1820s until the mid 1840s, but he never enjoyed the great financial success attained by leaders of the next generation of American landscape painters. Indeed, Cole's financial situation was especially precarious in the 1840s, when the cost of maintaining his growing family was increasing, demand

for his naturalistic landscapes was slowing, and he lost money on a bad investment in Manhattan real estate. It was at this point in his career that Cole, for the first time, agreed to instruct students. Cole's first student, and by far his most successful, was Frederic Church.[4]

The son of a prominent Hartford, Connecticut, jewelry manufacturer and dealer, Frederic Church was born on May 4, 1826. After showing an early interest in art, he began to study drawing in Hartford in 1842, when he was sixteen. The most important art collector in Hartford at that time was Daniel Wadsworth. Wadsworth was one of Cole's earliest and most generous patrons. Working through Wadsworth, Church's father arranged for his son to study with Cole in Catskill.[5] Church studied with Cole for two years, from early June 1844 until June 1846. Cole charged three hundred dollars per year tuition. Church did not live with Cole's family at Cedar Grove, but paid John Alexander Thomson twelve dollars a month for lodgings nearby—perhaps the same rooms Cole had used prior to his marriage. Church took many of his meals at Cedar Grove, and seems to have developed a close friendship with Cole's six-year-old son Theodore, known as Theddy. Thomas Cole treated Church as both a pupil and a friend, providing companionship as well as instruction. Throughout his career, Cole spent the summer and fall outdoors, making drawings which he used as sources and memory aids during the winter and spring, when he worked indoors on paintings, a pattern Church also adopted. Immediately upon Church's arrival at Cedar Grove, Cole took him on a sketching expedition into the Catskills, and Church seems to have spent most of that summer and fall drawing out-of-doors.[6] Cole probably did not begin serious instruction in the use of oil paints until the following winter. By the spring of 1845 Church had completed two modest-sized landscape paintings which he successfully submitted for display at the annual exhibition at the National Academy of Design in New York in May 1845. The whereabouts of one of these paintings is unknown. The other, *Twilight among the Mountains* (fig. 2.3), is a view from near Cedar Grove, looking west, with the Catskills in the distance. The figure at the right is based on Cole's son Theddy.[7]

The development and expansion of domestic patterns of landscape tourism and art in the United States was slowed by the inadequacy of roads, which made overland travel slow, expensive, and uncomfortable.

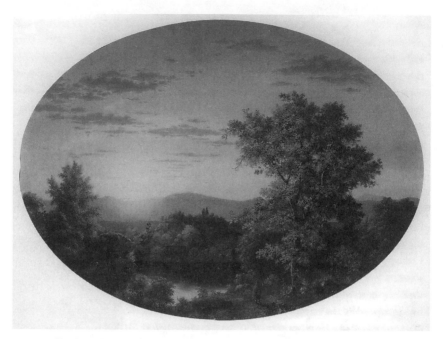

FIG. 2.3. Frederic Edwin Church, *Twilight Among the Mountains (Catskill Creek)*, by April 1865, oil on rectangular canvas, 18⅛ × 24 in. (oval image area). Olana State Historic Site, Hudson, New York, New York State Office of Parks, Recreation and Historic Preservation, OL.1981.25.

When possible, early-nineteenth-century travelers in search of picturesque scenery preferred to travel by boat, which is why most early American scenic destinations were located near rivers or canals. In the early 1820s, a group of Catskill businessmen realized that their port village offered easier access to mountainous scenery than any other place in the northeastern United States. Between 1821 and 1825 they acquired several hundred un-usually scenic acres on the eastern edge of the Catskill escarpment, about fifteen miles west of the village, where they constructed a hotel. Originally known as the Pine Orchard House, the new hotel soon became famous as the Catskill Mountain House. The site is visible in Church's *Twilight among the Mountains,* although the white facade of the hotel is obscured by the bright glare of the setting sun. Published in London in 1831, the engraving after Cole's *View of the Cattskill Mountain House, N.Y.* (fig. 2.4), shows the hotel as it appeared when it first opened in early July 1825. Cole visited the area on his first trip to the Catskills, in late September or early

FIG. 2.4. Thomas Cole, *View of the Cattskill Mountain House, N.Y.*, 1831, steel-plate engraving, from John Howard Hinton, *History and Topography of the United States* (London: Fenner, Sears & Co., 1832). Image courtesy of Middlebury College.

October 1825, three months or so after the hotel had opened. Indeed, Cole no doubt chose to visit the Catskills *because* he had heard of the new hotel and the wonders of the local scenery. On this trip Cole stayed in the mountains for no more than three or four days, barely enough time to complete seven detailed pencil drawings—three of Kaaterskill Falls, one of the small lake directly behind the Mountain House, one of the hotel from the bend in the road (as in *View of the Cattskill Mountain House, N.Y.*), and two of the distant mountains from near the village of Catskill.[8] By mid October, Cole was back in New York where he soon completed two paintings of mountaintop scenery. *Lake with Dead Trees* (Allen Memorial Art Museum, Oberlin College) shows the lake located directly behind the hotel. The present location of the second painting is unknown, but we know that it looked much like *Kaaterskill Falls* (Wadsworth Atheneum Museum of Art), a variant that Cole painted for Daniel Wadsworth during the fall of 1826. One of the tallest and most spectacular waterfalls in the northeastern United States, Kaaterskill Falls is located about two miles west of the site of the hotel. Indeed, the stream which forms Kaaterskill Falls is the outlet from the lake shown in *Lake with Dead Trees*.[9]

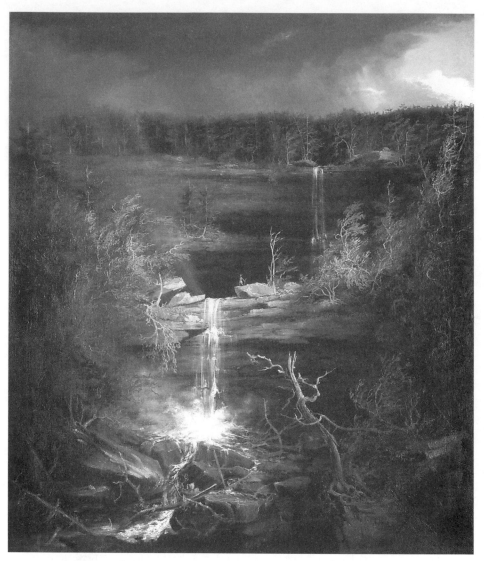

FIG. 2.5. Thomas Cole, *The Falls of Kaaterskill*, 1826, oil on canvas, 43 × 36 in. Property of the Westervelt Collection and displayed in The Westervelt-Warner Museum of American Art in Tuscaloosa, Alabama.

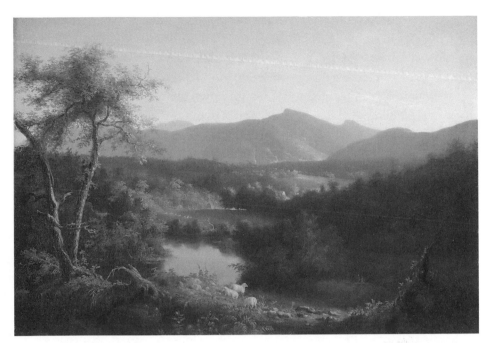

FIG. 2.6. Thomas Cole, *View near the Village of Catskill*, 1827, oil on wood panel, 24½ × 35 in. Fine Arts Museums of San Francisco, gift of Mr. and Mrs. John D. Rockefeller 3rd, 1993.35.7.

Between his first trip to the area around the Mountain House and his June 1829 departure for Europe, Cole completed about fifty major paintings, of which twenty or so were of the Catskills. Most of these showed wild scenes on the mountaintop near the Mountain House. These early views of the Catskills can be divided into three main groups. One focuses on the lake above Kaaterskill Falls and the falls itself. This group includes *Lake with Dead Trees* and five views of the falls, including *From the Top of Kaaterskill Falls* (Detroit Institute of Arts) and *The Falls of Kaaterskill* (fig. 2.5). Another group consists of ten or so views of the narrow mountain valleys which the Dutch settlers of New York called cloves (see fig. 2.14). The third group is the smallest, consisting of two views of the mountains as seen from the banks of Catskill Creek, about a mile west of Cedar Grove: *View near the Village of Catskill* (fig. 2.6) and *View near Catskills* (private collection). In both of these paintings, the white, rectangular outline of the Catskill Mountain House is faintly visible silhouetted against the sky.[10]

After his November 1832 return to the United States, Cole produced numerous major paintings showing the Catskills from the banks of Catskill Creek near Cedar Grove, of which the largest and most important was the memory painting *View on the Catskill—Early Autumn* (Metropolitan Museum of Art), painted a few months after the construction of a local railroad had resulted in the destruction of many of the mature trees shown in the painting. Cole painted numerous variations on this basic view even after the construction of the railroad, but between 1832 and Church's June 1844 arrival in Catskill, Cole does not seem to have produced any paintings of the mountaintop. As a young man with artistic interests growing up in Hartford, Church would have seen Cole's paintings of both the Catskills and the White Mountains in Daniel Wadsworth's collection, but it is doubtful that he had had any opportunities to experience high mountains for himself before he started his studies with Cole.[11] Once in Catskill, Church seems to have spent as much time on the mountaintop as he could. Notations in his account books and dated drawings show that he drew on the mountaintop in June, July, and September 1844; May, June, July, August, and September 1845; and March 1846.[12] Cole accompanied Church on many of these excursions, and the experience of working with the younger artist seems to have rekindled his old interest in the mountaintop as a subject. Cole's last major view of the Catskill mountaintop, *A View of Two Lakes and Mountain House, Catskill Mountains, Morning* (Brooklyn Museum), is dated 1844, but was not completed until March or April of 1845. Exhibited at the National Academy of Design in May 1845, it shows the hotel from a recently completed hiking trail on North Mountain.[13]

During the two years that Church studied with him, Cole completed four historico-moral landscapes. These included a lost biblical scene, *Elijah at the Mouth of the Cave*; a pair of European subjects alluding to John Milton's famous pair of poems, *L'Allegro* and *Il Penseroso*; and *The Cross in the Wilderness* (fig. 2.7), illustrating a then-popular poem by Felicia Hemans. During Church's second year in Catskill, Cole completed preliminary designs for an ambitious series of five paintings eventually titled *The Cross and the World* (see fig. 2.16), which contrasted the life of a sinner with the life of a believer. But Cole could not find a patron to commission *The Cross and the World* or any of the other three- or four-painting series of moral or historical landscapes he conceived during these years,

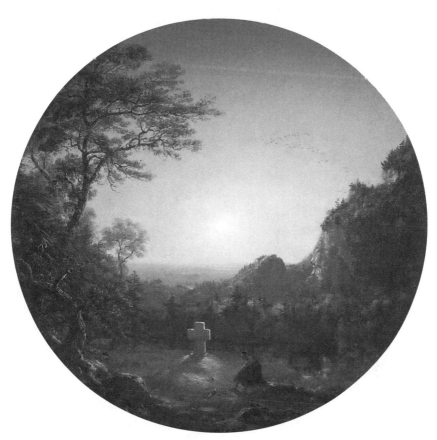

FIG. 2.7. Thomas Cole, *The Cross in the Wilderness*, 1845, oil on canvas, 28 in. (in diameter). Musée d'Orsay, Paris. Photo by Erich Lessing / Art Resource, NY.

and financial necessity forced him to spend most of his time working on naturalistic landscapes. In July 1844, he complained to his journal, "I have no great works [meaning no historical landscapes] at hand. Circumstances are against me & I have much to struggle with. God grant that I may soon [be] relieved of these pecuniary embarrassments so that I may engage in those works consonant to my taste & such as may edify as well as amuse." One year later, frustrated by his continuing inability to find a patron willing to support his work on *The Cross and the World*, Cole tried to reassure himself that although "I must labor yet awhile longer on ordinary subjects for pecuniary means. God willing I will execute the Series [meaning *The Cross and the World*] for myself & for the public."[14]

As one would expect, most of Church's earliest paintings are naturalistic landscapes, and most of those are of Catskills subjects. In 1847, the year after he completed his studies with Cole, Church completed at least six paintings of the Catskills. Three, including *July Sunset* (fig. 2.8), which Church showed at the National Academy of Design in the spring of 1847, and *Scene on Catskill Creek* (Washington County Museum of Fine Arts), which he sold to the American Art-Union the following autumn, are views of the mountains from the banks of Catskill Creek near Cedar Grove. The subject and, to a lesser extent, the style of these paintings are so closely associated with Cole, that when *July Sunset* was shown at the National Academy of Design, one reviewer commented, "the first glance at this picture impresses us with the idea that it must be one of Cole's."[15] As with *Twilight among the Mountains,* the child in *July Sunset* is based on Cole's son Theddy. Church also completed at least four views of the area near the Mountain House, including two small views of the lake which he probably did not send to public exhibition, and *Storm in the Mountains* (fig. 2.9 and plate 6), which he also sold to the American Art-Union in 1847.[16] By this time Church had probably seen many of Cole's early views of the mountaintop, since most were in accessible private collections in New York and New England.

Storm in the Mountains is closely related to Cole's now-unlocated painting, *The Whirlwind,* which had been published as an engraving in 1836, although the tree in Church's work was directly inspired by a shattered birch near the Catskill Mountain House he had drawn in July 1845. Like Cole in several of his earliest paintings of the Catskills, including *Sunrise in the Catskills* (National Gallery of Art), Church tried to capture in *Storm in the Mountains* the elusive texture of storm clouds as they formed and reformed in the confines of the narrow clove.[17]

In a May 1844 letter thanking Cole for agreeing to take him on as a student, Church wrote that "My highest ambition lies in excelling in the art. I pursue it not as a source of gain or merely as an amusement. I trust I have higher aims than these."[18] Like Cole in the late 1830s and 1840s, Church was religiously observant in his private life and hoped to produce morally significant art. Cole apparently discouraged Church from attempting an historico-moral landscape during his first year of study, but

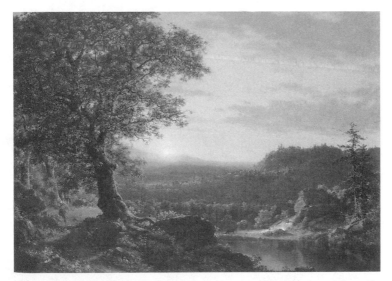

FIG. 2.8. Frederic Edwin Church, *July Sunset*, 1847, oil on canvas, 29 × 40⅓ in. Private collection. Image courtesy of Jonathan Boos.

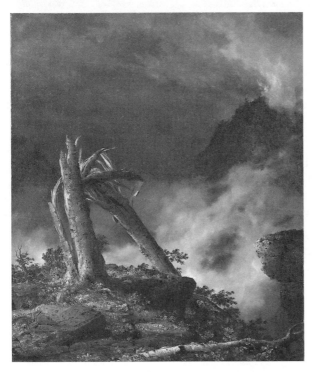

FIG. 2.9. (Plate 6.) Frederic Edwin Church, *Storm in the Mountains*, 1847, oil on canvas, 29¾ × 24¾ in. The Cleveland Museum of Art, gift of various donors by exchange and purchase from the J. H. Wade Fund, 1969.52.

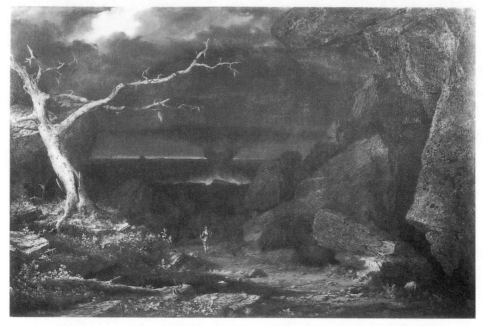

FIG. 2.10. Frederic Edwin Church, *Christian on the Borders of the "Valley of the Shadow of Death," Pilgrim's Progress,* by March 1847, oil on canvas, 40½ × 60½ in. Olana State Historic Site, Hudson, New York, New York State Office of Parks, Recreation and Historic Preservation, OL.1981.50.

must have been intimately involved with the production of Church's first major historical subject, *The Hooker Company Journeying through the Wilderness in 1636 from Plymouth to Hartford* (Wadsworth Atheneum Museum of Art), which Church completed two or three months before concluding his studies with Cole, and exhibited at the annual exhibition of the National Academy of Design in April 1846. When Church sent the *Hooker Company* to the National Academy of Design, he paired it with an unlocated naturalistic landscape titled *Winter Evening.* He submitted similar pairings of naturalistic and historical subjects to the National Academy of Design in both 1847 and 1848. Thus, in 1847, he sent only two works, the naturalistic view on Catskill Creek titled *July Sunset* and a historico-moral subject illustrating John Bunyan's spiritual allegory, *The Pilgrim's Progress,* titled *Christian on the Borders of the "Valley of the Shadow of Death"* (fig. 2.10). In 1848 he again sent only two paintings, pairing a naturalistic *View near Stockbridge, Massachusetts* (private collection), with another scene il-

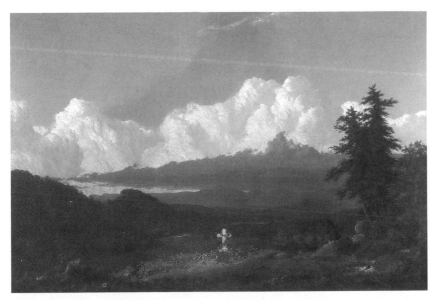

FIG. 2.11. Frederic Edwin Church, *To the Memory of Cole,* 1848, oil on canvas, 32 × 49 in. A. J. Kollar Fine Paintings, Seattle.

lustrating *The Pilgrim's Progress,* a now lost painting titled *The River of the Water of Life.*[19]

Cole died after an unexpected and very brief illness, on February 11, 1848. Within the year, Church had completed two paintings which, explicitly or implicitly, serve as memorials to his teacher and mentor: *To the Memory of Cole* (1848; fig. 2.11) and *Above the Clouds at Sunrise* (1849; see fig. 2.1). The two were never exhibited as a pair, and the fact that they differ in size suggests that they may not have been conceived as a pair. But, visually and conceptually, they function as a pair. *To the Memory of Cole* is a view of the Catskills from near Cedar Grove looking west; *Above the Clouds at Sunrise* is a view from the mountaintop near the Mountain House looking east towards Cedar Grove. The light effects in *To the Memory of Cole* are complicated, but the painting is basically a sunset, while *Above the Clouds* is a sunrise. *To the Memory of Cole* is an explicitly allegorical historico-moral landscape. *Above the Clouds at Sunrise* can be read as a pure, naturalistic, landscape.

As soon as they learned of Cole's death, his friends organized a large memorial exhibition, which opened at the American Art-Union building

in New York on March 27, 1848. Church must have begun *To the Memory of Cole* almost immediately after Cole's death, since the painting is dated "April 1848." Church painted *To the Memory of Cole* in his studio in the Art-Union building, and by the end of April it was on public view near the Cole Memorial Exhibition. As Sweeney has shown, to compose his memorial Church combined Cole's iconic distant view of the Catskills from Catskill Creek with the cross imagery Cole had used in *The Cross in the Wilderness* (see fig. 2.7) in 1845. In the left foreground is the stump of a cut tree, a motif that Church used rarely, but which Cole often used to suggest the advance of civilization. Here, it figures the absent Cole, cut down in his prime. Wreathed in a blooming vine, the cross at the center suggests Christ's triumph over death, evoking his words in John 15:1, "I am the true vine, and my father is the husbandman." At the right, three evergreens suggest the three crosses on Calvary, Christ's triumph over death, and Cole's assumed rebirth into heavenly grace. Although the shadows on the distant Catskills suggest that the time of the scene is sunset, the cross at the center is illuminated by a meteorologically impossible shaft of light, another visual metaphor suggesting Cole's election. More speculatively, Sweeney suggests that Church cut his painting down after completing it, and that the perplexing orange cloud rising behind the strong white cumulous cloud once blossomed into an ethereal cross. If this was indeed the case, the heavenly cross in the sky, like the unnaturally lit, flower-wreathed cross on the hill, figured Cole's ascension to both artistic and spiritual glory.[20]

Church probably returned to Catskill in the winter or spring of 1848 in order to offer his condolences to the Cole family. He must have returned the following fall, since that is when he made the detailed drawing of Cedar Grove which he inscribed "Oct. 1848."[21] During the winter of 1848–49, Church sold two views of a sunrise over the Hudson River Valley from the general vicinity of the Mountain House, both of which he almost certainly painted after his October 1848 visit to the Cole family. The first, *Morning* (fig. 2.12), is dated 1848, and must have been completed by early December 1848, when Church sold it to the American Art-Union. *Above the Clouds at Sunrise* is dated 1849, and must have been completed by the end of March, when it was listed in the first American Art-Union catalogue for 1849.[22] Church had never painted the view from the Catskill

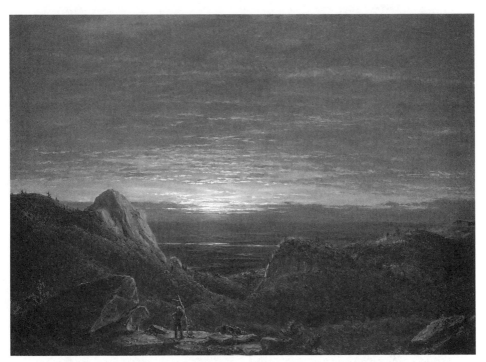

FIG. 2.12. Frederic Edwin Church, *Morning, Looking East over the Hudson Valley from the Catskill Mountains,* 1848, oil on canvas, 18 × 24 in. Albany Institute of History and Art, Albany, New York, 1940.606.7.

escarpment looking east before he painted these two views, and he never painted it again. Indeed, except for oil studies and small paintings related to his estate at Olana, which were produced after 1860 and are very different in size, style, and purpose, *To the Memory of Cole, Morning,* and *Above the Clouds at Sunrise* are the last three paintings of the Catskills Church every produced.

Period accounts of the Catskill Mountain House reveal that until the mid-1840s, when Charles L. Beach introduced new activities and upgraded the hotel in order to induce tourists to pay for longer visits, most tourists stayed at the Mountain House for only two or three nights and were mainly interested in seeing the panoramic view of the Hudson River Valley. Although we now take access to such views for granted, almost all early-nineteenth-century tourists lived on the coast, by a river, or in other low places and had few, if any, chances to see the world from up high.

Although most visitors to the Mountain House visited Kaaterskill Falls and some may have explored more accessible parts of Kaaterskill Clove, the view from the escarpment was the key selling point. Indeed, the hotel was built at the very edge of the escarpment so that visitors would have immediate access to that view.[23]

In the nineteenth century, landscape tourism was largely limited to July and August. Because of the temperature difference between the valley floor and the mountaintop, on summer mornings the Hudson Valley is often filled with clouds that burn off as the sun rises. Many visitors commented on what one described as "the novel feeling of having the clouds passing beneath me."[24] Indeed, period travel accounts make clear that for most visitors the most important Catskill experience was of being above the clouds, and especially of watching the sunrise over the cloud-filled valley. Many visitors compared the cloud-filled valley to an ocean. Thus, in 1819, Henry Dwight described the morning clouds as an "almost shoreless ocean." In 1823, James Pierce compared the cloud-filled valley to "a boundless ocean." In 1828, an unidentified visitor described how the morning mist was "borne round the mountain, and for a few moments the landscape was as distinct as the light of dawn could show it; but another and another overspread it, until the misty flood was whitened into a sea of foam by the beams of the rising sun; wave followed wave, parting as they rolled, and showing beneath, sunny spots of green fields and sparkling waters." Authors who noted the resemblance between the morning mist and the ocean often completed their descriptions by comparing the "ocean landscape" to either Noah's flood or the primal chaos out of which God created the heavens and the earth.[25]

Like other early visitors to the Catskills, Cole was inspired by the experience of watching the sun rise over low-lying clouds. Cole's notebooks and sketchbooks from the late 1820s contain numerous prose and verse accounts of it. His prose descriptions tend to be factual, emphasizing specific effects of light and color, and may have served as aids to memory. Cole titled the longest and most detailed of these "Sunrise on Catskill Mountains." Probably written in 1827, it begins:

The mists were resting on the valley of the Hudson and appeared like a wide plain of drifted snow. The tops of mountains were visible

on the other side. You might imagine them in another world
The sun rose from bars of a pearly hue which were upon the hori-
zon[,] above were clouds lighter & warmer. The clear sky had a cool
greenish tint. Those parts of the prospect not illumined by the rays
of the sun were of a coolish grey. Those lighted, warmer. The mist
immediately below the mountain first began to be lighted up, and
the trees on the tops of the green hills cast their shadows on the mist
which had a singular appearance of innumerable [streaks]. There
was one narrow line of light on the extreme horizon which was ex-
tremely beautiful. The mist appeared more scattered and [browner]
the nearer it was[,] owing I suppose to the angle in which it was
seen. It did not quite reach the foot of the mountains. And the fields
unshaded by it were a most beautiful fresh green. The mountain side
as brilliant though dark.[26]

The organization of the description is spatial, from far to near. The rush
of details effectively communicates both the visual complexity of the scene
and Cole's excitement, but it does not coalesce into a coherent verbal pic-
ture. The underlying difficulty seems to be that Cole sought to record
both what the scene looked like at a particular moment in time and the
innumerable ways in which it was constantly changing. The spatial orga-
nization of the verbal picture enabled him to describe the basic relation-
ship between background, middle ground, and foreground, but was inade-
quate to his simultaneous desire to represent the incessant transformations
which he experienced as the most essential characteristic of the scene.

Cole's most interesting verse account of the experience appears in a
topographical poem titled "The Wild," which he wrote in 1826. In this
poem, Cole, like Henry Dwight and James Pierce before him, familiar-
ized the unusual experience of being above the clouds by comparing the
low-lying mists to the sea. After inviting the reader to travel with him to
"those wild blue mountains / that rear their summits near the Hudson's
waves," Cole continues:

> From this rock,
> The nearest to the sky, let us look out
> Upon the earth, as the first swell of day
> Is bearing back the duskiness of night.

But lo, a sea of mist o'er all beneath;
An ocean, shoreless, motionless and mute.
No rolling swell is there, no sounding surf;
Silent and solemn all;—the stormy main
To stillness frozen, whilst the crested waves
Leap'd in the whirlwind, and the loosen'd foam
Flew o'er the angry deep.
 See! now ascends
The lord of day, waking with heavenly fire
The dormant depths. See how his luminous breath
The rising surges kindles: lo, they heave
Like golden sands upon Sahara's gales.
Those airy forms, disparting from the mass,
Like winged ships sail o'er the marvellous plain.
Beautiful vision! Now the veil is rent,
And the coy earth her virgin bosom bares
Slowly unfolding to the enraptured gaze
Her thousand charms.[27]

In comparison to "Sunrise on Catskill Mountains," the language in "The Wild" is strikingly abstract. Instead of naming specific shapes and colors, Cole relies on metaphor and personification to communicate his wonder at the sublimity of the scene and to give his description a narrative shape. Through a frozen sea of clouds, the Lord of Day awakes. Breathing fire, he burns off the veil of clouds, revealing the naked goddess, Earth, beneath.

Although Cole used rhyme in many of his poems, "The Wild" is written in blank verse—unrhymed iambic pentameter. John Milton wrote *Paradise Lost* in blank verse, and by the 1820s it was well established as the most common verse form for religiously or philosophically serious poetry in English. In "The Wild," Cole's use of blank verse, his reliance on personification, and his diction are all self-consciously Miltonic. Cole's account of the sunrise over the cloud-filled Hudson does not directly evoke Milton's description of the Creation, but many of Cole's well-read contemporaries would have made the connection. Notice, for example, Cole's use of the unusual word "disparting." In Milton's account of Creation, the

spirit of God broods upon Chaos, drawing away "The black tartareous cold infernal dregs / Adverse to life" so that the rest of primal matter

> to several place
> Disparted, and between spun out the air,
> And earth self balanced on her centre hung.

> Let there be light, said God, and forthwith Light
> Ethereal, first of things, quintessence pure,
> Sprung from the deep . . .

In "The Wild," Cole used "disparting" both to describe the melting of the morning clouds which revealed the green earth beneath, and—by allusion—to compare a common Catskill sunrise with the primal morning when God moved upon the face of the waters, separating Darkness from Light.[28]

Almost all of Cole's verbal descriptions of the sunrise from the Catskill escarpment were written between his initial 1825 trip to the Catskills and his 1829 departure for Europe—the years he was most active on the mountaintop. During these years, Cole also completed numerous pencil drawings of cloud effects, many showing the sea of clouds filling the Hudson Valley. As a group, these drawings are unusually sketchy, abstract, and word-filled. Cole often used words to make color notations on his sketches, but his drawings of clouds as seen from up high are exceptionally dependent on words. In many, words dominate, obscuring even as they clarify the visual subject.

Mist over the Lower Country from the Catskill Mountains (fig. 2.13) is characteristic of these drawings, although it reproduces better than most because Cole subsequently reinforced his original pencil lines and notations in ink. Almost certainly completed during the late summer or early fall of 1827 at a spot on the Catskill escarpment near the Mountain House, the drawing is inscribed at the upper right, "mist over the lower country from the Catskill Mountains." At the bottom left, Cole noted the time, "sun an hour high." Cole probably added this notation early in the process of composition, before he surrounded and obscured it with the long inscription which now visually dominates the entire bottom of the sheet: "on

FIG. 2.13. Thomas Cole, *Mist over the Lower Country from the Catskill Mountains,*
ca. 1827, graphite and ink on paper, 6⁹/₁₆ × 4 in. Detroit Institute of Arts, Founders
Society Purchase, William H. Murphy Fund, 39.558.137.

the underside of some of the heavier rolls of clouds beyond there is a warm
reflected light on the underside below which you can see the landscape
some distance." A swirl of lines and letters, the drawing initially resists
interpretation as an intelligible landscape. But, with effort, Cole's inscrip-
tions make it possible for persistent viewers eventually to recognize the
subject. At the top of the sheet, above the notation "tops of the mountains
are darker than the lands immediately under," the long wavy line repre-
sents the summits of the Berkshires, a mountain range in Massachusetts
that defines the eastern limits of the Hudson Valley. In the middle, above
"river in shadow," two pairs of short parallel lines represent sections of the
partially veiled Hudson. At the lower left, the squiggly slanting line at first
seems to represent the edge of a cloud, but the notation "green" suggests
that the line marks the edge of the escarpment, and that the small cross-
like shapes rising from it are meant to represent trees poking up through
either mist or the surrounding forest. Dominating the expansive middle
of the sheet, curved squiggly lines and color notations represent the sea of
shape-shifting clouds which both conceal and reveal the valley below.[29]

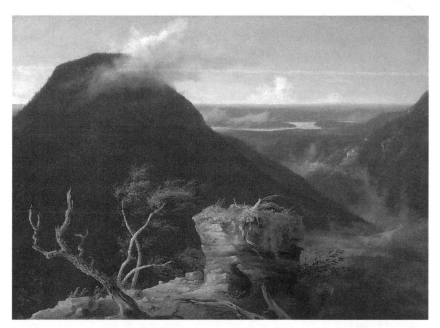

FIG. 2.14. (Plate 7.) Thomas Cole, *View of the Round-Top in the Catskill Mountains,*
1827, oil on panel, 18⅝ × 25⅜ in. Museum of Fine Arts, Boston, gift of Martha C.
Karolik for the M. and M. Karolik Collection of American Paintings, 1815–1865,
47.1200. Photograph © 2011 Museum of Fine Arts, Boston.

The fact that Cole reinforced the pencil lines and notations in *Mist
over the Lower Country from the Catskill Mountains* suggests that at one
time he considered using it as the basis for a painting. But although Cole
painted twenty or so views of the mountaintop between the fall of 1825
and his 1829 departure for Europe, he only showed clouds from above in
Mountain Sunrise (1826; National Gallery of Art) and *View of the Round-
top in the Catskill Mountains* (fig. 2.14 and plate 7), and in neither of these
paintings did he try to represent the vast sea of clouds described in "The
Wild" and so many other contemporary travel narratives. In these paint-
ings, Cole evaded the problem of representing an apparently infinite sea
of shifting clouds both by stepping back from the escarpment to focus on
the shadowed bulk of a looming mountain, and by choosing to represent
either a relatively cloudless morning or mid-morning after the rising sun
had already burned off most of the mists.[30]

Although Cole was widely identified with the Catskills, did more than

any other artist to popularize Catskill Mountain tourism, painted numerous views of the mountaintop, and made at least a dozen pencil drawings of cloud effects from the mountaintop, he never painted the sea of clouds filling the Hudson Valley, the most famous of all Catskill views. The fact that Cole did not paint this subject—and did not draw it except with the help of extensive written amplifications—suggests that he could not figure out how to craft a purely visual representation of it. As much as he may have wanted to, it seems that Cole was unable to represent visually the continual transformations essential to his experience of being above the clouds at sunrise.

The circumstantial evidence I have collected suggests that Church spent part of October or early November 1848 on the mountaintop, trying to develop a visual means for representing the paradigmatic Catskill subject which his master had failed to represent. In this effort, I think he carried two visual models with him. First, during the fall of 1848, Church almost certainly saw Andreas Achenbach's *Storm of Cyclops Rocks, in the Straits of Gibraltar, Coast of Africa*, at the American Art-Union exhibition in New York. Although the present whereabouts of this painting is not known, it was apparently similar to, and may even be identical with, the Achenbach painting now known as *Clearing Up, Coast of Sicily* (fig. 2.15 and plate 8), which was exhibited at the American Art-Union the following year.[31] Together with several of the prose fictions, essays, and poems collected in David Murdoch's tourist pamphlet, *The Scenery of the Catskill Mountains* (1846), Achenbach's seascape would have suggested that Church could represent the view from above the clouds at sunrise by treating the subject as an ethereal seascape.[32]

A second visual model Church must have been thinking of was Cole's *The Pilgrim of the Cross at the End of his Journey*. Cole began planning the five-painting series *The Cross and the World* while Church was still studying with him. The completed *Pilgrim of the Cross at the End of his Journey* was exhibited in the Cole Memorial Exhibition at the American Art-Union during the winter of 1848. It was returned to the Cole family the following summer, when it was installed in Cole's studio, where Church would have seen it when he visited the family at Cedar Grove in October 1848. Although now lost and presumed destroyed, we know what the painting looked like from both a late-nineteenth-century photograph

FIG. 2.15. (Plate 8.) Andreas Achenbach, *Clearing Up, Coast of Sicily*, 1847, oil on canvas, 32¼ × 45¾ in. Walters Art Museum, Baltimore, 37.116. Photo © The Walters Art Museum, Baltimore.

of the finished canvas and a detailed preparatory oil study (fig. 2.16 and plate 9) now at the Brooklyn Museum.[33] Where Cole's Pilgrim rests on the mountaintop, awaiting angels who will soon carry him to his heavenly reward, Church, like Achenbach in *Clearing Up, Coast of Sicily*, gives the viewer no firm ground upon which to stand. In Church's skyscape, as in Achenbach's seascape, the imagined viewer is thrust forward into a more direct experience of the unformed and infinite. The bird in the middle distance of Church's painting, winging its way towards the rising sun, seems to stand for both the imagined viewer's immersion in an experience of the infinite and for the flight of Cole's soul to heaven.

In *Above the Clouds at Sunrise*, Church simultaneously honors Cole and illustrates the limits of both his goals and his methods. As Franklin Kelly has argued, in *The Hooker Party, West Rock, New Haven* (New Britain Museum of American Art), and his numerous variations on Cole's theme of

FIG. 2.16. (Plate 9.) Thomas Cole, *Study for "The Cross and the World: The Pilgrim of the Cross at the End of His Journey,"* ca. 1846–47, oil on panel, 11⅞ × 18³⁄₁₆ in. Brooklyn Museum, gift of Cornelia E. and Jennie A. Donnellon, 33.274.

Home in the Woods (Reynolda House Museum of American Art), Church sought to bridge the gap between naturalistic landscapes and historico-moral ones by importing historical or moral meanings into fully naturalistic paintings.[34] Church attempted something similar in *Above the Clouds at Sunrise*, but *Above the Clouds* is more original because the moral content is so attenuated, almost vestigial. Here, for the first time in his work, we experience the interpenetration of the natural and the transcendent characteristic of Church's great mature works such as *The Heart of the Andes* (Metropolitan Museum of Art) and *Twilight in the Wilderness* (Cleveland Museum of Art). By combining representational strategies suggested by Achenbach's naturalistic seascape and Cole's moralizing landscape, Church figured out a way to represent the paradigmatic Catskill subject that Cole had both attempted and failed to represent. While seeking to create a fit memorial to his teacher and mentor, Church took a long stride towards the development of a more naturalistic style of sublime landscape which would soon make Cole's work seem conventional, literary, old-fashioned, out-of-date.

Notes

I would like to thank Marco Goldin and Linea d'ombra for giving me permission to rework ideas which I first explored in an essay titled "Frederic Church's Memorials to Thomas Cole," in Marco Goldin and H. Barbara Weinberg, eds., *Pittura americana del XIX secolo*, conference proceedings (Treviso, Italy: Linea d'ombra, 2008), 57–77.

1. All quotations in this paragraph are from Franklin Kelly, *Frederic Edwin Church and the National Landscape* (Washington, DC: Smithsonian Institution Press, 1988), viii–ix, except for "artistic divergences," which is from Gerald Carr, *Frederic Edwin Church: In Search of the Promised Land* (New York: Berry-Hill Galleries, Inc., 2000), 45. On the Cole–Church relationship, see also, John K. Howat, *Frederic Church* (New Haven: Yale University Press, 2005), 9–16; Franklin Kelly, "A Passion for Landscape: the Paintings of Frederic Edwin Church," in Franklin Kelly, ed., *Frederic Edwin Church* (Washington, DC: National Gallery of Art, 1989), 34–38; and J. Gray Sweeney, "'Endued with Rare Genius,' Frederic Edwin Church's *To the Memory of Cole*," *Smithsonian Studies in American Art* 2 (Winter 1988), 45–72. Everyone who writes on any aspect of Church's career continues to be influenced by David C. Huntington's pioneering monograph, *The Landscapes of Frederic Edwin Church: Vision of an American Era* (New York: George Braziller, 1966).

2. Julian Bell, "The Way to All Flesh," *New York Review of Books* 55 (March 6, 2008), 24.

3. For Cole, the most important sources are William H. Truettner and Alan Wallach, eds., *Thomas Cole: Landscape into History* (New Haven: Yale University Press and Washington, DC: National Museum of American Art, 1994); Ellwood C. Parry, III, *Thomas Cole: Ambition and Imagination* (Newark: University of Delaware Press, 1988); and Louis Legrand Noble, *The Life and Work of Thomas Cole*, Elliot S. Vesell, ed. (Cambridge: Belknap Press of Harvard University Press, 1964; orig. pub. 1853).

4. On Cole's financial situation in the 1840s, see Parry, *Ambition and Imagination*, 294–98, 310–18; and Noble, *Cole*, 264, 271. Cole's only other student was Benjamin McConkey, who started his studies with Cole by September 1845 and did not complete them until the spring of 1847. For McConkey, see Parry, *Ambition and Imagination*, 311, 321–23, 332, and 338; and Gerald L. Carr, *Frederic Edwin Church: Catalogue Raisonné of Works of Art at Olana State Historic Site*, vol. 1 (Cambridge: Cambridge University Press, 1994), 60, 72, 81, 98.

5. Howat, *Church*, 7–8.

6. For the financial arrangements, see Parry, *Ambition and Imagination*, 298–99; Howat, *Church*, 9; and Carr, *Catalogue Raisonné*, vol. 1, 37–39, 59–61, and 105. In an

April 7, 2008, e-mail to me, Gerald Carr confirmed that Church's Olana notebooks for 1844–46 show that during June–September and September–December 1844, Church paid Thomson thirty-six dollars for each three-month period.

7. The other painting Church sent to the National Academy of Design in May 1845 was titled *Hudson Scenery*. For Church's first experiments with oil paints, including *Twilight among the Mountains* and *Hudson Scenery*, see Carr, *Catalogue Raisonné*, vol. 1, 54–57; Howat, *Church*, 13–14; and Franklin Kelly, "The Legacy of Cole," in Franklin Kelly and Gerald L. Carr, *The Early Landscapes of Frederic Edwin Church, 1845–1854* (Fort Worth, Texas: Amon Carter Museum, 1987), 37–38.

8. The 1825 drawings are listed on pages 29–31 of Cole's 1825 sketchbook (Detroit Institute of Arts). The list is reproduced in Tracie Felker, "First Impressions: Thomas Cole's Drawings of His 1825 Trip Up the Hudson River," *American Art Journal* 24 (1992): 61–63.

9. For the early history of the Catskill Mountain House, see Kenneth John Myers, *The Catskills: Painters, Writers, and Tourists in the Mountains, 1820–1895* (Yonkers, New York: The Hudson River Museum of Westchester, 1988), 36–38; Alf Evers, *The Catskills: From Wilderness to Woodstock* (1972; reprint, Woodstock, N.Y.: The Overlook Press, 1982), 351–65; and Roland van Zandt, *The Catskill Mountain House* (New Brunswick, N.J.: Rutgers University Press, 1966), 28–42.

10. The Mountain House is clearly visible in reproductions of *View near the Village of Catskill* in *Masterworks of American Painting at the De Young*, Timothy Anglin Burgard, ed. (San Francisco: Fine Arts Museums of San Francisco, 2005), 67. *View near Catskills* is reproduced in Edward Nygren, ed., *Views and Visions: American Landscape before 1830* (Washington, D.C.: Corcoran Gallery of Art, 1986), 185. For Thomas Cole's early work in the Catskills, see Kenneth John Myers, "Thomas Cole and the Popularization of Landscape Experience in the United States, 1825–1829," in Marco Goldin, ed., *America! Storie di pittura dal Nuovo Mondo* (Treviso, Italy: Linea d'ombra, 2007), vol. 1, 67–79 (in Italian); vol. 2, 50–61 (in English); and Ellwood C. Parry, III, "Thomas Cole's Early Career," in Nygren, *Views and Visions*, 161–86.

11. In 1844, the only readily accessible mountain destinations in the United States were in the Catskills or the White Mountains of New Hampshire, although the Green Mountains in Vermont were in the first stages of being developed for mountain tourism. In a May 20, 1844, letter thanking Cole for agreeing to take him on as a student, Church noted that he had once "passed near" the village of Catskill, probably meaning that he had taken steamboat passage on the Hudson River, but had never spent time there. His first trip to the Green Mountains seems to have been in 1848. His first trip to the White Mountains seems to have been in 1850. Church's letter to Cole is quoted in Howat, *Church*, 8.

12. Carr, *Catalogue Raisonné*, vol. 1, 37, 60–61.

13. For *A View of the Two Lakes and Mountain House, Catskill Mountains, Morning*, see Parry, *Cole*, 303–4, and Teresa Carbone, *American Paintings in the Brooklyn Museum: Artists Born by 1876* (Brooklyn and London: Brooklyn Museum in Association with D. Giles, Ltd., 2006), vol. 1, 385–87. Charles L. Beach purchased the Mountain House in 1839. As Parry and Carbone both note, *A View of Two Lakes and Mountain House, Catskill Mountains, Morning*, shows the Mountain House before Beach rebuilt and expanded it. Beach completed his remodeling in 1846, at which time he commissioned Cole to paint a mid-sized view of it. That painting, *Catskill Mountain House* (Westervelt Warner Museum of American Art, Tuscaloosa, Alabama), although undated, was probably painted in 1846 or 1847. For Beach's renovations, see Van Zandt, *Catskill Mountain House*, 44, 55–56; and Myers, *Catskills*, 66–67, 112. An 1848 copy of Cole's painting of the remodeled Mountain House, by his sister Sarah Cole, is at the Albany Institute of History and Art.

14. Thomas Cole, journal entry for July 9, 1844, quoted in *Thomas Cole: The Collected Essays and Prose Sketches*, Marshall B. Tymn, ed. (St. Paul, MN: John Colet Press, 1980), 175–76; and Cole, unaddressed letter, June 11, 1845, quoted in Parry, *Ambition and Imagination*, 300. See also, Thomas Cole to Daniel Wadsworth, February 19, 1844, in *The Correspondence of Thomas Cole and Daniel Wadsworth*, J. Bard McNulty, ed., (Hartford: Connecticut Historical Society, 1983), 70–73, in which Cole confessed that he was struggling "hard to keep from debt," tried to interest Wadsworth in commissioning either of two series of multi-panel historical landscapes, "of a moral or religious nature," and complained that if he could not find patrons for his more ambitious works, he would have to keep churning out naturalistic landscapes. Parry, *Ambition and Imagination*, 318, notes that by May 10, 1846, Cole's cash flow problems had become so severe that he had to get a thirty-day loan of five hundred dollars from John Alexander Thomson. For the best general discussion of Cole's desire to pursue "a higher style of landscape," see Alan Wallach, "Thomas Cole: Landscape and the Course of American Empire," in Truettner and Wallach, eds., *Thomas Cole*, 42–49.

15. "The Fine Arts Exhibition at the National Academy. Second Saloon," *The Literary World* 5 (June 1847): 419.

16. The small paintings are *A Sunset Landscape* (14½ × 17½ in.), reproduced in Kelly and Carr, *Early Landscapes*, 88; and *North Lake* (12 × 19 in.), reproduced in Gerald L. Carr, *Frederic Edwin Church: Romantic Landscapes and Seascapes* (New York: Adelson Galleries, 2007), 18. As noted by Carr, *Catalogue Raisonné*, vol. 1, 81, despite its current title, *New England Landscape* (14¼ × 20¼ in.), also dated 1847, incorporates material from drawings Church made near the Mountain House and was probably intended to represent that locale. *New England Landscape* is reproduced in *Colorado Springs Fine Arts Center: A History and Selections from the Permanent Collections* (Colorado Springs: Colorado Springs Fine Arts Center, 1986), 136.

17. For information on the dating and exhibition history of Church's 1847 paintings of the mountaintop, see Kelly and Carr, *Early Landscapes*, 86–87; and Carr, *Catalogue Raisonné*, vol. 1, 69–71. The engraving after Cole's *The Whirlwind* is reproduced and discussed in Parry, *Ambition and Imagination*, 163.

18. Frederic Church to Thomas Cole, May 20, 1844, quoted in Howat, *Church*, 9.

19. For Church's two paintings after *The Pilgrim's Progress*, see Carr, *Catalogue Raisonné*, vol. 1, 114–19; and Kelly, *Church and the National Landscape*, 18–19.

20. Almost all of the information and ideas in this paragraph derive from Sweeney, "Endued with Rare Genius," 45–50 and 56–60, which also includes a proposed reconstruction of the "complete" *To the Memory of Cole*. Sweeney, 49, notes that *To the Memory of Cole*, which is signed and dated "April 1848," is "the only known easel painting by Church dated by month as well as year."

21. For the timing of Church's visit and a detailed description of the Cedar Grove buildings, see Carr, *Catalogue Raisonné*, vol. 1, 149–50.

22. The American Art-Union published updated catalogues as they acquired paintings. *Morning* was American Art-Union number 348 for 1848. The Art-Union catalogue published in early December included all numbers up to 339. The next catalogue, issued on December 22, included numbers up to 454, suggesting that *Morning* was purchased after the early December issue went to press. *Above the Clouds at Sunrise* was number 22 for 1849. The first 1849 catalogue was published in early April, and included fifty works purchased since the beginning of the year. Information from Mary Bartlett Cowdrey, *American Academy of Fine Arts and American Art-Union* (New York: New-York Historical Society, 1953), vol. 1, 276–77, and vol. 2, 70.

23. For the length of time that typical tourists stayed at the Mountain House, and what they did while there, see Myers, *The Catskills*, 50–51, 66–69.

24. "A Visit to the Catskills," *The Atlantic Souvenir* (Philadelphia: Carey, Lea & Co., 1828), 280.

25. Henry Edwin Dwight, "Account of the Kaatskill Mountains," *American Journal of Science and Arts* 2 (November 1820): 11; James Pierce, "A Memoir on the Catskill Mountains with Notices of their Topography, Scenery, Mineralogy, Zoology, Economical Resources, &c," *American Journal of Science and Arts* 6 (1823): 92; and "A Visit to the Catskills," 280. These and other period accounts of being "above the clouds" are discussed in Myers, *The Catskills*, 60–63.

26. "Sunrise on Catskill Mountains," Thomas Cole Papers, New York State Library; reproduced in Archives of American Art microfilm reel ALC–3. For a briefer and less accurate transcription of the passage, see Noble, *Cole*, 39.

27. Noble, *Cole*, 39–40. For the original manuscript, see Thomas Cole Papers, New York State Library, box 4, folder 13. For other Cole poems that include descriptions of the view from the Catskill escarpment, see "The night was calm. Clad

in her mantle darkness," and "To CBT," both in *Thomas Cole's Poetry*, Marshall B. Tymn, ed. (York, PA: Liberty Cap Books, 1972), 39 and 190. Tymn dates "The night was calm. Clad in her mantle darkness" to 1825. "CBT" was Cole's friend Charles B. Trego. "To CBT," was probably written in late 1826 or early 1827, since Trego, who lived in Philadelphia, visited the area around the Mountain House with Cole in September 1826. For Trego's visit, see Charles B. Trego to Thomas Cole, September 28, 1826, Thomas Cole Papers, New York State Library; box 2, folder 1.

28. John Milton, *Paradise Lost*, VII: 238–45, in *The Poems of John Milton*, John Carey and Alastair Fowler, eds. (London and New York: Longman Group and W. W. Norton & Co., 1972). Milton used a version of the word only one other time in *Paradise Lost*, in his description of Satan's journey from Eden to Hell after the fall of Adam and Eve, X: 415–16, "on either side / disparted chaos." For Milton's impact on early-nineteenth-century American literary culture, see Keith W. F. Stavely, *Puritan Legacies: "Paradise Lost" and the New England Tradition, 1630–1890* (Ithaca, NY: Cornell University Press, 1987), and Kevin P. Van Anglen, *The New England Milton: Literary Reception and Cultural Authority in the Early Republic* (University Park: Penn State University Press, 1993). Cole's use and understanding of blank verse would have been influenced by later poems in the Miltonic tradition, including James Thomson's *The Seasons* (1728–30), William Cowper's *The Task* (1785), and William Wordsworth's *The Excursion* (1814).

29. All quotations in this paragraph are from Cole's drawing, *Mist over the Lower Country from the Catskill Mountains* (Detroit Institute of Arts 39.558.137). Similarly sketchy and wordy drawings of cloud effects from the escarpment near the Mountain House include *Clouds near Sunset* (DIA 39.558.30), *From Cattskill Mountain, before Sunrise* (DIA 39.558.31), *Looking East, Thunderstorm after Sunset* (DIA 39.558.126), *Clouds and the Green Mountains from the Catskill Mountain* (DIA 39.558.127); and *The Clouds below the Mountain* (DIA 39.558.130).

30. *Mountain Sunrise* is reproduced in Truettner and Wallach, eds., *Thomas Cole*, 139.

31. For William Sidney Mount's description of *Storm of Cyclops Rocks, in the Strait of Gibraltar, Coast of Africa*, which he saw at the American Art-Union on November 2, 1848, see Alfred Frankenstein, *William Sidney Mount* (New York: Harry N. Abrams, 1975), 187. Achenbach's *Clearing Up, Coast of Sicily* was first exhibited at the American Art-Union in 1849. The unidentified author of "Chronicle of Facts and Opinion, American Art and Artists," *Bulletin of the American Art-Union* 2 (August 1850): 81, commented on the impact of *Clearing Up, Coast of Sicily* on young American landscapists, noting that "Church, Gignoux, and Hubbard have gone to the coast of Maine, where it is said that the marine views are among the finest in the country. None of these artists, we believe, have hitherto attempted such subjects, and we look forward to the results of this journey. The exhibition of the

magnificent Achenbach last year at the Art-Union Gallery seems to have directed the attention of our younger men to the grandeur of coast scenery." The impact of Achenbach's work on Church and his contemporaries is discussed in Franklin Kelly, "Lane and Church in Maine," in John Wilmerding, ed., *Paintings by Fitz Hugh Lane* (Washington, DC: National Gallery of Art; and New York: Harry N. Abrams, 1988), 135–36; and William H. Gerdts, "'Good Tidings to the Lovers of the Beautiful': New York's Düsseldorf Gallery, 1849–1862," *American Art Journal* 30 (1999): 76–77.

32. David Murdoch, ed., *The Scenery of the Catskill Mountains* (New York: D. Fanshaw, [1846]). For the publication history of Murdoch's pamphlet, see Myers, *The Catskills*, 68.

33. The photograph of the completed painting is reproduced in Sweeney, "Endued with Rare Genius," 52. Sweeney, 54, also reproduces a second, somewhat different, and presumably earlier, oil study for *The Pilgrim of the Cross at the End of his Journey*, now in the collections of the Smithsonian American Art Museum.

34. Kelly, *Church and the National Landscape*, 6–9, 22–24, and 53–60.

Andrew Jackson Downing and the Sentimental Domestic Landscape

Sentimentality, as Shirley Samuels has written, lay "literally at the heart of nineteenth-century American culture."[1] In the antebellum era, sentimental cultural productions—that is, productions intended to develop empathetic bonds and to evoke softer emotions such as tenderness, affection, pity, and nostalgia—were assigned vital social roles.[2] They were to increase attachments to home and country, provide a corrective to the heart-hardening mechanisms of market capitalism, foster sympathy for the less fortunate, and elevate moral character. No single place was considered more important to the cultivation of sentimental feelings than the family home. Andrew Jackson Downing (1815–52), the most influential American writer on architectural and horticultural topics at mid-century, believed that "the mere sentiment of home, with its thousand associations, has . . . saved many a man from shipwreck in the storms of life."[3] This chapter will explore the ways that Downing, through his designs for houses and particularly home grounds, sought to both symbolize and facilitate the formation of sentimental domestic bonds.

More broadly, examining Downing's work allows us to interrogate the long-standing feminine gendering of American sentimental culture in the antebellum era. Recently scholars such as Mary Chapman and Glenn

Hendler have challenged the "now canonical association of sentimentality with femininity."[4] I wish to join them by making clear the extent to which men such as Downing not only participated in but also dominated the formulation and dissemination of a sentimental domestic architecture and horticulture. Although much has been written about women's dominance of the field of sentimental domestic literature in the antebellum era and about the nineteenth-century "cult of domesticity" that defined the home as women's domain, focusing on the works of Downing and other architectural and horticultural writers of his era raises questions about the real extent to which the domestic realm and sentimentality itself had been gendered in the decades before the Civil War.

In Washington Irving's "The Legend of Sleepy Hollow" (1819–20), a story that Downing much admired, the lanky protagonist Ichabod Crane arrives at the farmstead of Baltus Van Tassel intent on courting the farmer's blossoming daughter, Katrina. Enraptured by her rosy cheeks, and even more so by the prosperous abundance of her "paternal domain," he envisions how the farm "might be readily turned into cash, and the money invested in immense tracts of wild land, and shingle palaces in the wilderness." He imagines himself wedded to Katrina, placing her "on the top of a wagon" and "setting out for Kentucky, Tennessee, or the Lord knows where."[5] Oblivious to Van Tassel's attachments to his home and his daughter, Ichabod would tear both from the farmer to satisfy his own voracious appetites and restless disposition. He is Irving's embodiment of the selfish, avaricious, unsettled aspects of the Yankee temperament. In his fictional realm, Irving was able to drive off Ichabod with the aid of a ghost and a well-aimed pumpkin. In the real United States during the tumultuous decades of the early to mid-nineteenth century, it was far less clear how these worrisome traits of the American character might be countered.

Concern about Americans' feverish pursuit of wealth and their restless disposition to change (manifested in westward migration as well as the influx of youths into cities) runs as a refrain through antebellum writings— both fiction and nonfiction, by foreign visitors and native authors alike. While acknowledging that these traits were playing an important role in building the nation, many feared that, at the same time, they were undermining morals, weakening family bonds, breaking intergenerational ties,

destabilizing local institutions, and, ultimately, threatening the stability of the nation itself British visitor James Johnston observed in 1851 that in his travels through New England and New York he had found "scarcely any such thing as local attachment—the love of place. . . . Speaking generally, every farm from Eastport in Maine to Buffalo on Lake Erie is for sale."[6] J. H. Hammond, author of *The Farmer's and Mechanic's Practical Architect* (1858), worried that "These frequent changes of residence . . . are destructive of much of that home-feeling which is essential to the education of the affections and moral sentiments."[7]

Downing often expressed similar concerns, lamenting that Americans "are too much occupied with *making a great deal*" and too much subject to the "*spirit of unrest*" which "makes of a man a feverish being . . . unable to take root anywhere."[8] [Italics in original. Downing was particularly fond of italics, and all those in subsequent quotations from his writings are his.] While he admired "the energy of our people," he also valued "the love of order, the obedience to law, the security and repose of society, and the partiality to localities endeared by birth or association, of which it is in some degree the antagonist."[9] Yet rather than simply wringing his hands over the state of American society, Downing proposed a remedy, at least a partial remedy, rooted in what he called "rural improvement." By increasing the "home expression" of country houses and their grounds, by making rural dwellings as comfortable, convenient, and beautiful as possible, he sought to heighten their "moral influence" and strengthen those chains of affection that bound the inhabitants to each other and to their home ground.[10] As family members engaged in improving their dwellings, and in planting and nurturing tree groves, orchards, vines, and flower gardens, they would, Downing believed, discover a new spirit of repose. Their domestic enjoyments would increase and their local attachments deepen to the point that they would no longer feel the allure of the alehouse or the city or the distant western territories. Indeed, they would become better citizens, their patriotism strengthened, since the "love of country is inseparably connected to the *love of home*."[11]

Downing's approach to rural improvement was fundamentally sentimental. His designs for rural dwellings and gardens were to make their appeals to the feelings, to the hearts, of their inhabitants and onlookers; they were to instill and elicit those softer sentiments at the core of the sen-

timental: affection, sympathy, tenderness, attachment, and nostalgia. As Downing put it, he sought to create homes "in whose aspect there is something to love." A house, he wrote, should have rooms "where all domestic fireside joys are invited to dwell" and "have something in its aspect which the heart can fasten upon and become attached to, as naturally as the ivy attaches itself to the antique wall, preserving its memories from decay."[12] Those who inhabited such homes would find their hearts softened, their social sympathies increased, and their benevolent impulses heightened. Those who simply gazed upon such homes would feel the stirrings of nostalgia as they recalled their own childhood homes or perhaps recollected images of happy homes of which they had heard or read.

Downing's employment of a sentimentalized rationale for his house and garden designs became increasingly pronounced over the years, reaching its height in the late 1840s and early 1850s. In the course of his short career (he was killed in a steamboat accident on the Hudson River at the age of thirty-six), Downing published three major books on domestic architecture and garden design: *A Treatise on the Theory and Practice of Landscape Gardening adapted to North America* (1841; hereafter, *Landscape Gardening*), *Cottage Residences* (1842), and *The Architecture of Country Houses* (1850), all of which passed through numerous editions. Both the texts of these books (which address the history and theory of architecture and landscape design) and the designs themselves owe a significant debt to European architectural and landscape theory and to British pattern books of the late eighteenth and early nineteenth centuries, especially those of John Claudius Loudon (1783–1843). Yet as indebted as Downing was to these works, they do not seem to have been the source for his sentimentalized vision of domestic architecture and landscape gardening.

Late eighteenth- and early nineteenth-century British pattern books often contain sentimental rhetoric, but, for the most part, it assumes different forms and is used to address different ends than in Downing's publications.[13] Both Downing and his British sources extol the quiet joys of rural life as an antidote to the corruptions of commerce and fashion, but from there they diverge. The British authors describe the picturesque Old English cottage and the "wild hedge-rows and irregular plantations" of the English countryside with a tender nostalgia—a nostalgia suffused with patriotism and a longing for the "Old England" that seemed to be rapidly

disappearing in the face of enclosure and encroaching modernity.[14] Such sentimentalized descriptions were especially common during the years of the Napoleonic Wars when these traditional forms were threatened not just by modernity, but also by the possibility of French invasion. The authors' proffered designs for thatched-roofed cottages, Tudor villas, and informal, naturalistic landscapes both evoked and sought to preserve something of this Old England. They were, to that extent at least, sentimental designs.

A number of British authors also enlisted the sentimental in the service of social reform.[15] With appeals rooted in the language and assumptions of class privilege, they sought the help of their readers (whom they generally assumed to be wealthy members of the nobility and gentry) in ameliorating the wretched living conditions of the British poor. They appealed to their readers as genteel "men of feeling," seeking to touch their hearts, arouse their pity, and elicit their beneficence, picturing for these men the great good they could do in building model cottages for their poor but worthy tenants. Their books offer designs for cottages and even whole villages usually in traditional styles that would blend harmoniously and picturesquely with an estate's existing architecture as well as the local scenery. Thus the new cottages would be both comfortable for the tenants and aesthetically pleasing to the landowner. While Downing would call on American men of wealth to create houses and grounds that could serve as models of refined taste for their fellow citizens, he never issued the sort of sentimental appeals on behalf of the poor that the British authors did.

On the other hand, critical to Downing's conceptualization of a sentimental domestic architecture was the insistence by J. C. Loudon, the influential British architectural and horticultural writer, that one of the fundamental principles of architectural design is "Expression of the End in View." By this Loudon meant that each building should express the use for which it is erected. For a dwelling house, this required emphasizing those aspects of its form that differentiated it from other building types such as barns and factories: chimneys, windows filled with glass, porticoes and balconies suggesting "comfort and elegant enjoyment," and "turrets and projections" suggesting "commodiousness and convenience."[16] This notion that particular architectural forms could be expressive of domestic ideas and ideals would become essential to Downing's formulation of a sentimental domestic architecture. He would draw on this idea to create

a symbolic vocabulary of forms that he could deploy to articulate "home feeling" in his designs. Yet Loudon's own books are not particularly notable for their sentimental themes. The British author occasionally makes reference to domestic "happiness" and once states that the possession of a country home offers something "on which we can set our hearts and affections," yet these are only scattered phrases among the thousands of pages that constitute his architectural writings.[17] Downing, in fact, once criticized Loudon for his lack of sentiment.[18]

As dependent as Downing was on his British sources, he was, of course, writing for a different audience living under different social, political, economic, and physical conditions, and he was keenly aware that he needed to modify his borrowed designs and theories to suit their new American setting. Indeed both his *Landscape Gardening* and his *Cottage Residences* include in their extended subtitles the words "adapted to North America." Downing would follow the British pattern books in offering designs for picturesque rustic cottages and villas in various styles including the Tudor, Elizabethan, and Gothic, but he discarded thatched roofs and clay walls as inappropriate for the American climate, removed crenellated battlements as out of place in the generally peaceful American countryside, and offered nothing comparable to the palatial estates so common in the British books. He also adopted a more egalitarian rhetoric, suppressing the language of class privilege and promoting republican ideals (though not enough to avoid charges of elitism from some of his critics).

Downing's elevation of the sentimentalized concept of home into a central theme of his works—his insistence on the creation of a domestic architecture that could "touch the heart" and foster "home feeling"—seems to have been another of the ways in which he sought to adapt his foreign sources to the needs and interests of his American audience. He was, after all, writing at a time when John Howard Payne's "Home, Sweet Home" (1822) was among the most popular songs in the country, when ministers offered sermons every Sunday on themes such as "The Blessings of Home," and when the nation's newspapers and journals were daily publishing more poems, short stories, and essays on topics such as the joys of domestic life, the pangs of homesickness, and the anguish of leaving home. In many of these literary works, the ideal home is pictured as a snug, vine-covered cottage, framed by trees, and graced by a flower garden

filled with roses and hollyhocks. Downing offered his American readers practical advice and concrete plans for creating just such a home.[19]

Downing's understanding of how houses and gardens might operate upon the feelings was grounded in European aesthetic and epistemological philosophy, especially theories of associationism and environmental determinism. In an address delivered at the Massachusetts Horticultural Society's annual fête, Downing declared, "I am, sir, an associationist."[20] He thus openly professed his allegiance to the ideas of the Scottish philosopher Archibald Alison, whose 1790 *Essays on the Nature and Principles of Taste* established the fundamentals of associationism. According to Alison, the pleasure we derive from looking at objects arises not from the forms of the objects themselves but from the trains of associations—the ideas and emotions—that the objects elicit in our minds. In his own writings, Downing refers to this as the "beauty of expression" or the "beauty of sentiment." Departing from Alison, however, he also recognized, following classical architectural theory, a "beauty of form," residing in such features as proportion, symmetry, variety, and unity. Drawing on the work of other British aesthetic theorists such as William Gilpin and Uvedale Price, he argued that forms are in themselves capable of expressing and eliciting emotions. A symmetrical, unified composition, for example, would tend to induce feelings of calm. Downing believed that together the beauty of sentiment and the beauty of form were responsible for the delight we derive from both the built and natural environment.

Applying associationist theory to domestic architecture, Downing (following Loudon's lead) argued that for a house to evoke those warm, pleasurable associations that we have with the idea of "home," it needed to look like a house and not like a barn or a Greek temple or a feudal castle. In the December 1847 issue of *The Horticulturist,* the journal he edited from 1846 until his death in 1852, he illustrated how to imbue a building with domestic associations. The frontispiece contrasts two houses (fig. 3.1). According to Downing, one elicits appropriate home feelings, the other does not.

The top image represents a typical "New England Suburban Dwelling." A simple variant on the Greek revival style, the house is a rectangular box with a peaked roof and a gable-end entrance. The entrance façade is adorned with Doric corner boards visually supporting a plain entablature,

FIG. 37. THE NEW ENGLAND SUBURBAN DWELLING

FIG. 38. DESIGN FOR IMPROVING THE SAME.

[Hort: Dec. 1847.]

FIG. 3.1. The upper image represents a "typical" New England suburban dwelling. The lower image shows the same building "improved" to heighten its domestic character. Frontispiece to *The Horticulturist*, vol. 2, December 1847. Courtesy, American Antiquarian Society, Worcester, MA.

cornice, and pediment. These architectural details, together with the building's white paint, suggest a temple front, eliciting associations with the public buildings of pagan antiquity.

The lower image represents the same building "improved" to give it a more domestic character. The classicizing details have been removed, and the building has been repainted a quiet gray or fawn color so that it will better harmonize with its natural surroundings. More importantly, Downing emphasizes those aspects of the building that mark it as a dwelling and that evoke sentiments proper to a home such as protection, support, warmth, comfort, and welcome. The eaves in the "improved" dwelling project about two feet from the façade. Functionally, they protect the façade from inclement weather and help keep the upper story cool in the summer.[21] Metaphorically, they reinforce the impression of shelter and protection, as does the increase in overall roof area. The brackets beneath the eaves are "not only for actual support, but to suggest the idea of support directly to the eye."[22] The vertical board-and-batten siding, advocated by Downing as more economical, durable, and truthful than clapboarding, was to suggest strength and permanence.[23] Of the veranda stretching across the front, Downing writes that such porches become, in the warm seasons of the year, "the lounging apartment of the family" and hence suggest ideas of comfort.[24] The veranda also offers the visitor a "friendly preparation" before entering the house and visually reinforces the building's domestic character since a "house in which the front door is bare, is not always easily distinguished from an office or any place of business."[25] Finally, chimney tops, Downing argues, are so "associated with all our ideas of warmth, the cheerful fire-side, and the social winter circle" that "they should in all dwellings not only be boldly avowed, but rendered ornamental."[26] He thus replaces the low squat chimney in the upper image with a taller, more decorative, more prominent version. Together these features, according to associationist theory, would act upon the viewer's imagination, evoking thoughts of the pleasures and enjoyments of domestic life and enable the building to, in a phrase Downing often used, "touch the heart."

Associationist theory led Downing to develop a symbolic approach not just to architecture, but also to landscape gardening. A garden, with all

its associations of rootedness, nurturance, and growth, was as essential to establishing the home feeling of a dwelling as the architecture itself. In *The Architecture of Country Houses* (1850), Downing makes this point with another contrasting pair of images. Figure 3.2 shows a "small bracketed cottage" with the projecting eaves and ornamental chimneys that mark it as a home, and yet it appears rather bleak and bare. It "wants," he writes, "the softening and humanizing expression" which plantings can give.[27] In figure 3.3, he shows the same house "*affectionately* embosomed in foliage."[28] Graceful trees and flowering shrubs frame the house, while vines clamber over its arbors and entrance porch. It thus exhibits, he writes, "a good deal more *feeling*."[29]

Of all plantings, none heightened the domestic expression of a dwelling more effectively than vines. A drapery of wisteria, roses, honeysuckle, ivy, grapes, or even hops could transform a "soulless habitation into a home that captivates all eyes."[30] Vines' associations with domestic felicity were particularly strong because, according to Downing, they were never planted by architects or builders, but only by a home's inhabitants, usually mothers and daughters, who nurtured them as "a labor of love offered on the domestic altar." They thus always expressed "domesticity and the presence of heart."[31] As vines clung to porch columns and bound themselves to walls, they became metaphors for domestic attachment and for the support that the stronger members of the family offered to the frailer. A graceful drapery of well-tended vines could also act, Downing believed, as a "philter" against that "spirit of unrest" that kept Americans continually on the move. He assured his female readers that, when their husbands and brothers found their homes wreathed in sweet-smelling verdure, they "would no more think of giving up such houses, than they would of abandoning you."[32]

While Downing wrote extensively about the ways that the physical appearance of dwellings could give visual expression to the warmth and comforts of domestic life, he also understood that it was the inhabitants' active engagement in the creation and embellishment of their dwellings that most effectively engendered the sentiments that made the house a home. Our "love of home," he writes, "will be sure to grow with every step we take to add to its comforts, or increase its beauty."[33] Horticultural pursuits, in particular, he thought, would root the family to its home ground.

[Fig. 1I.]

FIG. 3.2. A small bracketed cottage without plantings, from
A. J. Downing, *The Architecture of Country Houses* (1850), p. 80.

DESIGN II.

SMALL BRACKETED COTTAGE.

Fig. 9.

FIG. 3.3. A small bracketed cottage with plantings, design II, from
A. J. Downing, *The Architecture of Country Houses* (1850), p. 79.

Children who were raised engaging in such activities would "sigh no more for town or city life, but love with intense affection every foot of ground they tread upon, every tree, and every vine, and every shrub, their hands have planted, or their tastes have trained."[34] To plant trees with one's own hands and watch them grow and develop over the years, to see vine tendrils twining up the arbors one has built, to gather fruit from one's own orchard or flowers from one's own garden, to see a home made beautiful through one's own efforts—such things created both fond memories and "that feeling of pride in home that has so much share in fostering the simple virtues that make after-life [that is, life after leaving the childhood home] so happy."[35]

Downing believed wholeheartedly that rural dwellings could exert a profound moral influence. He shared this belief with many others, both European and American, who accepted, as he did, that the environment in which one lived, and particularly the environment in which one was raised, had a lasting effect on one's moral character. Now sometimes referred to as environmental determinism, this theory had become well-established in British architectural literature at least as early as the late eighteenth century, and was often used by British writers, including Loudon, to encourage attention to the housing of the nation's poor. Ultimately, the theory has its roots in the proto-Enlightenment epistemology of John Locke, who postulated that at birth the mind is a *tabula rasa* to be shaped by experiences derived from sense perceptions. Locke's theory led him to place great emphasis on childhood education and experiences, writing in *Some Thoughts Concerning Education* (1693): "the little and almost insensible impressions on our tender infancies have very important and lasting consequences."[36] Locke's ideas underlay much of the emphasis placed on the home environment and on home education in the nineteenth-century United States. In a review of Downing's *Architecture of Country Houses* for *The New Englander,* the Connecticut minister N. H. Eggleston wrote, "The importance of the home world is probably felt at the present day more deeply than ever before." This was particularly true, he felt, in relation to children, as more and more people were recognizing, "how much the place of a child's residence has to do with a child's character."[37] Hence, he argued, the great importance of Downing's schemes for the improvement of rural residences.

Downing viewed the country home as an agent of moral and social reform, capable of exerting its influence over children, certainly, but over adults as well. "There is nothing," Downing writes, "that more powerfully affects the taste and habits of a family—especially the younger members of it—than the house in which it lives.[38]

As Eggleston noted in explaining Downing's underlying reasoning: "The world of ideas, thoughts, and feelings is most intimately connected with the world of matter, and the former world will take its tone and shape very much from the latter."[39] Family members, Downing believed, would respond unconsciously, or to use his word, "insensibly," to their home environment—their feelings and their characters would be molded by its traits. A neat, orderly, well-arranged home would likely instill habits of neatness and orderliness in its inhabitants. On the other hand, a squalid, ill-kept house, arranged with little thought to the comfort and convenience of the inhabitants, and with little in its appearance to distinguish it from a barn, would likely produce coarse and brutish manners. As Gervase Wheeler, an architect and pattern-book author who was much influenced by Downing, wrote: "The neat cottage tempts the indwellers to a neatness in harmony, and leads them to adorn the little garden-plot, and cultivate flowers, and the children have at life's early steps a perceptive appreciation of beauty given by their home associations, which never leaves them, even amid the distraction of business pursuits."[40] To Eggleston, "a properly constructed dwelling," built according to the designs in Downing's books, would "educate its inhabitants, generation by generation," begetting "in them the home feelings which rightfully belong to such a place."[41] Through educating and elevating inhabitants' affections, feelings, and taste, such homes could contribute to the civilizing of American society, creating, as one etiquette book author put it, "a community of those who think and feel correctly."[42] Conversely, to adopt such homes became an outward expression of one's inner refinement, of one's participation in a middle-class culture dedicated to social uplift and moral reform.[43]

Crucial to the morally elevating and heart-softening influence of the homes Downing described and promoted in his writings was their location in the countryside. "In the United States," Downing wrote, "nature and domestic life are better than society and the manners of towns."[44] While cities could harden and corrupt a man's character by exciting his

passions, feeding his vanity and ambition, and sharpening his competitive and acquisitive urges, the country offered occupations "full of health for both soul and body. . . . The heart has there, always within reach, something on which to bestow its affections."[45] In the country, a man's life was united to "the life which animates all creation," for there he was in the presence of nature, and hence in the presence of God.[46] Surrounded by the beauties of nature, his heart would be constantly uplifted, while rural activities, especially the cultivation of the soil, would strengthen his body, calm his mind, and lead him to cherish with "tender affection" the grounds he tended. Such a connection to nature was lauded as therapeutic by a reviewer of Downing's *Landscape Gardening*, who argued that horticultural pursuits have a "sanative virtue" that will "surely exert a spell over all the heart's malignant diseases, banishing its selfishness, assuaging the fever of its ambition, restraining the rage of its revenge, and quelling its every baser passion. . . . When we till the ground under the open expanse of heaven, out in the glorious presence of God's works, we are invited to a free and loving communion with the Spirit of Solitude and of Life."[47]

In his house and garden designs, Downing sought to give visual expression to that ameliorating intimacy with nature that a rural residence allows. In this he was again following British precedents. While city homes were often tall and narrow—forced upward by high lot prices—a country home, Downing argued, should spread out across the ground and look as though it had grown naturally from its site. To enhance this impression, it should be built, if possible, from local materials, and painted, if necessary, a soft, neutral, "natural" hue. Downing several times quoted Sir Joshua Reynolds's advice on how to select the color for a country dwelling: "turn up a stone, or pluck up a handful of grass by the roots, and see what is the colour of the soil where the house is to stand, and let that be your choice."[48] The building's design should also take its cue from the character of local scenery. For example, in a hilly or mountainous area, the dwelling's roofline could be boldly varied with towers, gables, and pinnacles (fig. 3.4), but in a tamer terrain, a more subdued roofline was the better choice.

Grounds likewise should be laid out to enhance the harmony between the home and its setting. Like the house, they should respond to the character of the local environment. In a wild, wooded area, the landscape design could be strikingly picturesque with spired conifers in irregular

FIG. 3.4. Design XXXII, "A Lake or River Villa," from A. J. Downing, *The Architecture of Country Houses* (1850), p. 342. Downing describes this design as suitable for the wild, picturesque scenery of the Hudson Highlands, where its irregular roofline would echo the broken, hilly terrain.

groupings, occasional thickets, and bare outcroppings of rock (fig. 3.5). In a more settled, domesticated area, the landscaping should tend towards softer, rounder, more manicured forms (fig. 3.6). In keeping with the well-known advice of the English poet Alexander Pope, who urged landscape gardeners to "consult the genius of the place," Downing advised the purchaser of a country home to carefully study the existing advantages of its site, and to preserve as many of its surface features and well-developed trees as possible.[49] For those amateur landscape gardeners seeking inspiration beyond the plans in his books, Downing recommended consulting God's own creation. On their country walks and drives, they should observe the majestic grouping of trees, the intricate thickets, and the sunny expanses of open meadows composed by nature's own hand.

FIG. 3.5. A landscape design suitable for bold scenery, from A. J. Downing, *A Treatise on the Theory and Practice of Landscape Gardening adapted to North America*, fifth edition (New York: G. P. Putnam & Co., 1853), p. 273.

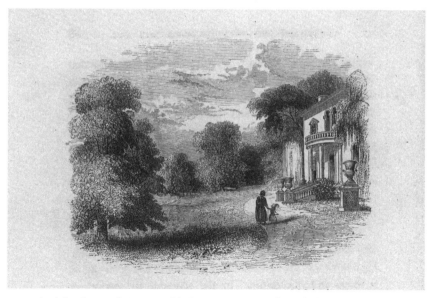

FIG. 3.6. A landscape design suitable for tame scenery, from A. J. Downing, *A Treatise on the Theory and Practice of Landscape Gardening adapted to North America*, fifth edition (New York: G. P. Putnam & Co., 1853), p. 273.

For a country residence to exert its proper moral and spiritual influence, Downing advised, both house and grounds should be designed to enhance the inhabitants' appreciation and enjoyment of their rural setting and entice them to spend time out of doors. Grounds should be arranged to take advantage of any attractive views, and the home's windows should be disposed to look out over them. In the ideal country house, verandas, terraces, and balconies offered comfortable places to sit and enjoy the home's lawns and gardens. Sweet-smelling shrubs, planted near the house where their odors could waft through open windows, enticed the inhabitants onto the grounds, and gently curving graveled walks drew them out further to explore its more distant corners. The more time the family spent in the open air, discovering the beauties of natural forms and tending their gardens, the greater would be their understanding and appreciation of God's works and their attachment to their home.

Those who engaged in rural improvement, Downing argued, could consider themselves public benefactors, for when a man's neighbors saw his beautified home and grounds, their competitive and emulative instincts would be aroused and they would exert themselves to improve their own homes. A true benefactor, however, would extend his concerns beyond his own homestead. He would campaign for the improvement of his entire neighborhood, as Downing did in his hometown of Newburgh, New York. He would see that trees were planted, roads tended, and pigs and chickens banned from the village streets. When villagers saw graceful elms arching over clean roads and neat homes set into well-tended gardens, their affection for their hometowns would increase, and they would be more disposed to "settle" there. Furthermore, following the logic of environmental influence, such a pleasant town would induce "order, good character, and virtuous deportment . . . in the lives and daily conduct of its people."[50] Rural improvement thus had the potential to exert a political influence, affecting the moral health not only of individuals, but of communities, and even the entire nation.

Ann Douglas, in *The Feminization of American Culture*, indicts middle-class white Protestant women and ministers for the sentimentalization of American culture between 1820 and 1875.[51] Yet the sentimentalization of architecture, landscape gardening, and horticulture—in the antebellum era at least—seems to have been largely the work of men, and men who

were, in many cases, members of the intellectual, social and, sometimes, economic elite. Downing was the most prominent of these—his books selling out in edition after edition—but he was joined by countless others. Dozens of architects and architectural writers chose to follow Downing's example in producing house-pattern books that promoted sentimentalist agendas. Such books include Gervase Wheeler's *Homes for the People* (1855), Oliver Smith's *The Domestic Architect* (1852), and *Village and Farm Cottages* (1856) by Henry Cleaveland, William Backus, and Samuel D. Backus. Journals such as *The New Englander, The North American Review, The Knickerbocker,* and *The United States Magazine and Democratic Review* published glowing reviews of Downing's work and endorsed his sentimental approach. Publishers of agricultural journals (all of them male) also took part, reproducing Downing's plans, along with their sentimentalist rationales. These journals disseminated Downing's ideas across the country. The editor of the *Ohio Cultivator,* for example, urged his subscribers to read Downing's books and to engage their children in the embellishment of their dwellings so that the children would grow up with a true "love of home."[52] *The Southern Planter* (published in Richmond, Virginia) echoed these sentiments, advising readers who were about to build a home to consult Downing's books so that they could erect "a fit temple in which to enshrine those holy domestic ties which are the boast and the happiness of our people."[53] The article is illustrated with a design for an "ornamental farm house" borrowed from Downing's *Cottage Residences* (fig. 3.7).

Women, of course, took part in this enterprise. Beginning in 1846, *Godey's Lady's Book,* under the editorship of Sarah Hale, published hundreds of house patterns, some of them lifted directly from Downing's books.[54] As the most widely circulated magazine in the antebellum United States (with 150,000 subscribers in 1860), it introduced sentimental domestic architecture to a nationwide readership of women.[55] Women also unquestionably read Downing's books, along with the journals mentioned above. In 1856 a subscriber to *The Horticulturist* wrote the editor: "I have a friend so well versed in Downing's writings that her husband says his sayings are household words—oracles not to be disputed."[56] When Mrs. Matilda W. Howard submitted a design for a farmhouse to a competition sponsored by the New York State Agricultural Society in 1848, she

FIG. 3.7. Design for "An Ornamental Farm House," from A. J. Downing, *Cottage Residences* (1842), as reproduced in *The Southern Planter* (July 1844), p. 157.

borrowed it, with only a few alterations, from one in Downing's *Cottage Residences.*[57]

Antebellum women also published architectural treatises, although these are, perhaps surprisingly, far more free of sentimental rhetoric than the works of Downing and his male followers. Catherine Beecher's best-selling *Treatise on Domestic Economy* (1841) offers house plans, but her discussion of these plans focuses on the convenience of their layouts, not on their potential impact on "the heart." Her overarching ambition was not to heighten "domestic feeling," but to professionalize women's housework, set it on a more scientific footing, and arrange the home so that it could be more conveniently executed. (Beecher would adopt a more sentimentalized view of domestic life in *The American Woman's Home*, which she co-wrote with her sister Harriet Beecher Stowe, but it was not published until 1869, after the Civil War.) Louisa Tuthill's volumes on architectural history, such as her *History of Architecture from Earliest Times* (1848), also indulge little in sentimental rhetoric.

Antebellum women writing in other genres, such as fiction, adopted a

wide range of stances on domesticity—not all of them, by any means, sentimental. Conversely, authors, both male and female, could be sentimental without embracing domesticity. Some writers celebrated women's home-based "influence," especially their role as Christian nurturers, and exalted the home as the central site for the cultivation of the affections. Others offered devastating critiques of domesticity, often exposing women's physical and economic vulnerability in a society that allowed them so little legal and financial autonomy; still others presented inspiring stories of women achieving success beyond the confines of the domestic sphere.[58] In a particularly interesting article about *Godey's Lady's Book,* Laura McCall has shown that, in the fiction published by the magazine between 1830 and 1860, only about a quarter of the female characters found home-life to be emotionally satisfying.[59] Such close examination of antebellum women's writings suggests that these authors were at least as likely to critique, reject, or offer alternatives to women's sentimentalized role as "angels of the home" as they were to embrace and endorse it.

Downing promoted a number of women authors who addressed domestic and horticultural topics. Of these, none offered an image of home as idealized as his or adopted a language as full of sentiment. Susan Cooper's *Rural Hours* (1850) and Alice Cary's *Clovernook, or Recollections of our Neighborhood in the West* (1852), both praised by Downing in the pages of *The Horticulturist,* were among the most popular books about rural life written in the antebellum era.[60] Cooper's book, a journal of a year spent living in the country, records with precise naturalistic detail the changes she observed in the natural world as the seasons turned. Much influenced by Downing, Cooper follows him in presenting rural life as an antidote to the fevered political passions and frenzied commercial speculations of the era. She celebrates the spiritual influence of nature, and advocates gardening as "a civilizing and improving occupation" that makes people more generous, "more industrious, and more amiable." Her language, however, is, for the most part, grounded in natural history rather than in domestic sentiment.[61] Cary's *Clovernook,* a series of short stories set in rustic Ohio, extols the Christian faith, appreciation for nature's beauties, and loving family bonds that sustain her characters, yet she also vividly evokes the hardships and deprivations of their rural lives. Besides Cooper and Cary's books, Downing also recommended to his readers Jane Loudon's *Gar-*

dening for Ladies (London, 1840). This volume, as free from sentimental rhetoric as Beecher's *Domestic Economy*, offers straightforward, practical advice on topics ranging from how to hold a hoe to the proper application of manure.

Downing applauded the work of these female authors and urged his readers to purchase their books. His constant lament was that so few American women took an active interest in architecture and horticulture. To his friend the Swedish author Fredrika Bremer, he expressed his wish "that the taste for rural science and occupations would more and more be cultivated by the women of America."[62] Indeed in 1843 he edited an American edition of Loudon's *Gardening for Ladies* in hopes of enticing more of his countrywomen to take up horticultural pursuits.[63]

While women played a part in formulating and disseminating a sentimental domestic architecture and landscape gardening, men were its most significant authors and its most prominent promoters. They were also meant to be its major beneficiaries. Their more direct engagement with commerce and manufacturing supposedly placed men in greater danger than women of having their ambitions swollen, their hearts hardened, and their characters sharpened by the "ambitious strifes and competitions" of the business world.[64] They were thus more in need of the softening influences offered by a rural or suburban home. Downing once described his overarching ambition as bringing "men back to their better feelings."[65] Susan Cooper, acknowledging the ameliorating influence that horticulture could have on the male character, remarked, "Persuade a careless indolent man to take an interest in his garden, and his reformation has begun."[66]

Underlying these ambitions to soften the hearts of men was a particular ideal of American manhood, one that seems to have been embraced by a significant percentage of the northeastern intellectual elite, but one that also competed with other ideals of masculinity in the antebellum era. This ideal man was to combine strength, industriousness, independence, and self-reliance with a tender heart and a sympathetic understanding. In 1855 a writer for the *Christian Examiner* extolled rural life and horticultural pursuits for making men "more manly and yet more gentle."[67] Indeed a number of nineteenth-century authors—both male and female—cast the landscape gardener as the new beau ideal of the American man. In Louisa Tuthill's novel *True Manliness; or, the Landscape Gardener*, the central char-

acter Clarence Rose is transformed from a spoiled, selfish, effeminate boy into a strong, independent, hard-working man through his discovery of a career in landscape gardening.[68] Caring for plants instills in him a tender regard for fragile life that he is able to transfer into newly sympathetic human relationships. The landscape gardener seems to have been an elite counterpart to the ideal of the yeoman farmer—that somewhat boorish democratic hero of the Jacksonian era.[69] Like the farmer, the landscape gardener grew physically strong and healthy from his work out of doors, yet he was more distanced from the world of commerce since his aim was not the production of crops for profit but the production of beauty. He was a man of refined, educated taste and tender sentiments—a man like Downing.

Focusing on Downing allows us to examine (and contribute to revisions of) a number of long-standing assumptions about the antebellum era. Twentieth-century historians wrote extensively about the gradual bifurcation of home and work over the course of the nineteenth century, as home manufacture receded into the past, and as men increasingly spent their days at the factory or office, while women remained at home caring for children.[70] With this shift, the home was increasingly cast as a place of emotional refuge for men, while for women it remained their primary workplace. This gender-bifurcated vision of the domestic realm offers an explanation for why male architectural writers such as Downing tended to sentimentalize the home more than women writers such as Beecher and Tuthill.

Yet in recent years scholars have questioned how broadly or deeply this gendered division of home and work ran, suggesting that it was a phenomenon confined primarily to the white middle classes of the urban northeast.[71] Downing belongs to this latter group and yet even in his case it is difficult to tell how much he was aware of or responding to these changes. In his writings, he once or twice mentions the advantages of the new transportation systems (steamboats and railroads) that were allowing more and more families to live in the country—presumably because of the ease with which men could get to the city to work—but in discussing his designs for dwellings he rarely assumes that the male head of household will be working elsewhere and he never casts the home as primarily women's domain. Moreover, his own home and work were never divided. He grew up in a house on the grounds of his family's nursery business in

Newburgh, New York. Later, when he launched his own career, he built a house on the same grounds, and he worked from his study until he added an architectural office to his house in 1850. His circle of friends and acquaintances in the Hudson River Valley was composed largely of writers, architects, artists, and retired men of wealth, many of whom worked from their home-based studios, libraries, and studies. In envisioning the audience for his writings, Downing probably imagined such men, as well as, more broadly, all those who lived in or hoped to live in the country. At the time he was writing, more than half the population of the United States still lived on farms where the division between work life and domestic life had yet to be strongly felt. So from Downing's perspective, the sentimentalized landscape of the country home would be able to exert its uplifting influence over all—regardless of age or gender. Male and female, as well as young and old, would feel its softening and exalting power.

From at least the 1940s until very recent years, it has been commonplace in academic discussions of antebellum art and literature to assume a tripartite union of the sentimental, the domestic, and the feminine.[72] When two of the factors are present, the third usually has been assumed. Again, Downing's work and that of other architectural writers of his era suggests that we should rethink this equation. Downing unites the sentimental and the domestic, yet the feminine is not a crucial part of his formulations. The sentimentalized home is never, in his writings—at least never exclusively or even principally—a feminine realm. He certainly recognized certain gendered divisions of labor and space. He assumed, for example, that women would oversee the kitchen. He would also describe a mother and her daughters gathering in the parlor or family room after their chores were done (although he also envisioned the father and sons joining them when they completed their day's work). He hoped that women would care for the home's flower gardens and vine drapery, while he assigned the care of the rest of the home's grounds, including the kitchen garden and orchard, to the male members of the family. Yet the house as a whole remained consistently the domain of the entire family—ungendered. At the heart of his vision of the home lay an ideal of companionate family relations—of family members working together to beautify their home and embellish its grounds. To him, the dwelling place was always the "family home."

By the opening years of the twentieth century, sentimentality had become feminized, commercialized, and, at least in elite intellectual circles, despised. In the antebellum era, however, it was widely valorized for its elevating moral and social influence, and its gendering was very much in flux. Both men and women were deeply engaged with sentimental culture. A soft and sympathetic heart could be considered a positive male as well as female attribute. Women were producing more and more of the nation's sentimental fiction, yet in other fields sentimental production was the province of men. This was certainly the case with domestic architecture and landscape gardening, which were both exclusively male professions until the late nineteenth century. Downing, along with many other architects and landscape gardeners of his time, unembarrassedly (and I believe sincerely) promoted sentimental ideologies in their work, popularizing a sentimental domestic landscape that, their writings suggest, they conceived as neither masculine nor feminine. In the antebellum era, the sentimental was, in domestic architecture and horticulture at least, yet an ungendered domain.

Notes

I wish to thank my generous friends and colleagues—Peter Fergusson, Wendy Greenhouse, Janet Headley, Martha McNamara, James F. O'Gorman, Jay Panetta, and John Rhodes—for their help with this essay.

1. Shirley Samuels, ed., *The Culture of Sentiment: Race, Gender and Sentimentality in Nineteenth-Century America* (New York: Oxford University Press, 1992), 4.

2. In defining the sentimental (and sentimentality) as I do here, I am seeking to avoid the judgmental connotations and denotations that have attached themselves to these words at various points since they came into common use in the eighteenth century. In this, I am following the lead of June Howard, "What is Sentimentality?" *American Literary History* 11 (Spring 1999): 63–81.

3. Andrew Jackson Downing, *The Architecture of Country Houses* (New York: Dover Publications, 1969; reprint from the 1850 edition), xx. The most essential sources for the study of Downing's ideas are his own writings, especially *The Architecture of Country Houses, A Treatise on the Theory and Practice of Landscape Gardening adapted to North America* (New York: Wiley & Putnam, 1841; hereafter, *Landscape Gardening*), *Cottage Residences* (New York: Wiley & Putnam, 1842), and his editorials for *The Horticulturist,* most of which were collected in *Rural Essays* (New York: George A. Leavitt, 1969; University of Michigan Historical Reprint Series; first

published in 1853). Important secondary sources include Clifford Edward Clark, Jr., *The American Family Home, 1800–1960* (Chapel Hill: The University of North Carolina Press, 1986); John Conron, "The American Dream Houses of Andrew Jackson Downing," *Canadian Review of American Studies* 18 (1987): 9–40; Arthur Channing Downs, *Downing and the American House* (Newton Square, PA: Downing & Vaux Society, 1988); David P. Handlin, *The American Home: Architecture and Society, 1815–1915* (Boston; Little, Brown and Co., 1979); Rochelle L. Johnson, *Passions for Nature: Nineteenth-Century America's Aesthetics of Alienation* (Athens: University of Georgia Press, 2009); Judith K. Major, *To Live in the New World: A. J. Downing and American Landscape Gardening* (Cambridge, MA: The MIT Press, 1997); David Schuyler, *Apostle of Taste: Andrew Jackson Downing, 1815–1852* (Baltimore: The Johns Hopkins University Press, 1996); Vincent J. Scully, Jr., "Romantic Rationalism and the Expression of Structure in Wood: Downing, Wheeler, Gardner, and the 'Stick Style,' 1840–1876," *The Art Bulletin* 35 (June 1953): 121–42; Adam W. Sweeting, *Reading Houses and Building Books: Andrew Jackson Downing and the Architecture of Popular Antebellum Literature, 1835–1855* (Hanover, NH: University Press of New England, 1996); George B. Tatum, *Andrew Jackson Downing, Arbiter of American Taste, 1815–1852* (PhD dissertation, Princeton University, 1949); George B. Tatum and Elisabeth Blair MacDougall, eds., *Prophet with Honor: The Career of Andrew Jackson Downing, 1815–1852* (Washington, DC: Dumbarton Oaks, 1989).

 4. Mary Chapman and Glenn Hendler, eds., *Sentimental Men: Masculinity and the Politics of Affect in American Culture* (Berkeley: University of California Press, 1999), 3.

 5. Washington Irving, "The Legend of Sleepy Hollow," *The Sketch Book of Geoffrey Crayon, Gent.* (1819–20); Downing was both an acquaintance and a great admirer of Irving. He mentions Irving numerous times in his writings, and included a wood engraving and appreciative description of Irving's home, Sunnyside, in his *Landscape Gardening* (1841). In his discussion of Sunnyside, Downing notes that it was the model for the home of Baltus Van Tassel in "The Legend of Sleepy Hollow" and describes the tale as "delightfully told" (p. 379). On Downing's relationship with Irving, see Sweeting, *Reading Houses and Building Books*, especially 7–8, 133–139.

 6. James F. W. Johnston, *Notes on North America: Agricultural, Economical, and Social* (Edinburgh: William Blackwood, 1851), 1:162, qtd. in Sarah Burns, *Pastoral Inventions: Rural Life in Nineteenth Century American Art and Culture* (Philadelphia: Temple University Press, 1989), 51.

 7. J. H. Hammond, *The Farmer's and Mechanic's Practical Architect* (Boston: John P. Jewett and Co., 1858), 27, qtd. in Clifford Edward Clark, Jr., *The American Family Home, 1800–1960* (Chapel Hill: The University of North Carolina Press, 1986), 23.

 8. *Rural Essays*, 294, 14.

9. *Rural Essays,* 15.

10. "Home expression" and "moral influence" are phrases that Downing uses repeatedly. He discusses his ideas about "home expression" at some length in "On the English Rural Cottage," *The Horticulturist* 2 (August 1847): 66–67.

11. *Landscape Gardening,* fifth edition (New York: G. P. Putnam & Co., 1853), ix. Italicized emphasis in original.

12. *Architecture of Country Houses,* 263. Although the quoted passages refer specifically to a villa for a "man of feeling," Downing makes very similar remarks about farmhouses, cottages, and other types of homes. See, for example, *Cottage Residences,* 82.

13. In the more than two dozen British pattern books that I read, I found only one passage comparable to Downing's in its sentimentalized references to the home. Edmund Bartell, in his *Hints for Picturesque Improvements in Ornamented Cottages* (London: J. Taylor, Architectural Library, 1804), writes: "Perhaps, of all situations, the romantic retirement of a rural cottage is likely to produce the highest and most refined relish for social happiness: 'True and social happiness,' says Zimmerman, 'resides only in the bosom of love, or in the arms of friendship; and can only be really enjoyed by congenial hearts and kindred minds in the domestic bowers of privacy and retirement'" (ix–x).

14. James Malton, *An Essay on British Cottage Architecture, Being an Attempt to Perpetuate on Principle, that Peculiar Mode of Building, which was Originally the Effect of Chance* (London: Hookham and Carpenter, 1798), 6–7.

15. See, for example, Edmund Bartell, *Hints for Picturesque Improvements in Ornamented Cottages* (London: J. Taylor, Architectural Library, 1804); Richard Elsam, *Hints for Improving the Condition of the Peasantry* (London: R. Ackerman, 1816); John Buonarotti Papworth, *Rural Residences,* second edition (London: R. Ackermann, 1832).

16. J. C. Loudon, *An Encyclopedia of Cottage, Farm, and Villa Architecture and Furniture* (London: Longman, Rees, Orme, Brown, Green, & Longman, 1835), 1112–13.

17. J. C. Loudon, *The Suburban Gardener and Villa Companion* (London: Longman, Orme, Brown, Green, and Longmans, 1838; reprint New York: Garland Publishing, 1982), 8–9.

18. Schuyler, *Apostle of Taste,* 39.

19. A search for the word *home* in the online databases *American Historical Newspapers* and *American Periodical Series* for the period from 1810 to 1860 yields literally thousands of entries. I read hundreds of poems, short stories, sermons, and essays on the subject of home, but will refrain from listing them here. A few examples of poems that depict the idealized home as a vine-covered rural cottage include, "The Cotter's Home," *The Amaranth; or Masonic Garland* 1 (June 1828): 85; "The Home of the Heart," *The Knickerbocker; or New York Monthly Magazine* 6 (November 1835):

400; "My Cottage Home," *The Genesee Farmer and Gardener's Journal* 7 (22 April 1837): 128. In Payne's song the home is a thatched roof cottage.

20. "The Horticultural Festival at Faneuil Hall, Boston," *The Horticulturist* 3 (November 1848): 224–30.

21. Downing discusses the two images in "Rural Architecture—Suburban Cottages," *The Horticulturist* 2 (December 1847): 272–73.

22. *Architecture of Country Houses*, 113.

23. *Architecture of Country Houses*, 49–52. Downing considered board-and-batten construction more truthful because it visually expressed the vertical orientation of the main timbers of the house.

24. *Cottage Residences*, 14.

25. *Cottage Residences*, 14; "Rural Architecture—Suburban Cottages," 273.

26. *Cottage Residences*, 12; *Landscape Gardening*, 374.

27. Downing illustrates and discusses this pair of images in *Architecture of Country Houses*, 78–81.

28. *Rural Essays*, 514.

29. *Architecture of Country Houses*, 79.

30. *Rural Essays*, 90.

31. *Architecture of Country Houses*, 79.

32. *Rural Essays*, 89.

33. *Cottage Residences*, 82.

34. "Major Patrick's Address before the Jefferson County Agricultural Society," approvingly quoted by Downing in *The Horticulturist* (January 1852); see *Rural Essays*, 399–403.

35. Gervase Wheeler, *Homes for the People in Suburb and Country; The Villa, The Mansion, and The Cottage* (New York: Charles Scribner, 1855; reprint New York: Arno Press, 1972), 302.

36. John Locke, *Some Thoughts Concerning Education and Of the Conduct of the Understanding*, edited by Ruth W. Grant and Nathan Tarcov (Indianapolis: Hackett Publishing Co., 1996), 10. On Locke's impact on American ideas about childhood and family, see Jay Fliegelman, *Prodigals and Pilgrims: The American Revolution against Patriarchal Authority, 1750–1800* (Cambridge: Cambridge University Press, 1982).

37. [N. H. Eggleston], "Domestic Architecture," *New Englander* 9 (February 1851): 59.

38. "Rural Architecture: Design for Improving an Ordinary Country House," *The Horticulturist* 1 (July 1846): 14.

39. [Eggleston], "Domestic Architecture," 59.

40. Wheeler, *Homes for the People in Suburb and Country*, 331.

41. [Eggleston], "Domestic Architecture," 60.

42. *Manual of Politeness, Comprising the principles of etiquette, and rules of behavior in genteel society, for persons of both sexes* (Philadelphia, 1842), qtd. in Wendy J. Katz, "Lilly Martin Spencer and the Art of Refinement," *American Studies* 42.1 (Spring 2001): 9.

43. On the intersecting discourses of sentimentalism, refinement, and social reform in the antebellum era, see Wendy Jean Katz, *Regionalism and Reform: Art and Class Formation in Antebellum Cincinnati* (Columbus: Ohio State University Press, 2002); Clifford Edward Clark, Jr., *The American Family Home, 1800–1960* (Chapel Hill: The University of North Carolina Press, 1986).

44. *Rural Essays,* III.

45. *Architecture of Country Houses,* 258.

46. *Rural Essays,* 410.

47. "Landscape Gardening and Rural Architecture in America," *United States Magazine and Democratic Review,* n.s. 16 (April 1845): 348–64.

48. "On the Color of Country Houses," *The Horticulturist* 1 (May 1847): 491.

49. Pope's words are from his *Epistle to Lord Burlington* (1731). Pope's ideas about landscape gardening were well known to Downing, who discusses and quotes Pope in his *Landscape Gardening* (1841), pp. 16, 50. See Major, *To Live in the New World,* 40–42.

50. "The Improvement of Country Villages," *Rural Essays,* 230.

51. Ann Douglas, *The Feminization of American Culture* (New York: Alfred A. Knopf, 1977).

52. "Home Education and Home Influence," *Ohio Cultivator* 8 (April 1, 1852): 107–8.

53. "An Ornamental Farm House," *Southern Planter* 4 (July 1844): 157–58.

54. On *Godey's* model house plans, see George L. Hersey, "*Godey's* Choice," *Journal of the Society of Architectural Historians* 18 (October 1959): 104–11.

55. I should qualify this by noting that, in the 1840s, the majority of the house designs reproduced in *Godey's* were borrowed from British publications such as those by John Claudius Loudon. Most consist of simple line drawings with no indication of plantings. The text is limited to straightforward descriptions of construction and room function. Although many of the designs present the projecting eaves and ornamental chimneys that were central to Downing's sentimental domestic architecture, no sentimental rationales inflect the readers' understanding of the designs as they do in Downing's publications.

56. Qtd. in Tatum, *Andrew Jackson Downing,* 37–38.

57. Schuyler, *Apostle of Taste,* 114–16. Schuyler reproduces Mrs. Howard's submission along with Downing's Design V, from which it was copied.

58. The literature on nineteenth-century American women's domestic fiction is vast. Important works include Samuels, *The Culture of Sentiment;* Jane Tompkins,

Sentimental Designs: The Cultural Work of American Fiction, 1790–1860 (New York: Oxford University Press, 1985); Lora Romero, *Home Fronts: Domesticity and Its Critics in the Antebellum United States* (Durham: Duke University Press, 1997), Mary P. Ryan, *The Empire of the Mother: American Writing about Domesticity, 1830–1860* (New York: Harrington Park, 1985); Nina Baym, *Woman's Fiction: A Guide to Novels by and about Women in America, 1820–70* (Urbana: University of Illinois Press, 1993). On men's participation in this genre, see Chapman and Hendler, eds., *Sentimental Men*, and Thomas N. Baker, *Sentiment and Celebrity: Nathaniel Parker Willis and the Trials of Literary Fame* (New York: Oxford University Press, 1999).

59. Laura McCall, "'The Reign of Brute Force Is Now Over': A Content Analysis of *Godey's Lady's Book*, 1830–1860," *Journal of the Early Republic* 9 (Summer 1989): 217–36.

60. Review of *Rural Hours, The Horticulturist* 5 (October 1850): 230–32; review of "*Clovernook, or Recollections of our Neighborhood in the West* by Alice Carey [sic]," *The Horticulturist* 7 (April 1852): 182–88.

61. Susan Fenimore Cooper, *Rural Hours* (New York: George P. Putnam, 1850), 131. On Cooper's and Downing's differing approaches to nature, see Johnson, *Passions for Nature*.

62. Adolph V. Benson, "Fredrika Bremer's Unpublished Letters to the Downings," *Scandinavian Studies and Notes* 11 (November 1931): 264–74.

63. See, "Preface to the American Edition," [Jane] Loudon, *Gardening for Ladies; and Companion to the Flower Garden*, edited by A. J. Downing, first American from the third London edition (New York: Wiley and Putnam, 1843).

64. "Landscape Gardening and Rural Architecture in America," *United States Magazine and Democratic Review*, n.s. 16 (April 1845): 348–64.

65. *Rural Essays*, 304.

66. Cooper, *Rural Hours*, 116.

67. H.W.S.C., "Landscape Gardening," *Christian Examiner and Religious Miscellany* 58 (May 1855): 386.

68. Louisa Tuthill, *True Manliness; or, The Landscape Gardener* (Boston: Crosby and Ainsworth, 1867).

69. On nineteenth-century images of the farmer, both positive and negative, see Burns, *Pastoral Inventions*, especially chapters 5 and 6.

70. Charles Sellers, *The Market Revolution: Jacksonian America, 1815–1846* (New York: Oxford University Press, 1991) is one of the most important works on this subject.

71. See, for example, Scott C. Martin, ed., *Cultural Change and the Market Revolution in America, 1789–1860* (Lanham, MD: Rowman & Littlefield, 2005); Cathy N. Davidson and Jessamyn Hatcher, eds., *No More Separate Spheres!* (Durham: Duke University Press, 2002).

72. See, for example, Herbert Ross Brown, *The Sentimental Novel in America* (Durham: Duke University Press, 1940), Ann Douglas, *The Feminization of American Culture,* and much feminist scholarship from the 1960s onward about antebellum women's writing, including Baym, *Woman's Fiction*, and Samuels, *The Culture of Sentiment.* On recent challenges to the equation of sentimentality, domesticity, and femininity, see Chapman and Hendler, eds., *Sentimental Men,* and Davidson and Hatcher, eds., *No More Separate Spheres!*

The aestheticism of the nineteenth century cannot be understood internally . . .
but only in relation to its real basis in social conflicts.—Theodor Adorno[1]

Rethinking "Luminism"

Taste, Class, and Aestheticizing Tendencies in Mid-Nineteenth-Century American Landscape Painting

Since the late 1960s, historians of American art have debated the applicability of the term Luminism to the work of such mid-nineteenth-century artists as Fitz Henry Lane, Martin Johnson Heade, John F. Kensett, and Sanford Robinson Gifford (fig. 4.1 and plate 10). The term and the concepts it represents remain current in certain quarters, for example, at the National Academy of Design Museum, which in 2006 mounted an ambitious exhibition called "Luminist Horizons," which featured the work of the New York painter James A. Suydam (1819–65).[2] Still, historians of American art are now almost unanimous in their rejection of the term. That rejection, however, takes a peculiar form: instead of omitting the term from their writings or attempting to substitute another, they surround it with scare quotes; or they preface it with the phrase "so-called"; or they employ both phrase and scare quotes. Thus we encounter such formulations as "so-called 'Luminism,'" and "so-called 'Luminist' painting." What these rhetorical tactics demonstrate, besides rejection as acceptance, is that the field of American art history cannot live with Luminism, and yet cannot live without it.

FIG. 4.1. (Plate 10.) Sanford Robinson Gifford, *The Palisades*, 1877, oil on canvas board, 5¹⁵⁄₁₆ × 11½ in. Williams College Museum of Art, Williamstown, Massachusetts, gift of Dr. and Mrs. Gifford Lloyd (78.24.2).

The term Luminism has been used to describe the work of Lane, Heade, Kensett, Gifford, and others for more than half a century, but only relatively recently have scholars begun to develop critical analyses of the term and the conceptual framework it represents. In *Empire of the Eye,* which appeared in 1993, Angela Miller argued that during the 1850s and 1860s a number of American landscapists, in particular Kensett and Gifford, redefined the sublime, as it had been understood by the leading painters of the Hudson River School, in effect employing a language of gender and sentimentalism that emphasized femininity.[3] A decade after the appearance of Miller's book, J. Gray Sweeney published a lengthy article in the *Oxford Art Journal* in which he detailed how, "the origins of luminism as an art-historical term were deeply entwined with the interests of elite collectors, prominent art dealers, influential curators, art historians, and constructions of national identity during the Cold War."[4] Any scholar who undertakes a critical assessment of Luminism owes a debt of gratitude to Miller and Sweeney. Yet their analyses, useful as they may be, do not go far enough. Miller's argument for the feminization of Hudson River School landscape painting operates primarily on the level of metaphor: it assumes, not unreasonably, that new artistic forms emerged in response to a changing cultural and political climate, but it fails to

examine underlying relations between the social and the aesthetic. In reviewing the history of Luminism, Sweeney offers much new information, but he barely hints at a new approach to his historical materials. Instead, he ends up arguing that fifty years of scholars' intensive research into the lives and works of luminist artists, along with the increased availability of source materials, allows us to study in greater depth the work of the artists in question—and has thus eliminated the need for labels like Luminism.[5] Still, art history as a discipline lives and dies by the label. Labels can be imprecise, distorting, tendentious. Once established, however, they are difficult if not impossible to eliminate or dislodge from the discourses of art history. The term Luminism, as Sweeney demonstrates, is especially problematic. Unlike *Impressionism, Fauvism, Cubism,* and *Hudson River School, Luminism* was invented nearly a century after the fact and therefore lacks the historical resonance of the other terms. Moreover, as will become evident, the term Luminism freezes or reifies a diffuse set of historical developments. These developments are, in my view, better described as "*aestheticizing tendencies*." Consequently, in what follows I use *Luminism* and *luminist* to indicate the beliefs of art historians and critics who have employed, or continue to employ, these terms, and reserve *aestheticizing tendencies* to characterize the work of a number of landscapists active in New York in the period from 1840 to 1880.

Because my topic is large and my space limited, this essay can be little more than an outline of three interrelated arguments.[6] First, I maintain that however much their scholarship was distorted by nationalist belief, cold-war ideological imperatives, and collecting preferences, the early students of Luminism identified artistic tendencies or currents in mid-nineteenth-century American landscape painting that contrasted with, and in some respects stood in opposition to, the Hudson River School "mainstream," represented by the work of such artists as Frederic Church, Albert Bierstadt, and Thomas Moran. Second, I argue that the appearance of aestheticizing tendencies in American landscape painting in the period 1840–80 is inextricably bound up with the growth of New York City's bourgeois fractions, which, as Sven Beckert and other historians have shown, coalesced to form a unified bourgeois class or *bourgeoisie* in the years following the Civil War. My argument here mainly concerns the class's evolving cultural needs, especially its need to institutionalize

and thereby exert control over the definition of art. Third, I show that far from being an offshoot of the Hudson River School or a peripheral phenomenon, the aestheticizing tendencies under consideration originated within the school, and their appearance can be attributed to the contradictory needs and expectations of artists, patrons, and publics (none of these terms, I would add, can be separated from the issue of class). These tendencies represented a radical shift in meaning and artistic value. The growing popularity during the 1840s, 1850s, and 1860s of the painted sketch as well as more finished, small-scale landscapes anticipated the aesthetic exclusivity that increasingly defined fine or high art in the United States during the decades following the Civil War.

Inventing Luminism

John Baur, a pioneering curator at the Brooklyn Museum, was the first art historian to employ the term Luminism to describe the work of a group of mid-nineteenth-century American landscape painters. In an eight-page article that appeared in 1954 in a journal called *Perspectives USA,* Baur argued that "there is ample evidence that, to the artist, American light *looks* different from that of Europe," and that "long before the impressionists of the late nineteenth century, who are generally considered the official painters of light, a group of obscure American artists made this discovery and turned it to a quietly poetic use."[7] Because it proved authoritative for later scholars, Baur's argument deserves to be quoted at length:

> Technically [the American artists in question] were extreme realists, relying on infinitely subtle variations of tone and color to capture their magical effects. Spiritually they were lyrical poets of the American countryside and the most sensitive to its nuances of mood. In both respects they were quite different from their better remembered contemporaries of the Hudson River School, who were freer in their handling, more romantic in their compositions, and a little operatic in their celebrations of native scenery.[8]

Baur went on to assert that "Luminism reached its fullest expression during the 1850's and '60's, particularly in the work of two men, Fitz Hugh Lane and Martin J. Heade"—artists who would become virtually synonymous with Luminism.[9]

Baur's choice of the term Luminism might have seemed logical if it simply denoted the productions of artists preoccupied with the representation of light. But by choosing an "ism" to describe a diffuse set of stylistic trends and tendencies, Baur implied that Luminism stood on a more or less equal footing with the self-conscious European artistic movements of the period. The term Luminism suggested not only a style but a shared set of aesthetic doctrines and beliefs. As with other commonly used art-historical terms such as Realism and Impressionism, terminological confusion proved inevitable. Luminism as a style became Luminism as an artistic movement, and eventually Luminism as the epitome of what was at the time often called "the Americanness of American art"—a development Baur may not have entirely anticipated but that followed almost inevitably from the logic of his argument, which was grounded in his long-standing attempt to define uniquely American traits. While Baur described Luminism as "a neglected aspect of the Realist Movement in nineteenth-century American painting," this did not prevent him from asserting that "the main and the peculiarly native line of luminism's development in America led directly from the descriptive realism of Heade and Lane to the visual realism of [Winslow] Homer."[10]

Many of the ideas Baur set forth in his 1954 essay had appeared five years earlier in a text he wrote for the catalog for the M. and M. Karolik collection of American art.[11] In 1928, Maxim Karolik, a Rumanian immigrant, a singer by profession, and an orthodox Jew, married Martha Codman, a Boston Brahmin descended from Amorys, Pickmans, and Derbys.[12] With Codman's fortune in hand and working in association with the staff of the Boston Museum of Fine Arts, between 1945 and 1948 Karolik assembled a collection of American painting of the period 1815–65, which he and his wife passed directly to the museum. Carol Troyen has observed that an "egalitarian attitude became the impetus for [Maxim Karolik] to form his . . . collection," which included the work of outsider artists as well as that of artists who are well known today but were obscure or half-forgotten at the time.[13] The collection contained paintings by such Hudson River School stalwarts as Thomas Cole, Asher B. Durand, Frederic Church, Albert Bierstadt, and Worthington Whitredge, although Karolik had no liking for what he considered the Victorian "grandiloquence" of the Hudson River School.[14] The collection also featured twenty-five

works by Heade and eight by Lane. As Sweeney remarks, "Heade's elevated reputation today is profoundly entwined with the development of Karolik's collection."[15] Something similar might be said about Lane. In 1951, Karolik wrote Baur, "I have a coordinated Heade and Lane plan."[16] Three years later, in 1954, Knoedler Galleries in New York mounted a show called "Commemorative Exhibition of Lane and Heade from the Karolik Collections."[17]

The ideas Baur developed for "American Luminism" deeply influenced the next generation of Americanists. As doctoral students at Harvard in the 1950s and early 1960s, Barbara Novak, Theodore Stebbins, and John Wilmerding became closely familiar with the paintings in the Karolik collection, and went on to devote a major portion of their careers to the study of Luminism. Perhaps more by accident than by design, a division of labor was established. Wilmerding specialized in Lane and, over the course of a long career, wrote two books on the artist; in 1988, he organized a major retrospective that was seen at the National Gallery and the Boston Museum of Fine Arts.[18] Stebbins focused on Heade, producing two exhibitions—the more recent was at the Boston Museum of Fine Arts and the National Gallery in 1999—and a catalogue raisonné.[19] Novak was in effect the theoretician of the group. In *American Painting of the Nineteenth Century*, which appeared in 1969, Novak located Luminism at the center of the history of American art. *American Painting of the Nineteenth Century* massively expanded Baur's Luminism project.[20] As Novak wrote in her preface, her primary purpose was, "to isolate . . . certain characteristics in American art that we can with some degree of confidence denote as American."[21] She acknowledged the influence of European art, observed that the history of American painting comprised many traditions, and attempted to develop an analytical vocabulary from sources ranging from the nineteenth-century American critic James Jackson Jarves, a favorite of Baur's, to Heinrich Wölfflin. In *American Painting of the Nineteenth Century*, American art is characterized not only in terms of the real and the ideal, à la Jarves, but also in terms of a stylistic pathology in which Americanness falls on the side of the classical, the linear, and the planar in Wölfflin's cyclical scheme, and is often associated with the primitive.[22] Almost all of Novak's chapters focus on individual artists, beginning with John Singleton Copley and Washington Allston and

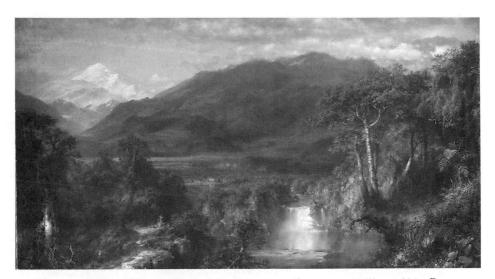

FIG. 4.2. Frederic Church, *Heart of the Andes*, 1859, oil on canvas, 66⅛ × 119¼ in. Bequest of Margaret E. Dows, 1909 (09.95). The Metropolitan Museum of Art, New York, NY. Image copyright © The Metropolitan Museum of Art / Art Resource, NY.

ending with Homer, Thomas Eakins, Albert Pinkham Ryder, and the still-life painter William Michael Harnett; however, a separate chapter is devoted to the topic of Luminism, and it is followed by chapters dedicated to Lane and Heade. The leading mid-century Hudson River School painters are barely mentioned, or rather their work is summarily dismissed as, among other things, "popular art."[23] Church's *Heart of the Andes* (fig. 4.2) is the only "popular" Hudson River School work illustrated, and it, along with the other "large, symphonic paintings" of the School, are characterized as so many instances of "a rhetoric of grandeur . . . that has to do with a domestication of a kind of Wagnerian titanism for democratic purposes."[24] By contrast, Novak celebrates Luminism as "one of the most truly indigenous styles in the history of American art, a way of seeing so intimately related to the artist's idea of world and his relation to it that it can be identified not only in landscape painting but also in still life, genre, and portraiture."[25]

American Painting of the Nineteenth Century represented a wholesale reconceptualization of the history of American art. Its thesis, although controversial when the book was published, proved highly influential during

the 1970s and 1980s, a time when interest in, and the market for, American art was skyrocketing.[26] In 1980, eleven years after the publication of Novak's book, John Wilmerding, by then curator of American art at the National Gallery, organized an exhibition that drew heavily upon Novak's work. Called "American Light: The Luminist Movement 1850–1875" (the exhibition's title perhaps a deliberate echo of Baur's earlier nationalist claims), it brought together more than 350 paintings and photographs. Predictably, "American Light" featured the work of Kensett, Gifford, Heade, and Lane (a detail of Lane's *Ships and an Approaching Storm Off Owl's Head, Maine* graced the exhibition catalog's cover, fig. 4.3), but it also expanded the Luminist canon to include Church, who was now celebrated as a painter of light, and whose recently rediscovered *Icebergs*, which had made a record price of $2.5 million at auction, was allotted a prominent place in the exhibition.[27] In his foreword to the massive catalog, J. Carter Brown, then the National Gallery's director, articulated the exhibition's underlying rationale: "Concentrating on a crucial period in the middle of the nineteenth century, ["American Light"] examines a style now called *luminism*, widely practiced by a number of fascinating figures only fully discovered in recent years."[28] Brown went on to say that Church, "the most crucial artist of the period . . . now emerges as the most technically able and original painter in America prior to Homer and Thomas Eakins."[29]

Essayists in the first part of the catalog sounded familiar themes. Resorting to *Zeitgeist* theory, Wilmerding wrote that Luminism's "crystalline pictures of the 1850s stand as supreme manifestations of Jacksonian optimism and expansiveness—along with America's belief in the transcendent beauty of nature."[30] In the catalog's opening essay, Novak, still preoccupied with the problem of definition, asked "Which paintings do we call *luminist* and which do we not?" and attempted to "establish a scale of priorities [sic] that must be discernable in a work before we can call it *luminist*."[31] Part two of the catalog, ambiguously titled "Oppositions & Balances: Collateral Views of Luminism," took a different tack. While not directly questioning the exhibition's premises, David Huntington, in an essay called "Church and Luminism: Light for America's Elect," made no argument for Church as a luminist—indeed, the word Luminism appears only in his essay's title.[32] Theodore Stebbins, Jr., dissociating himself somewhat from Wilmerding and Novak, argued that luminist paint-

American Light

THE LUMINIST MOVEMENT ❧ 1850-1875

FIG. 4.3. Cover of *American Light*, edited by John Wilmerding, with a detail of Fitz Henry Lane's *Ships and an Approaching Storm Off Owl's Head, Maine.* © 1989 Board of Trustees, National Gallery of Art, Washington, DC. Reprinted with permission of Princeton University Press.

ings "are far from typical of the art of their time in America," questioned whether Luminism could be understood as a purely national style, and drew parallels between American luminist painting and the work of such nineteenth-century Europeans as Casper David Friedrich, Edward Lear, Christian Ekersberg, and Christian Købke.[33]

"American Light" thus represented a turning point. While celebrating Luminism as *the* quintessentially American style, it also set the stage for the now nearly total scholarly rejection of the term. Today, thirty years after "American Light," it is necessary to ask what, if anything, remains of Luminism as a stylistic category or art-historical concept. Of course, the discovery of Lane, Heade, and other half-forgotten mid-nineteenth-century American artists can only be counted a plus. Nonetheless, the

historian of American art will want to see these artists in historical perspective. As should be clear, Baur, Novak, and Wilmerding exaggerated the art-historical importance of Luminism and overstated the historical significance of Lane and Heade. Lane was, after all, a provincial artist working in the marine painting tradition, who was mainly unknown outside of the Boston area.[34] Heade, a friend of Church, played a minor role in the New York art world of the 1860s. A gifted painter often overlooked by his contemporaries, Heade ended his career as an artist-in-residence at a Florida hotel, where he specialized in flower painting.[35] Nonetheless, using methods associated with formal analysis, Baur and the other early scholars of Luminism, identified, if somewhat obliquely, a hitherto unnoticed historical current or tendency.

To begin with the obvious, the paintings that interested them were small, especially compared to the outsized productions for which the Hudson River School was famous. Novak was correct in seeing Church's *Heart of the Andes* and other large works of the period as popular art, although she failed to draw out the implications of this insight.[36] In nineteenth-century America, a large painting was almost invariably intended to be seen by a large audience, and Church, Bierstadt, Moran, and other major Hudson River School painters, showmen all, created works calculated to appeal to a broad public. Small paintings presume a much more intimate relationship between viewer and work of art. It is also important to emphasize that the leading Hudson River School painters often chose subjects of immediate national significance: Niagara Falls, the Rocky Mountains, Yosemite, the Arctic, the Andes of Ecuador. Their "rhetoric of grandeur," linked as it was to belief in Manifest Destiny, was nothing if not deliberate. Durand, Gifford, and Kensett (fig. 4.4 and plate 11), by contrast, put relatively less emphasis on subject matter. What increasingly counted for them was the artist's sensibility—and ultimately the viewer's.

Institutionalizing High Art

The period 1840–80 witnessed the emergence of a bourgeoisie or national upper class. Rooted in New York City's mercantile elite of the first half of the nineteenth century, this class came to dominate American politics and the American economy during the epoch of what is sometimes called the second industrial revolution.[37] As Sven Beckert writes, after the Civil War

FIG. 4.4. (Plate 11.) John F. Kensett, *Long Neck Point from Contentment Island*, 1870–72, oil on canvas, 15⅜ × 24⅜ in. Carnegie Museum of Art, Pittsburgh; purchase; gift of the Women's Committee, 80.51. Photograph © 2010 Carnegie Museum of Art, Pittsburgh.

rapid industrialization deepened social cleavages, and the combined effects of rising inequality and proletarianization created tensions that . . . at times drove workers and farmers to mobilize collectively, in turn motivating upper-class New Yorkers to define themselves against these "dangerous classes." This greater sense of class identity, as well as the overcoming of the deep divisions that had characterized the age of the Civil War, enabled wealthy New Yorkers to translate their ever-growing economic power into unprecedented influence on the institutions and policies of the state.[38]

The relation between class formation and the art of the period played out first of all in the history of New York City's art institutions. I would emphasize that the creation of art institutions was not separate from, but an integral part of, the process. An overview of art institutions in the period from 1800 to 1865 reveals repeated, unsuccessful efforts to found institutions of high art.[39] To create such institutions, certain criteria had

to be met. In a study of the founding of the Boston Museum of Fine Arts and the Boston Symphony Orchestra, the sociologist Paul DiMaggio suggests that three interlocking factors had to be present in order to establish institutions of high culture in the United States: first, there had to be *elite entrepreneurship*, meaning the creation of organizational forms that the elite group or faction could control (these organizational forms were invariably corporate and nonprofit, thus insulating them from the market and to some extent from the state); second, *classification*, the erection of strong and clearly defined boundaries between art and entertainment, with the former appropriated by the elite as its own cultural property and, crucially, "the acknowledgment of that classification's legitimacy by other classes and the state"; and third, *framing*, the creation of "a new etiquette of appropriation, a new relationship between the audience and the work of art."[40]

The American Academy of Fine Arts, founded in 1802, was New York City's first art institution.[41] The second was the National Academy of Design, created in 1825 by artists fed up with the American Academy's indifference to their needs, and intending to exert greater control over their market.[42] The American Academy, essentially a patronage organization and exhibition space run by John Trumbull and the remnants of New York's old Federalist elite, did not long survive the competition with the National Academy, its failure symbolic of the decline of the city's old aristocratic order. Until the founding of the Metropolitan Museum of Art in 1870, the National Academy remained New York's most powerful art institution. As an art academy, however, its role was limited to training artists and holding an annual exhibition and sale of works by its members. While it conscientiously attempted to set artistic standards, it could not function as an art museum: in other words, it could not begin to lay down aesthetic standards for society as a whole.

The American Academy's demise coincided with a growing interest on the part of New York's nouveau-riche merchants, bankers, and financiers in acquiring something of the aura of aristocracy that accompanied the possession of works of art. In the early 1830s, Luman Reed, a self-made merchant in the wholesale grocery and dry goods business, built a mansion on Greenwich Street in lower Manhattan. It included a large gallery where Reed exhibited a collection of mediocre Old Masters and works he

had commissioned from contemporary artists, including Thomas Cole's *Course of Empire* series.[43] Reed died in 1836; in 1844, a group led by Jonathan Sturges, Reed's former business partner, and made up primarily of wholesale grocers formed the New-York Gallery of Fine Arts, which purchased Reed's collection from his widow.[44] Taking as its model London's National Gallery, the New-York Gallery's "object," according to its organizational document, was "to establish in the city of New York a permanent Gallery of Paintings, Statuary, and other Works of Art."[45] However, the gallery's backers ran into opposition from the mayor and other members of the city government. The dispute engendered wide public interest and about three hundred merchants manifested their support by signing a petition which asserted that public art galleries were a prominent feature of European cities and that Americans would do well to emulate European precedent; while about fifty bank presidents and Wall Street brokers opposed the gallery—a series of splits (between bankers and brokers, merchants and the city government), symptomatic of deep divisions within relatively weak elite factions.[46] The New-York Gallery finally opened. Yet despite early interest in its exhibitions, the gallery ran a deficit throughout its history. Surviving less than a decade, in the end, its collection was turned over to the New-York Historical Society, which was then becoming an important showcase for American art.

Something similar occurred with the American Art-Union.[47] An art lottery, whose subscribers paid for a chance to win paintings and received steel engravings as a premium for joining, this organization was set up in New York in 1839 and took as its mission awakening national interest in contemporary American art. At its height it attracted almost 19,000 subscribers nationwide and its annual drawings were social events of note (fig. 4.5). The Art-Union's program, based upon eighteenth-century republican assumptions, aimed at, among other things, diminishing class antagonisms. As Rachel Klein has observed, it excluded from the realm of art anything that smacked of "selfish" or "interested" motives while creating "an uplifted, unified sense of national identity."[48] The Art-Union thus represented an attempt by an elite faction to create an organization it could control, define a uniquely American high art aesthetic, and prompt a broad public to distinguish between fine or high art and popular entertainment. But the Art-Union had its enemies in the press and even among

FIG. 4.5. Tompkins H. Matteson, *The Distribution of the American Art-Union Prizes at the Tabernacle—Broadway, New York, 24th December 1847*, lithograph, drawn on stone by Francis Davignon, 15¾ × 20¾ in. (New York: Sarony & Major, 1848). Library of Congress, Prints and Photographs Division, LC-DIG-pga-02613.

artists, who worried it would monopolize patronage. They mounted an escalating legal attack which ended in 1851, when the New York State Supreme Court declared the Art-Union an illegal lottery.[49]

What we have then is, on the one hand, growing demands for high-art institutions, either public art galleries along the lines of European museums supported by the state, or adhering to an innovative, entrepreneurial form (the lottery); and, on the other hand, bourgeois factions too weak and divided to sustain such institutions, economically or politically, especially since at this point they could conceive of establishing art institutions only on a profit-making or break-even basis. There was thus a powerful

impulse towards classification and framing (in DiMaggio's terms), but, ironically, the class's entrepreneurship proved insufficient: it had yet to develop the corporate organizational forms necessary to sustain high art institutionally or the strength to dictate state policy.

And yet, despite the institutional failures I have described, the New York art world expanded at a tremendous rate during the period 1840 to 1860. In 1847, the Century Association was established to bring together artists, writers, and wealthy patrons such as Jonathan Sturges, John Jacob Astor, and James W. Beekman.[50] During this period, the National Academy of Design flourished as never before. Its yearly exhibitions grew steadily and by the mid-1850s it began contemplating a move to a larger building.[51] The Tenth Street Studio Building, which opened in 1858, also helped bring together artists and patrons.[52] Openings and soirées at the Academy, at the Tenth Street Studio Building, and at other venues were fashionable events. For example, in February 1860, *The Crayon,* which was founded in 1855 and was, until it ceased publication in 1861, the leading art journal of the period, described an opening at Dodworth's, at the time a genteel dancing academy on lower Fifth Avenue and the site of an annual art exhibition:

> The first reception of the season came off at Dodworth's on the 4th ult. with such success as to make it evident that periodical receptions have become an indispensable institution. Over 1200 guests were present. As usual, the *élite* of the city appeared there, both the honored and the beautiful, to say nothing of the large crowd of appreciative observers. The exhibition of works of art was quite as large as any exhibition of the past season, the entire collection, with the exception of one picture . . . being by native artists.[53]

Thus, while the history of New York's art institutions during the period from 1800 to 1865 can be read in terms of a series of contradictory and thwarted impulses towards the institutionalization of high art, it can also be interpreted in opposite terms, as evidence for the class's growing determination to create art institutions as part of an effort to consolidate its economic, political, and cultural power.

This history came to a head in 1863 with the founding of New York's Union League Club. The league, formed in the early days of the Civil War,

was a political movement that spawned clubs in New York, Chicago, Philadelphia, Brooklyn, and New Haven. As Beckert observes, the New York club gave form and structure to the demands of the most politically radical wing of the bourgeoisie.[54] Against the opposition of New York's political machine dominated by Boss Tweed, and of the city's white working class, it called for national unification by force of arms, emancipation, and the strengthening of the nation state. In the short time between its founding in 1863 and Union victory in 1865, the club's membership grew from 350 to 800. The club included in its ranks members of once-competing class fractions—merchants, bankers, industrialists, and professionals, as well as a surprisingly large contingent of artists. (Gifford, Heade, and Kensett, along with Albert Bierstadt, Jasper Cropsey, and Samuel Colman, were early members.) In defiance of its political enemies, the club sponsored two black regiments, raised money for the United States Sanitary Commission, a forerunner of the American Red Cross, and took the lead in organizing the 1864 Metropolitan Sanitary Fair, a fundraising event which included a highly successful exhibition of American and European paintings.[55]

In 1865, a few months after Lee's surrender, John Jay, a wealthy New York financier and lawyer, and one of the league's first presidents, addressed the topic of an American art museum in an after-dinner speech at an elaborate Fourth of July celebration held in Paris.[56] According to a reporter from the *London Times*, the "fête was organized through the active agency of some patriotic gentlemen," and brought together such notables as the U.S. minister (ambassador), the assistant secretary of war, and the U.S. commissioner to the Universal Exhibition of 1867.[57] Speaking as it were in the shadow of the Louvre, Jay asserted, as he later recalled, that "it was time for the American people to lay the foundation of a National Institution and Gallery of Art and that the American gentlemen then in Europe were the men to inaugurate the plan."[58] Jay's words spurred some of the men present to form a committee which went on to lobby the Union League Club for "the foundation of a permanent national gallery of art and museum of historical relics" to be located in New York.[59] In November 1869, the league, with Jay once again serving as president, organized a dinner at which three hundred of the city's wealthiest men gathered to hear some stirring oratory from William Cullen Bryant, who

called for the establishment of a museum of art in New York. The meeting resulted in the creation of a provisional committee that went on to lay the organizational framework for the Metropolitan Museum (the name probably a deliberate echo of the name given New York City's Sanitary Fair). Through the efforts of a board of trustees, which included leading merchants, industrialists, and financiers as well as a number of artists, the museum received a grant of incorporation from the New York state legislature in April 1870. On February 20, 1872, the museum held a gala to mark the opening of its galleries in the building that had formerly served as the home of Dodworth's Dancing Academy. The museum later occupied the Douglas Mansion on Fourteenth Street before taking up permanent residence in Central Park in March 1880, in a "Venetian" or Ruskin Gothic building designed by Calvert Vaux and Jacob Wrey Mould.[60]

In his address to the Union League Club, Bryant lamented that the United States lacked a significant public art museum while even Spain, "a third-rate power of Europe and poor besides, [could boast of] a Museum of Fine Arts at her capital, the opulence and extent of which absolutely bewilder the visitor."[61] As a would-be rival of not only the Prado but also the Louvre, the Metropolitan would press a claim for the United States as a center of refinement, of culture, of civilization. As an institution very much influenced by the example of the recently established South Kensington Museum (later the Victoria and Albert), it would educate lower-class and immigrant audiences.[62] The museum's aims may have ultimately served the bourgeoisie's cultural needs, but they were premised upon its growing power to enforce distinctions between art and entertainment, and to put into practice, in DiMaggio's words, "a new etiquette of appropriation, a new relationship between the audience and the work of art."[63]

The Rise of a Proto or Would-be High Art

In theory, an art museum provides an authoritative answer to the question of what constitutes fine or high art. Yet high art is never an undivided or uncontested category, as the history of the Metropolitan Museum amply demonstrates. Before there was a Metropolitan, the definition of fine or high art was even more contested. Artists, critics, the public, and institutions, each with an interest in improving or uplifting American taste, staked a claim to one or another concept of high art. Consider, for ex-

ample, the efforts of the history painter John Vanderlyn, who returned to the United States in 1815 after almost two decades in Paris, where he had studied with François André Vincent and exhibited at the Salon. Vanderlyn had been a protégé of Aaron Burr, and with the help of Burr's political connections obtained aid from the New York City Common Council in building a rotunda in which to exhibit panoramas; but his real purpose, he claimed, was to raise American artistic standards by acquainting the New York public with the results of his years of work in France, Davidian paintings which he also exhibited in the rotunda building—*The Death of Jane McCrea* (1804), *Ariadne* (1809), and *Marius Amid the Ruins of Carthage* (1807), which Napoleon had awarded a gold medal at the 1807 Salon.[64]

Or to take another example: in the 1840s the American Art-Union, concerned that its nationalist program might be criticized for lowering artistic standards, promoted what it explicitly called "high art"—although in this instance high art meant simply art with elevated religious or moralizing subject matter rather than art defined in terms of the academic system of history painting. In 1847 it distributed to its members a mezzotint reproduction of George Caleb Bingham's *The Jolly Flat Boat Men* and then issued a second membership print after Daniel Huntington's *Sibyl*, one of the artist's classical allegories. William J. Hoppin, the editor of the Art-Union's *Bulletin*, presented a resolution to the Art-Union's annual meeting in which he proclaimed, "it is the duty of this Association to use its influence to elevate and purify public taste, and to extend among the people, the knowledge and admiration of the productions of 'HIGH ART.'"[65] In support of his motion, Hoppin asserted that while "the very name [*Jolly Flat Boat Men*] . . . gives a death blow to all one's preconceived notions of 'HIGH ART.' . . . the engraving of 'SIBYL' . . . will amply atone for all that the other may lack."[66] The Art-Union's membership peaked two years later when it raffled off Thomas Cole's four-part religious allegory, *The Voyage of Life*. That year, the Art-Union also offered James Smillie's engraving of *Youth* from Cole's series as a premium for membership.[67]

For the Art-Union, subject matter determined the status of a work of art. A few years later, *The Crayon* began developing different criteria. Edited by William Stillman and John Durand, son of the painter Asher B. Durand, and drawing upon the talents of well-known writers and poets, *The Crayon* is usually if somewhat mistakenly remembered as an American

vehicle for Ruskin's ideas. Ruskin played an important role in the early years of the journal but, as Janice Simon has shown, under the influence of German idealism, it evolved a Unitarian-Transcendentalist critique of Ruskin.[68] Although *The Crayon* has been understood primarily in terms of the history of American aesthetic thought, it can also be studied as an institution within the New York art world. As we might expect, the aesthetic theories it promoted were never entirely disinterested but connected with the needs and concerns of a group of artists and patrons based mainly in the Century Association. *The Crayon* can be read in a number of ways but, if we consider it with respect to contemporary artistic practice, we quickly discover a tendency to favor what Simon describes as a "Crayonist" landscape aesthetic. *Crayon* reviewers were predisposed towards modest paintings representing scenes of calm, silence, and repose, and, as Simon writes, "repose transformed the material into the spiritual."[69] *The Crayon* also disparaged the work of artists pursuing more popular forms, for example, Frederic Church, probably the most acclaimed painter in the United States during the years in which the journal was published.[70] Moreover, if *The Crayon* was mildly disparaging towards Church, it was positively hostile to the work of Church's teacher, Thomas Cole, especially his *Voyage of Life* series which, during the 1850s, continued to enjoy great popular esteem. Cole had been celebrated as the United States' leading landscape painter and his untimely death in 1848 had been represented in the press as a national calamity. Yet eight years later, *The Crayon* did not hesitate to condemn Cole's *Voyage of Life* and his art in general in the harshest terms imaginable: "Cole, in his 'Voyage of Life,' has grounded on both rock and quicksand, and the success of his allegories, generally, has been as injurious to the ideal of Art, as instrumental to his own success in life."[71] In other words, by catering to popular taste, Cole had betrayed an ideal that was by implication accessible only to an artistically educated elite.

Among New York landscapists active in the mid-1850s, Asher B. Durand perhaps best exemplified *The Crayon*'s aesthetic ideals. Durand, who was born in 1796, had been a highly successful engraver until the 1830s, when he took up genre and portrait painting, and then, with encouragement from Thomas Cole, switched to landscape. In 1845, he was elected the National Academy of Design's second president; in 1847 he was a

founding member of the Century Association.[72] In 1848, he was one of three landscape artists—the other two were Church and Cropsey—who in effect were vying for Cole's mantle. Yet unlike his rivals, Durand's landscape vision became progressively less heroic (fig. 4.6 and plate 12). A disciple of Ruskin and emphatic in his insistence upon truth to nature—he spelled out his beliefs in nine letters on landscape painting published in early issues of *The Crayon*—he had in the mid-1840s begun incorporating highly detailed renditions of natural features in the foregrounds of his paintings. Vertical rather than horizontal—the latter the preferred format of the majority of Hudson River School painters—Durand's *sous bois* landscapes were based upon plein air studies, which the artist executed during summers spent in the Catskills and New England. As Linda Ferber has observed, "Durand's studies were recognized in his day as vivid documents of practice and creative process, evidence of an artistic quest for truth about the natural world deemed essential to the mission of the progressive landscape painter."[73]

Durand's practice both reflected and contributed to the growing interest among artists, collectors, and the public in the painted sketch. Eleanor Jones Harvey has detailed how "between 1830 and 1880 oil sketches, notably of landscapes, became fixtures in exhibitions at the National Academy of Design, studio soirées, and collectors' homes," and how Durand abetted the appreciation of the painted sketch as a work of art not only via the example of his own work but also as president of the National Academy of Design, which in accord with his wishes featured a "sketch room" at its annual exhibitions.[74] The American Art-Union also exhibited and sold painted sketches, including works by Church, Kensett, Gifford (fig. 4.7 and plate 13), and Durand. Harvey notes that the decade following Cole's death in 1848 saw "the growing presence of the oil sketch, notably the 'finished sketch' as recognized works of art in exhibitions and private collections," a development that is central to my argument.[75] Popular taste of the period ran towards religious allegories such as *The Voyage of Life*, and spectacle pictures such as Church's *Heart of the Andes*; appreciation of the painted landscape sketch points to far more self-conscious forms of artistic enjoyment. As Harvey, Ferber, and others insist, the sketch (in Harvey's words) exudes "a palpable individuality that provides an intimate view into the artist's creative process."[76] The focus is then on the artist's choices, his

FIG. 4.6. (Plate 12.) Asher B. Durand, *Landscape with Birches,* ca. 1855, oil on canvas, 24¼ × 18⅛ in. Museum of Fine Arts, Boston, bequest of Mary Fuller Wilson, 63.268.

technique, his touch. The viewer might appreciate the extraordinary—I am tempted to say photographic—exactitude of one of Durand's finished sketches (fig. 4.8) but, if it can be considered a record of the appearance of nature, it is also a record of a second nature. For it is the artist's sensibility, his refined perception of qualities of light, color, and atmosphere, and his unique way of translating visual experience into an artistic language or code which the viewer also admired. And this admiration was then reflected back upon the viewer: for to appreciate a painted sketch required the cultivation of skills associated with connoisseurship. Subject matter lost some or perhaps most of its importance: as a record of artistic sensibility, a sketch of a moss-covered rock located somewhere in the Catskills might prove as compelling as a finished painting of Niagara Falls. The viewer's capacity for appreciation, his cultivated aesthetic sensibility, his aspiration to what *The Crayon* called "the ideal of Art," demonstrated a love of art—what Pierre Bourdieu describes sardonically as "l'amour de l'art."[77] And it is to Bourdieu that we must now turn to begin to account for the transformation of taste and the redefinition of high art that led to the rise of aestheticizing tendencies. For if we accept Bourdieu's argument that a striving for "distinction" lay at the core of bourgeois identity, then it stands to reason that the trends I have been describing—the increasing popularity of the painted sketch during the period under consideration, the appearance of aestheticizing tendencies in approximately the same period—roughly coincided with, and were integral to, the emergence of an increasingly powerful and unified bourgeoisie, a class working towards securing cultural hegemony via the creation of institutions like the Metropolitan Museum of Art.[78]

Finally, I want to argue that John F. Kensett's career most fully demonstrates how deeply the aestheticizing tendencies I have been describing were implicated in the cultural aspects of class formation.[79] Born in 1816, Kensett was trained as an engraver but, in his early twenties, decided to become a painter. In 1840, he traveled to Europe in the company of Durand and two younger landscapists, John Casilear and Thomas Rossiter. Kensett is reported to have had a congenial personality and a gift for what today would be called networking. In the 1840s he corresponded with A. M. Cozzens, Robert Hoe, Henry Marquand, Frederick Sturges,

FIG. 4.7. (Plate 13.) Sanford Robinson Gifford, *Mist Rising at Sunset in the Catskills*, ca. 1861, oil and pencil on canvas, 6¾ × 9½ in. The Art Institute of Chicago, gift of Jamee J. and Marshall Field, 1988.217.

and Robert Olyphant—financiers and industrialists with an interest in art (Olyphant was later widely recognized as Kensett's chief backer). The artist also counted among his friends the collector-clergymen Henry W. Bellows, Elias Magoon, and Samuel Osgood, the politician Hamilton Fish, the historian George Bancroft, the publisher George P. Putnam, and the writers William Cullen Bryant and Nathaniel Parker Willis. Well liked and well connected, Kensett was elected an associate of the National Academy of Design in 1848 and full academician a year later. His election to membership in the Century Association that same year was, according to John Howat, "central, perhaps key, to his career at this time," but it was also the inevitable outcome of the connections and alliances he had formed during the preceding eight years.[80] Kensett was an early member of New York's Union League Club and the principal organizer of the league's art exhibition at the 1864 Metropolitan Sanitary Fair. He was also

FIG. 4.8. Asher B. Durand, *Study from Nature: Rocks and Trees*, ca. 1856, oil on canvas, 21 × 16½ in. New-York Historical Society, gift of Mrs. Lucy Maria Durand Woodman, 1907.26.

a founding trustee of the Metropolitan Museum of Art and, at his death in December 1872, president of the Artist's Fund Society.[81]

Kensett's success as an artist can be attributed not only to whatever talents he possessed but also to a sharp instinct for what was possible. John Paul Driscoll has observed that, in the mid-1850s, the painter "shifted from the more conventional anecdotal picturesque mode derived from the tradition of Cole and Durand, to the quiet openness, light, and simplification of form, color and composition that is now recognized as his mature style and associated with the phenomenon of 'luminism.'"[82] This shift, which came at a moment when new aesthetic criteria were being put forth in the pages of *The Crayon* and elsewhere, could not have been at all fortuitous. The line that stretches from Kensett's Newport and Shrewsbury

FIG. 4.9. (Plate 14.) John F. Kensett, *Beacon Rock, Newport Harbor,* 1857, oil on canvas, 22½ × 36 in. The National Gallery of Art, Washington, D.C., gift of Frederick Sturges, Jr., 1953.1.1.

River paintings of the later 1850s (fig. 4.9 and plate 14) to the minimalist landscapes that comprise the "Last Summer's Work," as it is now called, accorded with both the artist's inclinations and his patrons' taste for increasingly rarefied art forms (see fig. 4.4).

When Kensett died in 1872, his memorial began with a meeting of the Century Association, followed by a retrospective exhibition that literally filled the Academy of Design's galleries, and an executors' sale that reaped the stupendous sum of $130,000.[83] No artist of the preceding decade had been more identified with the New York bourgeoisie and its interests, and none had done more when it came to making artistic sensibility the subject of art. As we have seen, Kensett's late landscapes stood in opposition to the more popular forms of Hudson River School painting. They thus presaged the school's demise even as they anticipated the aesthetic exclusivity that would characterize a good deal of American painting in the decades ahead.

The Failure of Luminism

Adhering to the formalist orthodoxies of the 1950s and 1960s, the early critics of Luminism first endeavored to define luminist style and then, in order to account for Luminism as a historical phenomenon, adduced apparent philosophical and other parallels in the larger culture; in other words, attempted to vindicate the "Americanness" of luminist painting by resorting to the mystifications of *Zeitgeist*. More recent students of Luminism have added to our knowledge of the artists and the social contexts in which they worked, and have produced more credible descriptions of the style in question ("a distinctly modernist approach to landscape, accentuating formal qualities"[84]), but their efforts to salvage the term for art-historical discourse have produced no new insight into the art under consideration. Instead such efforts have inevitably resulted in confusion, leading one well-known scholar to concede that Luminism is "an enigmatic word"—as if the enigma originated with the term and not in the failed attempts to define it.[85]

The term Luminism still flourishes as an art-historical brand, but as should now be clear, it is worthless when it comes to analyzing styles and accounting for the rise of aestheticizing tendencies in mid-nineteenth-century American landscape painting. In this chapter, I have attempted to demonstrate that these tendencies were in fact an integral part of a larger historical process—a process in which the rise of a seemingly autonomous art was inseparable from the dynamics of class formation. The latter were, in Adorno's phrase, its "real basis."

Notes

I presented earlier versions of this text, or portions thereof, at the Clark Art Institute in Williamstown, Massachusetts; at University College, London, as part of its Marxism and the Interpretation of Culture Series; at the College Art Association's 2009 Annual Meeting; at the Department of Art and Art History at the University of Oklahoma; at the Department of Art and Art History at the College of William and Mary; at the Smithsonian American Art Museum as part of its scholars' lunch bag series; and at Syracuse University. I am grateful to the audiences who attended these talks for their questions, comments, and criticisms. Andrew Hemingway, J. Gray Sweeney, and William Truettner proved to be the best of colleagues by challenging my thinking on key issues. I would also like to thank Marc Gottlieb, Kenneth Haltman, Michael Ann Holly, Michael Leja, Catherine Levesque,

W. J. T. Mitchell, B. Byron Price, and Robin Veder for their observations, suggestions, and encouragement. I can only begin to indicate my indebtedness to Phyllis Rosenzweig, as always my first and most critical reader, my inspiration, and my dearest friend.

1. Theodor Adorno, *Minima Moralia*, trans. E.F.N. Jephcott (London: Verso, 1978), 93.

2. See Katherine E. Manthorne and Mark D. Mitchell, *Luminist Horizons: The Art and Collection of James A. Suydam* (New York: The National Academy of Design Museum and School of Fine Arts, and George Braziller, 2006).

3. See Angela Miller, *The Empire of the Eye: Landscape Representation and American Cultural Politics, 1825–1875* (Ithaca: Cornell University Press, 1993), 243–88.

4. J. Gray Sweeney, "Inventing Luminism: 'Labels are the Dickens,'" *Oxford Art Journal* 26.2 (2003): 93.

5. Sweeney, 120.

6. I plan to develop these arguments more fully in a future publication which will take up a number of topics omitted or only briefly touched on here, in particular the history of New York collecting, the influence of the art market, and the role of collectors, critics, and dealers in encouraging or reinforcing aestheticizing tendencies. A suggestive model for this type of analysis is Nicholas Green, "Dealing in Temperaments: Economic Transformations of the Artistic Field in France during the Second Half of the Nineteenth Century," *Art History* 10.1 (March 1987): 59–78.

7. See John I. H. Baur, "American Luminism: A Neglected Aspect of the Realist Movement in Nineteenth-Century American Painting," *Perspectives USA* 9 (1954): 90. Emphasis in the original.

8. Ibid., 90–91.

9. Ibid., 92.

10. Ibid., 90, 95.

11. See John I. H. Baur, "Trends in American Painting," in *M. and M. Karolik Collection of American Paintings, 1815–1865* (Cambridge, MA: Harvard University Press for the Museum of Fine Arts, Boston, 1949).

12. See Carol Troyen, "The Incomparable Max: Maxim Karolik and the Taste for American Art," *American Art* 7.3 (Summer 1993): 65–87.

13. Ibid., 75.

14. Cited in Sweeney, 98.

15. Sweeney, 108.

16. Cited in Sweeney, 108.

17. See Sweeney, 109.

18. See Wilmerding, *Fitz Hugh Lane, 1804–1865, American Marine Painter* (Gloucester, MA: P. Smith, 1967 [1964]); *Fitz Hugh Lane* (New York: Praeger, 1971);

and Wilmerding ed., *Paintings by Fitz Hugh Lane* (Washington, DC: National Gallery of Art; and New York: Abrams, 1988).

19. See Theodore E. Stebbins, Jr., *Martin Johnson Heade* (College Park: University of Maryland Art Dept., 1969); Stebbins, ed., *Martin Johnson Heade* (Boston: Museum of Fine Arts; and New Haven: Yale University Press, 1999); and Stebbins, ed., with the assistance of Janet L. Comey and Karen Quinn, *The Life and Work of Martin Johnson Heade: A Critical Analysis and Catalogue Raisonné* (New Haven: Yale University Press, 2000).

20. At some point between 1950 and 1953, Novak spent a year working at the Brooklyn Museum, where Baur served as chief curator until 1952. See "In Conversation: Barbara Novak with Adrienne Baxter Bell and Phong Bui," in *The Brooklyn Rail* (April 2007); http://www.brooklynrail.org/2007/04/art/novak-april (accessed 6 February 2011). I have been unable to ascertain whether or not Novak worked directly with Baur, but it seems likely she got to know him either at the Brooklyn Museum or as part of the small band of curators and scholars who, during the 1950s, were interested in the history of American art. In any event, as should be evident, his essay in *Perspectives USA* powerfully influenced her thinking.

21. Novak, *American Painting of the Nineteenth Century: Realism, Idealism, and the American Experience,* third edition (New York: Oxford University Press, 2007 [1969]), xiii (preface written in 1968).

22. Baur was deeply influenced by Heinrich Wölfflin and Henri Focillon, two leading proponents of formalist theories of art history. (See Sweeney, 98, n. 11.) Novak twice refers to Wölfflin directly in *American Painting of the Nineteenth Century* (5, 81), and his influence is apparent throughout the book. See Jochen Wierich, "Mutual Art History: German Art History and American Art," in Barbara Groseclose and Wierich, eds., *Internationalizing the History of American Art* (University Park: The Pennsylvania State University Press, 2009), 54–57.

23. *American Painting of the Nineteenth Century,* 73.

24. Ibid., 71–73.

25. Ibid., 74.

26. For the beginnings of the controversies over luminism, see James Thomas Flexner's review of *American Painting of the Nineteenth Century,* which was tellingly headlined, "Fitz Hugh Lane is the hero, 'luminism' is the touchstone," *New York Times Book Review* (25 January 1970): 244. Flexner argued that "'luminism' was not a deviation from the central Hudson River style but one of its more profoundest aspects," and asserted that Novak "would surely have broadened her conclusions had she not so rigidly honored the academic shibboleth that separates art from life." See also Novak's letter to the *Book Review* editor and Flexner's reply (15 March 1970). Novak charged that Flexner misunderstood her position and argued that her "formalism" did not exclude "consideration of environmental factors," including "philo-

sophical attitudes to nature, to the machine, to mathematics and to spiritualism"; Flexner replied that Novak "makes my review seem more negative than it was."

27. See John Wilmerding, ed., *American Light: The Luminist Movement, 1850–1875, Paintings, Drawings, Photographs* (Washington, DC: National Gallery of Art, 1980). For an account of the rediscovery and sale of *The Icebergs*, see Eleanor Jones Harvey, "The Other Seven-Eighths," in Harvey, ed., *The Voyage of the Icebergs: Frederic Church's Arctic Masterpiece* (New Haven: Dallas Museum of Art and Yale University Press, 2002), 71–82.

28. J. Carter Brown, "Foreword," in Wilmerding, *American Light*, 7. Emphasis in the original.

29. Ibid.

30. Wilmerding, "Introduction," *American Light*, 11. I would also observe that Novak's approach to the relation between art and its cultural and historical contexts is as arbitrary and uncritical as Wilmerding's—in effect yet another variant of *Zeitgeist* theory. Thus, in her interview with the *Brooklyn Rail* (as in n. 20 above), Novak recalled how she "tried, both in teaching and writing, to read the art itself, and then search for confirmation for what I read through context." The fatal flaw inherent in such a procedure should be obvious.

31. Novak, "On Defining Luminism," in Wilmerding, ed., *American Light*, 23. Emphases in the original.

32. Huntington, "Church and Luminism: Light for America's Elect," Wilmerding, ed., *American Light*, 155–90.

33. See Stebbins, "Luminism in Context: A New View," in Wilmerding, ed., *American Light*, 215 and passim.

34. For a Lane chronology, see Wilmerding, ed., *Paintings by Fitz Hugh Lane*, 9–14; for Lane's attachment to Gloucester and Cape Ann, see Elizabeth Garrity Ellis, "Cape Ann Views," in ibid., 19–44. Sweeney, 110, rightly notes that Lane worked "in relative isolation in Gloucester, Massachusetts," and that he "was virtually ignored; not even mentioned by [Henry Theodore] Tuckerman [an authoritative biographer of New York artists during the 1860s], although he received enthusiastic reviews from New York art critic Clarence Cook."

35. See Stebbins, *Martin Johnson Heade* (1999), passim. In his introduction, Stebbins observes that although Heade "won only a minor reputation in his own day and after his death was forgotten for many decades, he is now rightly regarded as an artist of great significance and originality" (1). Of course Stebbins himself has played a central role in establishing Heade's current reputation.

36. "Popular" large-scale paintings very likely appealed to middle-class and lower-middle-class audiences, who possessed the leisure in which to visit art galleries and could pay the entrance fees for special exhibitions. Moreover, because the distinction between high or fine and low or popular art was not well established

during the period under consideration (see section two, below), collectors had no qualms about acquiring "popular" as well as aestheticizing works. It is only during the 1870s that stronger distinctions between high and popular art began to take hold, and consequently the work of such artists as Church and Bierstadt began to fall out of fashion.

37. See Sven Beckert, *The Monied Metropolis: New York City and the Consolidation of the American Bourgeoisie, 1850–1896* (New York: Cambridge University Press, 2001); Frederic Cople Jaher, *The Urban Establishment: Upper Strata in Boston, New York, Charleston, Chicago, and Los Angeles* (Urbana: University of Illinois Press, 1982); Edward Pessen, *Riches, Class, and Power Before the Civil War* (New Brunswick: Transaction Publishers, 1990[1973]); E. Digby Baltzell, *Philadelphia Gentlemen: The Making of a National Upper Class* (New Brunswick: Transaction Publishers, 1989[1958]); Peter Dobkin Hall, *The Organization of American Culture, 1700–1900: Private Institutions, Elites, and the Origins of American Nationality* (New York: New York University Press, 1982).

38. Beckert, 237.

39. This section borrows elements from Alan Wallach, "Long-term Visions, Short-term Failures: Art Institutions in the United States, 1800–1860," in *Exhibiting Contradiction: Essays on the Art Museum in the United States* (Amherst: University of Massachusetts Press, 1998), 9–21.

40. See Paul DiMaggio, "Cultural Entrepreneurship in Nineteenth-Century Boston: The Creation of an Organizational Base for High Culture in America," in Richard Collins, James Curran, et al., eds., *Media, Culture and Society: A Critical Reader* (London: SAGE Publications, 1986), 194–211, and especially 196.

41. The most comprehensive study of the American Academy is Carrie Rebora, "The American Academy of the Fine Arts, New York 1802–1842" (PhD diss., City University of New York, 1989).

42. For the National Academy of Design, see Eliot Clark, *History of the National Academy of Design, 1825–1953* (New York: Columbia University Press, 1954), and Thomas Seir Cummings, *Historic Annals of the National Academy of Design* (New York: Kennedy Galleries, 1969 [1865]). See also Paul Staiti, *Samuel F. B. Morse* (Cambridge: Cambridge University Press, 1991), 149–74.

43. See Ella Foshay, *Mr. Reed's Picture Gallery, A Pioneer Collection of American Art* (New York: Harry N. Abrams, Inc., in association with the New-York Historical Society, 1990). Reed was a shrewd operator, but Foshay overestimates his understanding of art and underestimates the role of Thomas Cole and Asher B. Durand, who served as Reed's advisors.

44. For information about the gallery, see Maybelle Mann, "The New-York Gallery of Fine Arts: 'A Source of Refinement,'" *The American Art Journal* 11.1 (January

1979): 76–86; and Abigail Booth Gerdts, "Newly Discovered Records of the New-York Gallery of the Fine Arts," *Archives of American Art Journal* 21.4 (1981): 2–9.

45. Cited in Winifred E. Howe, *A History of the Metropolitan Museum of Art, with a Chapter on the Early Art Institutions of New York* (New York: Metropolitan Museum of Art, 1913), 1, 64f.

46. Information in Mann, "The New-York Gallery of the Fine Arts," 82.

47. For the American Art-Union, see Mann, *The American Art-Union*, rev. ed. (Jupiter, FL: ALM Associates, 1987); Rachel N. Klein, "Art and Authority in Antebellum New York City: The Rise and Fall of the American Art-Union," *The Journal of American History* 81.4 (March 1995): 1534–61; Patricia Hills, "The American Art-Union as Patron for Expansionist Ideology in the 1840s," in Andrew Hemingway and Will Vaughn, eds., *Art in Bourgeois Society, 1790–1850* (Cambridge: Cambridge University Press, 1997), 314–39; Arlene Katz Nichols, "Merchants and Artists: The Apollo Association and the American Art-Union," (PhD diss., City University of New York, 2003).

48. Klein, "Art and Authority in Antebellum New York City," 1540.

49. Ibid., 1548–60. *The Herald,* one of the first penny papers in New York, appealed to a white working-class audience, which it fed a poisonous diet of jingoism, "negrophobia," and outrage at some forms of corruption and injustice. In these respects it faithfully reflected the views of its proprietor, a "Hunker" or conservative Democrat with an insatiable appetite for sensationalism. James Gordon Bennett not only mocked the New-York Gallery of Fine Arts but personally directed his newspaper's vendetta against the Art-Union. See James L. Crouthamel, *Bennett's New York Herald and the Rise of the Popular Press* (Syracuse: Syracuse University Press, 1989), 40–41, and passim.

50. See John Hamilton Gourlie, *The Origin and History of "The Century"* (New York: W. C. Bryant & Co., printers, 1856); *The Century, 1847–1946* (New York: The Century Association, 1947); John K. Howat, "Kensett's World," in John Paul Driscoll and Howat, eds., *John Frederick Kensett, An American Master* (New York and Worcester: Worcester Art Museum in association with W. W. Norton, 1985), 35–37; Beckert, 58.

51. See Eliot Clark, *History of the National Academy of Design* (New York: Columbia University Press, 1954), 66–83.

52. See Annette Blaugrund, *The Tenth Street Studio Building: Artist Entrepreneurs from the Hudson River School to the American Impressionists* (Southampton, NY: The Parrish Art Museum, 1997).

53. "Domestic Art Gossip," *The Crayon* 7.2 (February 1860): 56.

54. See Beckert, 130–31. For a useful summary of the club's history and a list of prominent members, including artists, see the Wikipedia entry "Union League

Club of New York"; http://en.wikipedia.org/wiki/Union_League_Club_of_New_York (accessed 1 July 2009).

55. Beckert, 130–31.

56. Winifred E. Howe, *A History of the Metropolitan Museum of Art* (New York: The Metropolitan Museum of Art, 1913), I:99.

57. Cited in Howe, I:99.

58. Cited in Howe, I:100.

59. Cited in Howe, I:101.

60. See Howe, I:101–223; Calvin Tompkins, *Merchants and Masterpieces: The Story of the Metropolitan Museum of Art*, rev. ed. (New York: Henry Holt and Co., 1989), 11–59.

61. Cited in Howe, I:108.

62. See Michael Conforti, "The Idealist Enterprise and the Applied Arts," in M. Baker and B. Richardson, eds., *A Grand Design: The Art of the Victoria and Albert Museum* (New York: Harry N. Abrams; Baltimore: Baltimore Museum of Art, 1997), 23–47.

63. DiMaggio, 196.

64. See William Oedel, "French Neoclassicism and the Search for an American Art" (PhD diss., University of Delaware, 1981); Kevin J. Avery and Peter L. Fodera, *John Vanderlyn's Panoramic Views of the Palace and Gardens of Versailles* (New York: The Metropolitan Museum of Art, 1988); and Carrie Rebora, "John Vanderlyn's Panorama" (Master's thesis, UCLA, 1983).

65. Information and quotation from Mann, *American Art-Union*, 14–15.

66. Cited in Mann, *American Art-Union*, 15.

67. See Mann, *American Art-Union*, 18.

68. See Janice Simon, "*The Crayon* 1855–1861: The Voice of Nature in Criticism, Poetry, and the Fine Arts" (PhD diss., University of Michigan, 1990). For an earlier discussion, see Roger B. Stein, *John Ruskin and Aesthetic Thought in America, 1840–1900* (Cambridge, MA: Harvard University Press, 1967). See also William James Stillman, *The Autobiography of A Journalist* (Boston: Houghton, Mifflin and Co., 1901), 1, 222–31.

69. Simon, 350.

70. See Simon, 338–58.

71. "Allegory in Art," *The Crayon* 3 (April 1856), 113–14. Either Stillman or his co-editor, John Durand, wrote the review.

72. For a biographical outline, see Sarah B. Snook, "Chronology," in Linda S. Ferber, ed., *Kindred Spirits: Asher B. Durand and the American Landscape* (Brooklyn: The Brooklyn Museum in association with D. Giles Limited, 2007), 202–24.

73. Linda S. Ferber, "Asher B. Durand, American Landscape Painter," in Ferber, ed., *Kindred Spirits*, 181.

74. See Eleanor Jones Harvey, *The Painted Sketch, American Impressions from Nature, 1830–1880* (Dallas: Dallas Museum of Art, 1998), 15, 64–65.

75. Ibid., 99.

76. Ibid., 15.

77. See Pierre Bourdieu and Alain Darbell, *The Love of Art: European Museums and their Public,* trans. Caroline Beattie and Nick Merriman (Stanford: Stanford University Press, 1990); originally published as *L'amour de l'art* (Paris: Éditions de Minuit, 1966).

78. See Pierre Bourdieu, *Distinction: A Social Critique of the Judgment of Taste,* trans. Richard Nice (Cambridge, MA: Harvard University Press, 1984).

79. See Howat, "Kensett's World," 12–47.

80. Ibid., 35.

81. Ibid., 40–47.

82. Driscoll, "From Burin to Brush: The Development of a Painter," in Howat and Driscoll, eds., *John Frederick Kensett,* 99.

83. See Howat, "Kensett's World," 46f; Harvey, 101–4.

84. Manthorne and Mitchell, "Luminism Revisited, Two Points of View," in *Luminist Horizons,* 124. Manthorne and Mitchell notice that a group of New York artists including Kensett and Suydam advanced an aestheticizing or, as they put it, "modernist" aesthetic, but they fail to grasp the social and historical dynamics underlying this development.

85. Annette Blaugrund, "Introduction," in *Luminist Horizons,* 9.

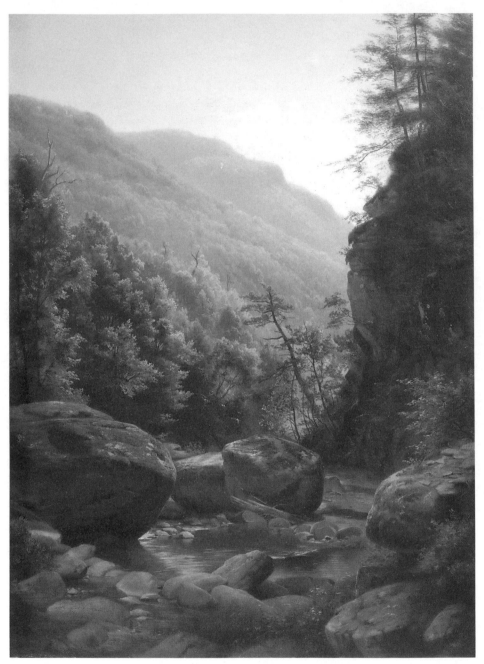

FIG. 5.1. (Plate 15.) Harriet Cany Peale, *Kaaterskill Clove*, 1858, oil on canvas, 36 × 25 in. Private collection.

"We the Petticoated Ones"
Women of the Hudson River School

"My dear Editor," wrote a lady traveler in 1857 for *Harper's Weekly*, "I told you in my last we were full of excitement, preparing to ascend Mount Washington and do our duty by that rugged and majestic presence." She continued:

> Well, it certainly does require more courage to go up that mountain than you gentlemen can realize. In the first place, *you* are not disfigured and disguised by the necessary costume as we are. *Your* dress is always hideous, therefore any unbecoming additions to it are of very little consequence. But with us it is quite different . . . we also put on shawls, palétots, jackets, cloaks, sometimes coats, anything that will shelter us from the blast, and not fly away. Then, resigning our hoops, we mount the poor horses.[1]

This correspondent, hired by *Harper's*, illuminates the fashionable compromises and endurance required of women in order to experience the American landscape at mid-century. Although the landscape was physically arduous at times and often involved multiple means of transportation, women indeed explored American scenery for both pleasure and profession. The above commentary makes all the more interesting a depiction of *Kaaterskill Clove* (fig. 5.1 and plate 15) painted by Harriet Cany Peale in

the following year. This location, already an established tourist destination by the 1850s, is depicted by Peale with precision and exacting detail in the foreground, as the eye is directed across the water, around the rocks, and off into a receding space of atmospheric haze. Suggesting firsthand observation, here is a painting by an artist able to translate the beauty of specific American scenery onto canvas while apparently unafraid to traverse the rough terrain.[2] Similar to Asher Durand's arbitrarily cropped close-up studies of nature from the same decade, Peale's perspective does not allow the viewer to enter the scene easily. The rocky stream in the foreground could lead to an unintended demise for the viewer should she or he venture too close to the edge. Such a balanced and spatially expansive composition marks Harriet Cany Peale as an accomplished member of the Hudson River School. Although contemporary women certainly produced artwork resulting from their travels throughout the American landscape, their perceived abilities in intellectual and artistic realms were often called into question.

In 1858, the same year in which Peale painted *Kaaterskill Clove*, the following essay appeared in the American edition of *The Westminster Review:*

> Volumes have been written on the long-disputed point, whether the mental powers of woman be equal to those of man. Women, say the defenders of the present system of things, have opened no new vistas in the realms of thought; with a few brilliant exceptions, they have produced nothing really great in art . . . and an exception does not form the rule. What they have not achieved in the course of eighteen centuries, they are not likely to achieve in the nineteenth . . . we [have] no female Raphael or Michael Angelo.[3]

The essay, "Die Frauen in die Kunstgeschichte," written by Ernst Guhl, a professor of history from Berlin, reflects the intellectual and aesthetic environment into which works by women artists such as Peale were received. Guhl continued:

> The profession of the painter would seem, in many respects, peculiarly fitted for women. It demands no sacrifice of maiden modesty, or of matronly reserve. It leads her into no scenes of noisy revelry or unseemly licence. It does not force her to stand up to be stared at,

commented on, clapped or hissed by a crowded and often unman-
nered audience, who forget the woman in the artist.[4]

Guhl's assessment is a mid-century barometer and summarized state of
the condition of women artists as he believed it to exist.[5] Yet, for women,
the overlay of domestic expectations must not be overlooked, for they,
unlike their male colleagues, maintained the private sphere of their house-
hold in addition to pursuing a public life in art—no simple feat in the
nineteenth century. However, by the early decades of the nineteenth cen-
tury, women traveled in increasing numbers to experience the American
landscape, as our correspondent from *Harper's Weekly* demonstrates, and
wrote poetically of their adventures. So too were seminaries, schools, and
private instruction established to provide artistic education for young la-
dies, especially in the art of landscape studies. Many of these women
aspired to paint professionally. They produced works of art, positioned
high and low on the artistic hierarchy, and were inspired by the landscape
just as Cole, Durand, and Church.

But who are these women? They are artists such as Susie Barstow, Jane
Stuart (daughter of Gilbert Stuart), Sarah Cole (sister to Thomas Cole),
Harriet Cany Peale (wife of Rembrandt Peale), Evelina Mount (niece to
William Sidney Mount), Julie Hart Beers (sister to William and James
Hart), and Eliza Greatorex, to name but a few. Beyond their supporting
roles as wives, sisters, nieces, and daughters, these are talented and accom-
plished landscape artists who, until recently, have received little scholarly
attention. Working alongside male companions or alone in their studios,
they captured on canvas the beauty and awe they experienced out of doors.
They annually exhibited their work at the National Academy of Design,
the Brooklyn Art Association, the Artist's Fund Society, and the Penn-
sylvania Academy of the Fine Arts—all prestigious venues. Indeed, some
of these women, including Frances (Fanny) Palmer, an important lithog-
rapher for the Currier & Ives Company, Jane Stuart, and Eliza Greatorex
supported themselves and their families through their art. While the
moniker of amateur artist was available equally to both men and women,
the designation of professional artist was far more restricted for women.

From reading personal accounts and diaries written as early as the
1820s, we know that women traveled to and explored places of natural

beauty. By the mid-1820s, a growing tourist industry in America resulted in the increased production of travel guides, which highlighted specific sites that women might enjoy, as well as offering detailed advice on appropriate clothing to bring on such excursions. Robert Fulton and Robert Livingston's 1807 voyage from New York City to Albany aboard the *North River Steam Boat* launched the inauguration of steamboat travel along the Hudson River.[6] Not only did this event improve commerce, but a growing number of Americans began to consider the Hudson Valley as a tourist destination. Steamboat companies flourished, offering passengers greater efficiency and speed than the sloops of the eighteenth century. In 1828 the *Lady Clinton* and *Lady van Rensselaer* (fig. 5.2) afforded tourists, male and female, panoramic views of the passing Hudson, the wide sweeping landscapes that artists such as Thomas Cole would capture on canvas. Travel expanded between Albany and New York City, and by 1848 a new steamboat, the *Rip Van Winkle*, made the trip three times a week. Although the name of the steamer does not instill notions of time efficiency, staterooms and berths were always reserved for railroad passengers, an acknowledgement of the multiple means of transport tourists often required. In increasing numbers, women desired to find sites of interest in the company of friends, kept safe from the peering eyes of men through their relegation to ladies' cabins on canal boats and steamboats. Affordable travel allowed not only greater access to view the landscape, but to be viewed as well. Willis Gaylord Clark commented in 1835, "did you never particularly relish a jaunt on board a steam-boat, when you found some beautiful women there? Tell me honestly, did they not, though strangers, materially enhance the delightfulness of the journey? . . . It is one of those pleasures that nobody writes about, and everyone feels."[7]

Undaunted by chance encounters and in fact excited by the prospects of travel, Miss Julia Adams, a school teacher from Dedham, Massachusetts, made her way along the Hudson in 1823 and wrote of her adventure:

> Since I last wrote you we have left N York for Albany to pass a few weeks with Mrs. Melville's mother. We came in the steam boat, had a delightful passage, passed the Highlands, West Point, and saw the Military Academy by moonlight. The Hudson is a beautiful river and the scenery on either side is incredibly beautiful. We went out

FIG. 5.2. Trade card, "The Splendid Safety Barges," 1828. The Winterthur Library, Joseph Downs Collection of Manuscripts and Printed Ephemera. Courtesy, The Winterthur Library.

about 10 hours, I felt no inclination to sleep and stayed on deck till 12 o'clock and then went down with extreme reluctance.[8]

Miss Adams's account of the beauty she witnessed along the Hudson River was not unique. Hannah Rogers (Mason) of Boston wrote in her diary on August 25, 1825, "Set off for the Catskill Mountains with Mother and brother John, Mrs. Deblois and Miss Joy with expectations of receiving a great deal of pleasure." Miss Rogers's subsequent entry in October tells of divine associations and interesting encounters:

> October 9th—Returned home from our journey in no way disappointed in my expectation—I think there is no scene in nature which would tend more to elevate the mind and impress us with the majesty and power of the Almighty—I never passed three weeks more to my satisfaction.[9]

Miss Rogers makes specific reference to the relationship between nature and God, demonstrating that the Romantic association between nature and the divine had already become part of a general parlance in America by the 1820s.

Niagara Falls in particular was a site of increasing wonder for Americans, regardless of gender. Rachel Wilmer wrote in her journal of June 26, 1834, "In viewing the scenery all around I was delighted and think it surpasses all description, it was calculated to raise my thoughts from nature up to nature's God. I was much indisposed all day but could not lose sight of the beautiful scenery." Up the Hudson she traveled aboard the steamboat *Erie* to "Catskill, where the mountain house was seen like a white cloud in the midst of the blue ridge. It afforded a beautiful change in the scene. . . . And then Albany, but 4 miles before we reached this city, the steam boat ran aground which is common in low tide, a smaller one called *The Albany* took all the passengers up to the city about 8 o'clock." By train, then stage, then canal boat, then finally another stage, Mrs. Wilmer reached Niagara Falls and:

> ascended a road 120 feet high around a winding rocky mountain covered with beautiful evergreens, this on the Canada side. Walked to Table Rock where Sam Patch took his leap then under the spray until quite wet, returned the same way after a most magnificent view and procuring some curiosities to the tavern on this side where after dinner we took the steam boat for Buffalo. . . . Arose early and walked down to the shop of Indian curiosities, purchased some bracelets for servants and did a little shopping.[10]

Harriet Martineau, an outspoken advocate for women's rights (and a well-heeled traveler), was referred to specifically by *The Hudson Illustrated* as "a person whose opinion mattered."[11] She observed, "I may be singular; but I own that I was more moved by what I saw from the [Catskill] Mountain House than by Niagara itself." Mrs. James Bogert was thrilled by the vacation she took from New York City to Niagara Falls in 1839. In her diary she noted her experience at Table Rock, "It is a fearful prospect when, from the water's edge, below, you cast an upward glance, at the tremendous Rock, overhanging the fearful height—the scenery here is very picturesque but borders rather too much on the terrific for my enjoyment, and I felt an anxious timidity, to make my hasty escape to the top of the mountain.—Purchased some specimens of the variety of minerals & departed."[12] This interest in minerals and botany also intrigued Ellen Bond who, like Thomas Cole, collected botanical specimens. She trav-

eled with her family from Cincinnati to Niagara Falls, from Lake George across New York State, and finally to Boston. She included specimens in her travel diary, juxtaposing botanicals with descriptions of her travels to Niagara and historic sites: "We arrived and came to the museum opposite Niagara then to Table Rock, where the greater part has fallen. The view of the falls from the Canadian side is sublime, much better than the one from the American side."[13] It becomes intriguing to note how words such as "picturesque" and "sublime" are used with great frequency; they are not solely the vocabulary of artists such as Cole, Durand, and Church.

Some of the most interesting early descriptions of the scenery of Niagara come from a young Boston artist, Louisa Davis Minot (1788–1858). She published her observations from an 1815 trip to Niagara in the March 1816 issue of *The North American Review*. Her essay, "Sketches of Scenery on Niagara River," provides extensive descriptions of the terrain in addition to the aural atmosphere:

> on approaching the Falls the scene changes. The roar deepens, the spray rises a lofty column of vapour in the heavens, the rapids, which commence about a mile above the brink of the Falls, now shew their white heads, and the current increases its force so fast, as to threaten to bear the frail bark along with it, to the Cataract. The sublimity of this scene is frequently heightened by a thunder storm.[14]

What sets Minot's observations apart from the previously mentioned letters and diary entries are the visual counterparts to her verbal descriptions of the area. The awe, joy, and excitement she experienced firsthand were translated by Minot from text onto canvas. In particular, two paintings by Minot from 1818, both in the collection of the New-York Historical Society, depict the tumult of the American and Horseshoe falls. Measuring thirty by forty inches, Minot's composition of *Niagara Falls* (fig. 5.3 and plate 16) is not merely competent; rather it suggests training and experience. The tumultuous sky, the spray from the falls, and the placement of figures to convey the geographical magnitude of the site result in a convincingly dramatic scene of the splendors of nature. Minot's placement of figures is interesting as well, including a woman in the company of a male companion. She adds what will become the ubiquitous Native American warrior close to the falls in the lower right, while the foreground contains

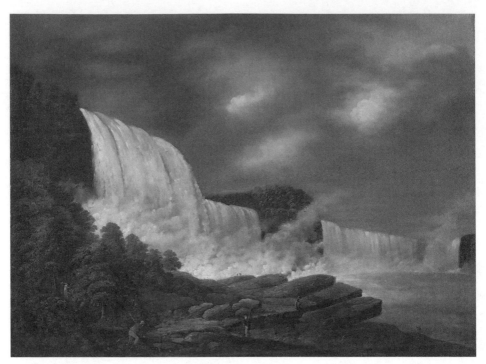

FIG. 5.3. (Plate 16.) Louisa Davis Minot, *Niagara Falls*, 1818, oil on linen, 30 × 40⅝ in. Collection of the New-York Historical Society, gift of Mrs. Waldron Phoenix Belknap Jr., 1956.4.

three men of different cultural and socioeconomic backgrounds. As Linda Ferber and Kathie Manthorne have noted, Minot was the daughter of a solicitor-general and married to a lawyer, and as the area was a recent site of conflict during the War of 1812 (noted by Minot in her essay), the artist's choice to include a variety of individuals, with respect to gender and class, may represent her attitudes toward a free and democratic society.[15]

Minot herself spent time sketching at Niagara. "I sat to take a sketch of the Falls," she wrote, "At that time I was alone."[16] While the popularity of Niagara for travelers and artists alike increased rapidly throughout the nineteenth century, Minot's artistic ability bears noting. Her work appears before Alvan Fisher's *The Great Horseshoe Fall, Niagara* (1820, Smithsonian American Art Museum) and more than a decade before Thomas Cole's *Distant View of Niagara Falls* (1830, The Art Institute of Chicago).[17] Minot's work demonstrates that she was able to travel and experience Ameri-

can scenery directly, yet her access to formal training poses additional questions. It remains important to keep in mind that major figures such as Thomas Cole received little formal artistic training. Although he, unlike Minot, received the benefit of studying copies and casts in the National Academy of Design, and had access to private collections from which to study, there were few established art schools in America at this time. However, private instruction, seminars, and published manuals would soon begin to fill the call for artistic training. As women of a rising middle class developed an appreciation for the American landscape through travel, instruction in the formal expressions of drawing, watercolor, and painting was promoted as part of an expanding educational program for women in the United States.[18] While an artistic career would become a proper vocation for men, artistic training for women was often discussed as part of the preparation for domestic success, making Minot's skill all the more important.

Private instruction in the art of landscape painting became plentiful by the early nineteenth century. Benjamin Latrobe wrote a lengthy treatise for a female student, Susan Catherine Spotswood, the twenty-four-year-old great-granddaughter of the governor of Virginia.[19] From 1798 to 1799, while working on the Virginia Penitentiary, Latrobe composed, "An Essay on Landscape," a two-volume, hand-colored, illustrated discourse on the art of landscape composition. The essay was intended to instruct Miss Spotswood on techniques in design and color. Latrobe provided precise and detailed instruction on color, brush size, and composition but also included stories about his travels and historical notes of interest. In fact, as the first volume continues, it becomes an illustrated letter to a friend, more conversational than instructional; the professional becomes personal, and it remains unclear if Latrobe had intended a more serious relationship with Miss Spotswood, other than as friend and pupil.[20] Latrobe's was not a particularly progressive manual—he ascribed to topographical accuracy and suggested that Miss Spotswood consult engravings after the masters of landscape, such as Claude Lorrain, to instruct in composition and drawing.[21] When commenting on techniques for sketching a single tree, Latrobe waxed poetic on nature as a force, the Chain of Being, and suggested that Spotswood consult Erasmus Darwin's poem, *The Botanic Garden*. Latrobe was clearly influenced by a youthful Romanticism about

the American landscape that would develop into a major compositional force for landscape painters of the 1830s and beyond. Latrobe also advocated for direct observation from nature in the tradition of Pierre-Henri de Valenciennes: "I would recommend to you to amuse yourself by taking every opportunity that offers to you, to sketch trees from nature. . . . By not copying in too great a hurry, you will become a good landscape painter before you are aware of it."[22] Latrobe's drawings of Richmond, Virginia, were included, representative of the "many hundred little picturesque scenes" that he hoped would inspire Miss Spotswood.[23]

Both professional and amateur artists often supported themselves by offering lessons to young men and women. Newspapers were the most common place of advertisement for classes in drawing and painting, in addition to watercolor, miniature work, jewelry, hair work, metalwork, waxwork, and embroidery. John Wesley Jarvis opened a drawing school in 1802, "where Young Ladies and Gentlemen may be taught to draw in Indian ink, Colours, or chalk, on paper, satin, vellum &c. or to paint in oil on canvas. Hours of attendance for Ladies from 11 to 1 . . . Terms 6 dollars per quarter . . . Private lessons 1 dollar."[24] In fact, Thomas Cole's early years in the United States were spent in part in Steubenville, Ohio, where his sisters established a seminary—similar to the hundreds of other educational establishments for young ladies developing in the early nineteenth century. In the April 2, 1820, *Western Herald and Steubenville Gazette,* the Cole sisters offered "Reading, Writing, Plain Sewing, and Muslin Needle work," while "Thomas Cole will instruct . . . in Painting and Drawing, three times a week between six and eight o'clock in the evening."[25] Thus, as an amateur artist, Cole was part of the arts education industry. Likewise, classes specifically for women were offered. *The Drawing Class* (ca. 1810–13; fig. 5.4) depicts an instructor observing the work of a female student while maintaining a physical and professional distance. Another woman has kept her bonnet on, as if eager to get to work upon her arrival to class or perhaps late due to pressing domestic duties, her supplies neatly lain beside her board. These are not women working from nature, sketching *en plein air.* Rather, they are at a physical remove from nature, working on subjects that remain unclear, although two of the four women work facing in the direction of the framed landscape views.

In addition to private lessons and classes, female seminaries for the

FIG. 5.4. Artist unknown, *The Drawing Class*, ca. 1810–13, watercolor over graphite on cream wove paper, laid down on cream board, 14⅔ × 24 in. Art Institute of Chicago, gift of Mrs. Emily Crane Chadbourne, 1951.202.

education of young ladies from financially able families—such as the Mount Holyoke Female Seminary in South Hadley, Massachusetts, and the Troy Female Seminary in New York—had opened in great numbers by the 1830s.[26] Along with the basics of reading and writing, these women were taught, for an additional fee, fancywork (needle skills), drawing, and painting—expected skills of the well educated.[27] Needlework in particular had been considered a standard element of female education from the early republic though mid-century. One student named Mary Connolly embroidered a silk view: *New York from Weehawk*. Made in 1847, while she attended the Ursuline Convent in Quebec, the landscape is embroidered in silk and chenille while the boats are actually painted on. At seventeen by twenty-three inches, it approximates the dimensions of the source for her work, an aquatint engraving of the same title by John Hill made after William G. Wall for the *Hudson River Portfolio* (1821–25).[28] Such work recalls the eighteenth-century tradition of needle painting—the copying of painted or printed works into embroidered form.[29] Frances Palmer, for example, who produced her own view of New York from Weehawk as a

lithograph for Currier & Ives, was in fact taught by Mary Linwood, a well-respected needle painter. Whereas samplers served as technical exercises to practice stitches or record events, Mary Connolly's embroidered pictorial reflects an advanced education and skill in both needlework and landscape composition. Her work should be viewed as no less original than Hill's work after Wall, thus calling for a reconsideration of the defined "canvas." For example, embroideries—like paintings—often were chosen to adorn the wall of a parlor or drawing room for public display. It was an expensive proposition to have one's work framed; framing therefore imbued the object with an aesthetic worth and value over and above the effort required for its production. How does this differ from the value ascribed to a painting by Cole or Durand? Women created exquisite landscape drawings, paintings, and embroideries, often to embellish the home. That these works were never intended to grace an academy wall or garner large commissions should not take away from their value as aesthetic objects. A painting by Cole or Durand in a private collection likely would have shared space in a library or drawing room with framed engravings, hand-painted porcelain, and embroidered needlework.

In addition to private and public schooling opportunities, published manuals became increasingly popular during the nineteenth century, as America's printing industry developed rapidly. Two well-known authors of the most widely read instructional publications are Benjamin Coe and John Chapman. Chapman certainly intended women to gain instruction from his books, as he included vignette engravings of women, not men, drawing from nature at the end of each chapter of his 1847 manual *The American Drawing-Book*.[30] With varying degrees of accomplishment, countless young female students filled their composition books with drawings copied from instruction manuals. Mollie Brooks, for example, was educated with basic drawing skills. Within her drawing book is the figure of a young boy leaning against a tree (fig. 5.5). Her drawing is an obvious copy from page 18 of *George Winchester's Drawing Series* (1851; fig. 5.6).[31] While we do not have extensive biographical information about many of these young women who may have aspired to become artists, their drawings, paintings, and needlework are important documents.[32] Emma Heely made paintings copied from engravings published in magazines and gift books. She became a watercolorist and teacher at the Orphan Asylum

FIG. 5.5. Mollie Brooks's drawing book, 1861. The Winterthur Library, Joseph Downs Collection of Manuscripts and Printed Ephemera. Courtesy, The Winterthur Library.

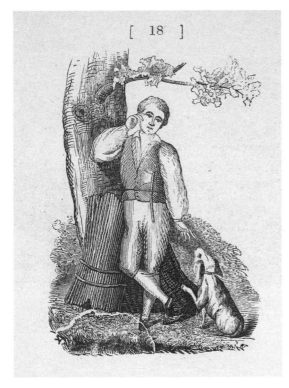

[18]

FIG. 5.6. George Winchester, from *Winchester's Drawing Series, in Four Books; accompanied by Exercises in Perspective,* fourth book (New York: Clark, Austin, & Co., 1851), p. 18. The Winterthur Library, Printed Book and Periodical Collection. Courtesy, The Winterthur Library.

A PIC-NIC PARTY.

FIG. 5.7. Emma Heely, *A Pic Nic Party*, ca. 1844, pen and ink drawing. The Winterthur Library, Joseph Downs Collection of Manuscripts and Printed Ephemera. Courtesy, The Winterthur Library.

in Albany, New York. Having received a diploma from the American Institute in 1846 for her watercolor flowers, she exhibited a series of her paintings there the following year.[33] Her pen-and-ink drawing, *A Pic Nic Party* (fig. 5.7) is clearly a copy of *Pic Nic on the Wissahickon*, an engraving by William Croome for *Graham's Lady's and Gentleman's Magazine* of 1844. The engraving accompanied "The Pic Nic: A Story of the Wissahickon," by Charles J. Peterson, and the scene depicts a group of young women and men enjoying an afternoon on the banks of the river, with a view of Fairmount Park mansions on the hill in the background. *A Pic-Nic on the Wissahickon* is also known as a needlework of wool and silk from Philadelphia (ca. 1850), demonstrating the variety of means by which popular sites in the American landscape resonated with women artists.[34]

Instructional guides also were produced by women artists. Frances Palmer's 1847 *New York Drawing Book: Containing a Series of Original Designs and Sketches of American Scenery* included a series of six lithographs of pastoral views, from which students of art could copy, rather than written instruction. After arriving from England in 1844, Palmer became the most important lithographer for Currier & Ives, producing both original and copied art for the firm. She was undoubtedly responsible for decorating more American parlors than any other artist at mid-century.[35]

Certain instruction manuals in the art of drawing, watercolor, and painting also were written specifically for women. Maria Turner's *The Young Ladies Assistant in Drawing and Painting* (1833) is a concise example of a text aimed at a female audience.[36] Turner instructed on process, form, and materials while providing rules for working with paper, stone, mezzotint, watercolors, and oils, as well as print transfer. In her lesson on landscape painting, she presupposes that her female students have already explored the American landscape:

> If you have ever taken a trip on the majestic Hudson, you will recollect, that the Highlands are reflected nearly in a straight line, from the summit to the base; the reason is, they are perpendicular to the water, or nearly so. . . . And so if you have glided over the beautiful Ohio, you must have seen innumerable trees on the verdant shores of Virginia, Kentucky, and Ohio, and on the enchanting islands on its smooth waters, stretch their plumy heads, as it were, over the space that intervenes, to get a peep at their own images, only reflected in part, on the bright mirror below.[37]

Here is an awareness of the fact that women were traveling to and taking creative inspiration from the American landscape just as their male counterparts were instructed to do. Maria Turner was fully of the opinion that women could, and should, become artists: "Young ladies spend years to acquire their native tongue, in which they are exercised daily; but many are sent to school to learn painting in one quarter. . . . This is a very mistaken idea. Painting, like all other art, is founded on elementary principles; and she who neglects them, or considers the time lost which she spends to acquire them, will fail of success of ever becoming a respectable artist."[38]

Yet prejudice often existed against "learned women," as some viewed education as a disruption from a woman's domestic identity.[39] Even Benjamin Rush was critical of teaching the fine arts to women, as he feared that the time necessary to devote to practice would, upon the onset of a young lady's marriage and family responsibilities, be wasted time in the end: "It is with reluctance that I object to drawing as a branch of education for an American lady. To be the mistress of a family is one of the great ends of a woman's being, and while the peculiar state of society in America imposes this station so early and renders the duties of it so numerous and difficult, I conceive that little time can be spared for the acquisition of this elegant accomplishment."[40] Herein lay an important factor. If Benjamin Rush, an outspoken advocate for the education of women in America, viewed the fine arts as a hindrance to familial duties, when would this change? Clearly Ernst Guhl's essay demonstrates that this pervasive attitude extended well into the nineteenth century.

It is also important to reflect on the historiography of aesthetic education in America and the growing movement to cultivate instruction in the arts. An abundance of printed essays and public lectures was available to both men and women in the early decades of the nineteenth century. William Dunlap, Samuel Morse, Thomas Cole, John Ruskin, and Asher Durand continued the conversation for an eager and interested public.[41] Statistics pertaining to the readership of these essays and treatises do not exist, yet we have reason to believe that they circulated beyond an elite group of interested aesthetes. Who was in the audience at Cole's "Lecture on American Scenery" at the New York Lyceum? A voluntary association, the Lyceum was committed to "ideas meant to instruct and encourage teachers and promote education in common schools."[42] In his 1855 "Letters on Landscape Painting" for *The Crayon*, for example, Durand tells his "student" that to study in the studio of Nature will lead to truthful representation. Technically, Durand explains the importance of form, color, atmosphere, and the sketch, but cautions that his intention was not to teach a student "*how* to paint so much as *what* to paint," recognizing that to provide further instruction "would only be a repetition of what has already been written and published throughout the land."[43] Although Durand employs a gendered vocabulary (his letters begin with "Dear Sir"), *The Crayon* was in no way limited to a male audience. The fifth letter in

the series, for example, appears after an essay directed toward women on the "Aesthetics of Dress," in which the author denounces the recent popularity of ladies' bloomers as undignified.[44] Worn underneath a skirt, bloomers were increasingly adopted by women (artists and tourists alike) who desired both modesty and greater comfort while hiking out of doors. This denouncement was a clear warning for women who may have been encouraged by Durand's advice to study in the "studio of nature."

For a woman in the early nineteenth century, the prospect of becoming a professional artist was daunting. While countless women and men achieved the status of talented amateur artist in the first decades of the nineteenth century, it is important to acknowledge those women who desired to rise above that level. The records of the Pennsylvania Academy of the Fine Arts, for instance, are replete with examples of exhibited landscapes by women artists. A small sampling begins with an unusual entry from Sarah Rogers, who painted her 1811 *Landscape* by holding the brush in her mouth. More conventional works include Mrs. Capron's *Landscape*, with filigree work, of 1812. In the same year, Catherine Groombridge, wife of artist William Groombridge, exhibited an unidentified landscape, while Mary Agnes La Trobe Bateman exhibited "two views from Nature" alongside her brother Benjamin Latrobe's architectural drawings (a remarkable occurrence given the ongoing war). Mrs. Samuel Richardson exhibited eighteen landscapes between 1818 and 1822. Other representative examples include Helen Lawson's *Landscape and Waterfall* (1830), and Emma Peale Peabody's *View on the Wissahiccon after Russell Smith* (1840).[45] Two better-known artists of the antebellum era are Rosalie Kemble Sully (1818–47), daughter of Thomas Sully, who exhibited her landscape paintings in New York in the 1830s, and Jane Stuart (1812–88), who assumed financial responsibilities for her family upon the death of her famous father, Gilbert Stuart, when she was just sixteen.[46] Jane Stuart had served as an assistant to her father, grinding his colors and helping to complete some of his portrait commissions by filling in the backgrounds. Although Gilbert Stuart thought little of his daughter's talent (she was apparently forbidden to enter his studio if he was not present), Jane was an eager student and forged a career at a time when her father's reputation was in question. In 1876, she wrote a series of essays for *Scribner's Monthly*, defending her father's compositions in light of what Dorinda Evans later

postulates was a possible bipolar disorder.[47] Jane Stuart never married (according to Charlotte Streifer Rubinstein, Stuart considered herself "too homely to get married") and supported herself, her mother, and three sisters through commissioned works, including numerous copies of her father's famous portraits of George Washington.[48] Paintings such as *Coach Fording a Stream* (ca. 1825–30; fig. 5.8) demonstrate the training Jane surely received from her father as well as the access she had to painted copies. On the far left, a family makes their way across a shallow portion of a stream set within a larger landscape. The father figure, in military dress, looks away as his wifely companion points to the landscape ahead. While the Stuart family achieved notoriety for portraits, Jane clearly demonstrates her acumen for the well-balanced composition in the tradition of Claude and Rosa. Her foreground is crisp and detailed, while she allows forms to soften and blend with the effects of atmospheric perspective. She frames the view with foliage as the eye moves back into a deep, recessive space leading to an open sky.

Access to instruction, commissions, and exhibition venues would further serve to encourage women artists. Sarah Cole (1805–57), younger sister to Thomas, stands out as an artist of great talent who moved increasingly in New York art circles. Sentimentalized by Thomas Cole's biographer Louis Legrand Noble, Sarah has been described as Thomas's childhood companion, exploring the English countryside while Thomas played his flute.[49] However, she was not merely a copyist of Thomas's work, as some have asserted, but an accomplished artist in her own right. Sarah frequently enjoyed the company of her brother, leaving her family responsibilities in New York to make the journey to Catskill as a single woman. Travel to and from the Catskills, while enabled by sloops, steamboats, and stagecoaches, remained difficult, time consuming, and at times dangerous. Upon her return to the city after a winter visit, Sarah wrote to Thomas on February 13, 1836: "I arrived last evening after a very tedious and disagreeable journey. Mr. T. Thompson will have told you that we did not leave Hudson until late in the evening, as the stages of the Red Bird line were full, and we had to wait for the old line which proved to be very poor and full of passengers, not the most agreeable . . . I was very sick all night, really & actively sick & this Mrs. Newton although she sat next to me never spoke one word to me, I might have died for what any one

FIG. 5.8. Jane Stuart, *Coach Fording a Stream*, ca. 1825–30, oil on canvas, 27½ × 31⅛ in. Wadsworth Atheneum Museum of Art, Hartford, Connecticut, bequest of Daniel Wadsworth, 1848.26. Image copyright © Wadsworth Museum of Art / Art Resource, NY.

would have known or cared."[50] Despite the drawbacks of travel, Sarah was enamored with the scenery of the Hudson and enjoyed experiencing the landscape firsthand. She accompanied her brother and a select group on a hiking expedition to Catskill High Peak in 1838. They went by way of the Clove and camped on the summit of High Peak, and as Thomas noted, the "ladies were delighted with the idea."[51]

Sarah Cole produced numerous paintings. Three of her original works are owned and displayed by the Thomas Cole National Historic Site: *Duffield Church*, *English Landscape*, and *Landscape with Church. A View of*

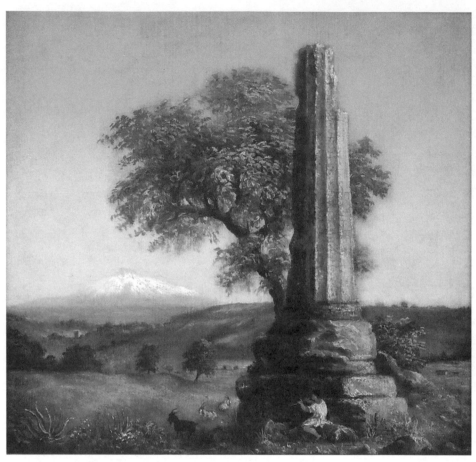

FIG. 5.9. Sarah Cole, *Ancient Column Near Syracuse,* ca. 1848, oil on canvas, 11⅞ × 11⅞ in. Neville-Strass Collection.

the Catskill Mountain House Copied from a Picture by T[homas] Cole (1848) and *Ancient Column near Syracuse* (ca. 1848; fig. 5.9) are two examples of copied works.[52] The latter may have been inspired by Thomas's *Column of Ancient Syracuse,* displayed at his memorial exhibition in 1848; the young boy playing a flute certainly would have brought back fond memories for Sarah. Sarah Cole exhibited paintings at the National Academy of Design, the Maryland Historical Society, and the American Art-Union. Based on sales records, her patrons included collectors from New York as well as from Pennsylvania.

Thomas was aware of his sister's artistic talent and supported her endeavors. In a December 1839 letter to Asher Durand, he wrote:

There is also another object of this letter, which is to ask a favour; but it is for what I will not ask you to grant unless it is perfectly convenient & agreeable—My sister has got a notion of trying to Etch a little—has the implements and had not my time been so fully occupied when I was in The City I intended to have given her information on the subject, such as I planned but I was prevented—Now the favour I ask of you is this—that some day when you are near Laight St. you will have the kindness to call on her & tell her to prepare her Etching materials & you will call again someday when you have a convenient opportunity & spend an hour with her & give her a little information on the subject. I do not wish to impose this thing upon you. I know how you are occupied & how precious your time is but if it does happen that you can do it without inconvenience I shall esteem it a great favour.[53]

Although none of Sarah's etched work has been located, three were listed in the catalogue of the highly publicized 1888 exhibition, "Women Etchers of America," at the Union League Club in New York. So significant was Sarah Cole to the painter-etcher movement that hers were the only non-contemporary works to be included (she died in 1857).[54]

On a personal level, Sarah returned her brother's support and understanding. Their letters often mentioned financial troubles but, during the summer of 1836—a pivotal time with respect to Thomas's *Course of Empire* series and marked by the recent death of his patron, Luman Reed—Sarah also addressed her brother's concern that he was losing his artistic ability. Sarah's response to his self-disparaging words, while loving and encouraging, also reflects their mutual love for landscape painting: "in a little while you will find that the art will return to you, and that you will return to the art with renewed pleasure. The lights and shadows of this life are like the light and shadows of your own pictures. The one makes the other more beautiful, and although we have had many troubles we have not found this life all shadows, it has been now a light and then a shadow, then a light and now a shadow, I really think that your fears of losing your art are groundless."[55] These are compassionate words from sister to brother,

artist to artist. Their relationship remained close until Thomas's death in 1848. In a letter to Jasper Cropsey, John Falconer wrote, "Miss Cole, more lonely yet, knowing more of that good being who had labored so hard to excel & who was to her brother that few can have—the stroke comes doubly hard."[56]

Sarah Cole is only one example of a nineteenth-century woman who traveled, enjoyed the American landscape, was instructed in the fine arts, produced paintings and etchings, and exhibited and sold her work through professional venues. Like the Stuarts and the Coles, the Peale family also included both male and female artists. As Charles Willson Peale and his brother James believed in the democratic education of the sexes, their sisters, wives, daughters, and nieces received artistic training. Harriet Cany Peale (1800–1869), the second wife of Rembrandt Peale, joined the family with financial assets from her previous marriage and a mercantile business. Before their union in 1840, a prenuptial agreement was signed to the effect that Rembrandt would claim possession neither to her property nor to her money. However, she assumed responsibility for maintaining their home during the two decades they were married. Rembrandt's portrait of his new wife shows a demure woman in a thoughtful pose, her forefinger lightly touching her face (The Chrysler Museum, Norfolk, Virginia). An educated and talented artist, Harriet exhibited her paintings at the Pennsylvania Academy of the Fine Arts (Rembrandt was one of its founding members) and the Artist's Fund Society, both before and after her marriage.[57] She often assisted her husband as a copyist of his portraits of George Washington, and was active throughout the 1850s. Paintings such as *Kaaterskill Clove* (see fig. 5.1) suggest that Harriet was well aware of a Ruskinian approach to the depiction of nature. Given the close relationship between Rembrandt Peale and Asher Durand, Harriet Cany Peale would have been well versed in the truth-to-nature philosophy espoused by both men. Her marital status was clearly part of her identity; she invariably signed her compositions "H. C. Peale" (on the front of her canvases) or "Mrs. Rembrandt Peale" (on the verso).[58] The use of her initials concealed her gender to the public (a device consciously employed by later artists such as Mary Nimmo Moran), but her work speaks not of the artist's gender but rather of a desire to capture the awe-inspiring American landscape on canvas.

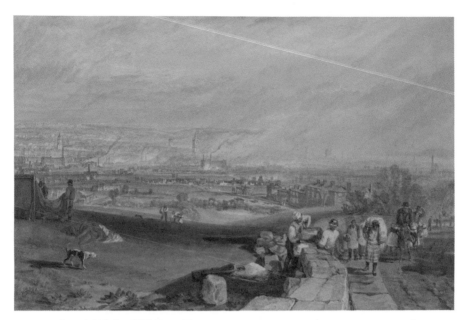

PLATE 1. Joseph Mallord William Turner, *Leeds*, 1816, watercolor, scraping out and pen and black ink, 11½ × 17 in. Yale Center for British Art, Paul Mellon Collection, B1981.25.2704.

PLATE 2. Thomas Cole, *View of Monte Video, the Seat of Daniel Wadsworth, Esq.*, 1828, oil on wood, 19¾ × 26¹/₁₆ in. Wadsworth Atheneum Museum of Art, Hartford, Connecticut, bequest of Daniel Wadsworth, 1848.14. Image copyright © 2011 Wadsworth Atheneum Museum of Art/Art Resource, NY.

PLATE 3. Joseph Mallord William Turner, *Snow Storm: Hannibal and His Army Crossing the Alps*, 1810–12, oil on canvas, 57½ × 93½ in. Tate Britain, Clore Gallery for the Turner Collection, London.

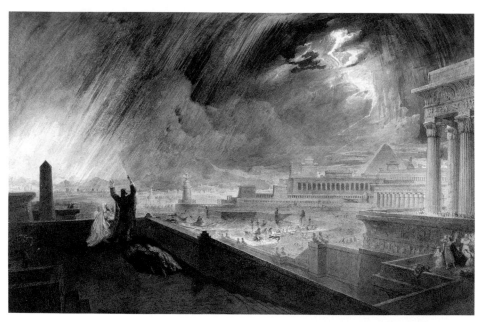

PLATE 4. John Martin, *Seventh Plague of Egypt*, 1823, watercolor, 9½ x 14½ in. Laing Art Gallery, Newcastle.

PLATE 5. Frederic Edwin Church, *Above the Clouds at Sunrise*, 1849, oil on canvas, 27 × 40 in. Property of the Westervelt Collection and displayed in The Westervelt-Warner Museum of American Art in Tuscaloosa, Alabama.

PLATE 6. Frederic Edwin Church, *Storm in the Mountains*, 1847, oil on canvas, 29¾ × 24¾ in. The Cleveland Museum of Art, gift of various donors by exchange and purchase from the J. H. Wade Fund, 1969.52.

(Above). Thomas Cole, *Mountain Ravine in the Catskills* oil on panel, 10⅛ × 25⅜ in. Museum of Fine Arts, Boston, gift of Martha the M. and M. Karolik Collection of American Paintings, 1815–1865. Photograph © 2011 Museum of Fine Arts, Boston

PLATE 8. Andreas Achenbach, *Clearing Up, Coast of Sicily*, 1847, oil on canvas, 32⅞ × 45¾ in. Walters Art Museum, Baltimore, 37.116. Photo © The Walters Art Museum, Baltimore.

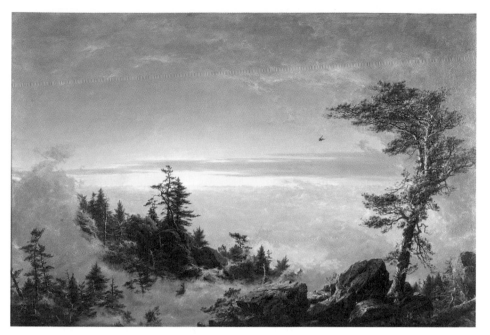

PLATE 5. Frederic Edwin Church, *Above the Clouds at Sunrise,* 1849, oil on canvas, 27 × 40 in. Property of the Westervelt Collection and displayed in The Westervelt-Warner Museum of American Art in Tuscaloosa, Alabama.

PLATE 6. Frederic Edwin Church, *Storm in the Mountains,* 1847, oil on canvas, 29¾ × 24¾ in. The Cleveland Museum of Art, gift of various donors by exchange and purchase from the J. H. Wade Fund, 1969.52.

PLATE 7. Thomas Cole, *View of the Round-Top in the Catskill Mountains*, 1827, oil on panel, 18⅝ × 25⅜ in. Museum of Fine Arts, Boston, gift of Martha C. Karolik for the M. and M. Karolik Collection of American Paintings, 1815–1865, 47.1200. Photograph © 2011 Museum of Fine Arts, Boston.

PLATE 8. Andreas Achenbach, *Clearing Up, Coast of Sicily*, 1847, oil on canvas, 32¼ × 45¾ in. Walters Art Museum, Baltimore, 37.116. Photo © The Walters Art Museum, Baltimore.

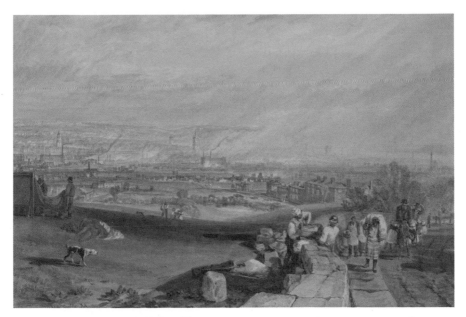

PLATE 1. Joseph Mallord William Turner, *Leeds*, 1816, watercolor, scraping out and pen and black ink, 11½ × 17 in. Yale Center for British Art, Paul Mellon Collection, B1981.25.2704.

PLATE 2. Thomas Cole, *View of Monte Video, the Seat of Daniel Wadsworth, Esq.*, 1828, oil on wood, 19¾ × 26¹/₁₆ in. Wadsworth Atheneum Museum of Art, Hartford, Connecticut, bequest of Daniel Wadsworth, 1848.14. Image copyright © 2011 Wadsworth Atheneum Museum of Art/Art Resource, NY.

PLATE 3. Joseph Mallord William Turner, *Snow Storm: Hannibal and His Army Crossing the Alps*, 1810–12, oil on canvas, 57½ × 93½ in. Tate Britain, Clore Gallery for the Turner Collection, London.

PLATE 4. John Martin, *Seventh Plague of Egypt*, 1823, watercolor, 9½ x 14½ in. Laing Art Gallery, Newcastle.

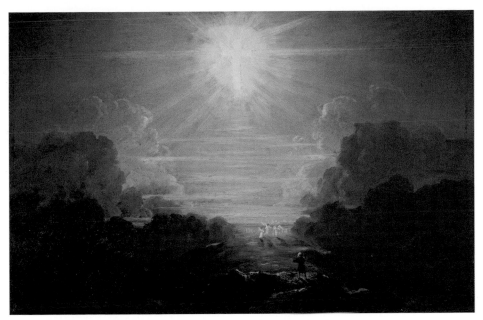

PLATE 9. Thomas Cole, *Study for "The Cross and the World: The Pilgrim of the Cross at the End of his Journey,"* ca. 1846–47, oil on panel, 11⅞ × 18³/₁₆ in. Brooklyn Museum, gift of Cornelia E. and Jennie A. Donnellon, 33.274.

PLATE 10. Sanford Robinson Gifford, *The Palisades,* 1877, oil on canvas board, 5¹⁵/₁₆ × 11½ in. Williams College Museum of Art, Williamstown, Massachusetts, gift of Dr. and Mrs. Gifford Lloyd (78.24.2).

PLATE 11. John F. Kensett, *Long Neck Point from Contentment Island*, 1870–72, oil on canvas, 15⅜ × 24⅜ in. Carnegie Museum of Art, Pittsburgh; purchase; gift of the Women's Committee, 80.51. Photograph © 2010 Carnegie Museum of Art, Pittsburgh.

PLATE 12. Asher B. Durand, *Landscape with Birches*, ca. 1855, oil on canvas, 24¼ × 18⅛ in. Museum of Fine Arts, Boston, bequest of Mary Fuller Wilson, 63.268.

PLATE 13. Sanford Robinson Gifford, *Mist Rising at Sunset in the Catskills,* ca. 1861, oil and pencil on canvas, 6¾ × 9½ in. The Art Institute of Chicago, gift of Jamee J. and Marshall Field, 1988.217.

PLATE 14. John F. Kensett, *Beacon Rock, Newport Harbor,* 1857, oil on canvas, 22½ × 36 in. The National Gallery of Art, Washington, D.C., gift of Frederick Sturges, Jr., 1953.1.1.

PLATE 15. Harriet Cany
Peale, *Kaaterskill Clove*,
1858, oil on canvas, 36 ×
25 in. Private collection.

PLATE 16. Louisa Davis Minot, *Niagara Falls*, 1818, oil on linen, 30 × 40⅝ in.
Collection of the New-York Historical Society, gift of Mrs. Waldron Phoenix
Belknap Jr., 1956.4.

PLATE 17. Susie M. Barstow, *Landscape*, 1865, oil on canvas, 30 × 22 in. Collection of Elizabeth and Alfred Scott.

PLATE 18. Mary Josephine Walters, *Hudson River Scene*, n.d., oil on canvas, 17 × 28 in. Neville-Strass Collection.

PLATE 19. Laura Woodward, *Untitled* (possibly Clarendon, Vermont), 1874, oil on canvas, 15¾ × 23½ in. Collection of Edward and Deborah Pollack.

PLATE 20. Jervis McEntee, *Grey Day in Hill Country*, 1874, oil on canvas, 12 × 16 in. Private collection. Photograph Questroyal Fine Art.

PLATE 21. Jervis McEntee, *The Fire of Leaves,* 1862, oil on canvas, 20 × 36 in. Private collection. Courtesy of Berry-Hill Galleries.

PLATE 22. Jervis McEntee, *Early Spring,* 1864, oil on canvas, 6¼ × 10⅛ in. The Century Association, New York.

PLATE 23. Jervis McEntee, *Winter Storm*, oil on canvas, 29 × 27 in. Private collection.

PLATE 24. William Hart, *Distant View of Albany*, 1848, oil on canvas, 20 × 27 in. Albany Institute of History and Art, purchase, 1942.74.

PLATE 25. Eliza Greatorex, *Landscape near Cragsmoor, N.Y.*, 1863, oil on canvas, 15 × 23 in. Private collection. Courtesy Westmoreland Museum of American Art, Greensburg, PA.

PLATE 26. Julie Hart Beers, *Hudson River at Croton Point*, 1869, oil on canvas, 12¼ × 20¼ in. Collection Nick Bulzacchelli. Courtesy Hawthorne Fine Art.

PLATE 27. Eliza Greatorex, *Joseph Chaudlet House on the Bloomingdale Road,* ca. 1868, oil on canvas, 17 × 33 in. Collection of Ronald and Carole Berg.

PLATE 28. Albert Pinkham Ryder, *Harvest,* early to middle 1890s, oil on canvas, 26 × 35¾ in. Smithsonian American Art Museum, Washington, D.C., gift of John Gellatly, 1929.6.96.

PLATE 29. (*Above*)
Abbott Handerson
Thayer, *Monadnock
No. 2*, 1912, oil on
canvas, 35½ × 35½ in.
Freer Gallery of Art,
Smithsonian Institution,
Washington, D.C., gift
of Charles Lang Freer,
F1913.93a.

PLATE 30. (*Left*)
Abbott Handerson
Thayer, *Winter,
Monadnock*, ca. 1900,
watercolor, gouache,
chalk, and pencil on
paperboard sheet, 20⅛
× 16⅜ in. Smithsonian
American Art Museum,
Washington, D.C.,
gift of John Gellatly,
1929.6.133.

PLATE 31. George Inness, *Early Autumn, Montclair*, 1888, oil on canvas, 30 × 45 in. Collection of the Montclair Art Museum, Montclair, New Jersey. Museum purchase; funds provided by Dr. Arthur Hunter in memory of Ethel Parsons Hunter, the Valley Foundation and Acquisition Fund, 1960.28.

PLATE 32. George Inness, *Old Aqueduct Campagna, Rome, Italy*, 1870, oil on canvas, 8¾ × 13 in. Collection of the Montclair Art Museum, Montclair, New Jersey. Gift of Mrs. Eugene G. Kraetzer, Jr., 1953.38.

Although the aesthetic appeal of landscape paintings by artists such as Harriet Cany Peale is evident, one wonders how—given the cumbersome complexities of contemporary dress—women were able to accomplish the task of getting to those hillside vistas. Even though horses and carriages assisted in transporting individuals to sites of interest, much was accomplished on foot. Women's fashions inflicted on wearers the extra burdens of long (often woolen) skirts, stockings, petticoats, and heels, making their climbs arduous and at times uncomfortable in the heat. Lady travelers could purchase these garments—considered "appropriate" for outdoor excursions—at dry goods and department stores such as John Wanamaker in Philadelphia, Burbank & Enright in Pittsfield, and Horton's of Boston.[59] Such encumbrances are noticeable in Winslow Homer's *The Bridle Path, White Mountains* (1868; fig. 5.10). Riding sidesaddle for modesty, a young woman in a long white dress and gloves guides her horse carefully over the rocky mountains of New Hampshire, without assistance. This is not a study of the forces of nature; the artist focuses on the woman, the horse, and the landscape—in that order. Rather than pair the rugged landscape with a male figure, Homer chooses to highlight the calm and serenity achieved through the experience of nature by a woman. This is a far more graceful account than the one provided from the same location by our *Harper's Weekly* correspondent in 1857. Coincidentally, Homer provided a large inventory of drawings to serve as wood-engraved illustrations for *Harper's Weekly*; his *The Summit of Mt. Washington* (*Harper's Weekly*, July 10, 1869) and *Under the Falls, Catskill Mountains* (*Harper's Weekly*, September 14, 1872) both depict sturdy yet demure women traversing the American landscape.[60]

By mid-century, increasing numbers of women had become educated in the mechanical arts and obtained wider access to formal artistic training at schools such as Sarah Peter's Philadelphia School of Design for Women. From the 1860s onward, as discussed in recent studies by April Masten, Laura Prieto, and Kirsten Swinth, women artists continued to pursue professional opportunities.[61] Despite obstacles, such as inflated tuition for women who wished to study at the Académie Julian, women artists participated in the 1876 Centennial Exhibition in Philadelphia, were involved with the Tenth Street Studio Building and in the painter-etcher movement, and exhibited in the Women's Pavilion at the Columbian

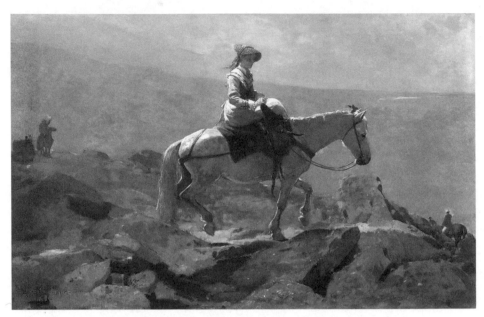

FIG. 5.10. Winslow Homer, *The Bridle Path, White Mountains*, ca. 1868, oil on canvas, 24⅛ × 38 in. Sterling and Francine Clark Art Institute, Williamstown, Massachusetts, 1955.2. Image © Sterling and Francine Clark Art Institute (photo by Michael Agee).

Exposition in 1893. Additionally, Brooklyn became an important location for the support of women artists. The *Brooklyn Eagle* noted in an 1868 "Art Gossip" column, "The number of women artists in New York and its neighborhood has for some time been steadily increasing, so much so indeed, as to justify the formation of a society whose object is to assist those ladies who may need help in the prosecution of their studies."[62]

Artists such as Susie Barstow, Mary Josephine Walters, Laura Woodward, and Eliza Greatorex, for example, demonstrate the varying degrees to which women artists variously struggled, flourished, and earned their living in the arts. What unites each of these artists is their commitment to the formal properties of the Hudson River School, including a Romantic sensibility, picturesque qualities, and well-balanced compositions resulting from direct observation of the American landscape. Susie Barstow (1836–1923) exhibited at the Pennsylvania Academy of Fine Arts and the Brooklyn Art Association, and showed landscapes such as *Sketch from Nature, Pembroke, Mass.* and *Clarendon, Vermont* at the National Academy

of Design in 1858, when her address was listed at 144 Madison Street, Brooklyn. Her works reflect her excursions throughout the Northeast and Europe, from the 1860s to the 1880s. Her Brooklyn studio was certainly well known to many:

> Miss S. M. Barstow has a dainty little studio in her house on Carlton Avenue. All of the rooms show careful decoration, but the back extension, with polished floor, covered with rare rugs, is most assuredly her sanctum. Her specialty is woodland scenes, with shadowy brooks and silver birches, she has a refined face, with her hair artistically curled around her broad, thoughtful brow and expressive eyes.[63]

The description of Barstow's woodland scenes could easily refer to *Landscape* (1865; fig. 5.11 and plate 17). Her mature work of the 1860s reflects a keen awareness of the artistic style of Durand. The framing boughs in the foreground triangulate into the distance as the perspective leads back to an endless sense of depth in this secluded woods. Her use of light, line, and pigment place her works squarely within the quintessential landscape school of the mid-nineteenth century. Barstow continued to paint landscapes throughout her career. A catalogue from the Woman's Work Exchange of 1890 notes two entries by Barstow: *A Camp in the Adirondacks*, offered at $300, and *Sunset in the Woods*, for $150. Close to one hundred paintings by Barstow have been documented, yet few are extant.[64]

Mary Josephine Walters (1837–83) received training from Asher Durand, and has been erroneously described as Durand's favorite woman student. John Durand, in his biography of his father, mentions "Miss Josephine Walters, whom he often advised in the pursuit of her studies," and suggests that she may have accompanied Asher Durand on excursions to the Catskills and beyond in search of scenery to paint.[65] The *Brooklyn Eagle* reported that: "Miss Walters has attained great excellence in landscape painting. Having been a student with Durand, Miss W. seems to have learned the manipulations of that master, and sketches and paints with delicacy and a good deal of elaboration." Walters maintained a studio in the YMCA Building in New York between 1867 and 1875; she lived in Brooklyn, like many other women artists, in the 1860s and 70s, but by 1880 had moved with her mother to Hohokus, New Jersey. Walters did not marry nor did she have children; this freed her from the domestic

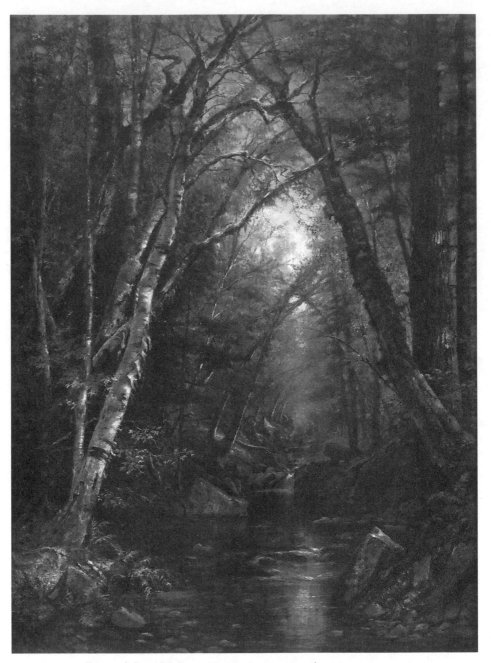

FIG. 5.II. (Plate 17.) Susie M. Barstow, *Landscape,* 1865, oil on canvas, 30 × 22 in. Collection of Elizabeth and Alfred Scott.

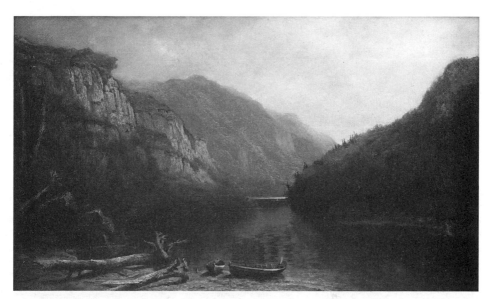

FIG. 5.12. (Plate 18.) Mary Josephine Walters, *Hudson River Scene*, n.d., oil on canvas, 17 × 28 in. Neville-Strass Collection.

expectations of marriage and afforded her time to travel to the woods of northern New Jersey and the Catskills. She exhibited actively at the National Academy of Design, the Brooklyn Art Association, and at venues as far west as the San Francisco Art Association from the 1860s through the 1880s.[66] Her undated *Hudson River Scene* (fig. 5.12 and plate 18) attests to her admiration for the woods and waters of the Hudson Valley. In this romanticized scene, the expansive sky, calm water, and framing mountains are coupled with a diminutive human presence via the canoes in the foreground. The unoccupied boats suggest that this is no longer a place of wilderness but of gentle commingling between man and nature, a notion further reinforced by the planks of wood resting on the naturally felled trees in the foreground.

While most of the artists associated with the Hudson River School stayed in the Northeast, Laura Woodward (1834–1926) and Eliza Greatorex (1819–97) ventured south and west, respectively. Like Sarah Cole and Mary Josephine Walters, Laura Woodward never married, which provided her a greater, if not suspect, sense of freedom and mobility. She traveled and sketched throughout the Catskill Mountains in the early to

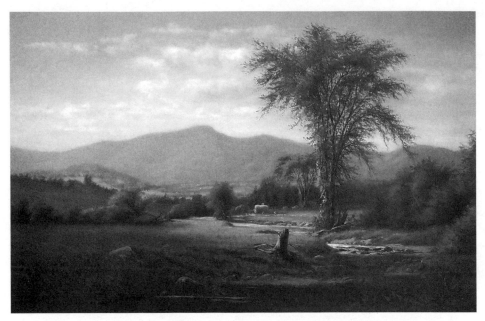

FIG. 5.13. (Plate 19.) Laura Woodward, *Untitled* (possibly Clarendon, Vermont), 1874, oil on canvas, 15¾ × 23½ in. Collection of Edward and Deborah Pollack.

mid-1870s, making plein air studies as far north as Clarendon, Vermont. Her 1874 untitled painting, possibly of Clarendon (fig. 5.13 and plate 19), demonstrates her exceptional skill and clear commitment to the aesthetic qualities of the Hudson River School. She moved to Florida in the 1880s, and as Deborah Pollack has recently noted, her work contributed to the development of Palm Beach as a resort destination.[67] Woodward provided some of the earliest views of the Everglades and the Florida landscape for a growing tourist industry in much the same way that artists such as Cole and Durand provided early romantic views of the Hudson River Valley in the 1830s and 40s.

Widowed early, Eliza Greatorex (who will be discussed at length in a following chapter) educated herself and her daughters in Europe and was part of the painter-etcher movement of the later nineteenth century. Her paintings demonstrate an admiration for the beauty of American scenery and place her work firmly within the Hudson River School. An associate member of the National Academy of Design, she often worked *en plein air*, as per her training, and her palette and depiction of light suggest in-

timate observations of the natural environment.[68] While her East Coast career included exhibiting her work in the Women's Pavilion at the 1876 Centennial Exhibition in Philadelphia, Greatorex ventured west in the early 1870s. *Summer Etchings in Colorado*, a record of her experiences in both images and text, was published in 1873. At a time when government-sponsored expeditions were documenting the American West, and Thomas Moran was producing engravings, watercolors, and panoramic paintings in a revamped Grand Manner style, Greatorex also was exploring that rugged terrain. Her description of Colorado scenery speaks to the perseverance, driving curiosity, and undaunted spirit necessary to seek out and capture on paper or canvas those locales in the American landscape that characterized the nineteenth-century landscape movement:

> I congratulated myself on being finely equipped for the tramp up the Cañon—short walking-dress, stout boots, and veil tied over my much suffering and rebellious nose, for the sun burns fearfully here. . . . My boots seemed most unfit to be trusted, my dress a mere incumbrance [sic], my veil no shield; for looking upward, there rose before us a straight wall of stones, bedded in gritty sand. . . . We, the petticoated ones of the party, tucked our draperies taut and snug, and *went* sliding, slipping, tripping, tumbling, till we felt we must be turning into atoms of an avalanche, whirling down that awful slide till we came breathless and almost stunned to the other side of "The Bath."[69]

While gender and cultural constructs have been contributing factors for this chapter, the paintings themselves reflect the American landscape experience as it evolved in the nineteenth century. As women were painting and sketching in the Catskills, around Lake George, in the mountains of Vermont, or on the rocky ledges of Colorado, they were committed to representing the beauty, awe, and majesty of the national landscape. Formally, their works demonstrate accomplished artistry and a passion for American scenery. Socially, they reflect the efforts of women who maintained individual lives and careers while assuming the collective struggle for women artists in the nineteenth century. In addition to Stuart, Peale, Cole, Barstow, Walters, Woodward, and Greatorex, there are many more women landscape painters of the nineteenth century who deserve schol-

arly attention: Julie Hart Beers, Fidelia Bridges, Charlotte Buell Coman, Edith Wilkinson Cook, Ann Sophia Towne Darrah, Elizabeth Jerome, Mary Blood Mellen—and this is far from a comprehensive list. When Thomas Cole ventured into the Catskill Mountains from the mid-1820s to the late 1840s, he was certainly not alone. It remains important to recast nineteenth-century American women landscape artists, to view them no longer as the exceptions, as Ernst Guhl would have had us believe but, rather, as exceptional.

Notes

I would like to acknowledge the generosity of the following institutions from which I have received research fellowships for this project: Winterthur Museum & Library, the American Antiquarian Society, and The New York State Library. Portions of this research were presented at the College Art Association 2009 Annual Meeting, the CUNY symposium "Home on the Hudson," the Thomas Cole National Historic Site, the Maier Museum of Art at Randolph College, and the Feminist Art History Conference at American University. My research in this area formed the basis for the exhibition, and corresponding exhibition catalogue essay of the same title, "Remember the Ladies: Women of the Hudson River School," at the Thomas Cole National Historic Site, Catskill, New York (May 2 to October 31, 2010), co-curated with Jennifer Krieger, managing partner of Hawthorne Fine Art. I also wish to thank Kathleen Parvin, Georgia Barnhill, Deborah Pollack, Stephanie Strass, David Schuyler, and Eleanor Harvey.

1. "The White Mountain (from our own correspondent)," *Harper's Weekly* (September 12, 1857): 579.

2. Harriet Cany Peale's precise travels in the late 1850s are uncertain. However, Rembrandt Peale's sketchbooks from the 1850s contain numerous sketches from nature in New York State. Given their marital pattern, it follows that she too would have been on those excursions. See Lillian B. Miller, *In Pursuit of Fame: Rembrandt Peale 1778–1860* (Washington, DC: Smithsonian Institution, 1992): 225–26. A second landscape known to have been painted by Harriet in 1858 is in the collection of the Newark Museum, Newark, New Jersey. The location of this scene, as suggested by geologist Robert Titus, is thought to be just below Fawn's Leap. See "Remember the Ladies," *Register-Star,* Thursday, June 3, 2010; www.registerstar.com.

3. Ernst Guhl, "Die Frauen in die Kunstgeschichte," *The Westminster Review* (American edition) 70 (July 1858): 91.

4. Guhl, "Die Frauen in die Kunstgeschichte," 92.

5. This calls to mind Linda Nochlin's 1971 essay, "Why Have There Been No Great Women Artists?" reprinted in Nochlin, *Women, Art, and Power and Other Essays* (New York: Harper & Row, 1988): 145–76. When Nochlin questioned the authority of academic art history, she called for a reevaluation of historical analysis and recognition for the achievements of women artists in the academy through their presence (or lack thereof) in texts and scholarly publications. This study seeks to focus that query to the evaluation of early-nineteenth-century American landscape painting and asks, why have there been no great women artists of the Hudson River School?

6. The boat was later called the *Clermont*. For discussions of the Hudson River see Tom Lewis, *The Hudson: A History* (New Haven: Yale University Press, 2005); Frances F. Dunwell, *The Hudson River Highlands* (New York: Columbia University Press, 1991); and Bonnie Marranca, ed., *Hudson Valley Lives* (New York: The Overlook Press, 1991).

7. Quote from Willis Gaylord Clark in the *Knickerbocker* (1835) as cited in Patricia Cline Cohen, "Women at Large: Travel in Antebellum America," *History Today* (December 1994): 47.

8. Julia Adams, letter book, 1819–1830, Winterthur Museum & Library.

9. Hannah Rogers Mason, "Diary, or an Account of the Events of every day," Boston, 1825, p. 15, Winterthur Museum & Library. Hannah was born in 1806.

10. Rachel Wilmer Diary, 1834, New York State Library. Wilmer refers to Sam Patch, who gained notoriety and fame for his jumps from waterfalls, including Niagara Falls in 1829.

11. *The Hudson Illustrated* (New York: T. W. Strong, 1852), 3.

12. Mrs. James Bogert, "Diary of a Western Town," 1839, Winterthur Museum & Library.

13. Ellen Bond Diary, 1850, New York State Library.

14. [Minot, Louisa Davis], "Sketches of Scenery on Niagara River," *The North American Review* 2 (March 1816): 322. This essay was brought to my attention by Kathie Manthorne in her essay, "Hudson River: Global Thoroughfare," *American Arts Quarterly* 26.4 (Fall 2009), a publication of the Newington-Cropsey Cultural Studies Center.

15. Biographical information about Minot comes from Linda Ferber's essay, "Landscape Views and Landscape Visions," in the exhibition catalogue *The Hudson River to Niagara Falls: 19th-Century American Landscape Paintings from the New-York Historical Society* (New Paltz, NY: Samuel Dorsky Museum of Art, 2009), 11; and Manthorne, "Hudson River: Global Thoroughfare," 3.

16. [Minot], "Sketches of Scenery on Niagara River," 324.

17. For a discussion of landscapes pre-1830, see Edward Nygren and Bruce Robertson, *Views and Visions: American Landscape before 1830* (Washington, DC: Corco-

ran Gallery of Art, 1986). No discussion of women landscape painters occurs in this important exhibition catalogue.

18. For a discussion of women and educational opportunities, see Mary Kelley, "'Vindicating the Equality of Female Intellect': Women and Authority in the Early Republic," *Prospects* 17 (1992): 1–27.

19. Edward C. Carter II, ed., *The Virginia Journals of Benjamin Henry Latrobe, 1795–1798*, vol. 2 (New Haven: Yale University Press, 1977), 457–66.

20. A widower, Latrobe would remarry in 1800, to Mary Elizabeth Hazelhurst. See Carter, *The Virginia Journals of Benjamin Henry Latrobe*, 458.

21. Latrobe, "An Essay on Landscape," in Carter, *The Virginia Journals of Benjamin Henry Latrobe*, 469.

22. Ibid., 511.

23. Ibid., 517.

24. *Mercantile Advertiser*, January 1, 1802, and *Commercial Advertisers*, June 10, 1800, in Rita Susswein Gottesman, *The Arts and Crafts in New York: 1800–1804* (New York: New-York Historical Society, 1965), 6–8.

25. Parker Lesley, "Thomas Cole and the Romantic Sensibility," *Art Quarterly* 5 (Summer 1942): 201, nn. 7–8; *The Western Herald and Steubenville Gazette*, January 29, 1820; April 2, 1820; and August 12, 1820, as quoted in Mary Katherine Donaldson, *Composition in Early Landscapes of the Ohio River Valley: Backgrounds and Components*, PhD diss., University of Pittsburgh (Ann Arbor: UMI, 1971), 102.

26. Mrs. Murray, *Mentoria, or the Young Ladies Instructor in Familiar Conversations* (New York: Robert Moore, 1812); "By A Mother," *Observations on the Importance of Female Education as Maternal Instruction with their Beneficial Influence on Society* (New York: Mahlon Day, 1825). See also Mrs. (Almira H. Lincoln) Phelps, *The Female Student; or, Lectures to Young Ladies on Female Education* (New York: Leavitt, Lord & Co., 1836).

27. Charlotte Streifer Rubinstein, *American Women Sculptors* (Boston: G. K. Hall, 1990), 30.

28. This embroidery is reproduced in Betty Ring, *American Needlework Treasures: Samplers and Silk Embroideries from the Collection of Betty Ring* (New York: E.P. Dutton, 1987), 105. *New York from Weehawk* (24¾ × 15¾ in.) was engraved by John Hill, painted and published by William Guy Wall, and inscribed: "To Thomas Dixon, Esq., this plate is respectfully inscribed by his original serv't. William G. Wall." Collection of the American Antiquarian Society.

29. My thanks to Heidi Strobel at the University of Evansville for discussing needle painting and Mary Linwood with me.

30. J. G. Chapman, *The American Drawing-Book: A Manual for the Amateur, and Basis of Study for the Professional Artist* (New York: J. S. Redfield, Clinton Hall, 1847), 9. For a broad discussion of drawing books, see Peter Marzio, "American

Drawing Books 1820–1860," in *Philadelphia Printmaking: American Prints Before 1860* (West Chester, PA: Tinicum Press, 1976), 9–41.

31. Mollie Brooks, drawing book, 1861, Winterthur Museum & Library. George Winchester, *Winchester's Drawing Series, in Four Books; Accompanied by Exercises in Perspective*, fourth book (New York: Clark, Austin, & Co., 1851), 18.

32. Such is the case with Louisa Clinton. Her *Untitled Landscape*, circa 1824, is a wonderful watercolor study, yet all that is presently known about her is that her art teacher was named Victoria. Her study suggests obvious talent; how that talent developed, we do not know. Louisa M. Clinton, drawings 1825–40, Winterthur Museum & Library.

33. "Paintings copied from engravings by Miss Emma A. Heely," Albany, 1847, 44 leaves, Winterthur Museum & Library. E. Richard McKinstry, *Guide to the Winterthur Library: The Joseph Downs Collection and the Winterthur Archives* (Winterthur, DE: Winterthur Museum & Estate, 2003), 257.

34. *A Pic-Nic on the Wissahickon*, W. Croome, del., engraved by Rawdon Wright & Hatch for *Graham's Magazine* (ca. 1844). Collection of Winterthur Museum & Library. The needlework version is known via M. Finkel & Daughter Antiques, Philadelphia.

35. Palmer worked with her husband, Edmund, as an independent lithographer and part time for Nathaniel Currier until 1851, when she began to work for the firm full time. Upon the death of her husband, Frances assumed the financial responsibility for her family, including her brother, Robert, and sister, Maria. See Charlotte Streifer Rubinstein, "The Early Career of Frances Flora Bond Palmer," *The American Art Journal* 17.4 (1985): 71–88.

36. Maria Turner, *The Young Ladies Assistant in Drawing and Painting* (Cincinnati: Corey and Fairbank, 1833).

37. Ibid., 26.

38. Ibid., introduction.

39. See Nancy F. Cott, *The Bonds of Womanhood: Women's Sphere in New England, 1780–1835* (New Haven: Yale University Press, 1977), 110.

40. See Benjamin Rush's essay, "Thoughts Upon Female Education, Accommodated to the Present State of Society, Manners, and Government in the United States of America" (Boston, 1787), in *Essays on Education in the Early Republic*, ed. Frederick Rudolph (Cambridge, MA: Belknap Press, 1965), 35.

41. See William Gerdts, "The American 'Discourses': A Survey of Lectures and Writings on American Art," *American Art Journal* 15 (Summer 1983): 61–79.

42. See Diana Korzenik, *Drawn to Art: A Nineteenth-Century American Dream* (Hanover, NH: University Press of New England, 1985), 21.

43. Asher Durand, "Letter on Landscape Painting, Letter III," *The Crayon* (January 3, 1855): 66.

44. See *The Crayon* (March 7, 1855): 145. Publications such as *The Crayon* and *Punch* included essays and cartoons satirizing this fashion trend throughout the 1850s, contrasting common sense with fashion sense.

45. *The Annual Exhibition Record of the Pennsylvania Academy of the Fine Arts 1807–1870,* ed. Peter Hastings Falk, reprint of Anna Wells Rutledge's 1955 edition, vol. 1 (Madison, CT: Sound View Press, 1988). Dunlap notes that Benjamin Latrobe married Mary Hazelhurst in 1799. William Dunlap, *A History of the Rise and Progress of the Arts of Design in the United States,* vol. 2 (Boston: C. E. Goodspeed & Co., 1918 [1834]), 231.

46. Charlotte Streifer Rubinstein, *American Women Artists: From Early American Times to the Present* (Boston: G. K. Hall, 1982), 43–45; Elizabeth Fries Ellet, *Women Artists in All Ages and Countries* (New York: Harper & Brothers, 1859), 315; "The Student (Rosalie Kemble Sully)," in John Caldwell and Oswaldo Rodriguez Roque, *American Painting in the Metropolitan Museum of Art,* vol. 1 (New York: Metropolitan Museum of Art, 1994), 353–56.

47. Dorinda Evans, "Gilbert Stuart and Manic Depression: Redefining His Artistic Range," *American Art* 18.1 (Spring 2004): 10–31.

48. Streifer Rubinstein, *American Women Artists,* 43–44.

49. Louis Legrand Noble, *The Life and Works of Thomas Cole,* ed. Elliot S. Vesell (New York: Black Dome Press, 1997 [1964]), 4–5.

50. Sarah Cole to Thomas Cole, February 13, 1836, Thomas Cole Papers, New York State Library.

51. Journal entry October 9, 1838, in Marshall Tymn, *Thomas Cole: The Collected Essays and Prose Sketches* (St. Paul: John Colet Press, 1980), 161.

52. The scene of the Catskill Mountain House is currently in the Albany Institute of History and Art. I appreciate the information on Sarah Cole's painting of the ruins from Stephanie Strass.

53. Thomas Cole to Asher Durand, December 18, 1839, Thomas Cole Papers, New York State Library.

54. Sarah Cole's etchings were never shown at the exhibition as John Falconer, who owned the plates, failed to provide impressions. See Phyllis Peet, *American Women of the Etching Revival* (Atlanta: High Museum of Art, 1988), 11.

55. Sarah Cole to Thomas Cole, July 3, 1836, Thomas Cole Papers, New York State Library.

56. Letter from John Falconer to Jasper Cropsey, February 24, 1848. Collection, Newington-Cropsey Foundation, reproduced in *American Art Journal* 15.4 (Autumn 1983): 76.

57. Miller, *In Pursuit of Fame: Rembrandt Peale 1778–1860,* 226, 234, 280; and George C. Groce and David H. Wallace, *New-York Historical Society's Dictionary of Artists in America 1564–1860* (New Haven: Yale University Press, 1957), 494.

58. Harriet has been discussed primarily as a copyist. Her painting *Braddock Field* (1855) is a copy after Paul Weber. See Carol E. Hevner's entry, "Harriet Cany Peale," in *A Gallery Collects Peales* (Philadelphia: Frank S. Schwarz & Son, 1987), 30. However, as Rembrandt wrote in his "Notes on the Painting Room" (1850), an instructional treatise similar to Durand's *Letters on Landscape Painting* (1855), a copy could serve equally well as an original as it allowed for the wider dissemination of visual imagery as part of the democratization of knowledge in America. Durand encouraged Rembrandt to publish his ideas in *The Crayon*. See Carol E. Hevner, "Rembrandt Peale's Life in Art," *The Pennsylvania Magazine* 110.1 (January 1986): 8. Notations on signatures can be found, for example, in Charles H. Elam, *The Peale Family: Three Generations of American Artists* (Detroit: Detroit Institute of Arts, 1967), catalogue entries on p. 134.

59. Joseph Downs Collection of Manuscripts and Printed Ephemera, Trade Card Collection, Winterthur Museum & Library.

60. Gail S. Davidson, "Landscape Icons, Tourism, and Land Development in the Northeast," in *Frederic Church, Winslow Homer, and Thomas Moran: Tourism and the American Landscape* (New York: Bulfinch Press, 2006), 28, 47. *The Bridle Path* resulted from this series of drawings, which Homer produced on a trip to Mount Washington.

61. April Masten, *Art Work: Women Artists and Democracy in Mid-Nineteenth-Century New York* (Philadelphia: University of Pennsylvania Press, 2008); Laura R. Prieto, *At Home in the Studio: The Professionalization of Women Artists in America* (Cambridge, MA: Harvard University Press, 2001); and Kirsten Swinth, *Painting Professionals: Women Artists and the Development of Modern American Art, 1870–1930* (Chapel Hill: University of North Carolina Press, 2001).

62. "Art Gossip: The Lady Artists of Brooklyn and Vicinity," *Brooklyn Eagle* (March 6, 1868): 2. I am grateful to Deborah Pollack for sharing this information.

63. "Miss Barstow's Dainty Studio," in *Catalogue of Art—Loan Exhibition—Woman's Work Exchange and Decorative Arts Society* (Brooklyn, 1890), 17, courtesy of Deborah Pollack.

64. *National Academy of Design Records: 1826–1860* (New York: New-York Historical Society, 1943), 23; Groce and Wallace, *New-York Historical Society's Dictionary of Artists in America*, 32. See also *Catalogue of Art—Loan Exhibition—Woman's Work Exchange and Decorative Arts Society*, 5. Biographical information can be found in Jennifer Krieger's essay, "Painting Her Way," in *Remember the Ladies: Women of the Hudson River School* (Catskill, NY: Thomas Cole National Historic Site, 2010), 28, in addition to Askart.com.

65. John Durand, *The Life of A. B. Durand* (New York: Charles Scribner's Sons, 1894), 184.

66. "Art Gossip," 2. I am grateful to Stephanie Strass for sharing biographical information from her research files about Walters.

67. Deborah Pollack, *Laura Woodward: The Artist Behind the Innovator Who Developed Palm Beach* (Palm Beach, FL: Blue Heron Press, 2009); see chapter 1 in particular, "Life in the Northeast, 1834–1889."

68. See Peet, *American Women of the Etching Revival,* 57–58; and Kathie Manthorne, "Eliza Pratt Greatorex: One of the Foremost Artists of Her Sex in America," in *Home on the Hudson: Women & Men Painting Landscapes, 1825–1875* (Garrison, NY: Boscobel House and Gardens, 2009), 8. Kathie Manthorne is completing a book manuscript on Eliza Greatorex titled, "Eliza Pratt Greatorex and her Artistic Sisterhood in the Age of Promise (1860s–1870s)."

69. Eliza Greatorex, *Summer Etchings in Colorado* (New York: G. P. Putnam's Sons, 1873), 63–65.

Jervis McEntee

The Trials of a Landscape Painter

Jervis McEntee was a landscape painter whose working career spanned the years from 1850 to 1890. He is probably better remembered as a diarist than as an artist, and indeed he wrote eloquently about his ideals of art yet also expressed frustration at the difficulties of forging a successful career in his chosen profession. McEntee shared with Frederic E. Church, John F. Kensett, and Sanford R. Gifford a love of the American landscape, though his approach to his art differed from that of his more famous friends. Moreover, perhaps because of the subjects he chose to depict and the changing tastes in the market for paintings as the nation's cultural orientation shifted away from the native landscape tradition and toward European directions in art, he encountered frequent, almost chronic financial difficulties that worsened in the changing economy of the post–Civil War years. But even as his bank account suffered, McEntee persevered, establishing a place for himself in the New York art world. A number of his contemporaries—critics, patrons, and fellow artists alike—considered the small, intimate landscapes for which he is best known, and the muted palette of late autumn and winter colors associated with his work, as original and important contributions to the American landscape tradition. McEntee's paintings, his poetry, his deep friendships with

other painters and writers, and his invaluable diary attest to the efforts of an individual struggling to achieve what he considered his rightful place among Hudson River School painters. Although he never achieved the sale prices or critical acclaim of the most celebrated painters of his time, McEntee nevertheless was an important and beloved artist. Yet he was also a troubled individual, as his diary entries reveal self-doubt, chronic frustration, loneliness, and a personality that his best friends considered melancholic. McEntee's psychological struggles undoubtedly shaped the paintings he created.

McEntee (fig. 6.1) was born in Rondout, New York, in 1828, the son of James and Sarah McEntee. The senior McEntee was an engineer involved in construction of the Delaware and Hudson Canal, which brought coal from Pennsylvania to the Hudson River at Rondout and contributed to Kingston's rapid transition from village into city.[1] Educated at the Clinton Institute, a Universalist school in Clinton, New York, the younger McEntee had a poetic and artistic sensibility nurtured by Henry Pickering, a patrician New Englander who boarded with the McEntee family for a time and who exemplified for Jervis the possibilities of a life devoted to intellect and culture. Henry T. Tuckerman's biographical sketch of McEntee in his *Book of the Artists* mentions Pickering prominently and was surely derived from conversations with McEntee, as Tuckerman had a room in the Tenth Street Studio Building while he was working on his history and thus had the opportunity to speak with the artist frequently. According to Tuckerman, Pickering made Jervis his companion on frequent excursions to the countryside beyond Rondout and "naturally awakened in his mind an appreciation of the beautiful, and of artist life as a resource and a pursuit."[2] Although surviving documents do not reveal any professional study in his early years, McEntee sold four paintings to the American Art-Union in 1850 (and a fifth in 1852), which may have persuaded Frederic Church to accept him as a student during the winter of 1850–51.[3] The two men formed a deep friendship that, while not without its tensions, especially as Church's work commanded unimaginably high prices while McEntee struggled to make ends meet, lasted until McEntee's death.

Following his studies with Church, McEntee returned to Rondout where, undoubtedly at the behest of his parents, he took a job in a flour and feed business. Given his poetic and artistic temperament, McEntee

FIG. 6.1. Jervis McEntee, photograph by Napoleon Saroney, ca. 1867. The Century Association, New York.

must have found the job tedious and longed for other outlets for his talents. Following the example of Pickering, who was a published poet, McEntee began writing verse. One of his early surviving efforts, "The Ruin" (1855), a forty-eight-line poem, evokes the familiar landscape of the Catskills:

Afar the soft, blue mountains stand,
 With sloping vales and woods between,
And many a stretch of pleasant land,
 And many a shaded, babbling stream.

The poem describes a once-vibrant building that had decayed to a point where tendrils of sweet-briar covered the walls and swallows darted through window openings and made the hallway their own. The "voiceless home" was filled not with human life but with a "sweet suggestion of the dead." In another, "The Trailing Arbutus" (undated), McEntee celebrates the beloved woodland wildflower that is a harbinger of spring in the northeast:

Pale, timorous flower, thy faint perfume
 That freights the fragrant breeze
Reveals to me thy hidden bloom
 Among the withered leaves.

However timid the arbutus, it weathered the blasts of winter that re-
turned after a succession of warm days and, in a metaphor for rebirth,
opened its "tender, hopeful eyes" each morning. Both poems make pointed
allusion to isolation and the cycles of nature and human life, themes that
would preoccupy McEntee in later years. "The Ruin" ends with the lines:

Dim, dying eyes turn longing back,
 With wishes of the banished heart.

Similarly, "Arbutus" closes with the poet promising to weave a wreath of
arbutus vine each year in memory of departed friends. These early poems
suggest a melancholy that contemporaries attributed both to McEntee and
to his paintings.[4]

While in Rondout, McEntee also began submitting his work to the an-
nual exhibitions of the National Academy of Design. A review of the 1855
exhibition published in *The Crayon,* for example, noted that it included
several of his paintings. In his painting and poetry McEntee clearly was
pursuing the possibilities of artistic life that Pickering had held up to him
as an ideal. The affirmation of having verse published in *Putnam's Monthly
Magazine* and paintings hung at the National Academy surely gave him
the confidence to follow that dream. Perhaps the best demonstration of
his determination to cast business aside and pursue painting as a career
was his decision, prior to 1854, to have architect Calvert Vaux—who would
soon become his brother-in-law—design a small board-and-batten studio
on the family property in Rondout.[5]

In 1854 McEntee married Gertrude Sawyer, the daughter of the prin-
cipal of the Clinton Institute. Prior to the wedding, Vaux designed an
addition to the studio to provide living quarters (fig. 6.2). The home and
studio stood on an elevated site on Weinbergh Hill and afforded what
Vaux described as "an extended view of the Kaatskills and the Hudson,"
a prospect that embraced a range of beautiful scenery—Mount Beacon to
the south, the Catskill high peaks to the west, and the rolling countryside

DESIGN FOR AN ARTIST'S STUDIO.

PLAN OF PRINCIPAL FLOOR.

N.E.VIEW.
SHOWING THE COTTAGE COMPLETED.

FIG. 6.2. McEntee studio and home, Rondout, New York, from Calvert Vaux, *Villas and Cottages: A Series of Designs Prepared for Execution in the United States* (1857; New York, 1864), p. 168.

adjacent to the river in between.[6] McEntee spent part of his wedding day preparing the new house for Gertrude's arrival before traveling to New York City for the ceremony.[7] But even as the young couple settled into happy companionship in their new dwelling, McEntee's ambition called him to the metropolis; in 1858, he took a studio with adjacent living quarters in the recently completed Tenth Street Studio Building. For the next twenty years, until Gertrude's death in October 1878, they would leave Rondout for New York City in October or early November, stay through the winter and early spring as McEntee worked at his profession, then return to their home.[8]

At the Tenth Street Studio Building, McEntee forged enduring friend-ships with Gifford, Kensett, John F. Weir, Worthington Whittredge, and Eastman Johnson. The friends would visit each other's studios for social events as well as for conversation and criticism of their work, and attend lectures, plays, and exhibitions together. One frequent topic of conver-sation was their abiding concern for the state of the National Academy and their profession, especially in the 1870s, as the effects of the long de-pression following the Panic of 1873 adversely affected the art market, and as American paintings faced increasing competition from European works due to changing tastes. Although the artists scattered to different locations during the warmest months—a phenomenon Thomas S. Cum-mings described as the "Summer stampede of artists"[9]—in autumn they often would head off on sketching expeditions with friends. In 1861, for example, McEntee, Gifford, and Whittredge embarked on one of their many sketching tours together, to the Shawangunk and Catskill moun-tains. Whittredge later recalled his delight in accompanying McEntee on outings to the Catskills, as he "knew every nook and corner" of the mountains and "every stepping-stone across their brooks."[10] McEntee and Gifford traveled to Europe for three months in 1863 and for a more extended stay in 1868–69. During these travels, McEntee undoubtedly had the opportunity to study recent developments in European landscape painting as well as the works of the Old Masters, though surviving docu-ments do not reveal what contemporary paintings he studied or what he thought of them at the time. On the second trip McEntee and Gifford met Church and Weir in Rome and sketched the Campagna. One result of this journey was a rare and remarkable collaboration, completed in 1871: McEntee, Church, and George Healy painted *The Arch of Titus* (fig. 6.3), which incorporates the three men in the foreground, Church sketching, the arch just behind and above them, and the Colosseum in the distance. Healy painted the figures, Church the arch, and McEntee the Colosseum. The man and child strolling under the arch are thought to be poet Henry Wadsworth Longfellow and his young daughter.[11]

In subsequent years, McEntee would travel to Mount Desert Island, on the Maine coast, with Gifford; to Cape Ann, Massachusetts, with Gifford and Whittredge; to Mount Katahdin with Church, Gifford, and Eastman Johnson, on several occasions; to Vermont with Church; to eastern Long

FIG. 6.3. G.P.A. Healy, Frederic E. Church, and Jervis McEntee, *The Arch of Titus*, 1871, oil on canvas, 74 × 49 in. Newark Museum, Newark, New Jersey. Image copyright © Newark Museum / Art Resource, NY.

Island with Weir; and to Nantucket with Johnson.[12] When Church was planning a trip to Mexico in the winter of 1889 and his wife Isabel was unable to make the journey because of eye trouble, he invited McEntee to accompany him, promising to pay all his expenses as well as buy a small picture. McEntee asked Church "if he thought my companionship would be worth what it would cost him" and Church replied, "ten times more."[13] Upon their return to New York from these various sketching expeditions, the artists would begin translating drawings and plein air studies into larger canvases for the annual Academy exhibition and potential sale.

McEntee's first acclaimed painting was *Melancholy Days* (unlocated), which earned his election as an associate member of the National Academy in 1860. In his memorial address at McEntee's funeral, Weir noted that the painting had been inspired by William Cullen Bryant's verse:

The melancholy days have come, the saddest of the year,
Of wailing winds and naked woods and meadows brown and sere,
Heaped in the hollows of the groves the withered leaves lie dead,
They rustle to the eddying gust and to the rabbits tread.

McEntee's *Melancholy Days,* Weir asserted, "made his reputation and gave him a permanent place in art." He was elected to full membership in the National Academy the following year.[14] According to Tuckerman, the painting was acquired by fellow artist James A. Suydam and later bequeathed to the National Academy.[15] Perhaps the title of that painting, along with his penchant for depicting the waning days of autumn, as the brilliant foliage was fading, led many of his contemporaries to describe McEntee as melancholic. But there were aspects of the artist's appearance and personality that contributed to this characterization. When inviting McEntee to visit him at his summer retreat in Milford, Pennsylvania, in 1867, for example, Weir wrote, "I long to see your pale and melancholy phiz."[16] Whittredge described the "somber mood" of McEntee's paintings and found in them "a tenderness and loneliness, born of his peculiar disposition, which was not gloomy, but tinged with a gentle melancholy."[17] *Grey Day in Hill Country* (1874; fig. 6.4 and plate 20) exemplifies the mood of much of McEntee's art. Birch trees in the left foreground and in the right middle distance frame the composition. Some leaves remain on the branches, and small flecks of paint give evidence of leaves that have al-

FIG. 6.4. (Plate 20.) Jervis McEntee, *Grey Day in Hill Country,* 1874, oil on canvas, 12 × 16 in. Private collection. Photograph Questroyal Fine Art.

ready fallen. A farm building stands in the distance, and behind it a small spot bathed in light. The dark gray sky that gives the painting its title is broken only at the horizon, where the last rays of the setting sun illuminate the lowest clouds.

McEntee came of age at a time when landscape painting was challenging portraiture as the dominant mode of artistic expression in the United States. Although there was a landscape tradition in American painting before Thomas Cole electrified the New York art world in 1825, it was that artist's success that inspired Asher B. Durand, a talented engraver, to take up the brush and begin painting American nature, and his student John W. Casilear and other artists followed suit. During the 1840s and early 1850s, the American Art-Union, a membership organization that purchased works of art and distributed them through an annual lottery, promoted landscape over other forms of painting. Part of this was practi-

cal: as John K. Howat has pointed out, members of the Art-Union would not be very interested in winning a portrait of someone else's grandfather in the lottery.[18] But the increasing popularity of landscape was also a response to an important current in American thought and culture at the time, a generational search for an American national identity. As a new nation, the United States lacked the centuries of tradition—of history in buildings, the arts, folklore, and culture—that characterized Europe. Sidney Smith's infamous remark demanding to know who had read an American book or attended an American play or looked at an American work of art was a challenge that resonated in the new nation: the United States needed to produce a culture worthy of respect or cede its claim to a place among enlightened nations.[19] An American culture distinct from that of the Old World would necessarily have to rise out of the unique qualities of the New, a landscape largely untouched by the human presence. Perhaps Nathaniel Hawthorne captured this best when he wrote about the difficulties of an author trying to write about a new country, a place "where there is no shadow, no antiquity, no mystery, no picturesque and gloomy wrong."[20] Although Cole believed that the United States did indeed have a history sanctified by the Revolutionary War, most American artists and writers, bereft of tradition, turned to what they believed was distinctive about the United States—its landscape.[21] William Cullen Bryant's advice to Cole, to "keep that earlier, wilder vision bright," was widely shared by fellow artists.[22] Durand's "Letters on Landscape Painting," published in the influential *Crayon,* which became obligatory reading for aspiring artists, advised Americans to stay at home and study nature rather than travel abroad (though Durand and virtually every other significant painter of these generations traveled to Europe to study).[23] During these decades, many artists of the Hudson River School also embraced the influential English critic John Ruskin's dictum of "truth to nature."[24] Studying nature close at hand would ensure a distinctiveness and originality that artists would never attain in museums and palaces or amid the ruins of the Old World.

But if national identity was a critical component in the celebration of the American landscape, so was the ideology of Manifest Destiny, the belief that the United States should extend beyond the Louisiana Purchase territory, across the Rocky Mountains to the Pacific Ocean. If the

search for an American cultural identity through art and literature was one side of "Young America," as numerous commentators described the time, Manifest Destiny was its other, much more aggressive side. William Truettner and his collaborators have demonstrated that landscape painting was at least a complicit component of the ideology of Manifest Destiny, reinforcing a sense that the land was largely unoccupied, or at least underutilized, and that the nation must fulfill its mission in settling the West. Albert Bierstadt's paintings of the Yosemite Valley and Thomas Moran's of Yellowstone and the Grand Canyon acquainted Americans with the wonders of the region and, in a way, asserted that the majesty of the American landscape was comparable to Europe's ancient ruins and centuries of artistic achievement.[25]

McEntee does not fit comfortably into this ideological mix. He lived in a long-settled place and, save for his sketching tours and seasonal residence in New York City, seemed quite content there. If his personality struck contemporaries as melancholic, so did his choice of images for his canvas: whereas many painters of the Hudson River School chose panoramic subjects of spectacular scenery, and layered paint on enormous canvases, McEntee was most comfortable creating smaller pictures of scenes close at hand. To be sure, he did paint at least one large canvas for the annual exhibitions of the National Academy of Design, as well as some distant views in the Catskills, but even in those works he chose a different path than Church, Bierstadt, or Moran. He preferred to portray intimate glimpses of the landscape, especially of the area around Rondout and the nearby mountains. "I don't care for mere scenery or 'views,'" he told George W. Sheldon, "unless they have some peculiar or distinctive character, which makes places that at first are not picturesque really picturesque." To demonstrate this point McEntee added, "From my home in the Catskills I can look down a vista of forty miles, a magnificent and commanding sight. But I have never painted it; nor should I care to paint it. What I do like to paint is my impression of a simple scene in nature." He wanted to capture the thoughts and moods of a landscape, its human and humanized elements, not its more spectacular features. Rather than paint the brilliant colors of autumn, as did so many of his fellow artists, McEntee chose the more muted palette of late fall and winter. To critics who argued that McEntee's landscapes were "gloomy and disagreeable,"

the artist responded, "I would not reproduce a late November scene if it saddened me or seemed sad to me. In that season of the year Nature is not sad to me, but quiet, pensive, restful."[26]

A number of the paintings that McEntee submitted to the National Academy of Design in the early 1860s attracted generous praise, though, like *Melancholy Days*, few of them survive in public or identifiable private collections. *The Fire of Leaves* (1862; fig. 6.5 and plate 21) demonstrates how quickly McEntee adopted a pictorial strategy more akin to Durand than to Church, whose canvases, such as *Heart of the Andes* and *Cotopaxi*, recorded the landscape in fine-grained detail. When McEntee learned of Durand's death in 1886, he described the older artist and mentor as a "sincere and simple lover of the quieter aspects of nature."[27] Those words could have described McEntee's art as well. In *The Fire of Leaves*, the viewer's eye passes between rock outcrops in the foreground, where two children are playing, following a path that leads between the trees. The birches and other trees in the middle distance have dropped their leaves, while the colors of distant trees as well as the sky are muted. Together with the children, the path and building to the right give evidence of a human presence in the landscape, but it is a quiet one. There is nothing panoramic or spectacular about *The Fire of Leaves*, nor anything like the vibrant autumnal colors many Hudson River School artists employed and contemporaries often likened to fire. Instead, the painting evokes contemplation, repose. As the *Evening Post* observed, "there is yet that dreamy solitude about the scene." The reviewer concluded by describing McEntee's approach to painting as "peculiar and original, but always truthful, and often very impressive."[28] *Continental Monthly* praised another early McEntee painting of Mt. Marcy, *Mt. Tahawas, Adirondacks* (1863), as a work of "great simplicity and grandeur" and noted that it "bears the impress of a poet-soul." For this reviewer the painting evoked a "vague stretching forth toward the regions of the infinite, a melancholy remembrance of some enduring sorrow, a tender reminiscence of scenes peculiar to certain heartfelt seasons of the year." As a group, McEntee's four submissions to the 1863 annual exhibition (which included *Twilight, October on the Hudson*, and *Late Autumn*) were "excellent specimens of his tender and poetical mode of handling a subject."[29] *The Woods and Fields in Autumn* (unlocated), exhibited at the National Academy in 1864 and purchased by

FIG. 6.5. (Plate 21.) Jervis McEntee, *The Fire of Leaves*, 1862, oil on canvas, 20 × 36 in. Private collection. Courtesy of Berry-Hill Galleries.

McEntee's dear friend Edwin T. Booth, the celebrated actor, also received favorable reviews. *Continental Monthly* described McEntee's rendering of the trees and the "exquisite harmony of color in his poetic representation of autumn scenery" as deserving "*all praise*."[30]

On November 5, 1864, McEntee joined with fellow members of the Century Association in a celebration to mark the seventieth birthday of William Cullen Bryant. As the beloved poet and editor entered the exhibition hall, he found a display of twenty-five paintings and one sculpture, each a gift from the artist members of the Century. According to Bryant's biographer, John Bigelow, "the most esteemed artists of the country, among them Durand, Huntington, Kensett, Eastman Johnson, Church, Gifford, Gray, Colman, Lafarge, Leutze, Hennessey, J. G. Brown, Bierstadt, McEntee, and Hicks, united in presenting Bryant with a portfolio of pictures from their respective easels." Collectively, the artists were expressing their esteem for Bryant and gratitude for his longtime support of their endeavors. McEntee must have been delighted to participate, as Bryant's poetry had inspired *Melancholy Days*. The small sketch he prepared for the event, *Early Spring* (fig. 6.6 and plate 22), was also inspired by one of Bryant's poems, "The Return of the Birds":

Brown meadows and the russet hill
Not yet the haunt of grazing herds,
And thickets by the glimmering rill,
Are alive with birds.

The painting, unusual for McEntee in its depiction of the spring, has a characteristic white birch tree in the left foreground, just beginning to leaf, with a number of birds on its branches and several feeding on the ground nearby, just as Bryant's verse described. A barn stands in the middle distance. Perhaps most unusual for McEntee is the sky, which is muted, to be sure, but with a coloration almost pastel-like in effect.[31]

Another painting that earned praise from a discerning critic was *Autumn*, one of four paintings he exhibited at the National Academy in 1875. In reviewing that exhibition, the novelist Henry James criticized Thomas Moran's painting of rocks in Utah and expressed the wish that the artist would choose subjects closer to home. James then praised McEntee as "the author of the landscape which most took our own individual fancy—a pond in a little scrubby, all but leafless wood, on a gray autumn afternoon." *Autumn*, James wrote, was "excellent in tone; it is a genuine piece of melancholy autumn" that gave the reviewer a sense of identification with the children playing next to the pond.[32]

If painting simple autumnal scenes from nature was McEntee's professional calling card, he came of age when tastes were changing. McEntee served in the Union cause; he was a devout nationalist who erected a flagpole on the family property in Rondout and almost invariably voted the Republican ticket in elections. But even steadfast allegiance to the nation could not insulate him from forces far beyond his control. The Civil War chastened the American cultural and intellectual elite, many of whom had assumed an inexorable march of national progress. The sheer carnage of battle, the everyday reality of maimed veterans in every small village and town, were constant reminders of a war that shattered American ideals. The aftermath of the Civil War was a time of questioning, of doubts about the nation's direction, especially as Reconstruction ended and immigration from abroad increased, swelling the population of already overcrowded cities. Other troubling changes included the growth of major corporations, the consolidation of wealth, and corruption in business and

FIG. 6.6. (Plate 22.) Jervis McEntee, *Early Spring*, 1864, oil on canvas, 6¼ × 10⅛ in. The Century Association, New York.

politics that led Mark Twain and Charles Dudley Warner to vilify the time as the Gilded Age.[33]

The years from the 1860s to the mid-1870s were the first, most successful phase of McEntee's artistic career. His large paintings apparently sold reasonably well. Of the thirty-eight works he included in the annual National Academy of Design exhibitions between 1861 and 1875, fifteen were sold either prior to or during the exhibition.[34] Moreover, his smaller pictures regularly attracted buyers. Although few surviving letters from the 1860s provide information on sales, on March 5, 1873, he reported selling five of his smaller works to visitors to his studio. At the invitation of Haven Putnam and undoubtedly with the author's assent, McEntee also prepared nineteen drawings to illustrate an edition of William Cullen Bryant's poem *Among the Trees*, which was published in 1874 (fig. 6.7). The illustrations in *Among the Trees* are a curious mix: the first four are landscapes that reflect McEntee's forte, but the remaining fifteen, probably drawn at Putnam's request, contain fussy details and sentimental scenes not otherwise found in his work.[35]

During the first half of his career, McEntee was generally pleased with his work and its reception, both in the press and with the picture-buying

OH ye who love to overhang the springs,
And stand by running waters, ye whose boughs
Make beautiful the rocks o'er which they play,
Who pile with foliage the great hills, and rear
A paradise upon the lonely plain,
Trees of the forest and the open field!
Have ye no sense of being?

9

FIG. 6.7. Joseph S. Harley, engraving after drawing by Jervis McEntee for William Cullen Bryant's *Among the Trees* (New York, 1874). The Century Association, New York.

public. In May 1873, as he was preparing to return to Rondout for the summer, he reviewed his finances and concluded: "I find my receipts have been larger than last year. I have paid off some debts, and looking over the whole field I find after all I have reason to be encouraged."[36] McEntee was especially gratified that he had "gained in reputation" as a result of his recent work.[37] He also took pride in appraisals of his work by knowledgeable individuals. He was delighted, for example, when in 1873 Edmund Clarence Stedman described McEntee as the most "characteristic American artist";[38] later that year the visiting English artist Henry Blackburn told Richard Henry Stoddard and Calvert Vaux that he considered McEntee "the best and most original landscape painter in America."[39]

Three years later, at roughly the midpoint in McEntee's New York career, *The Art Journal* published an admiring account of his work: "Very few American painters have acquired in the broad field of landscape Art, particularly in the illustration of autumn and winter scenes, so prominent a position as JERVIS MCENTEE." The author described McEntee's "tender-toned brown landscapes" as "true impressions of the solemn phases of the season he loves so sincerely to paint" and praised "the purity and originality of his style and the poetical sentiment expressed in his work."[40] In that same year, 1876, the Spanish painter Ignacio de Leon y Escosura, when visiting New York galleries, stopped to admire one of McEntee's paintings. According to the *New York Tribune*, Escosura remarked, "I don't know this artist; I never saw any of his work before; but I know no one in Europe who could do better." John F. Weir wrote McEntee that a number of newspapers around the country had reprinted Escosura's remark and assured his friend, "your stock is up."[41]

Although he occasionally complained that his work was underappreciated and expressed concern about the increasing popularity of European art, McEntee was optimistic in the mid-1870s. But McEntee's stock did not rise as Weir had predicted, and the second phase of his career was much less successful, at least in terms of recognition and reception by the picture-buying public. If the search for an American cultural identity had defined the decades prior to the Civil War, in the years that followed nationalism gave way to cosmopolitanism, what historian Daniel Walker Howe has termed the "international quality of Victorian culture." Howe

argues that the nation's cultural proclivities shifted toward European tastes in the postwar era, and nowhere was this more immediate than in painting.[42] In one of the earliest entries in his diary, in November 1872, McEntee noted that "foreign pictures are pouring in in a perfect deluge." He feared that the market for foreign paintings would leave no place for Americans, especially those who devoted their energies to the landscape.[43]

The influx of foreign paintings, along with a cataclysmic shift in the American art world—from the ascendancy of the Hudson River School to a preference for new, European-influenced styles and Old Masters—took place as McEntee was trying to eke out a living painting landscapes and resulted in disappointing sales. "All I hear about the condition of American art is discouraging," he wrote in 1880.[44] There simply weren't enough people buying paintings. A year later he decried the "neglect of the American Artists" and expressed exasperation over the public's lack of appreciation of his art.[45] McEntee was right to feel discouraged. Between 1876 and 1890 he exhibited forty-one paintings at the National Academy but sold only four.[46] Perhaps nothing demonstrates this change in taste more clearly than events surrounding the death of Sanford Gifford.

In the summer of 1880, an ailing Gifford traveled to the Midwest in the hope that a more salubrious climate would be curative, but to no avail. He returned to New York, where his condition fluctuated, then worsened. Mary Gifford, the artist's sister, telegraphed McEntee that he was living hour to hour; his steadfast friend wrote in his diary that "one by one break the links that hold us to this changeful life."[47] McEntee went to Hudson for the funeral and comforted the grieving family. Along with his fellow artists Weir, Whittredge, and Richard William Hubbard, McEntee carried the casket to the cemetery, where he parted with his sketching companion, genial but constructive critic, and surely his best friend. "As I came home in the twilight," he wrote, "I looked at the beautiful mountains where we had been so much together and which glorify so many of his canvases." For McEntee, the Catskills would thereafter be sacred to the memory of Gifford.[48]

Gifford's death on August 29, 1880, was a signal moment. He was an important figure in American painting, a beloved denizen of the Tenth Street Studio Building who would go anywhere with friends to sketch the American landscape. The Metropolitan Museum of Art recognized Gif-

ford's significant accomplishments with a major retrospective exhibition soon after his death, the first such exhibition undertaken by the museum. McEntee, Richard Hubbard, and Richard Butler were appointed to "collect and arrange Giffords [sic] pictures for exhibition at the Art Museum." As Gifford's closest friend and sketching companion, surely McEntee was the person best able to conceptualize the exhibition and ensure that it represented the artist's accomplishments. He grieved as he pored over sketches and studies and helped organize the museum's acknowledgment of Gifford's career.[49]

But the reaction was nothing that McEntee, Gifford's family, or the museum could have anticipated. The exhibition consisted of 160 of Gifford's sketches, paintings, and drawings, with additional works that spanned the American art world since the days of John Singleton Copley. The *New York Times* praised the exhibition: it was a "highly commendable thing to bring together the works of an artist who has passed away, and thus to pay a tribute of respect to his memory." The *Times* singled out several studies of trees as particularly noteworthy, though it failed to explain why these paintings deserved special praise.[50] But not all reviews were favorable. The worst was a scathing piece in the *New York World* that Eastman Johnson forwarded to McEntee. In a piece titled "The New Loan Exhibition," the *World*'s critic derided the exhibition as consisting of "frightful examples of what should be avoided in art." Gifford, this critic wrote, "belonged to that class of artists who set themselves down deliberately to copy nature, rigidly stifling every attempt at utterance which the poetry and melody of their own souls might make. They were photographic, they were topographic, but they never succeeded in being artistic." But even as the critic dismissed much-beloved fellow Hudson River School artist John Kensett along with Gifford, and characterized the exhibition as the "Gifford Chamber of Horrors," equally upsetting to McEntee was the characterization of a companion exhibit at the Metropolitan Museum devoted to foreign artists. Paintings by Camille Corot, Theodore Rousseau, and others earned the praise not afforded to Gifford or his peers; worse, to McEntee, the critic noted that a rising generation of Americans "have been deeply influenced by foreign art of a true and noble kind."[51]

McEntee was also a member of the committee that organized the Century Association's memorial to Gifford and helped organize the collection

of Gifford's paintings that hung there for the event. At the association's November 19 meeting, Weir, Whittredge, and McEntee delivered orations that gave the full measure of their friend, while Richard Henry Stoddard and Edmund Clarence Stedman wrote poems for the occasion. Gifford and he had become "intimate friends," McEntee wrote, "passing much of the summers together and daily enjoying each other's society during the winter in the city." McEntee praised his friend's gentle spirit, "the very simplicity of his character," and his generosity. After describing the range of Gifford's paintings, he added, "whoever may cavil or question— his fame is secure. There is not a doubt of it and the future will confirm his position among the great landscape painters in the world." Gifford's paintings were "the clear and decisive expression of a profoundly thoughtful and poetic soul."[52]

Eleanor Jones Harvey has positioned Gifford as a key figure in the transition from the mid-century appreciation of landscapes to the emerging tastes of the Gilded Age. She also interprets the exhibition at the Metropolitan Museum as "a symbolic funeral for the fading Hudson River School aesthetic."[53] To be sure, McEntee, Whittredge, and other surviving members of the Hudson River School carried on, but even before Gifford's death McEntee had become keenly aware of the shifting sands of public taste. Years earlier, critics had begun to denounce Hudson River School landscapes for their formulaic qualities, their literal attention to detail, and their lack of poetic sensibility. McEntee's work stood apart from the mainstream of the Hudson River School—at its best it is imaginative and poetic—but he was nevertheless deeply affected by such criticism, both personally and professionally. If a number of his diary entries before 1876 sometimes expressed frustration at his inability to sell paintings or the invasion of foreign taste, after 1876 such complaints increased in frequency and tone. The tenor of these entries was undoubtedly affected by the deep and continuing grief he experienced after his beloved Gertrude's death in 1878, but McEntee was nevertheless describing how much and how rapidly the New York art world was changing.[54]

McEntee's technique as a painter had evolved significantly since his days as a student of Church. Over the course of his career he abandoned the highly detailed portrayal of the landscape favored by Church and Bierstadt and adopted a much looser brush stroke, and he came to believe that

FIG. 6.8. (Plate 23.) Jervis McEntee, *Winter Storm,* oil on canvas, 29 × 27 in. Private collection.

artists needed to paint imaginatively rather than simply record nature.[55] McEntee's *Winter Storm* (ca. 1885; fig. 6.8 and plate 23) is a powerful example of this. The ground is covered with snow, though some grasses and other vegetation are visible, and a deep evening haze suffuses the painting. A stream meanders through the center of the painting, while a human figure walks along a split-rail fence toward a barn in the middle distance and a house with a light in one window. The brushstrokes display a freedom that was not characteristic of McEntee's early work. Although the technique he employed in this painting is usually associated with the Barbizon School—and McEntee certainly had the opportunity to study recent French landscape painting during his two trips to Europe as well as in galleries and exhibitions in New York—nothing in the documentary record suggests a direct connection between Barbizon and his work. Nevertheless, the change did emerge after McEntee's 1868–69 visit to Europe, as the large paintings he completed while in Italy or shortly after returning home retain the careful articulation of detail he learned from Church. He may well have found in the Barbizon School a sense of liberation from the precise depiction of natural features that enabled him to paint with greater freedom, but he remained decidedly hostile to its

artists and their approach to landscape painting, and he deeply resented their popularity in New York. McEntee was quite dismissive of Camille Corot, whose work he found "unsatisfactory,"[56] really "incomplete and slovenly," as he explained to George W. Sheldon,[57] and he believed that "Wall street connoisseurs" were attracted to Barbizon painters more for their reputations than the quality of their art.[58]

As a student of Church and intimate friend of Gifford, Kensett, Whittredge, and Eastman Johnson, McEntee simply could not understand the new art: it didn't conform to all he had learned to value in painting over his long career. In 1884 he visited the exhibition of the Society of American Artists, the group that represented the newer trends in painting, and his comments reveal the chasm separating his world from current taste. "The ignoring of all grace and beauty seems the idea in most of the pictures," he wrote. "The landscapes to me are simply idiotic generally and the most of the collection is foreign to all my ideas of art, poor in color, in conception and exhibiting the utmost poverty of invention."[59] Two years later, he and Whittredge visited an exhibition of French impressionism. McEntee's reaction was predictable: "All that is really Impressionist is to me simply absurd, foolish and unlovely from any point of view." The exhibit, he concluded, "shocks all my ideas of art or even common sense."[60]

One consequence of the ascendancy of the new taste in art was a declining interest in McEntee's work. He found that fewer and fewer people visited his studio, where he had often sold smaller pictures. Those who were interested in acquiring his work often would offer far less than his asking price for a picture, sometimes about half of what McEntee considered fair value. At times he sold paintings at low prices simply because he desperately needed the money. He, Whittredge, and Johnson talked about starting an Art Union to support American art and artists—as opposed to European-trained or influenced painters—by providing a venue for the sale of their work. McEntee hoped that "our strictly American art will grow more into favor if we get an Art Union fairly going" because "people are getting tired of mere decoration."[61] To publicize the Art Union, McEntee and his collaborators began publishing a journal, but other artists refused to cooperate and his vision of a new institution to promote American painting would not be realized.

McEntee's effort to differentiate the native landscape tradition from

the invasion of foreign taste was, ironically, the reverse of the critics and artists who had been denouncing the Hudson River School as a stale, unimaginative artistic tradition that had outlived its usefulness. The new art was decorative, he insisted, not something creative that sprang from American soil.[62] But McEntee's comments were buried in his diary, not published in newspapers and prominent journals. Even if he had made his thoughts public, and written letters to editors or essays for publication, he would not have changed many minds. After all, the people who weren't buying his pictures were not likely to be convinced to sell their new art and buy what McEntee considered American paintings. In fact, the reverse was happening. People were selling their American paintings, often for substantially less than they had paid for them, and buying European art or works by European-trained artists. McEntee described a conversation with the critic George W. Sheldon, a champion of the new direction in art who had seen his painting *Over the Hills and Far Away* at an auction house and complimented the artist on it. McEntee had sold the painting to a Mr. Wickes at the annual Academy exhibition for half its listed price—an indication of how much he needed the money—and two years later the buyer had traded it for "foreign pictures."[63] The problem, as McEntee tersely put it, was that New Yorkers in particular and Americans in general simply didn't appreciate what he considered American art.

Throughout the 1880s McEntee became quite despondent if not outright depressed, and he often found it difficult to concentrate on his art. His finances were so desperate that his old friend Edwin Booth stepped into the breach. Booth had purchased McEntee's *The Woods and Fields in Autumn* in 1864, and when Booth himself had faced challenging financial circumstances, McEntee had helped (some of Booth's possessions were stored in Rondout for more than a decade). Knowing of McEntee's situation, Booth commissioned his friend to paint a series of portraits of him in his most important roles. This was a challenge, as McEntee was not a figure painter, as he put it, but he worked assiduously at the job and Booth was generally pleased with the results. Still, income from the Booth portraits only enabled McEntee to pay current bills; as he was not selling enough other paintings, his future looked bleak. Thus Booth purchased the mortgage on McEntee's Rondout house and studio, as well as on his father's much larger house. With continuing expenses and quarterly in-

terest payments, however, McEntee soon found it difficult to pay his bills once again.[64]

In 1886 McEntee was so desperate for money that he considered trying to sell a number of small painted sketches rather than one or two large canvases. Inspired by an advertisement for John Rogers's statuettes, he thought, "why should not I paint small sketches, frame them simply and tastefully and advertise them at $25 and $50 each." He anticipated that he could easily paint at least one such sketch a day, perhaps two or three, but worried that this marketing approach might devalue his work as an artist.[65] Nevertheless, he enlisted the aid of his nephew, Bowyer Vaux, who took McEntee's draft text and prepared an advertisement for the illustrated monthly *Century*. McEntee enjoyed painting a number of small sketches, but he found the cost of an ad prohibitive and nothing came of this venture.

McEntee continued to move to his New York studio each fall, but found himself isolated there. Though he anticipated few sales, he had no alternative: painting was the only profession he had ever known. Year after year he complained of few if any sales, either from his studio or the Academy exhibitions. McEntee's studio, once a lively place, visited daily by fellow artists and frequently by friends and people interested in viewing his art, was by the 1880s sorely lacking in sociability and potential patrons. Rarely did anyone come to visit. "So far as any interest in my work is manifested," he wrote resignedly, "I might as well be in Patagonia."[66]After a particularly bleak winter in New York, he conceded, "I seem to have dropped out of the public sight as an artist and if I were to die tomorrow I feel I should not be missed."[67] Moreover, the camaraderie of the Tenth Street Studio Building that he recalled so vividly from earlier years was gone—Kensett and Gifford were dead; Church, suffering from debilitating arthritis, was at Olana and rarely came to New York; Weir had long since moved to New Haven, where he was teaching art at Yale; Whittredge had left New York for a house in Summit, New Jersey—and McEntee felt uncomfortable with the new generation that had moved in. On varnishing day at the Academy in 1883, he found that he didn't know most of the artists and only one of the four paintings he submitted was hung on the line. "I could not help the feeling that times have changed since my pictures were a feature of the exhibition," he wrote. "A crowd of young men have come up since

but I look in vain in their work for the spirit which seemed to animate the older artists."[68]

Chronically short of money and with a studio cluttered with unsold paintings, McEntee was desperate. Whittredge had sold seventy-five paintings at an 1887 auction, which brought $12,000. Although Whittredge was "entirely satisfied" with the result, McEntee thought the crowd had assembled to buy cheaply and he fretted that one of Whittredge's best large works had sold for only $400.[69] Nevertheless, at Whittredge's urging, McEntee determined to put seventy-five of his own paintings on the auction block. When he had assembled the pictures for the sale, in February 1888, Casilear came by and, McEntee noted, was "greatly pleased as well as surprised by the variety and excellence of my collection."[70] So did Eastman Johnson, who told McEntee that "they were even more interesting than he thought they would be" and predicted a successful auction.[71] Just prior to the sale the *New York Times* published a favorable review of the collection, so McEntee must have been hopeful.[72] But the result was disastrous: the auctioneer, Ortgies & Company, expected the sale would surpass $10,000, but the bidding was "timid and spiritless." When the final gavel fell, the paintings realized only $6,375. The highest price, for *Fickle Skies of Autumn*, was $350, acquired by Samuel P. Avery on behalf of the Century Association. McEntee felt "humiliated and injured" and took consolation only in the realization that he needed the money so badly.[73]

Depressed as he was, and worn down by years of almost constant worry about making ends meet, McEntee nevertheless returned to his New York studio. He took little solace in the award of honorable mention for one of the works he had submitted to the 1889 international exhibition in Paris.[74] He submitted three small paintings at the 1889 National Academy exhibition and two larger ones in 1890, none of which sold. One of those paintings survives—*Winter in the Country* (1890), which was hung, McEntee wrote, "on the second line in the West room, with disagreeable greenish pictures about it entirely inharmonious with it."[75] The focus of the picture, in the middle distance, is a group of skaters. A man stands to the left, observing them, and patches of grass lead the viewer's eye to the pond. A split-rail fence extends to the left and right from either side of the pond, and dense foliage serves as a backdrop to human activity. Hills stand in the distance and a small flock of birds soars in a sky illuminated by the

sun, which has set just beyond the horizon. The last major work McEntee completed, *Winter in the Country* demonstrates his skillful composition and use of color in evoking the mood of the landscape in a season few other artists attempted to paint.

Even as he continued to work at painting, McEntee felt isolated and obsolete in New York, no longer at home in the place where he had established his reputation and lived a good part of the year for more than three decades. As he returned to Rondout in April 1890, he felt that he "had made little impression as an artist on the people among whom I have lived for the past thirty years" and wondered if he would ever return to New York City.[76] McEntee never did. He traveled to the Maine woods in October and returned to Rondout with failing eyesight and in poor health. The last entry in McEntee's diary, dated November 1, recounted these travails.[77] Learning of McEntee's decline, Whittredge wrote, "there are a great many outside of your kindred who love you and hope for your speedy recovery."[78] But it was not to be. Following McEntee's last diary entry, someone (probably his sister Sara) wrote: "Died Jan 27th 1891 11 A.M. Bright's Disease. Was in bed *sixteen* days."[79]

Weir faithfully traveled to Rondout to deliver an address at McEntee's funeral, which took place on January 30, 1891. He described McEntee's art as "an expression of pure poetic feeling" and stated that "Within the range of his powers he excelled." Weir spoke of McEntee's preference for late autumn and winter landscapes and related them to his personality: "the range of his art was adjusted to the scope of his sympathies in viewing the landscape," he said, "and within these limits he had no superior as an interpreter of Nature." Weir's remarks devoted considerable space to McEntee's personality as well—the purity of his life, his "sparkling wit," his keen awareness of his own limitations, his dedication to his profession and to the National Academy, above all his loyalty to family and friends. Reflecting on more than thirty years of intimate friendship—during which he and McEntee went on sketching trips to the Catskills, the seashore, and Italy, in addition to the time they spent together in New York City—Weir stated, "What now fills my mind in this connection is the thought of the value of that friendship, for it was based upon a reverence for all that is noble and pure and of good report."[80]

The Hudson River School painters were quickly passing away, the once

vibrant group of friends who shared both a camaraderie and a love of the American landscape was becoming smaller and smaller. Only Whittredge joined Weir at McEntee's funeral in Rondout.[81] Church was too infirm to attend, and Daniel Huntington was too ill (as was Booth). Church sent his condolences to Sara McEntee, "You have lost a brother and I a life-long friend—a man pure, upright, and as modest as he was gifted."[82] Huntington described McEntee's death as "a great loss to our circle of artists, to the Academy, the Century, and to the great number of his friends and admirers." Describing the artist as "hearty and keenly appreciative of all that was good and beautiful in nature and art," he stated that the loss of their friend "will be irreparable to all his artistic and literary associates."[83]

The coda was not yet complete. In March 1892, McEntee's estate auctioned eighty-six of his paintings at the Fifth Avenue Art Gallery in Manhattan, the same place where his previous auction had taken place. The *New York Times* reported that "Most of the lots were landscapes, for which the artist was especially noted, and many of them were Autumn scenes in Mr. McEntee's best style."[84] The results were even more dispiriting than the previous auction. Only one painting sold for a substantial price, *Clouds* ($1500), which was purchased by McEntee's Rondout neighbor Sam Coykendall, who had earlier purchased two of the artist's Academy paintings, *Ginevra* in 1875 and *Winter* in 1877. The average price for the other eighty-five paintings was $65, though some sold for as little as $20. If Gifford's funeral was a key moment in the slow decline of the Hudson River School, the McEntee estate auction was its elegy, a testament to how far out of public favor the American landscape tradition had fallen.[85]

Jervis McEntee was part of an important group of artists and writers who were central to New York's cultural milieu for more than thirty years. He was a complicated individual who was much more than a conscientious and insightful if at times opinionated diarist. *The New York Times* described him in 1888 as "a link between the old and new in American art"[86]—between the Hudson River School and recent developments in painting—but it is unlikely that the artist would have felt comfortable with that statement. Whatever stylistic differences there were between his work and that of his mentor Church or other artists associated with the landscape tradition, McEntee was devoted to his friends and fellow artists and deeply resented the new taste in painting that had supplanted

the Hudson River School. As a landscape painter, he developed a distinctive subject, the late autumn and winter landscape, and a style that focused intimately on the scene he was depicting. Worthington Whittredge captured the significance of McEntee's career in his *Autobiography:* "No painter of the period stamped his individuality upon his work more strongly than did McEntee." His paintings, Whittredge observed, were poems.[87]

Notes

For their helpful criticism of earlier versions of this chapter, I am indebted to Nancy Siegel, John K. Howat, Michael Clapper, Charles Beveridge, and Daniel Peck.

1. Kevin J. Avery, "McEntee, Jervis," in *American National Biography*, ed. John A. Garraty and Mark C. Carnes, 24 vols. (New York: Oxford University Press, 1999), electronic edition; John K. Howat, et al., *American Paradise: The World of the Hudson River School* (New York: Harry N. Abrams, 1987), 277–83. On James McEntee, see Nathaniel Bartlett Sylvester, *History of Ulster County, New York, with Illustrations and Biographical Sketches of its Prominent Men and Pioneers* (Philadelphia: Everts & Peck, 1880), facing p. 204.

2. Henry T. Tuckerman, *Book of the Artists: American Artist Life, Comprising Biographical and Critical Sketches of American Artists; Preceded by an Historical Account of the Rise & Progress of Art in America*, reprint ed. (New York: James F. Carr, 1967), 544. Thomas Bailey Aldrich also described Pickering's influence on the youthful McEntee in "Among the Studios. V," *Our Young Folks* 2 (October 1866): 624.

3. Mary Bartlett Cowdrey, *American Academy of Fine Arts and American Art-Union Exhibition Record 1816–1852* (New York: New-York Historical Society, 1953), 238.

4. Avery, "McEntee, Jervis"; "Arbutus" and "The Ruin" were included in *Jervis McEntee: American Landscape Painter* (n.p., 1892): 27–29.

5. J. Gray Sweeney, "McEntee & Company," in *McEntee & Company* (New York: Beacon Hill Fine Art, 1997), 4; "Exhibition of the National Academy. First Article," *Crayon* 3 (April 1855): 118; Calvert Vaux, *Villas and Cottages. A Series of Designs Prepared for Execution in the United States* second ed. (New York: Harper and Brothers, 1864 [1857]), 165–68.

6. Vaux, *Villas and Cottages*, 165; Francis R. Kowsky, *Country, Park, & City: The Architecture and Life of Calvert Vaux* (New York: Oxford University Press, 1998), 64–65.

7. Jervis McEntee, diary, November 1, 1883, Jervis McEntee Papers, Archives of American Art, Smithsonian Institution, Washington, DC. Hereafter cited as McEntee diary.

8. Annette Blaugrund, *The Tenth Street Studio Building* (Southampton, NY: Parrish Art Museum, 1997).

9. Thomas S. Cummings, *Historic Annals of the National Academy of Design . . .* (Philadelphia: G. W. Childs, 1865), 303.

10. Whittredge, *The Autobiography of Worthington Whittredge 1820–1910*, ed. John I. Baur (New York: Arno Press, 1969), 60; Sweeney, "McEntee & Company," 3–13 and Chronology, 36–37.

11. John K. Howat, *Frederic Church* (New Haven: Yale University Press, 2005), 151–52.

12. Sweeney, "McEntee & Company," 3–13, and Chronology, 36–37.

13. McEntee diary, Decemeber 11, 1888, and December 18, 1888.

14. The verse is from Bryant's poem "The Death of a Flower." Weir's "Memorial Address," delivered at McEntee's funeral at Rondout on January 30, 1892, was published in *Jervis McEntee: American Landscape Painter*, 7–13; Tuckerman, *Book of the Artists*, 545.

15. Tuckerman, *Book of the Artists*, 545.

16. John F. Weir to McEntee, October 17, 1867, McEntee Papers.

17. Whittredge, *Autobiography*, 60.

18. Howat, "A Climate for Landscape Painters," in *American Paradise*, 49–70.

19. Sidney Smith's remark was published in a review of Adam Seybert's *Statistical Annals of the United States* (1818), in *Edinburgh Review* 33 (January 1820): 79.

20. Nathaniel Hawthorne, *The Marble Faun: Or, The Romance of Monte Beni* (New York: New American Library, 1961 [1859]), vi.

21. Cole, "Essay on American Scenery," *American Monthly Magazine*, n.s. 1 (January 1836): 1–12.

22. William Cullen Bryant, "To Cole, the Painter, Departing for Europe," in John W. McCoubrey, ed., *American Art 1700–1960: Sources and Documents* (Englewood Cliffs, NJ: Pearson, 1965), 96.

23. Asher B. Durand, "Letters on Landscape Painting. Letter II," *Crayon* 1 (January 17, 1855): 34–35.

24. On Ruskin's influence, see Roger B. Stein, *John Ruskin and Aesthetic Thought in America, 1840–1900* (Cambridge, MA: Harvard University Press, 1967).

25. William Truettner, et al., *The West As America: Reinterpreting Images of the Frontier* (Washington, DC: Smithsonian Institution Press, 1991).

26. G. W. Sheldon, *American Painters: With One Hundred and Four Examples of their Work Engraved on Wood*, enlarged ed. (New York: D. Appleton and Co., 1881), 52–53.

27. McEntee diary, September 19, 1886.

28. "The Academy of Design. Second Notice: The Large Room," *New York Evening Post*, April 17, 1862.

29. "Visit to the National Academy of Design," *Continental Monthly* 3 (June 1863): 717.

30. "An Hour in the Gallery of the National Academy of Design," *Continental Monthly* 5 (June 1864): 686.

31. *The Bryant Festival at "The Century," November 5, M.DCCC.LXIV* (New York: D. Appleton and Co., 1865), 38–42; John Bigelow, *William Cullen Bryant* (Boston: The Riverside Press, 1890), 231; "The Bryant Album," *New York Evening Post*, January 16, 1865; curatorial files, The Century Association.

32. Henry James, Jr., "On Some Pictures Lately Exhibited," *Galaxy* 20 (July 1875): 95–96.

33. See George M. Frederickson, *The Inner Civil War: Northern Intellectuals and the Crisis of the Union* (New York: Harper and Row, 1965) and Drew Gilpin Faust, *This Republic of Suffering: Death and the American Civil War* (New York: Vintage, 2008).

34. Maria K. Naylor, comp., *The National Academy of Design Exhibition Record 1861–1900*, 2 vols. (New York: Kennedy Galleries, 1973), 1: 590–93.

35. McEntee diary, March 5, 1873

36. McEntee diary, June 19, 1874.

37. McEntee diary, May 25, 1873

38. McEntee diary, March 9, 1873.

39. McEntee diary, May 21, 1873.

40. "American Painters.—Jervis McEntee, N.A.," *The Art Journal* 2 (1876): 178. I am grateful to Jessica Waldmann for providing me with a copy of this article.

41. McEntee diary, September 20, 1876 (quoting the *New York Tribune*); Weir to McEntee, October 4, 1876, McEntee Papers.

42. Daniel Walker Howe, "Victorian Culture in America, " in Howe, ed., *Victorian America* (Philadelphia: University of Pennsylvania Press, 1976), 3.

43. McEntee dairy, November 10, 1872.

44. McEntee diary, December 15, 1880.

45. McEntee diary, January 18, 1881.

46. Naylor, *Exhibition Record of the National Academy*, 590–93.

47. McEntee diary, August 28, 1880.

48. McEntee diary, August 31, 1880.

49. McEntee diary, September 24 and 25, 1880. Gifford and McEntee were devoted friends, and Gifford was particularly generous. McEntee was often strapped for money and turned to Gifford at least once for a loan—in 1868, to enable him to accompany Gifford on an extended trip to Europe—and perhaps other times as well. When Gifford was failing, he instructed his sister Mary that McEntee's debt to him be forgiven. McEntee recorded in his diary that this was an act "plac-

ing me, as Mary kindly said with his brothers," who were also indebted to Gifford (McEntee diary, September 4, 1880).

50. "Metropolitan Museum of Art," *New York Times*, October 22, 1880.

51. Undated clipping of the *New York World* in McEntee Papers. In sending McEntee the *World* review of the Gifford Memorial Exhibition, Johnson conveyed his disgust with it and suggested "maybe you would get somebody to horsewhip" the critic. Johnson to McEntee, December 2, 1880, McEntee Papers.

52. McEntee, "Address by Jervis McEntee," *Gifford Memorial Meeting of the Century* (New York: The Century Association, 1880), 49–57.

53. Eleanor Jones Harvey, "Tastes in Transition: Gifford's Patrons," in *Hudson River School Visions: The Landscapes of Sanford R. Gifford*, ed. Kevin J. Avery and Franklin Kelly (New York: The Metropolitan Museum of Art, 2003), 87. See also Doreen Bolger Burke and Catherine Hoover Voorsanger, "The Hudson River School in Eclipse," in Howat, *American Paradise*, 71–90, and Kevin J. Avery, "A Historiography of the Hudson River School," ibid., 3–20.

54. McEntee diary, March 3, 1877, and March 19, 1885.

55. In 1885 McEntee wrote, "Sometimes I question the wisdom of so much actual study from Nature. The fault to my mind, of Modern Art is its realism and I am inclined to believe our pictures would be more interesting if we painted more from our impressions. This idea is not new to me. I know the best things I have done have been produced in this way. An artist should always be open to impressions from Nature and great Artists always are." McEntee diary, September 16, 1885.

56. McEntee diary, March 3, 1877.

57. Sheldon, *American Painters*, 51.

58. McEntee diary, March 19, 1885.

59. McEntee diary, June 12, 1884. See also McEntee diary, March 19, 1885.

60. McEntee diary, April 10, 1886.

61. McEntee diary, April 13, 1883.

62. McEntee described the American landscape tradition as "genuine native expression" and contrasted it with European and European-influenced contemporary painting. McEntee diary, March 31, 1877.

63. McEntee diary, January 18, 1881; May 23, 1878; January 26, 1881.

64. McEntee diary, January 27, 1880, and February 4, 1880.

65. McEntee diary, November 8, 11, 18, and 30, 1886.

66. McEntee diary, April 8, 1886.

67. McEntee diary, April 11, 1887.

68. McEntee diary, March 30, 1883.

69. McEntee diary, March 9 and 26, 1887.

70. McEntee diary, February 9, 1888.

71. McEntee diary, February 17, 1888.

72. "Paintings by M'Entee, N. A.," *New York Times,* March 2, 1888.

73. "Sale of M'Entee Paintings," *New York Times*, March 8, 1888; McEntee diary, March 7, 1888.

74. McEntee diary, December 26, 1889.

75. McEntee diary, April 3, 1890. For a more complete discussion of *Winter in the Country,* see Howat, *American Paradise,* 282–83.

76. McEntee diary, April 19, 1890.

77. McEntee diary, November 1, 1890.

78. Whittredge to McEntee, January 12, 1891, McEntee Papers.

79. McEntee diary, note following the artist's last entry of November 1, 1890.

80. Weir, "Memorial Address," 7–13, 22, 21.

81. An obituary in a Kingston newspaper lists a W. Withridge as attending McEntee's funeral (copy in McEntee Papers).

82. Church to Sara McEntee, January 30, 1891, in *Jervis McEntee: American Landscape Painter,* 22.

83. Huntington to Calvert Vaux, January 28, 1891, ibid., 21.

84. "Paintings by M'Entee," *New York Times,* March 2, 1888.

85. "Sale of M'Entee Paintings," *New York Times,* March 30, 1892; Naylor, *National Academy of Design Exhibition Record,* 1: 592.

86. "Paintings by M'Entee," *New York Times,* March 2, 1888.

87. Whittredge, *Autobiography,* 60.

Eliza Pratt Greatorex

Becoming a Landscape Painter

Positioning the Artist

In August 1867 the *Brooklyn Eagle* dutifully reported the summer activities of the New York–based artists:

> Gignoux, Page, LeClear, Hays, Heath, and Launt Thompson, in the Tenth street Studio Building; Bierstadt, Green, Richards, Hunt, and Mrs. Greatorex in Europe; Church, Gifford, Guy, Hubbard, Hicks, Rossiter and Weir on or near the shores of the Hudson; Casilear and DeHaas on Long Island; Wm. Hart in the White Mountains; Jas. Hart in Cayuga; Coleridge and Martin in the Adirondacks; Beard in Ohio; LaFarge and Thorndike at Newport; Kensett, Baker, Vincent, Collyer and Leutze in Connecticut; Gray and Stone in Lennox . . . Bradford on the coast of Labrador; Melby [sic] on a voyage around the world. What they are all doing we shall hereafter learn from their canvases.[1]

In this pictorial roll call, the name of "Mrs. Greatorex" is sandwiched between those of Albert Bierstadt and Frederic Church. No phrase is necessary to explain her identity; the address of her studio was not required. She was part and parcel of the artistic and social fabric of New York. Everyone

FIG. 7.1. Ferdinand Thomas Lee Boyle, *Portrait of Eliza Greatorex*, 1869, oil on canvas, 30 × 25½ in. National Academy Museum, New York.

in the art world of 1867 knew her, where she worked, and what she painted. Yet the name of the Irish-born Eliza Greatorex (née Pratt, 1819–97; fig. 7.1) is largely absent from our current telling of the history of American art. Pondering how this is possible, why such historical amnesia occurred, is beside the point. The time has passed to complain of gender-bashing, of anti-Irish prejudice, or of neglect suffered by women artists. It was not

Eliza's style to complain, but to act. Our energies should be devoted to revitalizing the career of this remarkable individual. This chapter seeks to reinsert her into the New York art world in which she functioned successfully in the heyday of the Hudson River artists, between 1850 and 1870, when her career trajectory most closely approximated theirs.

How did she and other women negotiate the art world? Did their artistic production differ significantly from their male counterparts? Did they share patrons with them, or did an entirely distinct group of collectors take interest in their work? How did they acquire training? What was their access to fieldwork and travel as they focused on landscape art? These questions and others are answered by following Greatorex's life and art.

Who was Eliza Pratt Greatorex? As Eliza Pratt, she left her native Ireland at about age twenty and moved to New York, where she became the most successful, internationally renowned woman artist before Mary Cassatt. Author Louisa May Alcott had her to tea, actress Charlotte Cushman and her partner, the sculptor Emma Stebbins, stopped in to see her whenever they were in New York. Martha Reed Mitchell—the wealthiest woman in the Midwest—acquired her work, and relied on her advice in shaping her art collection.[2] Within the New York art establishment, Greatorex was hailed as one of the first women nominated to the National Academy of Design, the only woman member of the Artists Fund Society, and a trailblazing woman etcher. She was a founding member of important art colonies at Cragsmoor, New York, and in Colorado Springs. She exhibited widely in New York, around the United States, and across Europe from 1855 through the 1880s. In the post–Civil War era, when emphasis was placed on cosmopolitan experience and training, she spent more time in Britain and on the Continent than George Inness or William M. Chase, who have long been recognized as leading trans-Atlantics. Her pioneering efforts in outdoor landscape painting gave way to pen and ink renderings of historic New York landmarks before she moved toward plein air etching. Connoisseurs praised her evolution from painter to tentative draughtsman to etcher of the modern school, even as she moved from middle into old age. And she did all this as a widow with four children and no property. Just as Asher B. Durand is considered Dean of the Hudson River School, so she was Dean of Women Artists. She was a role model to her artist-daughters Kathleen Honora and Eleanor Elizabeth

Greatorex and to their generation, a rare exemplar of a woman who became a landscape painter.[3]

It is helpful to situate her between two of her better-known sisters, Lilly Martin Spencer and Mary Cassatt. *Kiss Me and You'll Kiss the 'Lasses* (1856; Brooklyn Museum) is a typical work by Spencer, the mother of thirteen children. With her husband as helpmate and manager, she earned a name for herself with still-life paintings and domestic genre scenes. Her work appealed to middle-class audiences, who could identify with her subjects and slightly sassy humor. In *Kiss Me*, a young woman offers the viewer the opportunity to sample the molasses dripping from her spoon, or perhaps even a taste on her lips. While Spencer remained in America, Cassatt lived the life of an expatriate as a single woman in Paris. There she was the only American to exhibit with the French impressionists, and one of the few who could call Edgar Degas "friend." She applied the lessons learned from Japanese prints to her pictures, such as *Young Mother Sewing* (1900, Metropolitan Museum of Art), an example of her signature mother-and-child subject.[4]

The careers of both Spencer and Cassatt overlapped with that of Greatorex, and they shared some of the same features. But Greatorex departed from the other two women in one significant way: they practiced figure painting, with an emphasis on subjects associated with the feminine sphere. Greatorex, by contrast, struck out into the male-dominated field of landscape painting, and reinvented herself several times over during the course of her career, demonstrating immense resourcefulness and talent. A look at her background sheds light on her distinctive artistic life.

She was born in the north of Ireland, in County Leitrim, on Christmas Day, 1819. Her father was a Methodist minister, a follower of John Wesley, and devoted to Christian service as he traveled around the island. Little is yet known about her mother, but she must have been a woman of some standing, for she saw to it that her daughters were well educated by the standards of the day. By the time Eliza arrived in America, she had some artistic training, spoke French, and was sufficiently versed in literature to contemplate a career as an author before she settled on the visual arts.

Many left the British Isles in these decades bound for America. It is important to note that the Pratt family was not part of the famine migration (ca. 1845–55), but had established themselves in New York by 1840.

FIG. 7.2. *Battery and Castle Garden,* after a drawing by Eliza Greatorex in *Old New York: From the Battery to Bloomingdale,* 1875, etching, page size 13⁹⁄16 × 10¼ in. Emmet Collection, Miriam and Ira D. Wallach Division of Art, Prints and Photographs, The New York Public Library, Astor, Lenox, and Tilden Foundations.

They would have seen themselves as distinct in class and cultural background from those later, uneducated, and desperate arrivals. At the same time, however, their religious convictions made them sensitive to social inequalities.

Consider Greatorex's graphic *Battery and Castle Garden* (fig. 7.2). At the time of her arrival in New York (ca. 1840), ships still deposited passengers at one of the many wharves that punctuated the harbor. When she turned her attention to cityscapes, beginning in the late 1860s, this area at the southern tip of the island had become the point of entry for arriving immigrants. The picture, therefore, is not biographically accurate, but an idealized image of a more general experience of arrival in America, associated with new beginnings. Everything we know of Eliza Pratt tells us that she stepped off the ship after a long trans-Atlantic crossing with her head high, deliberate in her movements, and mindful that her father and

younger sibling did not fall prey to waiting thieves. Speaking in an accent we associate more with England than with Ireland, she must have been eager to start her new life in the United States. Ireland would always be in her; after all, she had lived there for the first twenty years of her life. But New York provided a home base during all her years of globetrotting, a safe haven whenever tragedy struck. As a result, Eliza Greatorex's story is inextricably intertwined with that of New York City and of American art.

Entering New York Art Circles, 1850s

Sometime in the late 1840s, Eliza Pratt met and fell in love with Henry Wellington Greatorex, an Englishman who had come to the United States a decade earlier. Greatorex was from a distinguished family. His father Thomas was an astronomer and organist at London's Westminster Abbey.[5] Henry followed in his footsteps, establishing himself as a noted organist and composer of ecclesiastical music. By the time he and Eliza were married in 1849, he was playing the organ at several churches around New York. Throughout their marriage Eliza sang while Henry accompanied her, and as children came along they took their places in the family musical events. They must have been a cultural power couple of their day, and enjoyed an exceptional marriage, supportive of both their careers. For as one historian noted, "She became as famous as her husband, though in a different line of work, for she studied art, and won considerable reputation with her pen and ink sketches."[6] That was a most unusual marital dynamic for the 1850s, shared by only a handful of their contemporaries: John Charles and Jessie Benton Frémont, Seth and Mary Eastman, or George and Libby Custer.

In 1855, Eliza made her debut at the National Academy annual exhibition with a work entitled *Moonlight* (unlocated). The words of a critic emphasize that, by this time, she was already becoming a recognized figure: "Mrs. Eliza Greatorex . . . has been rapidly rising into favor as an artist, and whose landscapes, both in crayon and oil, are now highly appreciated."[7] Her artistic attainments to this point are all the more remarkable when we realize that during the initial years of her marriage, while honing her artistic skills, she cared for Francis Henry (known as Frank, 1846–1905), Henry's son from his previous marriage, and had three children of her own: Thomas Walter in 1850, Kathleen Honora in 1851,

and Eleanor in 1854.[8] For a time, she, Henry, and their children resided in a household with other family members. They managed on fees from Henry's performances, the sale of his music, and lessons he gave, but they seemed to be always struggling financially. What, then, could have inspired her to become a professional landscapist?

During the time Eliza and Henry were courting, Thomas Cole—the founding figure in American landscape art—died. As John Falconer wrote to his friend Jasper Cropsey:

> Thomas Cole is no more; he died on the 11th of February at 8 o'clock in the evening—aged 47 years. His death has spread a gloom not only over the immediate circle of arts professors, but it extends far and near—and the nation may be said to mourn the loss of so great an artist and so good a man—and the press now teems with eulogistic notices.[9]

Given the publicity surrounding not only Cole's death but also his memorial exhibition, held at the American Art-Union in April, it is likely that Henry and Eliza were among the audience there viewing Cole's paintings. Henry's wide circle of acquaintances in Hartford, where he had resided in the early 1840s, included Daniel Wadsworth, Aaron Goodman, and others in Cole's circle, which would have provided added incentive for them to attend his retrospective exhibition.[10] It is not such a stretch to imagine Eliza being inspired by Cole's example to build on the training she received in Ireland, where young women were instructed in drawing and watercolor painting.

As a young artist in New York in 1827, Cole hosted the first meeting of what would become the Sketch Club in his rooms at 2 Greene Street. The Sketch Club provided a gathering place for the city's artists to work and socialize together. Greatorex became "one of the two lady members of the Club," as one journalist reported.[11] The Sketch Club provided a necessary social and professional forum while she was becoming a landscape painter. Most of the Hudson River men were also members, or at least attended occasional meetings. And yet the Sketch Club is not necessarily cited as a key factor in their developments, so what is different here? By 1847 the Century Club had evolved from the Sketch Club; it included many of the same members—that is to say, male members. The Century, like most of

the other clubs in the city, barred membership to women. Given that New York was and is a city of clubs, and that they provided major opportunities for professional networking, it was a hardship for women to be excluded. The Sketch Club therefore provided a rare opportunity for Eliza to interact with some of the leading artists of New York, to work side by side with them in congenial settings (the homes of the host-members), and to meet the important writers, critics, and patrons who also attended the meetings. By 1855 the press was reporting on the productivity and creativity she displayed in her work at club meetings.

Around this time, between 1854 and 1856, she met and began studying landscape with William Wallace Wotherspoon, a fellow club member who had come to America from Scotland. Throughout these years she seemed most comfortable with other former residents of the British Isles as teachers, supporters, and friends. She also sought instruction from William Hart, another member of the Sketch Club and one of a large family who had come from Paisley, Scotland, to settle in the Albany area. Hart's canvases (fig. 7.3 and plate 24) demonstrate his adherence to the Hudson River School principles codified by Cole and Durand, which he passed on to Eliza.

Ambitious for more advanced study, however, she initiated a pattern of leaving her children in the care of family members and heading across the Atlantic. "Went to England and Ireland for drawings of lake scenery in 1856/57," she tells us in her no-nonsense style.[12] There she painted the scenes she sent back to the National Academy of Design: *Glen of the Downs, Ireland*, shown in 1856, and *Wicklow Castle*, shown in 1857 (both unlocated).[13] At the time of the exhibition, *Glen of the Downs, Ireland*, was already in the collection of Madame Bailini, wife of the tenor Francesco Bailini, a member of the Astor Place Opera Company, who often performed in New York.[14] At this early stage in her career, Eliza was already receiving support from the city's musical and cultural elite and, increasingly, from other women.

Also dating from this formative period is *Tullylark near Pettigo, Ireland*, which contains the essence of the artist's approach to landscape art. Small in scale, it represents a picturesque Irish village on the border between the present-day counties of Donegal and Fermanagh. Eliza tended to favor settled over wild nature, and rendered the whitewashed façade of the Tul-

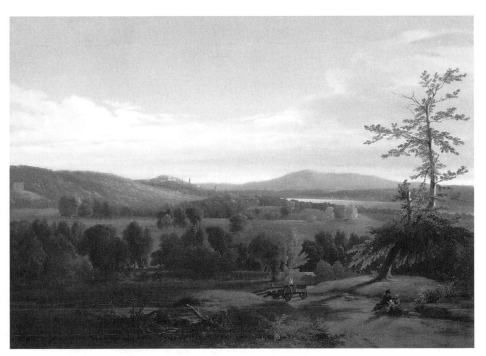

FIG. 7.3. (Plate 24.) William Hart, *Distant View of Albany*, 1848, oil on canvas, 20 × 27 in. Albany Institute of History and Art, purchase, 1942.74.

lylark homestead nestled among the vegetation. Like many of her other compositions, this one is bifurcated: one half is filled with a screen of trees, while the other features a lower horizon and fuller expanse of sky. She applied the paint in broad strokes of green and brown to suggest rather than detail the foliage and foreground terrain. The scene is contained in an arch-shaped frame, a format which harks back to earlier times, as does her subject. There is a romantic air about the picture, a striving to capture a feeling about nature and history rather than a portrait of the place. It emits nostalgia for a past time when man and nature were in harmony.

Her deep feelings for nature were expressed not only in pictures but also in poetry, a duality that had been characteristic of Cole. As noted in an 1855 issue of the *Knickerbocker* magazine, "At a late meeting of *The New-York Sketch Club*, the subject for illustration being 'Spring,' Mrs. Eliza Greatorex, in addition to a very beautiful drawing, contributed . . . exquisite verses, which were read before the Association by Mr. James Cafferty,

the host of the evening." Taking up the age-old theme of the passage of the seasons, Greatorex wrote:

> The meadows by the silver stream,
> The hawthorn in the glen,
> Are laughing out again,
> And ragged Robin-run-the-bush
> Is busy with his chain,
> Clasping the blushing briar-rose,
> That seeks escape in vain.[15]

In this single verse (which occurs midway through the poem) she conveys a view of animate nature. She emphasizes the inevitability of its cycles, the impossibility of escaping from its patterns, but at the same time captures the small joys to be gleaned from each element of its passing phenomena. For the *Knickerbocker* editor, her poem was "delicate and felicitous,"[16] aligned with a Romantic sensibility that looked to nature as a beneficial force, a source of sensual pleasure, moral instruction and, of course, artistic inspiration. She looked not to the crashing waterfalls of the sublime, but rather to the quiet "silver stream" of the picturesque. Although she faced the changes of the modern world, and arguably lived a liberated life, she was at heart a child of the late eighteenth century.

Also like Cole and his followers, Greatorex grounded her Romantic feelings for nature in direct study of it, at times identifying these origins by title. In 1858 she exhibited a work entitled *Sketch from Nature* at the Academy, followed in 1859 by *Study from Nature* (owned by a Mrs. Owen); *Village in the North Countrie, Ireland—Sketch from Nature*; and *Ross Castle, Killarney, Sketch from Nature*.[17] This empirical impulse must have been present from the moment she became interested in art, drawing flowers, trees, and the venerable buildings back in Ireland. Her picture-making linked a Romantic sensibility with direct observation of what she saw in front of her, a blending of the ideal with the real. Her contemporaries, after all, wanted neither a totally idealized work nor one that was too literal. She was a realist, in the sense that she had to work before the motif, at least in the early phase of the picture's creation. Sometimes she talked about her struggles with direct observation from nature, and the need to offset that with the demands of making a pleasing picture. "I am trying

in earnest to make my pictures like the real places," she explained.[18] That effort underlies all her work. She had no choice but to head out into the field, whether the men liked it or not.

Re-inventing Herself for the 1860s

Eliza Greatorex returned from Europe in the late fall of 1858, only to discover that her life had been permanently altered. Her beloved husband Henry had been performing in Charleston, South Carolina, when he was stricken with yellow fever and died. She was now a widow with four young children and no ready income. Among the many challenges she faced, none was more pressing than the support of her family. Her sister Matilda Despard traced her resolve to succeed as a professional artist to that moment: "Drawing and painting had been her gift always; but not till adverse fortune and her early widowhood had forced her from the dearly loved retirement of domestic life, did she dream of making it her profession and the bread-winner of her four children."[19] These comments may have been prompted by a desire to cloak Eliza's artistic ambitions in the mantle of maternal duty. For we have seen, and contemporary commentary reinforces the fact, that before Henry's death she was already functioning as a professional painter. Consider the praise of Elizabeth Ellet in her groundbreaking book, *Women Artists: In All Ages and Countries*, which appeared in 1859:

> Mrs. Greatorex is a landscape painter of merit, and is rapidly acquiring distinction. She has a deep love of wild mountain and lake scenery, dark woods, and rushing waters; and her productions are marked by the vigor of tone and dashing, impetuous freedom of touch especially adapted to that kind of subjects [sic].[20]

This appraisal marked a milestone for the artist, who "has painted many pieces of romantic scenery in Scotland and Ireland," which she had been exhibiting in New York since 1855. Furthermore, Ellet deliberately emphasized traits in her work that were generally regarded—by male critics—as the province of male artists: "This felicitous boldness she has in a remarkable degree, and her works are marked by truthfulness as well as strength."[21] At that time, women artists were rarely credited with being strong, bold, or true. The study she pursued throughout the 1850s had

brought her to this moment, when she was now pressed to make a living by the sale of her landscapes.

Following her husband's death, Eliza moved her brood up the Hudson to live with her sister. Long before the term "single mom" was coined, Eliza was faced with the dilemma of how to pursue landscape painting while caring for her sons and daughters. A journalist explained her solution: "When her children were a little older the family moved to Cornwall-on-the-Hudson, where they lived with Mrs. Despard . . . The little girls and their brother, with their cousins of similar age, made a solid body of young recruits in the service of art, for here began their first instruction and experience."[22]

Eliza began planning another trip to Europe, where she found the people and pace of life therapeutic. She also felt the need for additional training, and perhaps for the imprimatur of the Barbizon style then coming into fashion. Early in 1861 (likely before war broke out), she left her children with her sister and their cousins and headed for France, where she lived for a year: "The facilities for art studies in New York were very few . . . and in the spring of 1861 she went to Paris to study in the atelier of Edouard Lambinet. Here her natural feeling for color found great development."[23] Few details have been recorded about her study with Lambinet, a minor painter of the Barbizon School, who would have advocated that she divide her time between working in the field and viewing art collections, from Old Master to nineteenth-century French pictures.

Upon her return, she resumed the patterns of the Hudson River painter with renewed vigor, retiring to the studio for the winter and spending late spring to early fall in the field. The accepted wisdom is that social conventions prevented women from plein air work. Yet all evidence points to the fact that Eliza and her female compatriots headed out into the field to sketch. Even before her trip to France, it was reported that "Mrs. Greatorex went daily upon her sketching excursions, accompanied by this guard of youthful enthusiasts."[24] But after Europe, her commitment to outdoor work strengthened: "on her return from a year's close study, she applied her newly acquired knowledge to making many fresh and strong studies of American scenery: on the Hudson, on Lake George, in Maine and New Hampshire, where her summers, always filled with earnest, arduous work, were spent."[25]

FIG. 7.4. (Plate 25.) Eliza Greatorex, *Landscape near Cragsmoor, N.Y.,* 1863, oil on canvas, 15 × 23 in. Private collection. Courtesy Westmoreland Museum of American Art, Greensburg, PA.

A canvas she produced soon after her homecoming, *Landscape near Cragsmoor, N.Y.* (1863; fig. 7.4 and plate 25), depicts a locale on the edge of the Shawangunk Mountains. Comparison to the earlier *Tullylark near Pettigo, Ireland,* reveals a more sophisticated handling of paint and glazes, and an ability to balance specific details with general effect. She has moved from intimacy of the Irish landscape to the expansive space of upstate New York. *Landscape near Cragsmoor* embodies something of "the special-green vision" and "the sunny, silvery sky, the shady, woody horizon," as a character in Henry James's *The Ambassadors* fondly recalled of her teacher Lambinet.[26] Stylistically, Greatorex achieved her own synthesis of the Franco-American traditions.

Working Out of Doors

After sketching a scene, Greatorex would return to the motif several times over the following days to compare her picture against the original. Had she captured the look of the place? Had she selected the most advantageous point of view? Often she would revisit a motif under different conditions of light and from different angles of view, to rethink her approach. During her later excursion to Colorado, in the summer of 1873, she wrote: "Coming to the entrance of the cañon this morning very early, I turned to look

FIG. 7.5. (Plate 26.) Julie Hart Beers, *Hudson River at Croton Point*, 1869, oil on canvas, 12¼ × 20¼ in. Collection Nick Bulzacchelli. Courtesy Hawthorne Fine Art.

at the fountain playing in front of the house, and find I have not taken the best view. It is lovely now, when the trees make a somber background. . . . I stop to note down this new idea."[27] This incident reflects her long-time practice of revisiting and revising her motifs.

Did she travel alone on her painting excursions to upstate New York and New England, or did she go with a group? The male artists already had their regular companions and preferred sites, and probably would not have welcomed a female interloper. Julie Hart Beers, sister of her early teacher William Hart, was a more likely cohort for Eliza. In works such as *Hudson River at Croton Point* (fig. 7.5 and plate 26), Beers created a freshly observed composition of the lower Hudson. Note the figures on the path, seen from the rear; clearly a woman and a young child, they are likely the artist herself and her young daughter.[28] Greatorex too took her children with her, and confessed that she found their excursions liberating: "At last these children understand that I am just as young at heart as they, while I am at my out-of-door work, and I share their confidences and enter into their plans beautifully."[29]

Accustomed to having children around while she sketched, Greatorex developed the ability to focus on her work even while chatting with on-lookers or minding the youngsters, who might be running about, bringing her flowers and other specimens. Then as now, passersby would stop and stare at an artist at work, but her powers of concentration were such that: "it is quite the same to me that there is a storm coming, and that excursionists pass by, curiously peering at me."[30] This passage further confirms that women were beginning to take their easels, umbrellas, and paint boxes into the field, and Greatorex proves that they were coming home with studies that could be transformed into finished pictures, paintings that would hold their own with the work of their male counterparts.

It is difficult to reconstruct exactly what kind of sketching paraphernalia Greatorex and Beers carried around with them. Perhaps it resembled that of their associate Fidelia Bridges (1834–1923), whose carte de visite (ca. 1864; fig. 7.6) portrays her as an outdoor painter. She is dressed like a Zouave regiment *vivandière*, her skirt extending to just above the ankle, where a dark, geometric pattern reinforces the hemline. Her attire projects a severe, slightly military air: a deliberate contrast to the Second Empire–style dresses then worn by women in the parlor. She holds her field-sketching equipment: a wooden paint box with shoulder strap and folding umbrella. Frederic Church had a similar wooden sketch box which, when opened, served as an easel, with the interior of the lid supporting a panel or canvas.[31] He had it with him on all his expeditions, including his hunt for icebergs in the cold waters off Newfoundland and Labrador. In *After Icebergs with a Painter*, his traveling companion Louis Legrand Noble described Church sitting on the deck of a pitching ship, making sketch after sketch, "with his thin, broad box upon his knees, making his easel of the open lid . . . dashing in the colors. . . . Again the painter wipes his brushes, puts away his second picture, and tacks a fresh pasteboard within the cover of the box."[32] So perhaps Greatorex and Beers had equipment of that variety, or maybe it more closely resembled that of Sanford Gifford, who portrayed himself sitting atop Cadillac Mountain with his sketch box, looking south over Seal Harbor. His was different in size and shape: smaller and more square, instead of Church's broad, slim-profiled rectangular box, which looks a little like today's laptop computers.

The unidentified photographer shot Bridges in the studio, posed against

FIG. 7.6. Unidentified photographer, Fidelia Bridges, ca. 1864, photographic print on carte-de-visite mount, 4 × 2⅓ in. Oliver Ingraham Lay, Charles Downing Lay, and Lay Family Papers, Archives of American Art, Smithsonian Institution.

a painted woodland, but the sitter is surely the one who selected the clothing, props, and backdrop. In the mid-1860s, Bridges explored the places familiar to the Hudson River men, but relative terra incognita for women.[33] This self-presentation stakes her claim to equal standing with her male compatriots, and to the challenges of working in the field: tramping to motifs; lugging awkward, heavy equipment; spending long hours exposed to insects and the elements; working alone in remote spots.

How did the male landscapists respond to these developments? Because few mention the women one way or the other, we have to rely on visual evidence. Winslow Homer's *Artists Sketching in the White Mountains* (1868; Portland Museum of Art, Portland, Maine) provides a commentary on what, by the late 1860s, was becoming an increasingly common practice: artists heading for favored sites in places like New Hampshire, and scrambling for a spot to paint. Gone is any idea of originality or solitary contemplation of nature: artists pack onto hillsides, cheek by jowl, one echoing the next, as we look over their shoulders to detect a series of nearly identical motifs. Tossed on the ground is the tell-tale bag, in which the outdoor sketcher transports the necessary equipment. But what is wrong with this picture? Women, obviously, are absent. We wonder what would happen if Eliza or her friend Julie Beers had arrived and set up her stool and easel next to one of these diligent gentlemen?

As if to answer our query, Homer created a "sequel" to his painting for the cover of *Appleton's Journal* (fig. 7.7). A lady does in fact appear, but only to gaze lovingly over the shoulder of her male companion, to encourage and inspire his work. The thought that she would take up the brush and paint the scene before them both was apparently not entertained. But whether the men accepted it or not, the women were making their presence felt. Another of Eliza's contemporaries, Victoria Woodhull (fig. 7.8), was a remarkable woman who headed a stock brokerage, managed a periodical, and ran for U.S. president in 1872. Her stand on Free Love was only one of the many factors that contributed to her characterization as "Mrs. Satan"—probably not the best campaign platform! Predictably, she lost the election, which delivered a blow to the struggle for women's rights.

Undeterred, women persisted in making their presence felt in the cultural arena, including the visual arts. Greatorex's personal vision continued to evolve, evident in a comparison between *Landscape near Cragsmoor*

Appletons' Journal

OF LITERATURE SCIENCE AND ART.

ENTERED, according to Act of Congress, in the year 1869, by D. APPLETON & CO., in the Clerk's Office of the District Court of the United States for the Southern District of New York.

No. 12.—WITH PLATE.] SATURDAY, JUNE 19, 1869. [PRICE TEN CENTS.

THE ARTIST IN THE COUNTRY. BY WINSLOW HOMER.

FIG. 7.7. Winslow Homer, *The Artist in the Country,* wood engraving, 6⁵/₁₆ × 6⅝ in., published in *Appleton's Journal,* June 19, 1869.

"GET THEE BEHIND ME, (MRS.) SATAN!"—[See Page 143.]
Wife (with heavy burden). "I'D RATHER TRAVEL THE HARDEST PATH OF MATRIMONY THAN FOLLOW YOUR FOOTSTEPS."

FIG. 7.8. Thomas Nast, *"Get Thee Behind Me, (Mrs.) Satan!"* published in *Harper's Weekly,* vol. 16, no. 790 (February 17, 1872), p. 140. Library of Congress, Prints and Photographs Division, LC-USZ62-114834.

FIG. 7.9. (Plate 27.) Eliza Greatorex, *Joseph Chaudlet House on the Bloomingdale Road,* ca. 1868, oil on canvas, 17 × 33 in. Collection of Ronald and Carole Berg.

and her fine painting, *Joseph Chaudlet House on the Bloomingdale Road* (fig. 7.9 and plate 27), done five years later. The 1868 picture appears deceptively simple, a pastoral view of a country road dotted with several domestic structures. But the artist has actually created a complex composition in which the eye of the viewer is drawn in several competing directions: first to follow the path into the depth of the scene, second to move right and left to take in all the architectural detail, and finally to ascend to the glorious tree tops and sky above. Left and right are two houses, which could be dismissed as picturesque staffage, but which hold the key to her distinct contribution to American art. Not only has she evolved an individual visual language, but she has also linked it to a particular thematic regime. As New York grew and changed after the Civil War, the old architecture—especially Dutch farmhouses and early churches—was torn down to make way for more modern structures. At the same time, the city was expanding to areas such as Bloomingdale—now the Upper West Side—which until that moment had been relatively rural. Greatorex captured many of these old structures as wrecking crews (often made up of Irish laborers) were about to destroy them and their pastoral settings. Where did she acquire this feel for the past, when all those around her were rushing headlong to the new and the modern? This approach likely

FIG. 7.10. *Perrit Mansion at 76th Street in Bloomingdale,* after a drawing by Eliza Greatorex in *Old New York: From the Battery to Bloomingdale,* 1875, etching, page size 13⁹/16 × 10¼ in. Picture Collection, The New York Public Library, Astor, Lenox, and Tilden Foundations.

had its roots in her Irish childhood, where a sense of the past was more ubiquitous and more appreciated. The earlier works analyzed here demonstrate a strong nature aesthetic and pictorial skill. By the end of the 1860s, she has found her own voice, and the means to express it pictorially.

Backing into the Past

Greatorex was an inveterate walker. When family illness prevented her from making her usual summer excursion to the country, she explored Manhattan on foot, with special emphasis on the remaining rural areas. She grew dismayed at the loss of historic homes and churches, containers of memory that had survived since the Revolution and were now being razed to make way for commerce. She resolved to produce a series of pictures of these disappearing landmarks, and started on her way to becoming a visual preservationist. She transitioned from oil paints to pen and ink, producing drawings such as *Somerindyke Lane, Perrit Mansion* (fig. 7.10), which she later had printed and compiled in her book *Old New York:*

From the Battery to Bloomingdale.[34] It was during this transition, in 1869, that she was elected an associate to the National Academy, immortalized in her diploma portrait at age fifty (see fig. 7.1). That year she exhibited a combination of her standard landscape paintings and the more recent pen-and-ink drawings. Holding her quill pen prominently when she sat for the portrait, she purposely called attention to her new creative endeavor as a graphic artist. She had replaced her old sketch box with an ink horn, pen, paper, and stool. The change in medium increased her mobility as well as her perspective on her subjects. She was training herself to think as a graphic artist, to see the world translated into black and white.

Once Thomas Boyle had completed her likeness, she hosted her last artist's reception of the year. Then she and her growing children boarded the steamship *Hammonia*, bound for Germany, where they would spend the next three years.[35] Up to that point, she had worked on perfecting her craft while simultaneously searching for subject matter and a pictorial program she could make her own. Upon her departure, she could feel confident that she had become a landscape painter.[36]

Notes

1. "Topics of To-Day," *Brooklyn Eagle*, August 28, 1867, p. 2.

2. See my "Martha Reed Mitchell: Early Champion of Women Artists," *Fine Art Connoisseur* (March/April 2010): 57–61.

3. For general background, see my "Eliza Greatorex and Old New York, 1869," *The Magazine Antiques* (November 2009): 110–15.

4. On Spencer and Cassatt, see *American Stories: Paintings of Everyday life, 1765–1915* (New York: Metropolitan Museum of Art, 2009).

5. *Oxford Dictionary of National Biography* (Oxford: Oxford University Press, 2004).

6. Frank J. Metcalf, *American Writers and Compilers of Sacred Music* (New York: Abington Press, 1925), 258–59 provides the most complete biography; quote, p. 259.

7. Mary Bartlett Cowdrey, *National Academy of Design Exhibition Record, 1826–1860* (New York: New-York Historical Society, 1943), no. 96 in the exhibition; *New York Times,* March 20, 1855.

8. Sources vary on the life dates of her children, but my research with these corrected dates is based on the following records: Federal Census, New York, 1850, states that Thomas Walter was four months old in August 1850; on her 1921 passport application, Kathleen Honora states that she was born September 8, 1851, Hoboken, New Jersey.

9. John Falconer to Jasper Cropsey, February 24, 1848. Newington Cropsey Foundation, Hastings-on-Hudson, New York.

10. *Exhibition of the Paintings of the Late Thomas Cole at the Gallery of the American Art-Union* (New York: Snowden & Prall, 1848).

11. *New York Times*, March 20, 1855.

12. Eliza P. Greatorex to John Champlain [response to his query for biographical information], February 13, 1874. Private collection. First page of two unnumbered pages.

13. *Glen of the Downs, Ireland* (no. 13 in 1856); *Wicklow Castle* (no. 27 in 1857). National Academy of Design records.

14. Vera Brodsky Lawrence, *Strong on Music: The New York Music Scene in the Days of George Templeton Strong*, vol. 1 (New York: Oxford University Press, 1988), 484.

15. "Editor's Table," *The Knickerbocker; or New York Monthly Magazine* 45.4 (April 1855): 425.

16. Ibid.

17. Cowdrey, *National Academy of Design Exhibition Record*, provides the following information: 1858 (address: 806 Broadway) *Sketch from Nature* (no. 455); 1859 *Study from Nature* (no. 393), *Village in the North Countrie, Ireland—Sketch from Nature* (no. 508); *Ross Castle, Killarney, Sketch from Nature* (no. 773). These works remain unlocated.

18. Eliza Greatorex, *Homes of Ober-Ammergau* (Munich: Joseph Albert, 1872): 13–14.

19. M. Despard, "Eliza Greatorex," *The Aldine* 7 (February 1874): 46.

20. E. F. (Elizabeth Fries) Ellet, *Women Artists: In All Ages and Countries* (New York: Harper Brothers, 1859), 316.

21. Ibid.

22. M. B. W[right], "Eleanor and Kathleen Greatorex," *The Art Amateur* 13 (September 1885): 69–70.

23. M. Despard, "Eliza Greatorex," *The Aldine* 7.2 (February 1874): 46.

24. W[right], 69.

25. Despard, 46.

26. Henry James, *The Ambassadors* (Harmondsworth: Penguin, 1986 [1903]), 452.

27. Eliza Greatorex, *Summer Etchings in Colorado* (New York: G. P. Putnams, 1873): 57.

28. For background on Beers, see my *Home on the Hudson: Women and Men Painting Landscape, 1825–1875* (Garrison, NY: Boscobel House & Garden, 2009).

29. Greatorex, *Summer Etchings*, 51.

30. Ibid., 57.

31. Such a box appears on the table at Olana, as recorded in a photograph. See

Sandra S. Phillips, *Charmed Places: Hudson River Artists and their Houses, Studios and Vistas* (New York: Harry N. Abrams, 1988).

32. Louis Legrand Noble, *After Icebergs with a Painter: A Summer Voyage to Labrador and around Newfoundland* (New York: Appleton & Coll., 1861; reprint, New York: Olana Gallery, 1979), 255, 258; quoted in Eleanor Jones Harvey, *The Painted Sketch: American Impressions from Nature, 1830–1880* (Dallas: Dallas Museum of Fine Arts, 1998), 173.

33. For an overview of the artist's career, see Frederic A. Sharf, "Fidelia Bridges (1834–1923): Painter of Birds and Flowers," *Essex Institute Historical Collections* 104.3 (1968): 217–38.

34. Eliza Greatorex, *Old New York: From the Battery to Bloomingdale* (New York: G. P. Putnam's Sons, 1875).

35. See my "Bavarian Beginnings of Eliza Greatorex," in *American Artists in Munich: Artistic Migration and Cultural Exchange Processes,* ed. Christian Fuhrmeister (Berlin: Deutscher Kunstverlag, 2009).

36. We leave her here, poised for another phase of her life and work, her story to be resumed elsewhere. This essay is part of my forthcoming "Eliza Pratt Greatorex and her Artistic Sisterhood in the Age of Promise (1860s–1870s)."

Gestured marks are an embodied language—a flutter of the gut, the heave of breath, shoulders clenched and released—kinetic physical energies propelling material over a surface, fueled by pulses through the enteric nervous system, contractions of muscle, sensitivities of skin. This is a way of working that seeks and invites connection across multiple axes—body and medium, artist and subject, artwork and viewer.—Sarah Schneckloth[1]

Body-Nature-Paint
Embodying Experience in Gilded Age
American Landscape Painting

At least part of the achievement of abstract expressionism resides in the fact that its artists engaged physically with the materials of their art. Robert Goodnough described this physical interaction as "feverish activity"; for Clement Greenberg, it was "an affair of prodding and pushing, scoring and marking, rather than simply inscribing or covering."[2] Harold Rosenberg felt that the innovation of the "action painter" resided in his ability to "dispense with the *representation* of the [psychic] state in favor of *enacting* it in physical movement." He compared the process to dance: "In turning to action, abstract art abandons its alliance with architecture, as painting had earlier broken with music and with the novel, and offers its hand to pantomime and dance." Rosenberg likened this innovation (specifically, in the works of Hans Hofmann) to some lines by Rainer Maria Rilke: "Dance the orange. The warmer landscape, / fling it out of you, that the ripe one be radiant / in homeland breezes!"[3] More recently, the authors of the textbook *American Encounters: Art, History, and Cultural Identity* emphasized the kinesthetic nature of Jackson Pollock's work as follows: "the bodily rhythms of Pollock painting link his methods to the dance, in which art and act, work and creator, become one."[4] Following Willem

de Kooning's well-known statement that it was Pollock who had "broken the ice"[5] for the artists of his generation, it has also become fairly commonplace to characterize this era of physical engagement as "innovative" or "unprecedented" in the history of American painting.[6]

Historians of nineteenth-century American art have implicitly challenged the "unprecedented" designation by heralding *their* artists' engagement with the materials of art. For example, Elizabeth Broun has compared "overall rhythms" in the works of Albert Pinkham Ryder and Pollock.[7] (It was Pollock who famously observed, "The only American master who interests me is Ryder." [8]) John Wilmerding has seen "pulsing surges of energy, seemingly uncontainable within the . . . framing edges" of the paintings of both Frederic E. Church and Pollock.[9] My purpose here is not to resolve questions of chronology or to reiterate the well-tread theme of the prescient "modernity" of the late-nineteenth-century American painter. It is, instead, to highlight a somewhat neglected common denominator in the aesthetic strategies of three Gilded Age American landscape painters—Ryder, Abbott Handerson Thayer, and George Inness —namely, their unconventional regard for the communicative properties of paint and the physical act of applying paint to a support. It is to explore how the lives and works of these artists resonated with new identities for the body in Gilded Age America: for the body of the artist and the laborer, and for the body as an instrument in formulating knowledge and experience. It is to broaden our discourse on these familiar landscapes and to propose a new framework—that of embodied knowledge—in which to view them in conjunction with their twentieth-century American counterparts.

The Body in Late-Nineteenth-Century America

The Gilded Age art enthusiast would have been familiar with the idea of the laboring artist. Visitors to Spain, France, and Italy could study the late paintings of Velázquez, Fragonard, and Titian, among others, which were full of virtuosic brushstrokes and which clearly conveyed a sense of the artist's working hand. Viewers of art attuned to developments in French painting could examine Barbizon and, later, impressionist landscapes, which captured the changing effects of light and shade through

a rich vocabulary of activated brushstrokes.[10] At home, Americans could savor artistic dexterity—and sheer fortitude—in the panoramic vistas of Church and Albert Bierstadt, and in the veracious paintings of New Path artists. In all three cases, artists employed meticulously controlled brushwork to represent as many of the subtle details of nature, both terrestrial and celestial, as possible.

As Sarah Burns has shown, the identity of the American artist expanded considerably during the Gilded Age. Artists came to possess social "clout." They manipulated the press and the art market to their advantage. They capitalized on the power of critics, writers, dealers, patrons, and the public to construct distinctly modern characters for themselves, such as "radical" and "revolutionary." J.A.M. Whistler and John La Farge led the field in paying close attention to the monetary value of their works—in Whistler's case, even famously going to trial over what he felt was a libelous financial assessment of one of his paintings.[11] I would like to suggest that the burgeoning social identity of the American artist corresponded to novel pictorial developments in the works of Ryder, Thayer, and Inness. Indeed, for the first time in American art history, artists brought the materials of their trade—paint, brush, brush handle or stick, artist's fingers, wax, and other integrative objects—to the forefront of critical and public attention. Viewers could now sense that the physical engagement of the artist in the act of painting contributed, far more than previously suspected, to the meaning of the artwork.[12]

The interest in artistic process and materiality emerged concurrently with a fresh appreciation for labor, one of the most important social issues of Reconstruction. The seemingly endless supply of new immigrants, a newly freed population of African-Americans migrating northward for gainful employment, and women flooded the workforce and demanded reassessments of social expectations and political rights. Clear distinctions between the responsibilities of the genders and classes began, for the first time, to blur. White, middle-class males, once dominant in the country's social, political, and economic life—its "body politic"—saw their authority jeopardized by the cause for women's suffrage, which began in earnest at the Seneca Falls Convention in July 1848, and the ratification in 1870 of the Fifteenth Amendment to the Constitution, which gave African-

Americans the right to vote. Workers gained additional power after the founding, in 1869, of the Knights of Labor, the leading labor organization in America prior to the founding of the American Federation of Labor in the 1890s.[13]

The new authority given to the body emerged in American literature and the sciences as well. Walt Whitman, the self-described "poet of the Body," exalted "the Body electric" in *Leaves of Grass* and celebrated his faith in the sacred nature of that body, be it male or female.[14] "The armies of those I love engirth me and I engirth them," Whitman expansively proclaimed.[15] As David Reynolds has argued, Whitman, under the influence of Emanuel Swedenborg, interpreted the body as a locus for a form of "erotic mysticism"; it became a double-barreled vehicle for eternal bonding with, as Whitman put it, "all the men and women ever born."[16] We see the new authority in Emily Dickinson's highly conflicted treatment of the body—the fact that while "the White Moth of Amherst" shielded her own body from all but her closest friends and family, she used the body as a trope to explore everything from myriad psychological states to heterosexual, homosexual, and even asexual identities.[17] Moreover, the body was arguably one of Dickinson's greatest vehicles for knowledge. In a letter to Thomas Wentworth Higginson, she once observed, "If I read a book and it makes my whole body so cold no fire can ever warm me, I know that is poetry. If I feel physically as if the top of my head were taken off, I know that is poetry. These are the only ways I know it. Is there any other way?"[18] Dickinson's reactions, versions of which later psychologists will identify as "vitality affects," were central to her capacity to assess ideas and formulate decisions about topics most dear to her.

On the heels of the Darwinian revolution, American science was undergoing its own seismic changes with regard to the body. On the one hand, science created new lines of public and private communication. The typewriter and the telephone, both novelties at the 1876 Centennial in Philadelphia, generated the enticing illusion that Americans could be in closer touch with one another without physically leaving their homes. On the other hand, the invention of the X-ray in 1895 by Wilhelm Röntgen and the manipulation of chemicals to create "spirit photographs" helped to generate prevailing skepticism about the integrity of the human body, which could now be known internally and, in a sense, post mortem.[19]

At mid-century, scientists on both sides of the Atlantic were beginning to challenge the authority of Cartesian dualism and to explore the complexities of the mind through a biological lens; instead of being viewed as a disembodied metaphysical entity, the mind became the locus of "atoms of conscious experience."[20] In Germany, Hermann von Helmholtz and, later, Wilhelm Wundt laid the foundation for the new field of psychophysiology —the study of the relationship between emotions and the body. Alexander Bain represented the field in Scotland. In teasing out the relationship between sight and feeling, Bain observed that when "a new prospect bursts upon the view, there is a mental result of sensation, emotion, thought—terminating in outward displays of speech or gesture." The body responds to the "new prospect" by "activating various physical organs, such as the eye, the retina, the optic nerve, the optic centres, cerebral hemispheres, outgoing nerves, muscles," and the like. For every new mental state, Bain proposed, there are corresponding physical effects. In all, he concluded, "mental and physical proceed together, as undivided twins. When, therefore, we speak of a mental cause, a mental agency, we have always a two-sided cause; the effect produced is not the effect of mind alone but of mind in company with body."[21]

Bain's "New Psychology" migrated to America and took root in several key intellectual circles. In 1875, William James opened an experimental psychology laboratory at Harvard; the following academic year, he offered one of the first courses on physiological psychology. Throughout his work, James insisted that science turn away from abstraction, verbal solutions, fixed principles, and the pretense of truth. Taking a pragmatic approach, he laid the foundation for an understanding of psychology based on concreteness and on verifiable facts, one that paralleled Bain's recognition of the importance of physical reactions and physical behavior.[22]

Until the early 1880s, psychologists held that the mental perception of a fact excites the mental affection called the emotion, and that this latter state gives rise to bodily expression. In articles during the 1880s and later in *The Principles of Psychology* (1890), James reversed the sequence of events. He reasoned that *"the bodily changes follow directly the perception of the exciting fact, and that our feeling of the same changes as they occur* is *the emotion."*[23]

Here, James privileges the responsive role of the body in producing our emotions. As he put it, "we feel sorry because we cry, angry because we strike, afraid because we tremble, because we are sorry, angry, or fearful, as the case may be."[24] He reminded us that when we read an inspiring poem or hear an exhilarating piece of music, we can get a shiver down the spine, or a feeling of "heart-swelling." (The case of Dickinson comes quickly to mind.) When we see a friend approach a dangerous precipice, we get "the well-known feeling of 'all-overishness' and shrink back, although we positively *know* him to be safe, and have no distinct imagination of his fall."[25] These types of physiological symptoms led James to argue that feelings derive as much from muscular reactions to events as from mental states. Muscular reactions can even increase or decrease emotions. When we sob, for example, we tend to produce even more sobs and end only, as James deftly put it, with "the apparent exhaustion of the machinery."[26] Conversely, if we willfully suppress an emotion, it can dissipate: "Count to ten before venting your anger, and it occasionally seems ridiculous."[27] (Such vivid descriptions show why James referred to this area of study as "the aesthetic sphere of the mind."[28]) In this work, James revealed the body as a conduit and creator of human emotions; at the same time, he advanced his lifelong efforts to bridge the mind-body gap that had been established through Cartesian dualism.

Ryder's "Revelation"

I am treating the Lorelei in a way that I think will give you pleasure; . . .
it may be interesting to you to know that the treatment I am adopting for
the pictures is in a measure a kind for revelation or method to introduce in
some stage of my future work.—Albert Pinkham Ryder[29]

The late-nineteenth-century development of the body's identity as a political instrument, and the burgeoning understanding of the body's role in creating emotions, resonate with Ryder's painting practices and his view of artistic identity. In the past, historians have used these practices and this sense of identity to sustain a view of Ryder as the consummate Romantic, an emblem of all that is "transcendent" in late-nineteenth-century American art. William Innes Homer and Lloyd Goodrich have seen Ryder in just this light, that is, as "one of the most imaginative paint-

ers the American nation has produced." For Homer, Ryder's "work flowed from the deeper recesses of his mind, often unconsciously, like a dream." And although Homer acknowledged Ryder's debt to European painting—specifically, to Corot, Claude, Maris, and Turner—he saw the artist as an *isolato* whose "art remained individual and personal."[30]

Ryder never used the contemporary language of "embodied knowledge" or "embodied cognition" to describe his approach to painting. Unlike Thomas Cole and Inness, he resisted using philosophical terminology to reflect on his artistic practices. Moreover, there is little doubt that Ryder was, indeed, an exceptionally imaginative painter. Still, we may discern in the undeniable materiality of Ryder's work and in his idiosyncratic artistic statements a keen awareness of the body's capacity to produce emotions and convey knowledge. This point of view, which affiliates Ryder with concurrent advances in psychophysiology, accords more closely with Eric Rosenberg's assessment of the artist within the context of late-nineteenth-century social developments. Rosenberg emphasizes the sense of displacement, alienation, violence, and unrest in America and sees Ryder's subject matter—scenes from Shakespeare and mythology, often with isolated and alienated figures—as part of that uncomfortable social and political environment.[31]

Ryder reworked many of his paintings to such an extent that he often left them in a perilous state. He would varnish his paintings before they were dry and then overpaint them. Varnish and paint would dry at different speeds and cause deep surface cracks. Worse still, he would use bitumen as a glaze; unless it is thoroughly diluted, bitumen never fully solidifies and therefore causes paintings to deteriorate.[32] Broun suggests that Ryder, far from being an unskilled painter, was eminently aware of what he was doing and sought these specific effects in his work. In paintings such as *Christ Appearing to Mary* (n.d.; fig. 8.1), he built up dense layers of paint because he wanted, first, to create a heavy, textured surface. He then applied glazes to smooth and refine the surface, one that Broun likens to enamel, for it has "a hard, vitreous, baked, or molten quality very different from the irregular relief of impasto or the slick finish of academic painting."[33] This kind of "deep investment in the process of painting" is, for Broun, "one of the most forward-looking aspects of [Ryder's] art."[34] From Broun's perspective, we do not need evidence of dramatic brushwork to

FIG. 8.1. Albert Pinkham Ryder, *Christ Appearing to Mary*, n.d., canvas mounted on fiberboard, 14¼ × 17¼ in. Smithsonian American Art Museum, Washington, D.C., gift of John Gellatly, 1929.6.92.

realize that an artist could be deeply engaged by the process of painting and that he could value the richness of his materials—what we might term "pictorial corporeality"—as a meaningful aspect of his work.

Indeed, Ryder seemed to envision his artistic methods through a corporeal language of art. He melted wax into his paints to generate a more pronounced sense of three-dimensionality, of "body," in his work.[35] When chided for this unconventional technique, Ryder is said to have demurred, "I only used one candle."[36] The process was, as he astutely observed, a kind of "revelation," and one that American artists of the next generation, such as Arthur Dove, Jack Levine, and Hyman Bloom, would soon embrace.[37] Ryder did not stop with encaustic. Electron microscopic analysis of cross sections of paint samples taken from the wet-on-wet areas of cer-

FIG. 8.2. (Plate 28.) Albert Pinkham Ryder, *Harvest*, early to middle 1890s, oil on canvas, 26 × 35¾ in. Smithsonian American Art Museum, Washington, D.C., gift of John Gellatly, 1929.6.96.

tain works—for example, *The Story of the Cross* (middle to late 1880s)—reveals how he used "large chunks of dry paint or foreign matter [to] add bulk" to his paintings.[38] Likewise, in *Harvest* (early to middle 1890s; fig. 8.2 and plate 28), an unfinished composition, he used a palette knife to trowel on thick layers of colors. According to a conservation report on this painting, "[t]hick blobs of crusted paint, possibly intermixed with foreign matter for texture, are deposited irregularly over the surface. A stream is brushed in with a creamy white pigment so thick that the stiff bristles of the brush have left deep depressions in the paint."[39] The physical evidence of wax, of chunks of dry paint, and of what is loosely described as "foreign matter" is undeniably striking in Ryder's aesthetic. It underscores the fact that Ryder, consciously or not, challenged the more conservative strictures and expectations of traditional American landscape painting. It serves, too, as a kind of tangible correlate to the work of James, for just as

the psychologist privileged physical reactions when formulating his new theory of emotions, so, too, did Ryder value the sheer bulk of physical materials—paint, varnish, wax, and bitumen—on his canvases when formulating what would become a new pictorial language of landscape painting.

Published with the regrettably pejorative title "Paragraphs from the Studio of a Recluse," Ryder's reflections on painting join his poems and letters as some of the few literary sources that illuminate his artistic process. When we read them in concert with the expanding awareness, in late-nineteenth-century America, of the communicative power of the body, they disclose his perspective on the corporeal identity of his paintings. In fact, Ryder, who never married and never had children, viewed his works as animate beings, each one possessing a life of its own. When referring to them, he used a language of procreation. "Imitation is not inspiration," he observed, "and inspiration can only give birth to a work of art. An inspiration is no more than a seed that must be planted and nourished. It gives growth as it grows to the artist, only as he watches and waits with his highest effort."[40] In Ryder's worldview, "inspiration" is procreative; it is a "seed" embedded in a work at its conception; when present, the work can never be entirely destroyed. (How sharply the tenor of this reading diverges from that which sees many of Ryder's paintings as "muddied mockeries."[41]) Ryder viewed his role as parental: he would raise each work of art as he would a child to adulthood and maturity. When the child/painting was ready to receive intervention, Ryder would provide it; if not, he would wait. As he assured his friend Silvia Warner, "Everything comes to the patient artist."[42]

Occasionally, perhaps by nourishing a painting too much or, conversely, by not giving it sufficient attention, Ryder would lose control over it. When this happened, he nevertheless remained hopeful. As he wrote to his friend Harold Bromhead, "I lost both the Lorelei and the Passing Song but have them under way again."[43] Sounding very much like a parent, Ryder understood that the challenge of "nourishing" the "seed" of a painting was a lifelong process, one that he might continue for decades, even after the child/painting reached maturity. It comes as no surprise, then, that despite laboring for a decade over one work, Ryder often felt that he was just getting started. The fact that each painting possessed a

burgeoning identity may explain why Ryder found it so difficult to declare one "finished"; such a declaration may have constituted, in Ryder's mind, the implausible termination of parental rights, perhaps even the ending of a life that he had created.[44]

It is striking, too, that Ryder associated his effectiveness as an artist with his physicality. In one of his more famous statements from "Paragraphs," he described the sweeping transformation that occurred inside of *himself*—inside of his body—when he apparently realized that as an artist he could not imitate every detail in nature and, more important, that he did not need to. Echoing the tenor of a spiritual awakening, he recounted how, one day, he saw nature in three "solid masses of form and color—sky, foliage, and earth—the whole bathed in an atmosphere of golden luminosity." His reaction was a distinctly physical one: "I threw my brushes aside. . . . I squeezed out big chunks of pure, moist color. . . . I laid on blue, green, white and brown in great sweeping strokes. . . . Exultantly I painted until the sun sank below the horizon, then I raced around the fields like a colt let loose, and literally bellowed for joy."[45] Admittedly, Ryder may have been exaggerating, or he may have imagined the entire event. Still, when aligned with his highly tactile paintings and his views on their pullulative identity, this extraordinarily vivid description highlights the key role of the activated body—its capacity to throw, squeeze, lay on, paint, race, and bellow—within Ryder's aesthetics and his view of the life of the artist.

Squeezing on paint and bellowing for joy were not the only ways in which Ryder engaged his body in his artistic process. Ryder may have been sociable but there is little doubt that, in order to paint, he cultivated a monastic atmosphere in his New York apartment. As with the highly devout and the highly creative, he strove to disengage certain physical senses so that other, more instrumental ones might be called into service. He needed to minimize extraneous sights and sounds from the public sphere. Marcel Proust, who wrote *À la recherche du temps perdu* in a cork-lined, soundproofed room over the course of thirteen years, would have sympathized with Ryder's assertion that the "artist must buckle himself with infinite patience. His ears must be deaf to the clamor of insistent friends who would quicken his pace. His eyes must see naught but the vision beyond."[46] As part of this focusing process, Ryder cultivated the

autotelic aspects of his work; he felt satisfied and, at times, exhilarated by limiting physical comforts, by constraining intrinsic senses, and by deferring extrinsic rewards to dedicate himself to his work.[47]

For Ryder, sensory manipulation for the sake of one's art did not end with deafness and the selected suppression of vision; it also entailed denying himself certain basic physical needs, in this case, to determine when a work of art was complete. "It is a wise artist who knows when to cry 'halt' in his composition," he explained, "but it should be pondered over in his heart and worked out with prayer and fasting."[48] Ryder may well have been, as Albert Boime put it, "a conservative, a selfmade type like his patrons, who pursued a pure and lofty culture while caught within the meshes of a middle-class existence he professed to despise."[49] Such a reading does not contradict the evidence from Ryder's paintings and from his reflections on art that point to another identity as well: a man who was surprisingly alert to the fundamental role of the body and of the senses (or, when necessary, the suppression of the senses) when creating and nurturing works of art. While we may initially interpret this awareness as nothing more than the cliché of the isolated Romantic, the artist content to deny himself for the greater exigencies of his art, I would like to suggest that we view it in concert with the work of James and other physiological psychologists, who showed how the body plays a far more active role than previously suspected in our emotional lives and that, at times, the body is in fact responsible for the very construction of those emotions. Seen from this perspective, Ryder may have "bellowed for joy" not only because he realized the futility of copying nature leaf for leaf but also *because of* the new, aggressively physical way that he "squeezed out big chunks of pure, moist color" and "laid on" paint in "great sweeping strokes." Was he consciously aware of his body while forming this new, more physical relationship to his work? We will never know. It is likely, though, that the physical responses complemented and even augmented the artistic realizations.

Thayer: Cutting and Stabbing on Mount Monadnock

Little in the background of Abbott Handerson Thayer prepares us for the unconventional relationship to painting that he developed in his later years. As a young man, Thayer studied at the Brooklyn Art School and

then at the National Academy of Design. In 1875, he moved to Paris to study at the École des Beaux-Arts. The following April, he joined the atelier of Jean-Leon Gérôme, the embodiment of refined, meticulous painting. Given this background, Thayer might easily have developed a career as a rigidly academic painter.

However, Thayer had painted expressively as a young man and, under the influence of Theodore Robinson, who worked beside him in Gérôme's studio, explored his love of painting with thick impastos. Although Thayer is best known today for his rather conventional, Renaissance-inspired paintings of young madonnas or virgins in white gowns flanked by children, these somewhat nostalgic works should not prevent us from examining the methods and impetus behind his more challenging approaches to art.

An account of the creation of Thayer's *Stevenson Memorial* (1903; fig. 8.3) is particularly revealing in this regard. It comes to us from Rockwell Kent, who served as a copyist in Thayer's studio around 1905. (Thayer established a laborious system whereby a studio assistant would copy the painting on which he was working. He would then work on the copy to test new ideas. In this way, Thayer could proceed without fearing that he might ruin the original.) According to Kent, Thayer called the younger painter into his studio while the *Stevenson Memorial* was in progress. Kent then described the conversation that ensued:

> "Look at that rock," [Thayer] said, indicating the huge rock on which the winged figure sat. "What's wrong with it?" With not too much conviction I offered my criticism. "Good!" said Thayer. "Now I'll go out. You take my brushes and paint the rock the way you think it ought to be. And call me when you've finished." For once a critic had been served exactly right. So I went to work. And when I had done the best I could, I called Thayer back. Thayer was generous. "Yes," he said, "I think you've helped it." Suddenly he cried, "Look! We're both wrong—building it up little by little like that! God said: 'let there be a rock!'—and there it was." And picking up a broom he swept it right and left across the painting. It did the trick. "That's it," said Thayer, "that's it!" And so it stayed.[50]

Although the upper-left and lower-right corners of the *Stevenson Memorial* contain broad brushwork, it is not possible to identify those marks

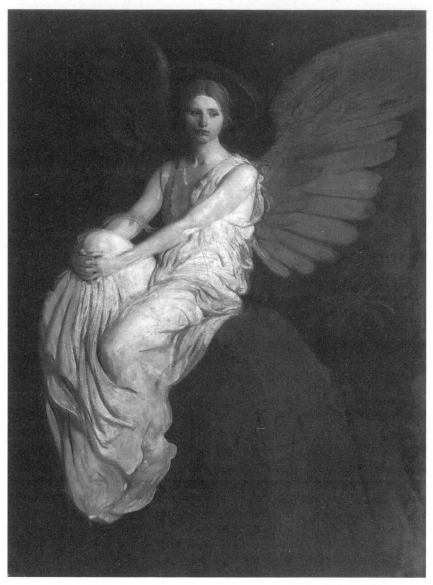

FIG. 8.3. Abbott Handerson Thayer, *Stevenson Memorial*, 1903, oil on canvas, 81⅝ × 60⅛ in. Smithsonian American Art Museum, Washington, D.C., gift of John Gellatly, 1929.6.127.

definitively as broom strokes. Nevertheless, Kent's account is compelling and, if accurate, would signal the presence of Thayer's impulse to contest the strictures of traditional painting. Moreover, as painting with a broom requires a greater engagement of the whole body in the act of painting—after all, one must stand and possess the strength to dunk the broom in a bucket of paint—it suggests that Thayer's body played an active role in the conception and execution of his works.

For Thayer, the relationship between the act of painting and the body of the artist grew even more symbiotic as he aged. His father, Dr. William Henry Thayer, had been especially sensitive to issues of health and disease. In response to the increasingly unsanitary living conditions in industrialized cities during Reconstruction, he moved his family to Woodstock, Vermont, and later to Keene, New Hampshire, to cultivate a more healthful way of life. His son inherited many of these concerns. He was determined to show his own family and friends that living in harmony with nature was the truest path to sustaining one's health and well-being. Always an outdoorsman, Thayer moved to Dublin, New Hampshire, in 1901. He would live there for the next twenty years and paint almost exclusively the surrounding landscape covered in snow during the winter months—the season, for Thayer, of its purest incarnation.

Inspired, according to Ross Anderson, by the "pure, clean air, harsh temperatures, and the still, silent ambience that enveloped the deserted little town,"[51] Thayer established an intense physical regime in Dublin. He hiked regularly in the mountains. He kept his children home from school to prevent them from catching illnesses and attracting germs. He insisted that the windows of his home be left open at all times and required his family to sleep outside in a variety of huts and lean-tos, some of them three-sided, even during the frigid winter months. Thayer captured his zeal for an intense, physical engagement with nature in the fresh, calligraphic brushwork and rich impastos of *Winter Landscape* (1902). Having lost two young sons and his first wife to illnesses, and always in a somewhat precarious physical condition himself, Thayer remained fiercely alert to the well-being of his three remaining children. As *Winter Landscape* suggests, he viewed nature as a temple of health and as the only true way to combat the toxicity of the modern world.[52] Another striking feature

of the setting is the absence of human figures. Thayer kept a tight circle of like-minded friends in Dublin and viewed most outsiders, whom he felt represented the degenerative forces of civilization, with skepticism. He was determined to keep the landscape around Dublin in a state of pure "virginity," the tacit property of viewers like himself, "accustomed to feed[ing] their souls by gazing at Monadnock."[53]

Thayer's Mont St. Victoire was Mount Monadnock, a geological formation in southern New Hampshire that provided him with endless sources of inspiration; it was the motif to which he returned over and over during the final two decades of his life. And yet, instead of describing the mountain and surroundings in a dispassionate, almost historical style (as did, for example, William Preston Phelps, Charles Curtis Allen, and even Rockwell Kent), Thayer described them as a living presence. In a letter to his daughter Gladys, he captured that vitality in the rhythmic, almost poetic cadence of his language when he wrote, "New, little snow over all today. Monadnock yesterday plum colored at noon with all its burnished silver stabbed vertically in between the purple tree verticals."[54] In *Monadnock No. 2* (1912; fig. 8.4 and plate 29), Thayer used a palette knife to trowel those silvers "stabbed vertically" onto his canvas. Here, mounds of snow formed through white spikes of pigment rise between black, stick-like tree trunks; a dense bank of snow, incarnated with bold streaks and slashes of lavender-white paint, cleaves to the side of the mountain. The striking physicality of these pictorial marks matches the sharp chiaroscuro of the scene, a product of the hard, frozen light of the morning sun on the vitreous terrain.

Just as Ryder fortified his paints with "foreign matter," so, too, did Thayer add detritus to his paints. In so doing, paint developed an even greater sense of three-dimensionality, of "body."[55] Conservators have found such detritus on Thayer's canvases, in paint applied not only with a broom but also with his highly activated palette knife. In *Winter, Monadnock* (ca. 1900; fig. 8.5 and plate 30), Thayer reversed our expectations of landscape painting; here, dark is above and light below. He then exploited the translucency of watercolor to great effect, leaving delicate, carefully considered facture on the paperboard surface. He complemented the viscosity of watercolor and gouache with detritus that helps to convey the illusion of crystalline snow and prickly pine needles; for Ross Anderson, the

FIG. 8.4. (Plate 29.) Abbott Handerson Thayer, *Monadnock No. 2*, 1912, oil on canvas, 35½ × 35½ in. Freer Gallery of Art, Smithsonian Institution, Washington, D.C., gift of Charles Lang Freer, F1913.93a.

inclusions, add a "seductive coarseness" to the composition.[56] In another version of the scene from circa 1910, also boldly executed in gouache, watercolor, chalk, and pencil on paperboard, Thayer again added "bits of foreign matter" to his paints for "increased depth and texture."[57] The unusual tactility of this detritus must have served a distinct purpose. On reflection, let us consider this: Thayer had transplanted his family to the vicinity of Mount Monadnock. On countless occasions, he climbed its escarpments.

FIG. 8.5. (Plate 30.) Abbott Handerson Thayer, *Winter, Monadnock,* ca. 1900, water-color, gouache, chalk, and pencil on paperboard sheet, 20⅛ × 16⅜ in. Smithsonian American Art Museum, Washington, D.C., gift of John Gellatly, 1929.6.133.

Regardless of climatic conditions, he often required his family members to camp out—to make their temporary home—in its shadow. He would even arrange to have his ashes spread on Monadnock. Might it be said that, by bulking up his paints with studio detritus, with "foreign matter," he was in a sense attempting, through the artistic language that he knew best, to bring his beloved mountain, his greatest source of inspiration, even more tangibly, even more corporeally into his art?

The relationship between man and mountain was, in fact, extremely deep. Profoundly inspired by Emerson's understanding of the spiritual identity of nature and by Thoreau's description of the area after a visit in 1860, Thayer saw nature through a spiritual lens, as nothing less, according to his student William James (Jr.), than the "path leading to the creator Himself." For Thayer, the artist possessed a distinct role: one who could poke his head through the clouds to "look all the way up to the blue zenith and to God."[58] His "terrestrial embodiment of the Infinite" was, quite simply, Mount Monadnock.[59] According to Barry Faulkner, a cousin of Thayer and one of his students in his later years, "Thayer shaped his life and the life of his family on . . . Monadnock. [It] was their totem, their fetish, the object of their adoration. They surrendered themselves to the sorcery of its primitive being."[60] Yet Thayer seems never to have relinquished his own sense of self, in an Emersonian fashion, to the mountain. He required daily physical interaction with nature in general and, specifically, with Monadnock, to guide him to "spiritual heights beyond natural beauty."[61]

It is this sense of intense, intimate, physical familiarity with the motif —both as a naturalist and as an artist—that emerges in such paintings as *Winter, Monadnock*, for only an artist thoroughly immersed in his subject could paint it with such a heightened sense of physical bravura. In this way, Thayer's work bears much in common with Chinese and Japanese art. Wen Fong has written eloquently of the central role of the body in the execution of Chinese calligraphy. He explains that in Chinese painting theory, "representation was linked through calligraphic brushwork to the artist's physical presence, and the calligraphic aesthetic was basic to the development of literati painting in that it was regarded as a form of self-expression." This connection is central to Far Eastern aesthetics but far

more problematic for Western art historians, who tend to privilege historical and theoretical contexts in their analyses of works of art. Fong takes for granted the idea that Chinese calligraphy embodies artistic identity; its gestures, he explains, "form a production of the artist's body language." When examining calligraphy, it is only by probing the intimate relationship between the artist's body and his medium that we can "begin to understand the relationship between presented structures of calligraphy and what they express."[62] Versions of these ideas were almost certainly familiar to Thayer, who would have encountered them by studying Japanese ink paintings in the collection of his chief patron, Charles Lang Freer.

Inness: Scratches and Hairs, Slurries of Paint, and Fingerprints

Our body is the ultimate instrument of all our external knowledge, whether intellectual or practical. In all our waking moments we are *relying* on our awareness of contacts of our body with things outside for *attending* to these things. Our own body is the only thing in the world which we normally never experience as an object, but experience always in terms of the world to which we are attending from our body. It is by making this intelligent use of our body that we feel it to be our body, and not a thing outside.
—Michael Polanyi, *The Tacit Dimension*[63]

The scene represents a swath of landscape near Inness's home in Montclair, New Jersey, a bucolic setting, with weedy grasses, an old apple tree at the left, a towering oak at the right, and a weather-beaten barn in the middle distance. A blustery wind seems to animate the terrain, setting the foreground grasses on edge and activating the darkened, rain-soaked sky. With its subtle balance of dark masses on the left and light masses on the right, its complementary contrast of red oak with green grass, and its carefully calibrated progression of spaces from foreground to middle ground to distance, *Early Autumn, Montclair* (1888; fig. 8.6 and plate 31) remains one of Inness's most compositionally successful late landscape paintings.

What we quickly notice about the work, however, are the myriad scorings, scratches, and fleckings that Inness inscribed onto the canvas with a stick or brush handle and dry brush. The scorings congregate primarily near the upper bowers of the trees and in areas representing overcast sky. On the one hand, they serve a mimetic role. When Inness scored deeply into the rich, wet, greenish-brown paint of the apple tree at the left, he re-

FIG. 8.6. (Plate 31.) George Inness, *Early Autumn, Montclair*, 1888, oil on canvas, 30 × 45 in. Collection of the Montclair Art Museum, Montclair, New Jersey. Museum purchase; funds provided by Dr. Arthur Hunter in memory of Ethel Parsons Hunter, the Valley Foundation and Acquisition Fund, 1960.28.

vealed a lighter brown below. In concert with the somewhat frenetic scorings themselves, this shift in hues helps to generate the illusion of wind coursing through friable leaves. When he used a dry brush to sweep and fleck out portions of the (then wet) lighter green and yellow-green paint on the upper surface of the grasses, he revealed a (then dried) darker green below. In this way, he generated the illusion of a contrast between light and shade that leads the viewer's gaze into the foreground space of the composition. By functioning as surrogates for the chaotic forces of wind and by embodying the principles of chiaroscuro, the scorings, scratches, and fleckings generate an appropriate aura of instability within a scene of climatic and temporal instability.

And yet, this reading is too straightforward, fundamentally incomplete, for when we revisit the scorings and fleckings of *Early Autumn, Montclair*, they are especially difficult to read, especially unruly. The circuitous, serpentine, frenetic scorings in the apple tree seem almost too prominent,

excessively dense, in the context of the composition. When we follow the trajectory of a single scored line in the bower of the apple tree, it ends not in the confines of that tree but, improbably, in the sky. This unexpected termination suggests that Inness was so deeply engaged in scoring that he lost track of the discrete identities of tree and sky; instead, he read them as kindred zones within the broader pictorial construction. Similarly, short, dark-green flecks of paint in the foreground fail to conform to the thin, delicate identity of grasses. As dots and smudges of paint, they nearly disconnect from their mimetic agenda.

Through this distinct vocabulary of pictorial marks, Inness bifurcates the temporal identity of the composition. In their iconic incarnation, the marks remain attached to the normative identity of the landscape, a setting of dense grasses, frangible leaves, and blustery winds operating under the aegis of our communal understanding of measured time. They seem to take a kind of vicarious pleasure in their own active independence. At their most aggressive (or perhaps carefree), the marks seem to disdain their mimetic function entirely. In this way, they encode the movement and trajectory of the artist's hand and become indices of his unique, temporal process of painting.[64]

Even more enigmatic marks—what I have identified elsewhere as Inness's "synoptic forms"—reside on the surface of this painting.[65] These forms, which we may find throughout his middle and later landscape paintings (works roughly of 1870 through 1894), capture the essence of natural objects by means of a limited number and range of brush marks; occasionally, they function through an individual, succinct, virtuosic gesture. In developing his syntax of synoptic forms, Inness derived inspiration primarily from the virtuosic handling of paint in Barbizon landscapes, which he saw at the Paris Salon in 1852 and again in Paris the following year. He gained additional exposure to the brushwork of Barbizon landscapes at the Crayon Art Gallery in New York, which the Francophile George Ward Nichols owned and operated. (Nichols, a close friend of Inness's, often exhibited his work.) Ultimately, Inness's synoptic forms would become so distinct that they would help, in part, to define his work as an artist.

While living in Italy during the early 1870s, Inness began to develop his facility for executing synoptic forms. In *Old Aqueduct, Campagna, Rome* (1870; fig. 8.7 and plate 32) and in *Albano, Italy* (1871), the forms appear in

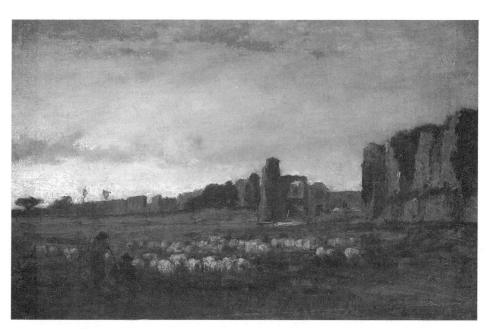

FIG. 8.7. (Plate 32.) George Inness, *Old Aqueduct Campagna, Rome, Italy*, 1870, oil on canvas, 8¾ × 13 in. Collection of the Montclair Art Museum, Montclair, New Jersey. Gift of Mrs. Eugene G. Kraetzer, Jr., 1953.38.

the lower foreground. As with the scorings in *Early Autumn, Montclair,* they possess a peculiar, bifurcated identity: when considered in the context of the scene, they are immediately recognizable as sheep, and so maintain their allegiance to mimesis and their iconic identity. At the same time, they are expressive marks of viscous oil paints, their brush-hair indentations still clearly visible on the surface of the canvas. Seen from this perspective, they embody the self-referential, indexical identity of the synoptic form.

In *Early Autumn, Montclair,* Inness deposited a synoptic form—a slurry containing a sensuous intermingling of pale yellows, ochers, and white—in the brightest swath of grass. As with the synoptic forms of sheep in his Italian landscapes, this slurry serves both the mimetic cause—in that it conjures a group of fallen branches—and the self-referential one—in that it emblematizes the virtuosic nature of Inness's painting techniques. In the case of all three paintings, the synoptic forms resist definitions because the relationship between their two identities is slippery, at best. How we

interpret the forms depends entirely on what we choose to value or to emphasize about the composition. If we wish to see *Early Autumn, Montclair* as a pleasing representation of the terrain near Inness's home, then we will discuss the synoptic form in the bright patch of grass as a fallen log, even as a symbol of decay, or the penultimate stage in nature's ongoing reflection of the cycle of life. However, by focusing on the various colors and expressive trajectory of the paints within the slurry, or on still-visible brush marks or brush hairs, we allow the slurry to transition gradually from its mimetic to its semiotic identity. Rather than existing as a sign of the cycle of nature's life, it speaks to Inness's artistic practices, specifically, to the working practices of his hand. (We wonder, how did he suggest so much with so little paint?) James Elkins has described how these types of marks possess unstable identities. As we become increasingly aware of them, they become increasingly self-referential, alerting us not only to their identity but to the identity of the painted field on which they reside. For Elkins, the marks tend to "exfoliate into fields and ultimately into surfaces" of paintings or drawings.[66] They exist, paradoxically, in a permanent state of "fading away" as they transition back and forth between their iconic and indexical identities.

Along with scorings, flecks, marks, and synoptic, slurried forms, stippled marks play an equally vital role in Inness's late landscape painting vocabulary and reassert his physical engagement with his art. To create stippled marks, Inness positioned his lightly loaded brush perpendicular to the canvas and gently stabbed the bristles so that the paint transferred to the canvas in tiny, clustered flecks. Stippled marks appear throughout *Early Autumn, Montclair,* notably in the burnt-orange bowers of the oak tree, where they contribute to the illusion of brittle leaves. They retain even looser ties to mimesis in the Cleveland Museum of Art's *Landscape* (1888). When superimposed on the tree at the right, dark orange stipples seem to represent desiccating foliage. However, as they approach the prominent red oak at the center and as they completely detach from the nearby tree trunk, they no longer function as optical correlates for leaves but, instead, as tiny patches of paint. Now seen exclusively as golden marks from Inness's brush, they provide sharp, appealing contrasts to the reddish hues of the oak and to the viridian green of the grass in sunlight. In this

way, they sublimate the identity of Inness's work *as landscape scenery* and highlight the central role of physicality in the artist's pictorial practices.

We have another clear indication of Inness's physical engagement with the process of painting in the countless brush hairs pulled from their support and deposited in pools of viscous oil paints on his canvases. We need not look far to find them: they populate *Early Autumn, Montclair,* especially the foreground, where they play a strangely mimetic role as surrogates for bristly, dried grasses. Congealed in paint, they call to mind a brief history of the brush in nineteenth-century American landscape painting: a tool used with gingerly respect by the Hudson River School landscape painter, a tool made to disappear by the luminist, a tool used to the brink of destruction by Inness, and a tool replaced entirely by Thayer's broom.

While it would take another fifty years for an American artist to abandon the paint brush, Inness would, at times, temporarily set the brush aside and turn to his own body—his fingers—for tools with which to paint. We find many of his fingerprints throughout his late landscapes, for example, in the areas surrounding the fallen log in *Etretat, Normandy, France* (1892). Such physical evidence correlates with some of the many eyewitness accounts of the artist at work. Frederick Stymetz Lamb, an artist and friend of Inness, described an occasion in which a group of young painters sought Inness's guidance and invited him to their studio. Inness arrived at the appointed hour and began to discourse on his "theories of painting" while offering some demonstrations of brushwork. At one point, he set aside both brush and palette. Then, taking his thumb, he "drew the color together with a few marvelous sweeps—as was often his habit." Inness was apparently so energized by this action that, as he explained his work, he grabbed his friend by the lapel of his coat and smeared it with "beautiful color combinations."[67] S.C.G. Watkins, Inness's dentist and a frequent visitor to his Montclair studio from 1889 until the artist's death in 1894, noted that Inness often received suggestions for his work from visitors. One time, when the two men were studying a painting of a sunset, Watkins asked Inness if the sun would not be improved if it had "a little more orange in it." According to Watkins, Inness then "grabbed a tube of orange, put a little on his thumb and rubbed it into the sun—jumped back

a couple of feet, looked at it, and said, 'That does help it; that does help it; that is an improvement.'"[68]

The accounts of Lamb and Watkins, two of many of their kind, confirm that Inness tended to rely, often at the end of his painting process, on physical contact with his canvases, especially during his late landscape period. He seems to have felt that, having exhausted all other options, he was compelled to call on the essential resource of his own fingers—his own body—to bring his work to fruition. Although he never discussed this topic in his writings, and although no one in his circle recorded his thoughts on it, he seems to have intuitively understood that the sense of touch possesses a distinct and incomparable authority—that nothing is truly known until it is touched. The accounts of Inness setting aside the brush in favor of his fingers and the evidence of fingerprints on his canvases together signal a new awareness on his part of the power of embodied knowledge.

The written accounts and pictorial evidence of Inness's occasional use of his fingers in place of his brushes seem somewhat surprising when viewed in the context of the conservative painting practices of his Hudson River School colleagues. In Daniel Huntington's portrait of Asher B. Durand (1857; fig. 8.8), for example, the artist is well coiffed, seated before an attractive landscape that he is clearly in the process of representing on his canvas. He holds, in his left hand, a beautifully constructed palette, with its full spectrum of colors neatly arranged from dark to light so that none abuts its neighbor. Five clean brushes rest on the outer edge of the palette, with only a drop of white paint on each tip to allude to their use. One can imagine how judiciously the artist used these brushes, how meticulously he applied paint to the landscape on his easel, and how surprised Durand would have been had he seen Ryder or the elderly Thayer or Inness at work, painting with their broom and fingers, and adding wax and foreign matter to their oil paints.

We view Inness's use of the fingers in a far less surprising fashion when we examine the practice in light of art history, for Leonardo, Titian, and Turner, among others—whose works Inness knew intimately—occasionally applied paint to their canvases in this way.[69] In 1660, Marco Boschini produced a now-famous account, probably based on the testimony of

FIG. 8.8. Daniel Huntington, *Asher Brown Durand*, 1857, oil on canvas, 56⅛ × 44 in.
The Century Association, New York, 1864.8.

Palma il Giovane, of the elderly Titian's working methods. He describes the process as follows:

> For the final touches [Titian] would blend the transitions from high-lights to halftones with his fingers, blending one tint with another, or with a smear of his finger he would apply a dark accent in some corner to strengthen it, or with a dab of red, like a drop of blood, he would enliven some surface—in this way bringing his animated figures to completion. . . . In the final stages he painted more with his fingers than with the brush.[70]

Again, as with Inness, it was in the final stages of painting that Titian turned to his fingers to intensify his engagement with his work. We note the striking comparison of the final "dab of red" to "a drop of blood," as though the paint on top of the finger and the blood inside the finger—located only millimeters apart—were interchangeable substances, both of which, in essence, sustained the artist. We note, too, the description of how Titian would "enliven some surface" with his painted fingers. As though capitalizing on the healing powers of touch, he would bring the figures in his composition to life through his physical engagement.

It is not surprising that Titian and Inness shared a commitment to working, at times, with their fingers. Both artists, along with Ryder, also superbly mastered the execution of the synoptic form. Boschini's account places Titian's treatment of this virtuosic entity in the context of his larger pictorial process. First, Titian would block in major forms with red ocher to function as a middle ground. Using "a stroke" of lead white, which he would mix with red, black, or yellow, he would then create "the light and dark areas of the relief effect." Finally, according to Boschini, "with four strokes of the brush," Titian was able to "suggest a magnificent figure."[71] Although Inness rarely focused on the human figure, he created a number of forms in his landscapes that accord with this description, such as the fallen log in *Early Autumn, Montclair.* Ryder serves as a kindred spirit in this regard, though less for his actions and more for his reflections on the topic. "The artist should fear to become the slave of detail," he famously observed in his "Paragraphs" interview. Probably referring to his painting *The Tempest* (1892), he continued, "A daub of white will serve as a robe to

Miranda if one feels the shrinking timidity of the young maiden as the heavens pour down upon her their vials of wrath."[72] In other words, for Titian, Inness, and Ryder, painting was no casual process and the synoptic form was no casual pictorial effect. Titian saw the canvas almost as an animate object on which he might bring his figures to life with a few, judiciously placed touches of paint from his fingers. Inness developed a repertoire of pictorial marks that constantly reminded viewers of his physical engagement with the creative process. While painting, Ryder's imagination functioned as his reality. Turning away from mimesis, he could embody ideas in synoptic forms. He could envision the materiality of paint as a vascular conduit for inspiration to his paintings, which he then nourished, like his children, to fruition.

Performing Painting

The animated scorings, slurries of paint, morsels of wax, foreign matter, fingerprints, brush hairs, and synoptic forms that we find in some or all of the late landscapes of Ryder, Thayer, and Inness create a new identity for these canvases. While each remains (more or less) a representation of a scene in nature, each also becomes a form of arena, that is, "a place or scene where forces contend or events unfold." As noted below, American landscape painting had, of course, witnessed its share of theatricality. Many of the paintings of Church and Bierstadt were nothing if not highly theatrical in both scale and execution. Indeed, they required a great deal of physical labor, even physical stamina, to complete. However, the labor of the late-nineteenth-century landscape painters was different. Church and Bierstadt remained largely bound to representational painting executed through deliberate, meticulously executed brushwork. By contrast, as the later artists moved away from representational painting, they transferred meaning to their work through their physical engagement with the canvas. They used broom strokes and rapidly executed synoptic forms; they bulked up their paints with melted wax and studio detritus. They scored into wet paint with sticks and fingernails. Few of these features appear in the works or working practices of earlier Hudson River School landscape painters.

By challenging pictorial traditions, Ryder, Thayer, and Inness risked

missteps and occasionally befuddled critics in ways that earlier American landscape painters did not. Writing for *Scribner's* in June 1879, one critic reflected on a few of Ryder's paintings at a Society of American Artists exhibition as follows: "Most people did not know what to think of Mr. Albert Ryder's mysterious pictures. . . . They have been much praised and much laughed at."[73] In assessing Ryder's *Spring* (late 1870s), a critic for the *New York Times* stated, "Like many of the modern painters, Mr. Ryder appears to be quite deficient in knowledge of the figure. He is an impressionist in so far as he strives for the 'feeling' of a figure rather than to express its anatomy in definite outlines."[74] What the critics gradually came to understand was that these artists were formulating a new identity for landscape painting; they were gradually transforming it from a space for scenes of visible reality to a place for performances of the artist's reality.

As noted above, Thayer's late landscape paintings and reports from students such as Kent attest to his physical engagement with his art. Ryder's remarks in "Paragraphs" and the cross sections of paint samples from his compositions suggest that he, too, painted aggressively. They support Broun's theory that Ryder "attacked the canvas with an energy and freedom that can scarcely be imagined from the refined, 'enameled' surface of the completed works."[75] Inness's student and friend Elliott Daingerfield, one of the many eyewitnesses to his work, recalled Inness's painting practices in a way that accords with the majority of the artist's late landscapes. "With a great mass of color," Daingerfield wrote, "[Inness] attacked the canvas, spreading it with incredible swiftness, marking in the great masses with a skill and method all his own, and impossible to imitate; here, there, all over the canvas, rub, rub, dig, scratch, until the very brushes seemed to rebel, spreading their bristles as fiercely as they did in the days of yore along the spine of their porcine possessor."[76] Detached bristles, which reside today within the paints of the majority of his late landscapes, provide tangible evidence of the aggressive physicality of Inness's painting practices.

Inness understood the performative identity of the painter in yet another way. He felt that the act of painting—the physical work of the artist —should attempt to mimic the work of other artists, including musicians and dancers. One day, in the midst of painting a landscape, he described this idea to his son, George Inness, Jr., as follows:

Just like music, George—the harmony of tone. We thump, thump, thump the keys to the distance, but don't forget to put in the harsh note, the accidental. It makes the contrast that gives interest and beauty to the whole, the gradation of light and shade which corresponds to music. What is art, anyway? Nothing but temperament, expression of your feelings. Some days you feel one way, some days another; all temperament. There, you see it's opening up. Tickle the eye, George, tickle the ear. Art is like music. Music sounds good to the ear, makes your feet go—want to dance. Art is art; paint, mud, music, words, anything. Art takes hold of you—sentiment, life, expression.[77]

Indeed, Inness saw all of the arts—painting, dancing, writing, and creating music—as one entity. In his worldview, a painting could effect a physical reaction on its viewer: it could "tickle the eye." Given the fact that, for Inness, art resembled music, it could also make "your feet go—want to dance." Along the same lines, according to Charles Fitzpatrick (the husband of Louise Fitzpatrick, who cared for Ryder in his later years), Ryder exerted so much effort when he painted that perspiration "poured in streams out of the top of his head." Moreover, as Ryder worked on the *The Lorelei* (early to middle 1890s and later), he would go about his room "singing the song of the Lorelei."[78] Inness's and Ryder's synesthesia—their association of images with physical movement and sound—suggests that they possessed an acute, intuitive appreciation for the role of the body as a vehicle for creative expression. It suggests that their work required the full investment of the somatic self: the capacity to touch, hear, move, and to see.

Other firsthand accounts of Inness at work help to press the point. They compare his work as a painter to the work of a dancer. Watkins, Inness's dentist, observed,

I have seen [Inness] stand in front of a picture and paint, with every nerve under tension, every muscle up under strain; he would be in a half-squatting position in front of the picture, painting like a boy at play, and quickly jump back about five or six or eight feet, bend down in a crouching position and again rush forward, brush in hand, and strain his eyes at the picture with such intensity that they would bulge from his head and his hair fairly stand on end.[79]

During a visit to Inness's studio, Sadakichi Hartmann recorded the artist's thoughts on affinities among creative fields. "It always needs the same thing in all the arts," Inness observed, "whether you work as a painter, sculptor, architect, or as actor or dancer." According to Hartmann, Inness "accompanied each word with an expressive gesture." He then rose from his chair and "pirouetted about the room," an extraordinary description for the actions of an elderly landscape painter. Hartmann added a final note from Inness: "'You need rhythm,' he said, 'and that must come from within. It cannot be taught. It must be there,' and he patted his chest."[80] Writing on the formation, during the Gilded Age, of paradigms of the modern American artist, Sarah Burns has used these kinds of highly theatrical descriptions (of which there are many) to show how Inness embodied the "sick genius" type. Inness's epilepsy and Swedenborgianism, in addition to his small stature, black eyes, and shaggy hair, all contributed to this reading.[81] I would like to suggest that all of this physical activity served a *constructive* purpose: although clearly not a dancer by trade, Inness, through his physical activity, through what we might term his "painting performances," embodied knowledge and experience in his canvases.

Inness's repeated references to the work of the musician and dancer seem surprising when considered in the context of late-nineteenth-century American landscape painting. They are far less unusual when compared, in a broader sense, to the work of other artists who regularly embody knowledge through their activities. Dance is, by its very nature, a form of embodied expression. Every gesture, every move, every expression of the dancer aspires to convey an idea or an emotion. The body of the dancer becomes a form of communication in itself. James Nelson takes this idea one step further. "The body is language," he writes. "As such, the body is not merely the necessary physical substructure through which the spoken and written word must come, as if the body were only vocal chords or fingers on typewriter keys. The body can be word itself."[82] Nor is the sense of inspiration that Inness seems to have felt when he rose from his chair and "pirouetted about the room" unusual in the context of embodied expression. During one interview, Tony Barrand, who studied and performed with the Mark Morris Dance Company for over twenty-five years, described the heightened experience of "being danced," that is, of experi-

encing the sense that the music or dance is performed not by but *through* the dancer. "It is not you but the spirit moving through you; something else is directing," he explained."[83]

Rebecca Sachs Norris links Barrand's experience to what Mihaly Csikszentmihalyi has described as the experience of "flow," a quest for expression that sublimates and at times even causes the disappearance of the self.[84] She notes that it "also occurs among musicians."[85] Indeed, the conflation of senses that Inness experienced when painting is not unusual at certain peak moments for musicians. In *Ways of the Hand*, the ethnographer, social psychologist, and pianist David Sudnow (1939–2007) describes his study of jazz in a kindred fashion. At the beginning, Sudnow feels awkward. His fingers fumble on the keys. He fails to absorb a sense of the distinct rhythms of the music. As his study progresses, however, he becomes immersed in the style. He relies less and less on his sense of sight—that is, looking at his fingers or a musical score—and more on his physical connection to the piano. Soon, he begins to conflate the senses; synesthesia takes over. His fingers, extraordinarily enough, seem to him capable of speech. "But standing back," he recalls, "I find that I proceed through and in a terrain nexus, doing singings with my fingers, so to speak, a single voice at the tips of the fingers." In his most advanced state, Sudnow, like Inness, has engaged his entire body in the creative process: "I sing with my fingers, so to speak, and only so to speak, for there's a new being, *my body*, and it is this being (here, too, so to speak) that sings."[86]

The Power of Touch and of "Vitality Affects"

Haptic visuality is distinguished from optical visuality, which sees things from enough distance to perceive them as distinct forms in deep space: in other words, how we usually conceive of vision. Optical visuality depends on a separation between the viewing subject and the object. Haptic looking tends to move over the surface of its object rather than to plunge into illusionistic depth, not to distinguish form so much as to discern texture.—Laura U. Marks[87]

I cannot forget . . . that it is through my body that I go into the world. —Maurice Merleau-Ponty[88]

The works of Ryder, Thayer, and Inness suggest that all three artists were intuitively aware of and exploited the communicative power of the body,

specifically, the power of touch. Psychologists have extensively investigated the central role of touch in human interactions; their work provides insight into universal modes of expression that undergird the unusual practices of the three artists. They have shown that the sense of touch functions in a variety of important ways in our lives.[89] It allows us to communicate with one another, to gain compliance, to convey status and power, to create attachments, and to express or reject intimacy. For example, in one experiment having to do with compliance, half of the participants were touched on the shoulder during the request to fill out a questionnaire and the others were not. The experiment showed that the former group spent significantly more time completing the request than the latter group.[90] The sense of touch is also necessarily associated with the body, specifically, with the boundaries of the body, or where the body meets the world. Matthew Ratcliffe writes that "by means of touch, we explore entities through the ways in which they come into contact with our boundaries."[91] In having awareness of our bodies (a sense of proprioception), we have a sense of touch. Building on research that has confirmed the central role of touch as a means of human communication, I would like to suggest that through their especially tactile means of production, these artists capitalized on a form of knowledge common to us all, one that transcends historical time and location, and that forms the basis of our fundamental heuristic processes. They may have turned to it, consciously or not, to stake new claims for American painting.

The powers of haptic perception and proprioception that the dancer and musician employ create a useful comparison with the capacity of the artist—also working in a non-linguistic world—to convey ideas through his physical relationship to his art. The artist who has chosen not to depict imagery gleaned exclusively through optics, nor to rely on landscape schemata, employs alternate sensory means of assimilating and conveying knowledge. The artist who occasionally paints with his fingers, who incorporates tactile "foreign matter" into his work, who uses the brush in an impactful way, or who abandons the brush for a more aggressive relationship to the canvas with a broom or stick uses the body to process ideas—and to convey them to the canvas. He orients himself in the world through his physical actions.[92] Given this context, how might we interpret the physicality of the swept brushstrokes, scratchings, and slurries of paint

in the canvases of Ryder, Thayer, and Inness? How do these marks "communicate" to the viewer? Again, psychological research provides guidance. From the time we are young, we learn about the world through "vitality affects," which Daniel Stern defines as "elusive qualities [that] are better captured by dynamic kinetic terms, such as 'surging,' 'fading away,' 'fleeting,' 'explosive,' 'crescendo,' 'decrescendo,' 'bursting,' 'drawn out,' and so on."[93] As with the "discrete" categories of affect, these "vitality affects" are essential to our development as sentient human beings. We perceive these qualities not in *what* is done to us but in *the manner* in which it is done. For example, vitality affects define *how* someone enters a room in which we are working or how someone shakes our hand (weakly, confidently, aggressively, and so on). They define the "'rush' of anger or joy" and the "accelerated sequence of thoughts" that James discussed in his essays on emotions. "Vitality affects" also embrace the idea of "an unmeasurable wave of feeling evoked by music."[94] For Stern, abstract dance and music are perfect examples of the expressiveness of vitality affects.[95] Unlike the more narrative dances of classical ballet, modern dance tends to value "a way of feeling, not a specific content of feeling."

In this context, we may revisit the works and lives of Ryder, Thayer, and Inness. As they grew older, each artist became decreasingly interested in narration. Each developed distinct pictorial practices that conveyed emotions or conditions of the self to the canvas. Each engaged physically—in Inness's case, almost like a dancer—with their art. (In an especially revealing moment, the artist confided to his son, George Inness, Jr., that he looked forward to a time when he could abandon even the materials of his art and produce something that, we imagine, would have the emotional impact of dance and music. In his words, he wanted, quite simply, to "paint without paint.")[96] Each artist capitalized on the power of what we might now call "pictorial vitality affects." For just as the "pauses between strokes" of a child's head are, according to Stern, crucially important in conveying an attitude toward that child, so, too, are the types of brushstrokes—long, short, thick, thin, delicate, forceful, dynamic, hesitant, loaded with paint or wax or foreign matter—crucially important in conveying the character of an artist's work. Pictorial vitality affects reside in the broom strokes of Thayer's *Stevenson Memorial*; they reside in the "daub of white" that could serve Ryder "as a robe to Miranda." They reside in the synoptic forms,

stippled marks, and scored lines of Inness's late landscape paintings. The power of these pictorial vitality affects emerged in some critical reactions. One critic of an early Inness landscape disdained its excessive "mannerism" and felt that the lack of distinction between foreground and middle ground "wounds the eye" of the viewer.[97] In this case, it was not the subject of the painting that offended. Rather, it was the manner of expression that functioned in such a profoundly communicative (and disturbing) way.

Forming an "Original Relation" to the Canvas

Until the late nineteenth century, American landscape painting was, by and large, ideologically based. The Hudson River School looked to the works of Claude Lorrain and Salvator Rosa, of John Constable and J.M.W. Turner, for reliable schemata on which to build new, American contributions to the genre. The art and aesthetics of John Ruskin guided artists of the New Path and generated a widespread following in America. Toward the end of their lives, however, some American landscape painters —among them, Ryder, Thayer, and Inness—thought about their work anew. Inspired by the vitality of the European painterly tradition, they sought to develop what Emerson might have termed "an original relation to the canvas." This "relation" coincided with the Gilded Age's treatment of the body as a political, social, economic, and even philosophical entity; it coincided with psychology's view of the body as a conduit for the expression and even creation of emotions.

Without announcing their new interests, the American artists turned to haptic perception for new aesthetic guidelines. With their slurries of paint, stippled marks, scored and scratched lines, fingerprints, and use of wax and bitumen, they engaged their bodies, sometimes almost like dancers, in the act of painting. They created original pictorial effects that aligned with non-linguistic "vitality affects," that is, subtle behavioral qualities to which we become attuned throughout our life but that we tend to discount or overlook in favor of the more socially acceptable skills of optical perception and verbal expression. With their work, a new space opened for artists, one oriented less toward the public world of visible reality and more toward the protean, private world of the self. Artists worked with renewed freedom and developed even more intimate, intuitive relationships with their canvases, ones that would help them to grapple with their rapidly

changing and highly indeterminate world. Would these artists have been surprised to learn that activities in this idiosyncratic space would come to dominate the history of art for the next century and beyond?

Notes

I would like to thank Nancy Siegel for inviting me to write for this publication and for handling the editorial logistics with skill and enthusiasm. I am also grateful to Sarah Burns, Diane Dillon, and Gregory Foster-Rice for inviting me to present a version of this text at the Newberry Library Seminar in American Art and Visual Culture in Chicago on 8 April 2011.

1. Sarah Schneckloth, "Marking Time, Figuring Space: Gesture and the Embodied Moment," *Journal of Visual Culture* 7.3 (December 2008): 279.

2. Robert Goodnough and Clement Greenberg, respectively, in Irving Sandler, *The New York School* (New York: Harper & Row, 1978), 15, 8.

3. Harold Rosenberg, "Hans Hofmann: Nature into Action," in *The Anxious Object* (Chicago: The University of Chicago Press, 1964), 158.

4. Angela Miller, et al., *American Encounters: Art, History, and Cultural Identity* (Upper Saddle River, NJ: Pearson, 2008), 557.

5. Cited in Mark Stevens and Annalyn Swan, *de Kooning: An American Master* (New York: Alfred A. Knopf, 2004), 292.

6. Miller, et al., *American Encounters*, 557. See also Marilyn Stokstad, *Art History* (Upper Saddle River, NJ: Pearson, 2008), 1135, on how Pollock's *Autumn Rhythm* (1950) and other works from this period "innovate in many ways," on the artist's "novel method of paint application," and on the way in which his works embody a "new level of physical involvement of the artist with his product."

7. Elizabeth Broun, *Albert Pinkham Ryder* (Washington, DC: Smithsonian American Art Museum, 1989), 174–76.

8. "Jackson Pollack [sic]," *California Arts and Architecture* (February 1944): 14; cited in Broun, *Albert Pinkham Ryder*, 175.

9. John Wilmerding, "Fire and Ice in American Art: Polarities from Luminism to Abstract Expressionism," in *American Views: Essays on American Art* (Princeton, NJ: Princeton University Press, 1991), 127.

10. On this topic, see Robert Herbert, "Method and Meaning in Monet," *Art in America* 67.5 (September 1978): 90–108.

11. Sarah Burns, *Inventing the Modern Artist: Art & Culture in Gilded Age America* (New Haven: Yale University Press, 1996). On the Whistler trial, see Linda Merrill, *A Pot of Paint: Aesthetics on Trial in* Whistler v. Ruskin (Washington, DC: Smithsonian Institution Press, in conjunction with the Freer Gallery of Art, 1992).

12. My perspective on this topic differs somewhat from that of Marc Simpson

in *Like Breath on Glass: Whistler, Inness, and the Art of Painting Softly*. I concur with Simpson's affiliation of Whistler and Inness for the kindred "sense of softness" in their works and for the fact that both artists tended to blur the details in their scenes. However, Simpson then aligns Inness with artists who "achieve these effects with indirect, mysterious means that minimize obvious traces of virtuosic brushwork from the picture's surface" (4). By contrast, I read Inness's brushwork—his stippled marks, slurries of paint, synoptic forms, scorings and scratchings with the brush handle—as extraordinarily virtuosic. While Simpson sees Inness's and Whistler's treatment of the canvas as "a technically challenging approach to picture-making, one that stands in quiet opposition to the direct, expressive paint-handling charac-teristic of much progressive painting in the decades around 1900" (4), I see Inness's handling of paint as very much a part of that progressive movement. My reading falls more closely in line with that of Joyce Hill Stoner in Simpson's catalogue. Stoner highlights the way in which Inness scrubbed the surfaces of some of his canvases with his brush. She reproduces a detail from Inness's *Niagara* (1889) that shows brush hairs embedded in the paint and cites the "labor-intensive" style of his work. Ultimately, though, Stoner returns to the theme of the catalogue, which is to link Inness to the "soft, thin, evanescent landscapes created by Tryon, Twachtman, and Whistler" (107). See Marc Simpson, "Painting Softly—An Introduction," and Joyce Hill Stoner, "Materials for Immateriality," in *Like Breath on Glass: Whistler, Inness, and the Art of Painting Softly* (Williamstown, MA: Sterling and Francine Clark Art Institute, 2008), 3–23 and 91–109, respectively.

13. After generations of mistreatment and abuse as unpaid laborers, children began to gain respect as a social group. They saw their first institutionalized form of protection established in the founding of The Society for the Prevention of Cru-elty to Children in 1875. The following year marked the founding of the National Consumers League, which ultimately became the most powerful anti-child-labor league in America. Families as a social group gained additional political authority after 1889, when Jane Addams and Ellen Starr founded Hull House in Chicago; it provided families in the community with extensive social services, including housing and day care. See A. R. Colón, with P. A. Colón, *A History of Children: A Socio-Cultural Survey Across Millennia* (Westport, CT: Greenwood Press, 2001), and William I. Trattner, *Crusade for Children: A History of the National Child Labor Committee and Child Labor Reform in America* (Chicago: Quadrangle Books, 1970).

14. Three of the many texts on this topic are Vincent J. Bertolini, "'Hinting' and 'Reminding': The Rhetoric of Performative Embodiment in *Leaves of Grass*," *English Literary History* 69.4 (Winter 2002): 1047–82; Rosemary Graham, "The Prostitute in the Garden: Walt Whitman, *Fanny Hill*, and the Fantasy of Female Pleasure," *English Literary History* 64.2 (Summer 1997): 569–97; and David Reyn-olds, *Walt Whitman's America: A Cultural Biography* (New York: Vintage Books,

1995), especially chapter 7: "'Sex Is the Root of It All': Eroticism and Gender" and chapter 8: "Earth, Body, Soul: Science and Religion."

15. Walt Whitman, *Leaves of Grass and Selected Prose*, edited and with an introduction by Scully Bradley (New York: Rinehart & Co., 1949), 80.

16. Quoted in Reynolds, *Walt Whitman's America*, 269–70.

17. See Sandra Runzo, "Dickinson's Transgressive Body," *The Emily Dickinson Journal* 8.1 (Spring 1999): 59–72. On Dickinson and homoeroticism, see Ellen Louise Hart, "The Encoding of Homoerotic Desire: Emily Dickinson's Letters and Poems to Susan Dickinson, 1850–1886," *Tulsa Studies in Women's Literature* 9.2 (Autumn 1990): 251–72. On the possibility that Dickinson was anorexic, see Heather Kirk Thomas, "Emily Dickinson's 'Renunciation' and Anorexia Nervosa," *American Literature* 60.2 (May 1888): 205–25.

18. Thomas Wentworth Higginson, "Emily Dickinson's Letters," *Atlantic Monthly* 68.4 (October 1891): 453.

19. See Michael Leja, *Looking Askance: Skepticism and American Art from Eakins to Duchamp* (Berkeley: University of California Press, 2004).

20. The phrase is William Wundt's. See Theodore Mischel, "Wundt and the Conceptual Foundations of Psychology," *Philosophy and Phenomenological Research* 31.1 (September 1970): 1–26.

21. Alexander Bain, *Mind and Body: The Theories of Their Relation* (London: Henry S. King, 1873), 131.

22. James based his chapter on "Habit" in *The Principles of Psychology* (1890; reprint New York: Dover Publications, 1950) on Bain's *The Emotions and the Will*. See Louis Menand, *The Metaphysical Club: A Story of Ideas in America* (New York: Farrar, Straus and Giroux, 2001), 354.

23. William James, "The Emotions," *The Principles of Psychology* 2:449. Originally published as "What Is an Emotion?" in *Mind* 9 (1884): 188–205. James also explored related ideas in "Are We Automata?" "The Spatial Quale," and "The Feeling of Effort." See William James, *Essays in Psychology* (Cambridge, MA: Harvard University Press, 1983).

24. James, "The Emotions," 2:450.

25. James, "What Is an Emotion?" 196.

26. Ibid., 197.

27. Ibid.

28. Ibid., 188.

29. Albert Pinkham Ryder to Harold Bromhead (an employee of Cottier & Co., of London and New York, Ryder's first dealer), 2 August 1901, Sherman scrapbook, Juliana Force Papers, Archives of American Art; quoted in Broun, *Albert Pinkham Ryder*, 123.

30. All quotations in this paragraph are from William Innes Homer and Lloyd

Goodrich, *Albert Pinkham Ryder: Painter of Dreams* (New York: Harry N. Abrams, 1989), 6. For Ryder's European influences, see the chapter, "Painting, Poetry, and the Creative Process," 51–60. Homer acknowledges two key sources here: Diane Chalmers Johnson, "Art, Nature, and Imagination in the Paintings of Albert Pinkham Ryder: Visual Sources" (paper delivered at the seventy-second annual meeting of the College Art Association of America, Toronto, Canada, February 23, 1984) and Dorinda Evans, "Albert Pinkham Ryder's Use of Visual Sources," *Winterthur Portfolio* 21 (Spring 1986): 21–40. Homer does link Ryder to Pollock but only to see both as isolated figures, as geniuses, working independently of the artists of their generation: "From Marsden Hartley to Thomas Hart Benton, from Arthur Dove to Jackson Pollock and beyond, [Ryder] remains alive—his dream transformed, but still vital—Albert Pinkham Ryder, a true American genius" (142).

31. Eric Rosenberg, "Albert Pinkham Ryder: A Kinder, Gentler Painter?" *Art History* 14.1 (March 1991): 129–35.

32. See Sheldon Keck, "Albert P. Ryder: His Technical Procedures," in Homer and Goodrich, *Albert Pinkham Ryder,* 182.

33. Broun, *Albert Pinkham Ryder,* 127.

34. Ibid., 122.

35. See Keck, "Albert P. Ryder," 175–84. Ryder is also known to have added aluminum to his paints.

36. Quoted in Broun, *Albert Pinkham Ryder,* 123.

37. See Gail Stavitsky, *Waxing Poetic: Encaustic Art in America* (Montclair, NJ: The Montclair Art Museum, 1999).

38. Quoted in Broun, *Albert Pinkham Ryder,* 124.

39. Ibid., 124–25.

40. Albert P. Ryder, "Paragraphs from the Studio of a Recluse," *Broadway Magazine* (September 1905): 10.

41. Keck, "Albert P. Ryder," 182.

42. Letter from Albert Pinkham Ryder to Mrs. Olin Warner, 3 April 1900; cited in Homer and Goodrich, *Albert Pinkham Ryder,* 205.

43. Quoted in Homer and Goodrich, *Albert Pinkham Ryder,* 187.

44. Salvator Anthony Guarino, "A Visit to Albert P. Ryder," a record dated 22 February 1919 of a visit to Ryder's studio in November 1907, typescript, reproduced in Homer and Goodrich, *Albert Pinkham Ryder,* 221. Ryder discussed the relationship of his work to Greek sculpture, specifically, the Venus de Milo: "its arms and nose have been knocked off but still it remains a thing of beauty because beauty was with it from the beginning; so why worry about my children?"

45. Ryder, "Paragraphs," 10.

46. Ibid., 11.

47. On creativity as an autotelic experience, see Mihaly Csikszentmihalyi, *Cre-*

ativity: Flow and the Psychology of Discovery and Invention (New York: Harper Perennial, 1996), esp. 121–26.

48. Ryder, "Paragraphs," 11.

49. Albert Boime, "Ryder on a Gilded Horse," *Zeitschrift für Kunstgeschichte* 56.4 (1993): 568.

50. Rockwell Kent, *It's Me O Lord; The Autobiography of Rockwell Kent* (New York: Dodd, Mead, & Co., 1955), 110; quoted in Ross Anderson, *Abbott Handerson Thayer* (Syracuse, NY: Everson Museum, 1982), 71.

51. Anderson, *Abbott Handerson Thayer*, 103.

52. Elizabeth Lee, "Therapeutic Beauty: Abbott Thayer, Antimodernism, and the Fear of Disease," *American Art* 18.3 (2004): 48.

53. Thayer quoted in ibid., 38.

54. Undated letter from Abbott H. Thayer to Gladys Thayer, Thayer Papers, Archives of American Art, Smithsonian Institution, D 200, Fr. 691; cited in Anderson, *Abbott Handerson Thayer*, 107.

55. According to Ross Anderson, "Thayer's methods were often unconventional in the extreme; today conservators continue to find dirt and other unlikely substances used as binder in his painting." See Anderson, *Abbott Handerson Thayer*, 71.

56. Ibid., 103.

57. Susan Hobbes, "Nature Into Art: The Landscapes of Abbott Handerson Thayer," *The American Art Journal* 14.3 (Summer 1982): 51. Note, too, that the connection to Ryder extends to the fact that John Gellatly, one of Ryder's greatest patrons, owned this painting.

58. Both quotations are from William James [Jr.], "Remembering Abbott H. Thayer," *The Christian Science Monitor* (4 May 1951): 8.

59. Anderson, *Abbott Handerson Thayer*, 105.

60. Barry Faulkner, *Sketches from an Artist's Life* (Dublin, NH: William L. Bauhan, 1973), 23–24; quoted in Anderson, *Abbott Handerson Thayer*, 105.

61. Anderson, *Abbott Handerson Thayer*, 105.

62. All quotations in this paragraph are from Wen Fong, "Chinese Calligraphy: Theory and History," in Wen Fong and Robert E. Harrist, Jr., *The Embodied Image: Chinese Calligraphy from the John B. Elliott Collection* (Princeton, NJ: The Art Museum, in association with Harry N. Abrams, New York, 1999), 29.

63. Michael Polanyi, *The Tacit Dimension* (London: Routledge & Kegan Paul, Ltd., 1967), 15–16.

64. Richard Shiff discusses the role of the iconic and indexical signs in abstract expressionist paintings in "Performing an Appearance: On the Surface of Abstract Expressionism," in Michael Auping, et al., *Abstract Expressionism: The Critical Developments* (New York: Harry N. Abrams, in association with Albright-Knox Art Gallery, 1987), 94–123.

65. I have defined and discussed the synoptic form in Inness's work in *George Inness and the Visionary Landscape* (New York: George Braziller, 2003), 38–42, and in "George Inness: Painting Philosophy" (PhD diss., Columbia University, 2005), 236–38.

66. James Elkins, "Marks, Traces, 'Traits,' Contours, 'Orli,' and 'Splendores': Nonsemiotic Elements in Pictures," *Critical Inquiry* 21.4 (Summer 1995): 845.

67. Frederick Stymetz Lamb, "Reminiscences of George Inness" (January 1917), reprinted in Adrienne Baxter Bell, ed., *George Inness: Writings and Reflections on Art and Philosophy* (New York: George Braziller, 2006), 219.

68. S.C.G. Watkins, "Reminiscences of George Inness, the Great Painter, as I Knew Him" (14 April 1928), reprinted in Bell, *Inness: Writings and Reflections*, 231–32.

69. On Turner's use of his fingers to paint: "There is evidence that Turner worked in paint with his fingers, both in water and oil media. In the case of water-colour medium he used the technique less after the 1820s. More late oil paintings show evidence of finger working than earlier ones, probably since Turner applied fewer glazes which conceal the application techniques in the later works. In paintings from the 1820s curved scratch marks are visible, apparently made by Turner's thumbnail. More than one contemporary of Turner's noted that he kept his thumbnail long for the purpose. He used the handles of brushes too, to make straighter, deeper, scratches. Works on paper were scratched with sharp points (pins?) as well as with brush handles and finger nails." See Joyce Townsend, *Turner's Painting Techniques* (London: Tate Gallery, 1993), 52–53. For a recent, excellent study of Titian's painting techniques, see Jody Cranston, *The Muddied Mirror: Materiality and Figuration in Titian's Later Paintings* (University Park: Pennsylvania State University Press, 2010).

70. Marco Boschini, "Breve instruzione per intender in qualche modo le maniere di gli auttori veneziani," prefacing *Le ricche minere della pittura veneziana* (1674), reprinted in Anna Pallucchini's edition of *La carta del navegar pitoresco* (Venice: Istituto per la collaborazione culturale, 1966), 752; reprinted in David Rosand, *The Meaning of the Mark: Leonardo and Titian* (Lawrence: Spencer Museum of Art, University of Kansas, 1988), 85.

71. Ibid.

72. Ryder, "Paragraphs," 11.

73. "Culture and Progress," *Scribner's Monthly* 18 (June 1879): 312; quoted in Broun, *Albert Pinkham Ryder*, 26.

74. "The American Artists," *New York Times* (8 March 1879): 5; quoted in Broun, *Albert Pinkham Ryder*, 26.

75. Broun, *Albert Pinkham Ryder*, 124.

76. Elliott Daingerfield, "A Reminiscence of George Inness" (March 1895), reprinted in Bell, *Inness: Writings and Reflections*, 200.

77. Inness quoted in George Inness, Jr., ed., *Life, Art and Letters of George Inness* (1917), reprinted in Bell, *Inness: Writings and Reflections*, 162–63.

78. Charles Fitzpatrick, "Ryder Remembered," reprinted in Kendall Taylor, "Ryder Remembered," *Archives of American Art Journal* 24.3 (1984): 9.

79. Watkins reprinted in Bell, *Inness: Writings and Reflections*, 231.

80. Quoted in Sadakichi Hartmann, "Eremites of the Brush" (June 1927), reprinted in Bell, *Inness: Writings and Reflections*, 229.

81. Sarah Burns, *Inventing the Modern Artist*, 114–15.

82. James B. Nelson, *Embodiment: An Approach to Sexuality and Christian Theology* (Minneapolis: Augsburg Publishing House, 1978), 35.

83. Conversation with Tony Barrand at Boston University, April 2001; quoted in Rebecca Sachs Norris, "Embodiment and Community," *Western Folklore* 60.2/3 (Spring-Summer 2001): 120.

84. Norris, "Embodiment and Community," n. 47.

85. Ibid., 120.

86. David Sudnow, *Ways of the Hand: A Rewritten Account* (Cambridge, MA: The MIT Press, 2001), 129–30.

87. Laura U. Marks, *The Skin of the Film: Intercultural Cinema, Embodiment and the Senses* (Durham, NC: Duke University Press, 2000), 162.

88. Maurice Merleau-Ponty, *Phenomenology of Perception*, trans. C. Smith (London: Routledge, 1981), 316.

89. Psychologists have focused the majority of their research on touch as it relates to infant development. They have shown how the power of touch allows us to navigate our earliest stages of life. In her prelinguistic world, the infant is highly alert to the ways in which she is held; her skin allows her to receive messages from the physical behavior of the person holding her. Skin belongs to a class of organs (exteroceptors) that pick up sensations from outside of the body. Receptors on the skin (forms of proprioceptors) are stimulated principally by the actions of the body. Ashley Montagu observed that even human embryos (organisms from conception to the end of the eighth week, which have no eyes and ears) possess a highly developed sense of touch. See Montagu, *Touching: The Human Significance of the Skin* (New York: Columbia University Press, 1971), 1–2, 82. Donald McIntosh reminds us that in the infant's world, ordinary divisions of awareness, such as perception, cognition, desire, and emotion, simply do not apply. "In perception," he states, "infants see (become optically aware) not only with their eyes but also with their fingers and tongues, and hear not only with their ears but also with their eyes." See McIntosh, *Self, Person, World: The Interplay of Conscious and Unconscious in Human Life* (Evanston, IL: Northwestern University Press, 1995), 35. Experimental psychologists Meltzoff and Borton, as well as Gibson and Walker, have shown that one-month-old infants optically recognize an object they have previously explored

orally through its texture (smooth vs. not smooth) and substance (hard or soft). See A. N. Meltzoff and R. W. Boren, "Intermodal Matching by Human Neonates," *Nature* 282 (1979): 403–4, and E. J. Gibson and A. Walker, "Development of Knowledge of Visual-tactual Affordances of Substance," *Child Development* 55 (1984): 453–60. For extensive, scientific analysis of haptic perception in infants, see Arlette Streri, Myriam Lhote, and Sophie Dutilleul, "Haptic Perception in Newborns," *Developmental Science* 3.3 (2000): 324–25, and Emily W. Bushnell and J. Paul Boudreau, "The Development of Haptic Perception during Infancy," in Morton A. Heller and William Schiff, eds., *The Psychology of Touch* (Hillsdale, NJ: Lawrence Erlbaum Associates, 1991), 139–61.

90. M. L. Patterson, J. L. Powell, and M. G. Lenihan, "Touch, Compliance, and Interpersonal Affect," *Journal of Nonverbal Behavior* 10 (1986): 41–50; quoted in Matthew J. Hertenstein, Julie M. Verkamp, Alyssa M. Kerestes, and Rachel M. Holmes, "The Communicative Functions of Touch in Humans, Nonhuman Primates, and Rats: A Review and Synthesis of the Empirical Research," *Genetic, Social, and General Psychology Monographs* (2006): 27.

91. Matthew Ratcliffe, "Touch and Situatedness," *International Journal of Philosophical Studies* 16.3 (2008): 306.

92. The historical background of ideas on the relationship between sight and touch in the acquisition of knowledge about objects is crucial to this discussion but too large to address here. However, any discussion of the topic in the modern era must begin with George Berkeley's *An Essay towards a New Theory of Vision (1709)*. Berkeley, who advanced a type of "subjective idealism," argued that everything exists in the mind or depends upon the mind for its existence. In his *Essay,* he held that the objects of sight and touch are distinct and incommensurable. For example, a building that we see in the distance and envision as small and round is actually large and rectangular when we touch it. There is, therefore, no direct correlation between the visual and the tactile. The Austrian art historian Alois Riegl extended Berkeley's discussion of optical and haptic knowledge in *Die Spätromische Kunstindustrie* (1901; reprint Darmstadt, 1973). Following Wölfflin's division of art history into two groups of qualities (linear vs. painterly, etc.), Riegl proposed the theory that human perceptual capacity is divided into two categories: the haptic, or tactile, which emphasizes touch, linearity, and shape, and the optical, which emphasizes vision, color, light, and shadow. Both touch and vision combine to produce information to the mind, which assimilates the information and produces, as Mike Gubser explains, "a sustained awareness of the continuous contours and borders of objects." For further analysis of Riegl's ideas, see Meyer Schapiro, "Style," in *Theory and Philosophy of Art: Style, Artist, and Society* (New York: George Braziller, 1999), 78–81, and Gubser, "Time and History in Alois Riegl's Theory of Perception," *Journal of the History of Ideas* 66.3 (July 2005): 451–74.

93. See Daniel Stern, *The Interpersonal World of the Infant: A View from Psycho-analysis and Developmental Psychology* (New York: Basic Books, 1985), 54–61. On the intimate connection between "vitality affects" in art and psychology, see C. Noland and S. A. Ness, eds., *Migrations of Gesture* (Minneapolis: University of Minnesota Press, 2008); quoted in Schneckloth, "Marking Time, Figuring Space," 280.

94. Stern, *The Interpersonal World of the Infant*, 55. Stern seems to be indebted here to the work of William James, who codified the idea that subjective psychic states and conditions, ones for which we have no real name, contribute to the process of shaping what we know and how we learn. See William James, "The Stream of Thought," in *The Principles of Psychology* 1:239. I have treated this subject as it relates to Inness's work in *George Inness and the Visionary Landscape* (New York: George Braziller, 2003), 53–64 and, in greater depth, in "George Inness: Painting Philosophy," 365–425.

95. Stern, *The Interpersonal World of the Infant*, 56.

96. Cited in Inness, Jr., *Life, Art, and Letters of George Inness*, reprinted in Bell, *Inness: Writings and Reflections*, 163.

97. "Editor's Table—National Academy of Design," *The Knickerbocker* 33.5 (May 1849): 468.

CONTRIBUTORS

TIM BARRINGER is Paul Mellon Professor and Director of Graduate Studies in the Department of the History of Art at Yale University. He has published and lectured widely on British art and visual culture, American art, and on art and empire. His books include *Reading the Pre-Raphaelites* (1998), *American Sublime* (with Andrew Wilton, 2002) and *Men at Work: Art and Labour in Victorian Britain* (2005). Exhibition-related publications include *Opulence and Anxiety* (2006), *Art and Emancipation in Jamaica* (co-edited, 2007) and *Before and After Modernism: Byam Shaw, Rex Vicat Cole, and Yinka Shonibare* (2010). He is co-curator of *Pre-Raphaelites: Victorian Avant-Garde* (Tate; National Gallery of Art, 2012–13) and is currently completing a book based on the 2009 Slade Lectures at the University of Cambridge, entitled *Broken Pastoral: Art and Music in Britain, Gothic Revival to Punk Rock.*

REBECCA BEDELL is an associate professor in the Art Department at Wellesley College. She is the author of the award-winning *The Anatomy of Nature: Geology and American Landscape Painting, 1825–1875* (2001), and a contributor to *Endless Forms: Darwin, Natural Science, and the Visual Arts* (2009). Her current book project is "Moved to Tears: Sentimentality and Anti-Sentimentality in American Art."

ADRIENNE BAXTER BELL is an assistant professor of art history at Marymount Manhattan College. Her scholarship centers on American art and social history from the Colonial period to the present with a focus on intersections among late nineteenth-century art, psychology, and spirituality. She is the author of *George Inness and the Visionary Landscape* (2003), which accompanied an exhibition of the same name that she curated for the National Academy Museum and the San Diego Museum of Art in 2003–2004, and "George Inness: Painting Philosophy" (Ph.D. diss., Columbia University, 2005). She also edited and introduced *George Inness: Writings and Reflections on Art and Philosophy* (2006).

KATHIE MANTHORNE is a scholar of art of the Americas, with particular expertise in the art of travel and exploration, and in women artists of the nineteenth century. She is completing a book that merges those interests: "Eliza Pratt Greatorex and her Artistic Sisterhood in the Age of Promise (1860s–1870s)." Another study-in-progress entitled "Sweet Fortunes" traces the trans-American artistic production surrounding the sugar and slave trade. Currently on the art history faculty at the Graduate Center, City University of New York, she frequently collaborates on exhibitions with museums—from the Smithsonian American Art Museum to the Museum of the City of New York. She is the author of *Tropical Renaissance: North American Artists Exploring Latin America, 1839–1879,* and monographs on James Suydam and Louis Rémy Mignot.

KENNETH JOHN MYERS is chief curator and curator of American art at the Detroit Institute of Arts, where he led the team that organized the reinstallation of the museum's collection of American art. Before joining the DIA, he was curator of American art at the Freer Gallery of Art. Earlier in his career, he taught at Middlebury College. He is the author of *Mr. Whistler's Gallery: Pictures at an 1884 Exhibition* (2003) and *The Catskills: Painters, Writers, and Tourists in the Mountains, 1820–1895* (1986). Major essays include "Thomas Cole and the Popularization of Landscape Experience in the United States: 1825–1829," in Marco Goldin, ed., *America! Storie di pittura dal Nuovo Mondo* (2007); "Art and Commerce in Jacksonian America: The Steamboat *Albany* Collection" in the *Art Bulletin* (September 2000); and "On the Cultural Construction of Landscape Experience: Contact to 1830," in David Miller, ed., *American Iconology: New Approaches to Nineteenth-Century Art and Literature* (1993).

DAVID SCHUYLER is Arthur and Katherine Shadek Professor of the Humanities and Professor of American Studies at Franklin & Marshall College. He is the author of *A City Transformed: Redevelopment, Race, and Suburbanization in Lancaster, Pennsylvania, 1940–1980* (2002), *Apostle of Taste: Andrew Jackson Downing 1815–1852* (1996), and *The New Urban Landscape: The Redefinition of City Form in Nineteenth-Century America* (1986), co-editor of *From Garden City to Green City: The Legacy of Ebenezer Howard* (2002), and co-editor of three volumes of *The Frederick Law Olmsted Papers.* He was an editor of the Creating the North American Landscape series at The Johns Hopkins University Press, has served as chair of the Pennsylvania State Historic Preservation Board, and is a member the Olana National Advisory Committee.

NANCY SIEGEL is an associate professor of art history at Towson University. She is the author of *River Views of the Hudson River School* (2009); *Within the Landscape: Essays on Nineteenth-Century American Art and Culture* (co-edited, 2005); *Along the*

Juniata: Thomas Cole and the Dissemination of American Landscape Imagery (2003); and *The Morans: The Artistry of a Nineteenth-Century Family of Painter-Etchers* (2001). In 2010 she co-curated *Remember the Ladies: Women of the Hudson River School* for the Thomas Cole National Historic Site. Her current book project is "Political Appetites: Revolution, Taste, and Culinary Activism in the Early Republic."

ALAN WALLACH is Ralph H. Wark Professor of Art and Art History and Professor of American Studies Emeritus at the College of William and Mary. He writes frequently about American art and art institutions and is the author of *Exhibiting Contradiction: Essays on the Art Museum in the United States* (University of Massachusetts Press). Wallach was the 2007 recipient of the College Art Association's Distinguished Teaching of Art History Award.

Numbers in **bold** denote illustrations. Figures are listed by page number, plates by plate number. Plates appear following page 170.

Above the Clouds at Sunrise, xiii–xiv, 53, 55, 67–70, 76–78, 82n22, **pl. 5**
abstract expressionism, 241, 282n64
Académie Julian, 171
Achenbach, Andreas, xii, 78; *Clearing Up, Coast of Sicily,* 76, 77, 83n31, **pl. 8**; *Storm of Cyclops Rocks, in the Straits of Gibraltar, Coast of Africa,* 76, 83n31
Adam and Eve, 29
Adams, Julia, 152–153
Adorno, Theodor, 115, 140
Alcott, Louisa May, 219
Alison, Archibald, *Essays on the Nature and Principles of Taste,* 91
Allen, Charles Curtis, 256
Allston, Washington, 120
American Academy of Fine Arts, 18, 126, 144n41
American Art-Union, 64, 67–68, 76, 127–128, **128**, 132, 134, 168, 186, 193–194, 223
American Institute, 162
American Light: The Luminist Movement 1850–1875, 122, **123**, 143n27, n30

American Revolution, 8, 33, 194, 237
Among the Trees, 199, **200**
Ancient Column Near Syracuse, **168**
Anderson, Ross, 255–256, 281n55
antebellum era, xv, 10, 85–86, 101–108, 112n43, 114n72, 165. *See also* Civil War
Appleton's Journal, 233, **234**
The Arch of Titus, 190, **191**
Ariadne, 132
art institutions, xv–xvi, 28, 42, 117–118, 124–134, 136–139, 206. *See also* American Academy of Fine Arts; American Art-Union; American Institute; Artist's Fund Society; Brooklyn Art Association; Century Association; Metropolitan Museum of Art; National Academy of Design; New-York Gallery of Fine Arts; New-York Historical Society; Pennsylvania Academy of the Fine Arts; Sketch Club; Society of American Artists; Tenth Street Studio Building; Union League Club
art instruction: Thomas Cole as teacher, 54, 57, 67, 78, 79n4, 158; for women artists, xvi, 151, 157–158, 160–164, 181n32, 223–224, 229. *See also* Durand, "Letters on Landscape Painting"

The Artist in the Country, 233, **234**
Artist's Fund Society, 138, 151, 170
Artists Sketching in the White Mountains, 233
Asher Brown Durand, **267**
Autumn, 198

Bain, Alexander, 245
Bancroft, George, 137
Barbizon School, 205–206, 228, 242, 262
Barrand, Tony, 272–273
Barringer, Tim, xii–xiii, xx
Barstow, Susie, xii, xvi, 151, 172–173, 177; *A Camp in the Adirondacks,* 173; *Clarendon, Vermont,* 172; *Landscape,* **174, pl. 17**; *Sketch from Nature, Pembroke, Mass.,* 172; *Sunset in the Woods,* 173
Bartow, Maria, xiii, 54–55
Bateman, Mary Agnes La Trobe, 165
Battery and Castle Garden, from *Old New York: From the Battery to Bloomingdale,* **221**
Baur, John, 118–120, 122, 124, 142n20, n22
Beach, Charles L. *See* Catskill Mountain House
Beacon Rock, Newport Harbor, **139, pl. 14**
Beckert, Sven, 117, 124–125, 130
Bedell, Rebecca, xiv–xv, xx
Beecher, Catherine, *Treatise on Domestic Economy,* 103, 105–106
Beecher, Catherine, and Harriet Beecher Stowe, *The American Woman's Home,* 103
Beers, Julie Hart, xvi, 151, 178, 230–231, 233; *Hudson River at Croton Point,* **230, pl. 26**
Bell, Adrienne Baxter, xviii, xx, 142n20
Bellows, Henry W., 137
Berkeley, George, Bishop of Cloyne:

An Essay towards a New Theory of Vision, 284n92; "Verses on the Prospect of Planting Arts and Learning in America," 33
Bierstadt, Albert, 117, 130, 195, 197, 204, 217; large-scale landscapes of, 119, 124, 144n36, 243, 269
Bigelow, John, 197
Bingham, George Caleb, *The Jolly Flat Boat Men,* 132
Blackburn, Henry, 201
Bloom, Hyman, 248, 280n30
Bogert, Mrs. James, 154
Boime, Albert, 252
Bolton-le-Moors (Bolton), 2–10, 14, 24–25, 31–32, 39, 41, 46
Bond, Ellen, 154–155
Booth, Edwin T., 197, 207, 211
Born, Wolfgang, *American Landscape Painting: An Interpretation,* 16
Boschini, Marco, 266, 268
Bourdieu, Pierre, 136
bourgeoisie, xv, 117, 124, 128, 130–131, 136, 139. *See also* middle class
Boyle, Ferdinand Thomas Lee, xii, 238; *Portrait of Eliza Greatorex,* **218**
Bridges, Fidelia, xii, 178, 231, **232**, 240n33
The Bridle Path, White Mountains, 171, 172, 183n60
British Institution, 28, 42
Brontë, Charlotte, 3, 47n7
Brontë, Emily, 3, 47n7
Brooklyn Art Association, 151, 172, 175, 252
Brooklyn Art School, 252
Brooklyn Eagle, 172–173, 217
Brooks, Mollie, 160–161; drawing book, **161**
Broun, Elizabeth, 242, 247, 270
Brown, J. Carter, 122
Bryant, William Cullen, xii, 1–2, 130–131, 137, 194, 197; *Among the Trees,*

199, 200; Cole funeral oration, 2, 16; "The Death of a Flower," 192, 213n14; McEntee funeral oration, 192; "Return of the Birds," 197–198

Bunyan, John, *Pilgrim's Progress*, 66–67

Burns, Sarah, 243, 272

Burr, Aaron, 132

Butler, Richard, 201

Byron, George Gordon, Lord, *Childe Harold's Pilgrimage*, 33

A Camp in the Adirondacks, 173

Capron, Mrs., *Landscape*, 165

Carr, Gerald, xiv, 53–54, 80n6, 81n16

Cary, Alice, *Clovernook, or Recollections of our Neighborhood in the West*, 104

Casilear, John, 136, 193, 209, 217

Cassatt, Mary, xviii, 220; *Young Mother Sewing*, 220

Catskill Mountain House, xiv, 69–70, 82n23, 154, 168; Church and, 64, 81n16; Thomas Cole and, 58–62, 73, 80n10, 81n13

Catskill Mountains: Church and, xiii–xiv, 54–57, 62, 64–69, 76, 78; Durand and, 134–136, 173; McEntee and, 187–188, 190, 195, 202, 210; Sarah Cole and, 166–168, 182n52; Thomas Cole and, xiii–xiv, 2, 17, 44, 54–55, 57–62, 67–68, 70, 75 (*See also* Cole, "Sunrise on Catskill Mountains"); travel to, 153, 171, 175, 178, 190; Walters and, 173, 175

Cedar Grove, 24, 46, 54–55, 56, 57, 61–62, 64, 67–68, 76, 82n21

Cedar Grove, Catskill, 56

Centennial Exhibition, Philadelphia, 171, 177

Century Association, 129, 133–134, 137, 139, 197, 203–204, 209

Chambers, William, *A Treatise on Civil Architecture*, 34

Chapman, John, *The American Drawing-Book*, 160

Chapman, Mary, 86

Chorley (Lancashire, England), 10–11, 14, 20, 24–25, 32, 39

Christ Appearing to Mary, 248

Christian Examiner, 105

Christian on the Borders of the "Valley of the Shadow of Death," Pilgrim's Progress, 66

Church, Frederic Edwin, xii–xiv, xvi, 81n16, 117, 133, 185, 195–196, 204, 231, 242–243, 269; *Above the Clouds at Sunrise*, xiii–xiv, 53, 55, 67–70, 76–78, 82n22, pl. 5; *The Arch of Titus*, 190, 191; *Cedar Grove, Catskill*, 56; *Christian on the Borders of the "Valley of the Shadow of Death," Pilgrim's Progress*, 66; *Cotopaxi*, 196; friendship with McEntee, 190–192, 208, 211; *The Heart of the Andes*, 78, 121, 124, 134, 196; *The Hooker Company Journeying through the Wilderness in 1636 from Plymouth to Hartford*, 66; *The Icebergs*, 122, 143n27, 231; *July Sunset*, 64, 65, 66; memorial paintings to Cole, 54, 67–69, 76–78; *Morning, Looking East over the Hudson Valley from the Catskill Mountains*, 68, 69, 82n22; *The River of the Water of Life*, 67; *Scene on Catskill Creek*, 64; *Storm in the Mountains*, 64, 65, 82n17, pl. 6; as student of Cole, 53–54, 57, 64–66; as teacher of McEntee, 186, 204–206; *To the Memory of Cole*, 67, 68–69, 82n20; *Twilight, "Short Arbiter 'Twixt Day and Night,"* 24; *Twilight among the Mountains*, 57, 58, 64, 80n7; *Twilight in the Wilderness*, 78; *View near Stockbridge, Massachusetts*, 66; *Winter Evening*, 66

Civil War, xv, xvii, 86, 103, 117–118, 124–125, 129–130, 185, 198, 201, 219, 236

Clarendon, Vermont, 172
Clark, Willis Gaylord, 152
Clearing Up, Coast of Sicily, 76, 77,
 83n31, **pl. 8**
Cleaveland, Henry, William Backus,
 Samuel D. Backus, Village and Farm
 Cottages, 102
Clouds, 211
Coach Fording a Stream, 166, **167**
Coe, Benjamin, 160
Cole, Elizabeth, 55
Cole, Emily, 55
Cole, James, 10, 16
Cole, Maria, 55
Cole, Sarah, xii, xvi, 166–170, 175,
 182n52, n54; Ancient Column Near
 Syracuse, **168**; Duffield Church, 167;
 English Landscape, 167; Landscape
 with Church, 167; A View of the Cats-
 kill Mountain House Copied from a
 Picture by T[homas] Cole, 167–168
Cole, Sarah (aunt), 9
Cole, Theddy (Theodore), xiii, 55, 57,
 64
Cole, Thomas, xii–xiii, xvi, xix; L'Alle-
 gro, 62; as American icon, 15–19;
 British tradition in, 19–25, 31–46;
 Catskills and (See Catskill Moun-
 tains); Column of Ancient Syracuse,
 168; The Course of Empire, series, xiii,
 30, 32–33, 35–39, 41–46, 55–56, 127,
 169 (See also specific titles); The Cross
 and the World, series, 62–63, 76; The
 Cross in the Wilderness, 62, **63**, 68;
 death of, 1–2, 53–55, 67–68, 133–134,
 170, 223; Distant View of Niagara
 Falls, 156; Elijah at the Mouth of the
 Cave, 62; "Essay on American Scen-
 ery," 18, 25, 31; Expulsion from the
 Garden of Eden, 29, 42; The Falls of
 Kaaterskill, **60**, 61; The Falls of Niag-
 ara, 28; Federalism of, 20–21, 23–24,
 32, 37, 46; From the Top of Kaaterskill

Falls, 61; historico-moral landscapes
 of, 42–43, 56, 62–64, 78, 81n14, 132–
 133; Home in the Woods, 77–78; Lake
 with Dead Trees (Catskill), 18, 59, 61;
 Mist over the Lower Country from the
 Catskill Mountains, 73, **74**, 75, 83n29;
 The Past, 25–26; Il Penseroso, 62; The
 Present, 25–26; religious influences
 on, 8–10, 64; socioeconomic influ-
 ences on, 2–8, 12–14; Study for "The
 Cross and the World: The Pilgrim of
 the Cross at the End of His Journey,"
 76, **78**, **pl. 9**; Sunrise in the Catskills,
 64; "Sunrise on Catskill Mountains"
 (prose), 70–72, 82n26; A Tornado in
 the Wilderness, 29; Turner, influence
 of, 25–32; View from Mount Holyoke,
 Northampton, Massachusetts, after a
 Thunderstorm (The Oxbow), xiii, 31;
 View near Catskills, 61; View near the
 Village of Catskill, **61**; View of Monte
 Video, the Seat of Daniel Wadsworth,
 Esq., 20–21, **22**, 23–24, **pl. 2**; View of
 the Cattskill Mountain House, 58, **59**;
 View of the Round-Top in the Catskill
 Mountains, 75, **pl. 7**; A View of Two
 Lakes and Mountain House, Catskill
 Mountains, Morning, 62, 81n13; View
 on the Catskill—Early Autumn, 62;
 The Voyage of Life, series, 132–134;
 The Whirlwind, 64, 82n17; "The
 Wild" (poem), 70–73, 75, 82–83n27
Cole, Thomas, Jr., 55
Colman, Samuel, 130, 197
Colman, William A., 18
Columbian Exposition, 171–172
Column of Ancient Syracuse, 168
Coman, Charlotte Buell, 178
Connolly, Mary: New York from Wee-
 hawk (after Hill), 159–160
Constable, John, xii, 3, 33, 35, 37, 43–44,
 276; Hadleigh Castle: The Mouth of
 the Thames—Morning after a stormy

night, 43, **45**; *The Opening of Waterloo Bridge ("Whitehall Stairs, June 18th, 1817")*, 37, **38**; *Stonehenge*, 35, **36**

Cook, Edith Wilkinson, 178

Cooper, Susan Fenimore, *Rural Hours*, 104–105, 113n61

Copley, John Singleton, 120, 203

Corot, Camille, xvii, 203, 206, 247

Cotopaxi, 196

The Course of Empire, series, xiii, 30, 32–33, 35–39, 41–46, 55–56, 127, 169

The Course of Empire: Arcadian, or Pastoral State, 35, **36**

The Course of Empire: The Consummation of Empire, 36–37, **38**, 39, 41

The Course of Empire: Desolation, 43, **45**

The Course of Empire: Destruction, **41**, 42

The Course of Empire: The Savage State, 34, **35**

Cozzens, A. M., 136

The Crayon, 129, 132–134, 136, 138, 164, 182n44, 183n30, 194. *See also* art institutions

Crayon Art Gallery, 262

Crompton, Samuel, 6, 10. *See also* textile industry

Croome, William: *A Pic-Nic on the Wissahickon*, 162, 181n34

Cropsey, Jasper, 130, 134, 170, 223

The Cross and the World, series, 62–63, 76

The Cross in the Wilderness, 62, **63**, 68

Cruickshank, George, xii; *Massacre at St. Peter's or "Britons strike home"!!!*, **8**, 9

Csikszentmihalyi, Mihaly, 273, 281n47

Cumberland Terrace, 39, **40**

Cummings, Thomas S., 190

Currier & Ives Company, 151, 159–160, 163

Daingerfield, Elliott, 270

Daniels, Stephen, 4, 47n8, 49n33, 51n72

Darrah, Ann Sophia Towne, 178

Darwin, Erasmus, *The Botanic Garden*, 157

The Death of Jane McCrea, 132

The Decline of the Carthaginian Empire, 39

Degas, Edgar, 220

de Kooning, Willem, 242

Despard, Matilda, 227–228

Dickinson, Emily, 244, 246, 279n17

Dido Building Carthage, or the Rise of the Carthaginian Empire, 37, 39

DiMaggio, Paul, 126, 129, 131

Dissenting tradition, 6, 8–10, 17, 28

Distant View of Albany, 225, **pl. 24**

Distant View of Niagara Falls, 156

The Distribution of the American Art-Union Prizes at the Tabernacle—Broadway, New York, 24th December 1847, **128**

Douglas, Ann: *The Feminization of American Culture*, 101–102

Dove, Arthur, 248

Downing, Andrew Jackson, xii, xiv–xv, 85–86; *The Architecture of Country Houses*, 88, 94, **95**, **96**, **99**; associationist theory and, 91, **92**, 93–94; *Cottage Residences*, 88, 90, 102, **103**; environmental determinism and, 96–97; "home expression" and, 87, 110n10; "moral influence" and, 87, 96–97, 101, 108, 110n10; Newburgh, New York, and, 101, 106–107; "rural improvement" and, 87, 101–102; sentimental domestic architecture of, xiv–xv, 85–90, 108, 112n55; sentimental domestic horticulture of, 86, 93–94, **95**, 96–101, 104–105, 108; *A Treatise on the Theory and Practice of Landscape Gardening adapted to North America*, 88, 90, 98, 100, 109n5

The Drawing Class, **159**

Driscoll, John Paul, 138

Duffield Church, 167
Dunlap, William, 10, 29, 49n45, 164;
 History of the Rise and Progress of the
 Arts of Design in the United States,
 16–18, 30, 182n45
Durand, Asher B., xii–xviii, 41, 132,
 144n43, 150–151, 155, 169–170, 173, 197,
 267; Hudson River School style of,
 21, 119, 124, 138, 193, 196, 224, 266;
 Kindred Spirits, 1–3, 12; *Landscape*
 with Birches, 134, **135, pl. 12**; "Let-
 ters on Landscape Painting," 134,
 164–165, 183n58, 194; painted studies
 of, 133–136; *Study from Nature: Rocks*
 and Trees, **138**
Durand, John, 132, 146n71, 173

Eakins, Thomas, 121–122
Early Autumn, Montclair, 260, **261,**
 263–265, 268, **pl. 31**
Early Spring, 197, **199, pl. 22**
École des Beaux-Arts, 253
Eggleston, N. H., review of *Architec-*
 ture of Country Houses, 96–97
Ekersberg, Christian, 123
Elijah at the Mouth of the Cave, 62
Elkins, James, 264
Ellet, Elizabeth, *Women Artists: In All*
 Ages and Countries, 227
Emerson, Ralph Waldo, xviii, 259, 276
English Landscape, 167
Etretat, Normandy, France, 265
Evans, Dorinda, 165
Expulsion from the Garden of Eden, 29,
 42

Falconer, John, 170, 182n54, 223
The Falls of Kaaterskill, **60,** 61
The Falls of Niagara, 28
Faulkner, Barry, 259
Fawkes, Walter, Farnley Hall, 21,
 49–50n51
Fenner, Sears & Co., xii

Ferber, Linda, 134, 156
Fickle Skies of Autumn, 209
The Fire of Leaves, 195, **197, pl. 21**
Fish, Hamilton, 137
Fisher, Alvan, *The Great Horseshoe*
 Fall, Niagara, 156
Fong, Wen, 259–260
Freer, Charles Lang, 260
Friedrich, Casper David, 123
From the Top of Kaaterskill Falls, 61
Fulton, Robert, 152

Gainsborough, Thomas, 11
Gérôme, Jean-Léon, 253
"Get Thee Behind Me, (Mrs.) Satan!",
 233, **235**
Gifford, Sanford Robinson, xii, xvii,
 115–116, 122, 124, 130, 134, 197, 217,
 231; death of, 202–204, 211; friend-
 ship with McEntee, 185–186, 190,
 214–215n49; memorial exhibition,
 203–204, 215n51; *Mist Rising at Sun-*
 set in the Catskills, 137, **pl. 13**; *The*
 Palisades, **116, pl. 10**
Gilded Age, xii, xiii, 199, 204, 242–243,
 272, 276
Gilmor, Robert, 26
Gilpin, William, 91
Ginevra, 211
Glen of the Downs, Ireland, 224
Godey's Lady's Book, 102, 104
Goodnough, Robert, 241
Goodrich, Lloyd, 246
Graham's Lady's and Gentleman's Maga-
 zine, 162
The Great Horseshoe Fall, Niagara, 156
Greatorex, Eliza, xvi–xviii, 151, 172,
 175–177, 217, **218;** *Battery and Castle*
 Garden, **221;** emigration from Ire-
 land, 219–222; family life of, 222–223,
 227–231; *Glen of the Downs, Ireland,*
 224; *Joseph Chaudlet House on the*
 Bloomingdale Road, 233, **236, pl. 27;**

Landscape near Cragsmoor, N.Y.,
229, 233–234, **pl. 25**; *Moonlight*, 222;
*Old New York: From the Battery to
Bloomingdale*, xviii, 237–238; and
outdoor landscape painting, 219,
228–231; poetry of, 225–226; *Ross
Castle, Killarney, Sketch from Na-
ture*, 226; *Sketch from Nature*, 226;
Somerindyke Lane, Perrit Mansion,
237; *Study from Nature*, 226; *Sum-
mer Etchings in Colorado* (illustrated
book), 177; training of, 224, 228;
travels to Europe of, 224, 228, 238,
240n36; *Tullylark near Pettigo, Ire-
land*, 224, 229; *Village in the North
Countrie, Ireland—Sketch from Na-
ture*, 226; *Wicklow Castle*, 224; and
work in New York, 222–224, 236–
238
Greatorex, Henry Wellington, 222–
223, 227
Greenberg, Clement, 241
Grey Day in Hill Country, 192, **193**,
pl. 20
Groombridge, Catherine, 165
Groombridge, William, 165
Guhl, Ernst, "Die Frauen in die
Kunstgeschichte," 150–151, 164, 178

*Hadleigh Castle: The Mouth of the
Thames—Morning after a stormy
night*, 43, **45**
Hale, Sarah, 102
Hammond, J. H., *The Farmer's and
Mechanic's Practical Architect*, 87
Harewood House, 21, **22**
Harewood House (J. Scott after J. M. W.
Turner), **22**
Harley, Joseph S., *Among the Trees*
(after McEntee), **200**
Harnett, William Michael, 121
Harper's Weekly, 149, 151, 171, 235
Hart, James, xvi, 151

Hart, William, xii, xvi, 224, 230; *Dis-
tant View of Albany*, **225**, **pl. 24**
Hartmann, Sadakichi, 272
Harvest, **249**, **pl. 28**
Harvey, Eleanor Jones, 134, 204
Hawthorne, Nathaniel, 194
Heade, Martin Johnson, 115–116, 118–
124, 130, 143n35
Healy, George, *The Arch of Titus*, 190,
191
The Heart of the Andes, 78, **121**, 124, 134,
196
Heely, Emma, 160, 162; *A Pic Nic
Party*, **162**
Hendler, Glenn, 85–86
Henry, Matthew, *Exposition of the Old
and New Testament*, 9. See also Dis-
senting tradition
Higginson, Thomas Wentworth, 244
Hill, John: *The Hudson River Portfolio*
(after William Guy Wall), 19; *New
York from Weehawk* (after Wall), 159,
180n28; *Picturesque Views of American
Scenery* (after Joshua Shaw), 19
Hoe, Robert, 136
Hofmann, Hans, 241
Home in the Woods, 77–78
Homer, William Innes, 246–247,
280n30
Homer, Winslow, xii, 119, 121–122, 171,
183n60, 233; *The Artist in the Country*,
233, **234**; *Artists Sketching in the White
Mountains*, 233; *The Bridle Path,
White Mountains*, 171, **172**; *The Sum-
mit of Mt. Washington*, 171; *Under
the Falls, Catskill Mountains*, 171
Honora, Kathleen, 219, 222, 238n8
*The Hooker Company Journeying through
the Wilderness in 1636 from Plymouth
to Hartford*, 66
Hoppin, William J., 132
The Horticulturist, 91, **92**, 102, 104
Howard, Matilda W., 102–103, 112n57

Howat, John K., xiv, 53–54, 137, 194

Howe, Daniel Walker, 201–202

Hubbard, Richard William, 83n31, 202–203, 217

Hudson River, 54, 186, 230; steamboat travel upon, 80n11, 88, 106, 152–154, 166, 179n6

Hudson River at Croton Point, 230, **pl. 26**

The Hudson River Portfolio (after Wall), 19, 159

Hudson River Scene, 175, **pl. 18**

Hudson River School, xi–xx; aesthetic principles of, 1, 117–118, 121, 124, 134, 139, 172, 176, 194–196, 224, 265–269, 276; challenges to principles of, 202–204, 206–207, 211–212; founding artists of, 116, 119, 121, 124, 186, 203–204, 210–211, 219; women artists of, 150, 172, 175, 178, 179n5, 219

Hudson River Valley, 1, 12, 20, 54, 68–69, 107, 176

Huntington, Daniel, xii, 132, 197, 211; *Asher Brown Durand,* 266–267; *Sibyl,* 132

Huntington, David, 122

The Icebergs, 122, 143n27, 231

impressionism, 117–119, 206, 215n55, 220, 242, 270

Inness, George, xii, xix, 219, 242–243, 247, 278n12, 285n94; and dance (*See* painting); *Early Autumn, Montclair,* 260, **261**, 263–265, 268, **pl. 31**; *Etretat, Normandy, France,* 265; *Landscape,* 264; *The Lorelei,* 246, 250, 271; *Old Aqueduct Campagna, Rome Italy,* 262, **263, pl. 32**; "synoptic form" in (*See* painting)

Inness, George, Jr., 270–271, 275

Inwood, W. & H. W., St. Pancras Church, 39, 40

Irving, Washington, 109n5; "The Legend of Sleepy Hollow," 86, 109n5

Italy, 21, 205, 210, 242, 262

James, Henry, 198; *The Ambassadors,* 229

James, William, *The Principles of Psychology,* 245–246, 249–250, 252, 275, 279n22, 285n94

James, William, Jr., 259

Jarves, James Jackson, 120

Jarvis, John Wesley, 158

Jay, John, 130

Jerome, Elizabeth, 178

Johnson, Eastman, 190, 197, 203, 206, 209

Johnston, James, 87

The Jolly Flat Boat Men, 132

Joseph Chaudlet House on the Bloomingdale Road, 233, **236, pl. 27**

July Sunset, 64, **65**, 66

Kaaterskill Clove, 1, 70

Kaaterskill Clove, **148**, 149, 150, 170, **pl. 15**

Kaaterskill Falls, 18, 56, 59

Karolik, Maxim, 119–120

Keats, John, "Sonnet VII," 12

Kelly, Franklin, xiv, 53–54, 77

Kensett, John, xii, xvii, 123–125, 130, 134, 185, 190, 197, 203, 206, 208, 217; "aestheticizing tendencies" and, 136–138, 147n84; *Beacon Rock, Newport Harbor,* **139, pl. 14**; *Long Neck Point from Contentment Island,* **125, pl. 11**; luminism and, 115–116, 122; memorial of, 139

Kent, Rockwell, 253, 255–256, 270

Kindred Spirits, 1, 3, 12

Kiss Me and You'll Kiss the 'Lasses, 220

Klein, Rachel, 127

The Knickerbocker, 102, 225–226
Købke, Christian, 123

labor: artist as laborer, 242, 250, 269; gendered division of, 106–107; Reconstruction and, 243–244, 278n13; Thomas Cole and, 4, 6, 10–11, 17, 63
La Farge, John, 197, 217, 243
Lake with Dead Trees (Catskill), 18, 59, 61
L'Allegro, 62
Lamb, Frederick Stymetz, 265–266
Lambinet, Edouard, 228–229
Lancashire, England. *See* Chorley
Landscape (Barstow), **174, pl. 17**
Landscape (Capron), 165
Landscape (Inness), 264
Landscape (Rogers), 165
Landscape and Waterfall, 165
Landscape near Cragsmoor, N.Y., **229,** 233–234, **pl. 25**
Landscape with Birches, 134, **135, pl. 12**
Landscape with Church, 167
Lane, Fitz Henry (Hugh), 115–116, 118–123, 142n26, 143n34; *Ships and an Approaching Storm Off Owl's Head, Maine,* 122, **123**
Late Autumn, 196
Latrobe, Benjamin, 180n20, 182n45; architectural drawings of, 158, 165; "An Essay on Landscape," 157–158
Lawson, Helen, *Landscape and Waterfall,* 165
The Leader of the Luddites, 6, **7.** *See also* Ludd, Ned; Luddite rebellions
Lear, Edward, 123
Leeds, 4, **5,** 9, **pl. 1**
Leon y Escosura, Ignacio de, 201
Levine, Jack, 248
Linwood, Mary, 160, 180n29
Livingston, Robert, 152

Llangollin in the County of Denbigh, from the Turnpike Road above the River Dee, 14, **15**
Locke, John, *Some Thoughts Concerning Education,* 96
London, England, 11–12, 26, 32, 37, 39–42, 50–51n68, 127, 222
Longfellow, Henry Wadsworth, 190
Long Neck Point from Contentment Island, **125, pl. 11**
The Lorelei, 246, 250, 271
Lorrain, Claude, 21, 23–24, 29, 35, 37, 43, 157, 166, 247, 276; *Seaport with the Embarkation of St Ursula,* 37
Loudon, Jane, *Gardening for Ladies,* 104–105
Loudon, John Claudius, 88, 91, 96, 112n55; "Expression of the End in View," 89–90
Ludd, Ned, 3, 6–8, 23, 41, 46
Luddite rebellions, xiii, 6, 8, 41, 47n7
luminism, xii, xiv–xvi; "aestheticizing tendencies" and, 117–118, 136, 140, 141n6 (*See also* bourgeoisie; middle class); conceptualization of, 115–117. *See also* art institutions; Heade; Kensett; Lane; Novak; Wilmerding

Magoon, Elias, 137
Maine, 83–84n31, 122–123, 190, 210, 228
Malthus, Robert, 37
Manthorne, Kathie, xvii–xviii, xx, 147n84, 156, 179n14
Marius Amid the Ruins of Carthage, 132
Marks, Laura U., 273
Marquand, Henry, 136
Martin, John, 29, 41–42, 50–51n68; *Adam and Eve,* 29; *Pandemonium,* 29; *Paradise Lost* (mezzotints), 29, 42; *Satan Presiding at the Infernal Council,* 29; *Seventh Plague of Egypt,* 42, 43, **pl. 4**

Martineau, Harriet, 154

Maryland Historical Society, 168

Massacre at St. Peter's or "Britons strike home"!!!, 8, **9**

Masten, April, 171

Matteson, Tompkins H., xii; *The Distribution of the American Art-Union Prizes at the Tabernacle—Broadway, New York, 24th December 1847*, **128**

McCall, Laura, 104

McEntee, Jervis, xii, xvi–xvii, 185–186, **187**, 211–212; *Among the Trees*, illustrations for, 199, **200**; *The Arch of Titus*, 190, **191**; *Autumn*, 198; *Clouds*, 211; critique of impressionism, 204–207; death of, 210–211; death of Gifford and, 202–204; decline in appreciation for works of, 207–210; *Early Spring*, 197, **199, pl. 22**; *Fickle Skies of Autumn*, 209; *The Fire of Leaves*, 195, **197, pl. 21**; friendships of, 190, 192; *Ginevra*, 211; *Grey Day in Hill Country*, 192, **193, pl. 20**; landscape paintings of, 192–201; *Late Autumn*, 196; *Melancholy Days*, 192, 196–197; *Mt. Tahawas, Adirondacks*, 196; *Over the Hills and Far Away*, 207; Rondout studio of, 188, **189**; "The Ruin" (poem), 187–188; as student of Church, 186, 204–206; "The Trailing Arbutus" (poem), 187; *Twilight, October on the Hudson*, 196; *Winter*, 211; *Winter in the Country*, 209–210, 216n75; *Winter Storm*, **205, pl. 23**; *The Woods and Fields in Autumn*, 196–197, 207

Melancholy Days, 192, 196–197

Mellen, Mary Blood, 178

Merleau-Ponty, Maurice, 273

Metropolitan Museum of Art, xv–xvi, 31, 126, 131, 136, 202–204

Metropolitan Sanitary Fair, 130, 137

middle class: aesthetic tastes of, 143n36,

157, 220, 243; Cole and, 16–17, 20, 32–33; Constable and, 32–33, 44; Dissenting tradition and, 8–9; home and, 97, 101, 106; Ryder and, 252

Miller, Angela, 32, 37, 116

Milton, John: *L'Allegro*, 62; *Paradise Lost*, 29, 42, 72, 83n28; *Il Penseroso*, 62

Minot, Louisa Davis, xii, 155–157; *Niagara Falls*, 155, **156, pl. 16**; "Sketches of Scenery on Niagara River" (essay), 155–156

Mist over the Lower Country from the Catskill Mountains, 73, **74**, 75, 83n29

Mist Rising at Sunset in the Catskills, **137, pl. 13**

Mitchell, Martha Reed, 219

Monadnock No. 2, 256, **257, pl. 29**

Monte Video, 20–21, **22**, 23–24, **pl. 2**

Moonlight, 222

Moran, Mary Nimmo, 170

Moran, Thomas, 117, 124, 177, 195, 198

Morning, Looking East over the Hudson Valley from the Catskill Mountains, 68, **69**, 82n22

Morse, Samuel, 164

Mount, Evelina, xvi, 151

Mount, William Sidney, xvi, 83n31, 151

Mount Holyoke Female Seminary, 159

Mount Monadnock, 256, **257**, 258–259, **pl. 29–pl. 30**

Mt. Tahawas, Adirondacks, 196

Myers, Kenneth John, xiii, xiv, xx

Nash, John, 32; Cumberland Terrace, 39, **40**

Nast, Thomas, xii; "Get Thee Behind Me, (Mrs.) Satan!", 233, **235**

National Academy of Design, 126, 129, 133–134, 137, 144n42, 190; women artists in, 151, 157, 168, 172, 175–176, 219, 222, 238

The New Englander, 96, 102

New Path artists, xviii, 243, 276

New York City, xv–xvii, 152, 154, 189, 195, 210, 222, 236; art market of, xvi, 20, 40, 42, 117, 120, 124–126, 132; Thomas Cole in, 24, 54–55. *See also* art institutions

New York from Weehawk (after Hill), 159–160

New York from Weehawk (after Wall), 159, 180n28

New-York Gallery of Fine Arts, 127, 144n44, 145n49

New-York Historical Society, 127, 155

Niagara Falls, 124, 136, 154–155, **156**, 179n10, **pl. 16**

Niagara Falls, 155, **156, pl. 16**

Nichols, George Ward, 262

Noble, Louis Legrand, 10–13, 16, 23, 166; *After Icebergs with a Painter*, 231

Norris, Rebecca Sachs, 273

The North American Review, 102, 155, 179n14

Novak, Barbara, 120–124, 142n20, 142n26, 143n26, 143n30

Ohio Cultivator, 102

Old Aqueduct Campagna, Rome Italy, 262, **263, pl. 32**

Old New York: From the Battery to Bloomingdale, xviii, 237–238

Olyphant, Robert, 137

The Opening of Waterloo Bridge ("Whitehall Stairs, June 18th, 1817"), 37, **38**

Osgood, Samuel, 137

Over the Hills and Far Away, 207

The Oxbow. See View from Mount Holyoke, Northampton, Massachusetts, after a Thunderstorm (The Oxbow)

painted sketch, xv, 118, 134, 136, 137–138, 208, **pl. 13**

painting: brushwork in, 204–205, 242–243, 247–250, 253–255, 259–265, 268–270, 278n12; as dance, xix, 241; 270–276; and poetry, 39, 72–73, 197–198, 203, 225, 280n30; stippled, scored marks in, xviii, 256, 262–265, 269, 274–276, 278n12, 281n55, 282n69; and synesthesia, 271–273; and "synoptic form," 262–263, 269, 275–276, 278n12, 282n65; and "vitality affects," 244, 273–276, 285n93

The Palisades, 116, **pl. 10**

Palmer, Frances (Fanny), 151, 159–160, 163, 181n35; *New York Drawing Book: Containing a Series of Original Designs and Sketches of American Scenery*, 163

Pandemonium, 29

Paradise Lost (mezzotints), 29, 42

The Past, 25

Payne, John Howard, "Home, Sweet Home," 90

Peabody, Emma Peale, *View on the Wissahiccon after Russell Smith*, 165

Peale, Charles Willson, 170

Peale, Harriet Cany, xii, xvi, 151, 170–171, 177, 178n2; *Kaaterskill Clove*, **148**, **149, 150**, 170, **pl. 15**

Peale, James, 170

Peale, Rembrandt, xvi, 151, 170, 178n2; "Notes on the Painting Room," 183n58

Pendlebury, Jonathan, 9

Pennsylvania Academy of the Fine Arts, 151, 165, 170, 172, 182n45

Il Penseroso, 62

Perrit Mansion at 76th Street in Bloomingdale (after Greatorex), **237**

Peterson, Charles J., "The Pic Nic: A Story of the Wissahickon," 162

Phelps, William Preston, 256

Pickering, Henry, 186–188

A Pic-Nic on the Wissahickon, 162, 181n34

A Pic Nic Party, **162**

Picturesque Views of American Scenery (after Shaw), 19

plein air studies, 134, 158, 176, 192, 219, 226, 228. *See also* sketching

Polanyi, Michael, 260

Pollack, Deborah, 176, 183nn62–63

Pollock, Jackson, xviii, 241–242, 277n6, 280n30

Pope, Alexander, 99, 112n49

Portrait of Eliza Greatorex, 218

The Present, 25–26

Price, Uvedale, 91

Prieto, Laura, 171

Proust, Marcel, *À la recherche du temps perdu*, 251

Putnam, George P., 137

Rain, Steam and Speed, 4

Ratcliff, Matthew, 274

Reed, Luman, 126–127, 144n43. *See also* New-York Gallery of Fine Arts

Reynolds, David, 244

Reynolds, Sir Joshua, 98

Richardson, Mrs. Samuel, 165

Rilke, Rainer Maria, 241

The River of the Water of Life, 67

Robinson, Theodore, 253

Rogers, Hannah, 153

Rogers, Sarah, *Landscape*, 165

Romanticism: British influence on Thomas Cole, 2–3, 12, 19, 25, 28, 35, 44, 110n13; of Hudson River School artists, 118, 153, 157, 172, 175–176, 225–227, 246, 252. *See also* sublime

Rondout, NY, 187–189, 195, 198, 201, 207, 210–211

Rosa, Salvator, 34–35, 166, 276

Rosenberg, Eric, 247

Rosenberg, Harold, 241

Ross Castle, Killarney, Sketch from Nature, 226

Rossiter, Thomas, 136, 217

Rousseau, Theodore, 203

Royal Academy, 17, 26, 42

Rubinstein, Charlotte Streifer, 166

Rush, Benjamin, 164

Ruskin, John, xviii, 12, 31–32, 131, 133, 164, 278n11; *Modern Painters*, 13–14; "truth to nature," 134, 170, 194, 213n24, 276

Ryder, Albert Pinkham, xii, xix, 121, 242–243, 246, 273, 275–276, 280–281n44, 280n30, 281n57; artistic practice of, 247–252, 256, 266, 268–271, 280n35; *Christ Appearing to Mary*, 248; *Harvest*, 249, **pl. 28**; *The Lorelei*, 246, 250, 271; "Paragraphs from the Studio of a Recluse," 250–251, 268, 270; *Spring*, 270; *The Story of the Cross*, 249; *The Tempest*, 268–269

St. Pancras Church, 39, 40

Sandby, Paul, *Llangollin in the County of Denbigh, from the Turnpike Road above the River Dee*, 14, **15**

San Francisco Art Association, 175

Sarah Peter's Philadelphia School of Design for Women, 171

Satan Presiding at the Infernal Council, 29

Sawyer, Gertrude, 188–189, 204

Scene on Catskill Creek, 64

Schneckloth, Sarah, 241

Schuyler, David, xvii, xx, 112n57, 178

Scott, Walter: *The Lady of the Lake*, 11; *Minstrelsy of the Scottish Border*, 11; *Waverly*, 11

Scribner's Monthly, 165, 270

Seaport with the Embarkation of St Ursula, 37

sentimentality, 85–86, 108, 108n2, 114n72; and American home, 90–91, 110n19; and domestic architecture, horticulture (*See* Downing)

Seventh Plague of Egypt, 42, **43**, **pl. 4**

Ships and an Approaching Storm Off Owl's Head, Maine, 122, **123**

Sibyl, 132

Siegel, Nancy, xvi, xix, 212, 277
Simon, Janice, 133
Sketch Club, 223–225
Sketch from Nature, 226
Sketch from Nature, Pembroke, Mass., 172
sketching: excursions, 57, 190, 192, 195, 210, 216, 218 (*See also* plein air studies); instruction, 163–164; women artists and, 156–158, 175, 177, 178n2, 229–231, 233
Smillie, James, *Youth* (after Cole, Thomas), 132
Smith, Oliver, *The Domestic Architect*, 102
Snow Storm: Hannibal and His Army Crossing the Alps, 27, 31, 42, **pl. 3**
Society of American Artists, 206, 270. *See also* art institutions
Somerindyke Lane, Perrit Mansion, **237**
The Southern Planter, 102–103
Spencer, Lilly Martin, xviii, 220; *Kiss Me and You'll Kiss the 'Lasses*, 220
"The Splendid Safety Barges" (trade card), **153**. *See also* Hudson River
Spotswood, Susan Catherine, 157–158
Spring, 270
Stebbins, Emma, 219
Stebbins, Theodore, 120, 122, 143n35
Stedman, Edmund Clarence, 201, 204
Stern, Daniel, 275, 285n94
Stevenson Memorial, 253, **254**, 255, 275
Stillman, William, 132, 146n71
Stoddard, Richard Henry, 201, 204
Stonehenge, 35, **36**
Storm in the Mountains, 64, **65**, **pl. 6**
Storm of Cyclops Rocks, in the Straits of Gibraltar, Coast of Africa, 76, 83n31
The Story of the Cross, 249
Stuart, Gilbert, xvi, 165
Stuart, Jane, xii, xvi, 151, 165–166; *Coach Fording a Stream*, 166, **167**
Study for "The Cross and the World: The

Pilgrim of the Cross at the End of His Journey," 76, **78**, **pl. 9**
Study from Nature, 226
Study from Nature: Rocks and Trees, 138
Sturges, Frederick, 136
Sturges, Jonathan, 127, 129
sublime, 27, 78, 116, 155, 226; Cole and, 3–4, 17, 19–21, 25, 31, 34–35, 41. *See also* Romanticism
Sudnow, David, *Ways of the Hand*, 273
Sully, Rosalie Kemble, 165
Sully, Thomas, 165
The Summit of Mt. Washington, 171
Sunrise in the Catskills, 64
Sunset in the Woods, 173
Suydam, James A., 115, 147n84, 192
Swedenborg, Emanuel, 244
Sweeney, J. Gray, xiv, 53–54, 68, 82n20, 84n33, 116–117, 120, 140, 143n34
Swinth, Kirsten, 171

Tawney, R. H., 10, 48n118
The Tempest, 268–269
Tenth Street Studio Building, 129, 171, 186, 189–190, 202, 208, 217
textile industry, 2, 4–6, 10, 28, 39–40
Thayer, Abbott Handerson, xii, xix, 242–243, 252–255, 269–270, 273, 275–276; and Chinese calligraphy, 259–260; *Monadnock No. 2*, 256, **257**, **pl. 29**; *Stevenson Memorial*, 253, **254**, 255, 275; use of detritus, 256–257, 281n55; *Winter, Monadnock*, 256–257, **258**, 259, **pl. 30**; *Winter Landscape*, 255. *See also* Mount Monadnock; painting, brushwork in
Thayer, Dr. William Henry, 255
Thomson, John Alexander, xiii, 54–55, 57, 80n6, 81n14
Thoreau, Henry David, 259
Titian, 242, 266, 268–269, 282n69
A Tornado in the Wilderness, 29

To the Memory of Cole, 67, 68–69, 82n20

Troy Female Seminary, 159

Trumbull, Colonel John, 18, 126

Tuckerman, Henry T., 2, 143n34, 186, 192; *Book of the Artists: American Artist Life*, 2, 186

Tullylark near Pettigo, Ireland, 224, 229

Turner, J. M. W., xii, 3, 12–14, 41, 43, 49–50n51, 247, 266, 276, 282n69; *The Decline of the Carthaginian Empire*, 39; *Dido Building Carthage, or the Rise of the Carthaginian Empire*, 37, 39; influence on Cole, 25–32; *Leeds*, 4–5, 9, **pl. 1**; *Rain, Steam and Speed*, 4; *Snow Storm: Hannibal and His Army Crossing the Alps*, **27**, 31, 41–42, **pl. 3**; *Ulysses Deriding Polyphemus*, 26

Turner, Maria, *The Young Ladies Assistant in Drawing and Painting*, 163

Tuthill, Louisa: *History of Architecture from Earliest Times*, 103; *True Manliness; or, the Landscape Gardener*, 105–106

Twilight among the Mountains, 57, **58**, 64, 80n7

Twilight in the Wilderness, 78

Twilight, October on the Hudson, 196

Twilight, "Short Arbiter 'Twixt Day and Night," 24

Ulysses Deriding Polyphemus, 26

Under the Falls, Catskill Mountains, 171

Union League Club, 129–131, 137, 145n54; "Women Etchers of America," 169

The United States Magazine and Democratic Review, 102

Untitled (possibly Clarendon, Vermont), **176**, **pl. 19**

Vanderlyn, John, 132; *Ariadne*, 132; *The Death of Jane McCrea*, 132; *Marius Amid the Ruins of Carthage*, 132

Vaux, Calvert, xii, 131, 188, 201, 208; "McEntee studio and home, Rondout, New York," from *Villas and Cottages: A Series of Designs Prepared for Execution in the United States*, 189

Victoria and Albert Museum (South Kensington Museum), 131

View from Mount Holyoke, Northampton, Massachusetts, after a Thunderstorm (The Oxbow), xiii, 31

View near Catskills, 61

View near Stockbridge, Massachusetts, 66

View near the Village of Catskill, **61**

View of Monte Video, the Seat of Daniel Wadsworth, Esq., 20–21, **22**, 23–24, **pl. 2**

View of the Cattskill Mountain House, 58, **59**

A View of the Catskill Mountain House Copied from a Picture by T[homas] Cole, 167–168

View of the Round-Top in the Catskill Mountains, **75**, **pl. 7**

A View of Two Lakes and Mountain House, Catskill Mountains, Morning, 62, 81n13

View on the Catskill—Early Autumn, 62

View on the Wissahiccon after Russell Smith, 165

Village in the North Countrie, Ireland—Sketch from Nature, 226

Vincent, François André, 132

von Helmholtz, Hermann, 245

Voyage of Life, series, 132–134

Wadsworth, Daniel, 21, 57, 59, 62, 81n14, 223

Wall, William Guy, 19, 180n28

Wallach, Alan, xv, xvi, xix, xx, 8–9, 11, 24, 32

Walters, Mary Josephine, xii, 172–173,

175, 177, 183n66; *Hudson River Scene,* 175, **pl. 18**
Watkins, S. C. G., 265–266, 271
Weber, Max, 10, 48n18
Weir, John F., 190, 201–202, 204, 208, 211, 217; McEntee funeral address, 192, 210
Westminster Review, 150
Wheeler, Gervase, 97; *Homes for the People,* 102
The Whirlwind, 64, 82n17
Whistler, J. A. M., 243, 278n11
Whitman, Walt, xviii; *Leaves of Grass,* 244
Whittredge, Worthington, 119, 190, 192, 202, 204, 206, 208–212
Wicklow Castle, 224
Willis, Nathaniel Parker, 137
Wilmer, Rachel, 154, 179n10
Wilmerding, John, 120, 122–124, 143n30, 242; *American Light: The Luminist Movement 1850-1875,* 122, 123, 143n27, n30
Winchester, George, *Winchester's Drawing Series, in Four Books; accompanied by Exercises in Perspective,* 160, **161**
Winter, 211

Winter, Monadnock, 256–257, **258,** 259, **pl. 30**
Winter Evening, 66
Winter in the Country, 209–210, 216n75
Winter Landscape, 255
Winter Storm, 205, **pl. 23**
Wolf, Bryan Jay, 19–20
Wölfflin, Heinrich, 120, 142n22, 284n92
Woman's Work Exchange and Decorative Arts Society, 173
women artists. *See* art instruction; Hudson River School; *names of women artists*
Woodhull, Victoria, 233, **235**
The Woods and Fields in Autumn, 196–197, 207
Woodward, Laura, xii, 172, 175–177; *Untitled* (possibly Clarendon, Vermont), **176, pl. 19**
Wordsworth, William, 4, 25, 83n28
Wotherspoon, William Wallace, 224
Wright, Joseph: *A Blacksmith's Shop,* 14
Wundt, Wilhelm, 245

Young Mother Sewing, 220
Youth (after Cole, Thomas), 132